Created by
Geoff Blackwell & Ruth Hobday

Photographs by
Kieran E. Scott

————

US editor: Sharon Gelman

200
WOMEN

who will change the way
you see the world

————

Updated and Abridged

CHRONICLE BOOKS
SAN FRANCISCO

in association with
Blackwell&Ruth.

There is no 'us and them.' There's just us. People like us.

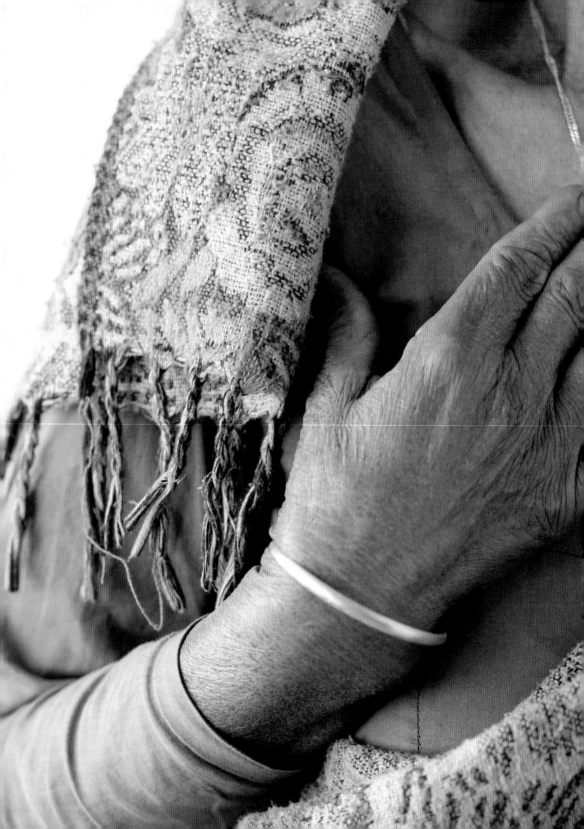

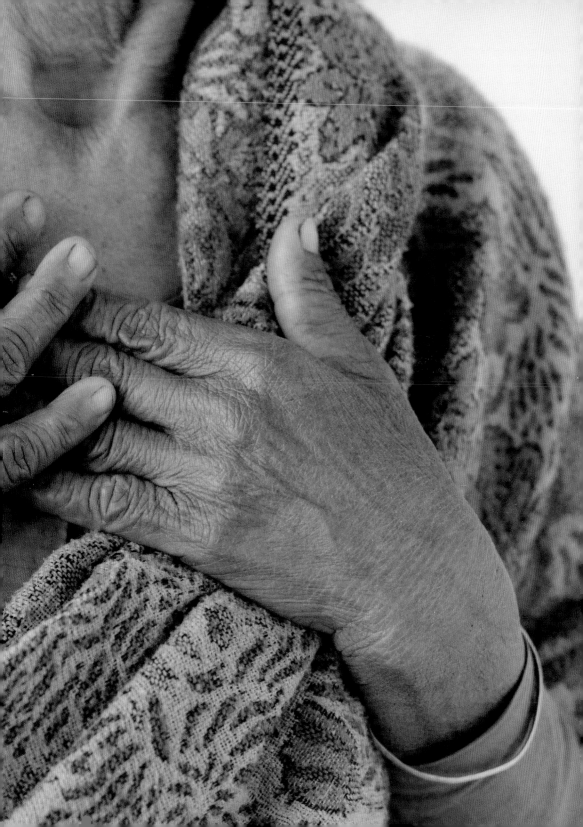

Contents

Introduction

Gloria Steinem once said, 'You can't empower women without listening to their stories.' We agree.

This book was inspired by that belief and our subsequent idea to persuade 200 women in different parts of the world – whether they be rich or poor, black or white, educated or uneducated, famous or unknown – to sit or stand in front of a plain sheet of fabric and to be photographed and filmed while answering five fundamental questions.

Our goal was not to make a book about just successful and powerful women; those stories are important, but we wanted diversity, and above all, authenticity. Two hundred 'real women' with 'real stories.'

We sought to cut away distractions and the visual context of each woman's life and to simply focus on her humanity as we asked:

What really matters to you?
What brings you happiness?
What do you regard as the lowest depth of misery?
What would you change if you could?
Which single word do you most identify with?

We travelled as a small, tight group. At every stop, we would set up our humble sheet of fabric in the quietest and lightest space we could find, from a dusty rooftop above the streets of Kolkata to a snow-covered art gallery in northern Sweden, to a Palestinian refugee camp in Beirut, to a hotel suite we could barely afford in New York, to a township in Cape Town where we were surrounded by beautiful kids who thought a Polaroid picture was a magic trick, to the earthquake-damaged hills of Nepal, to the leafy suburban streets of Sydney and to many other places.

With our backdrop in place, and a call for 'Quiet on the set,' one of us would begin asking each interviewee about her life and when they were ready, we would quietly ask our five questions, and we would listen.

The list of interviewees was a mix of well-known women and others we learned about as we researched and travelled. Many were introduced to us by generous

friends, friends of friends, colleagues and kindred spirits in various corners of the globe. Among them artists, activists, entrepreneurs and even an astronaut, alongside business leaders, a goat herder, a nurse and a brave Nepalese woman who has spent most of her life living on the streets of Kathmandu selling cigarettes – one at a time – to support her family.

Their responses simultaneously educated, humbled and inspired us. Some came from a place of deep sorrow, but over and over we encountered uplifting examples of kindness, selflessness, strength, wisdom, inspiration and the most compelling of all, truth. Writ large was the value, beauty and privilege of being able to just listen to these women, to truly see their humanity, and to recognize our own in doing so.

In the poorest places, we came face to face with the cruel and very real correlation between poverty and inequality. In those places we shed tears as we listened to the stories of girls trapped into the sex trade, married off to strangers at the age of ten or eleven, denied education and basic freedom, and subjected to all sorts of misery at the hands of men and a patriarchal culture that sadly is still very much in business.

Wherever we encountered these stories of 'us and them' there was almost always pain and division. But we also witnessed that when people truly see each other's humanity, beautiful things become possible.

Since the book was first published we have had the pleasure of meeting up again with many of the 200 women whose remarkable stories underpin this project, together with some new faces – six of whom we have the pleasure of introducing in this updated and abridged edition, including our own inspiring New Zealand prime minister, Jacinda Ardern.

Ultimately the lesson of creating this book, and now exhibitions, remains the same – that there are no ordinary women, and there is no 'us and them.' There's just us.

People like us.

– Geoff Blackwell and Ruth Hobday

Inna
Modja

———

Q. What really matters to you?

My life has never been perfect and it never will be, but I've decided that I deserve to be happy. I've realized that happiness is a day-to-day choice – no life is going to be perfect, so it's up to the individual to decide how they are going to react to a situation.

I'm the sixth of seven kids. When I was four, my family was living in Ghana, and my younger brother and I went to Mali with our mother for our holidays. When my mother was out one day, my grandmother's sister took me to a place where I was subjected to female genital mutilation. This happened without the knowledge of either of my parents; they are both vehemently against this practice. Looking back on this, as an adult, this is certainly something that forged my personality. I was always a feminist and had been raised a feminist by both my parents, but this instilled in me a desire to stand up for other women and to help them where I can. This desire is a part of my life and is a part of my art, and it made me into an activist. I consider myself very lucky to have had parents who always told my siblings and me that we were good enough – that we were worthwhile and could be whoever we wanted to be if we just put the work in. Having principles like that to guide you as a child is fundamental and is what formed the foundation of feminism for me.

Being an activist is about putting myself in the middle of what's going on in the field; it's about sharing my own story and bringing awareness to the issues I feel are important to deal with. I want to help by *doing*. My journey started in a place of pain, but it has become so important to transform that pain and let this event become something that can have positive effects through the sharing of it.

It baffles me that people continue to resist gender equality – with racial inequality, everyone can see the issues and seem far more willing to pursue change in this regard. I don't get it. To me, feminism is not about gender. It's about wanting equal rights for both women and men in the world, and equal opportunities for all. The world needs both women and men – feminism is not just women, for women, by women. Women are part of a greater societal context, so, if we want to improve our society, we need everyone working together for basic, equal rights.

Q. What brings you happiness?

I know that I cannot be completely happy if there is someone in need of my help; if I know that I can do something to change somebody's life, but am not doing it, I can't have peace. As an artist, I believe that the gifts I have, I have for a reason. People can choose to use their gifts in different ways; I choose to focus my energies on things that matter, things that will bring about some good – however small. That decision leads me to happiness.

And happiness is different things. It's a choice I make every day, asking myself, 'What is going to make me happy today?' It could be a nice lunch with my family, spending time with my husband, being with my friends or taking time to be by myself. So, great happiness is about being aware of my feelings and deciding that each day will be a good day, regardless of the baggage that goes with it.

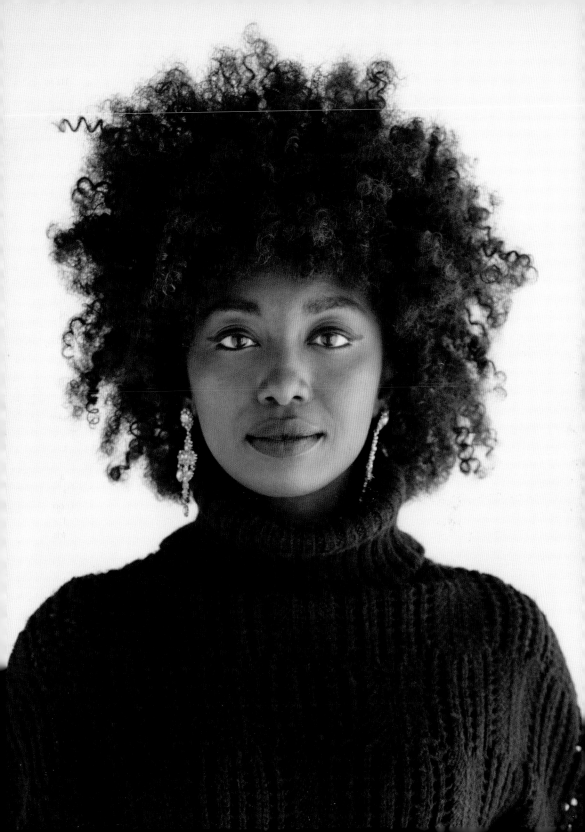

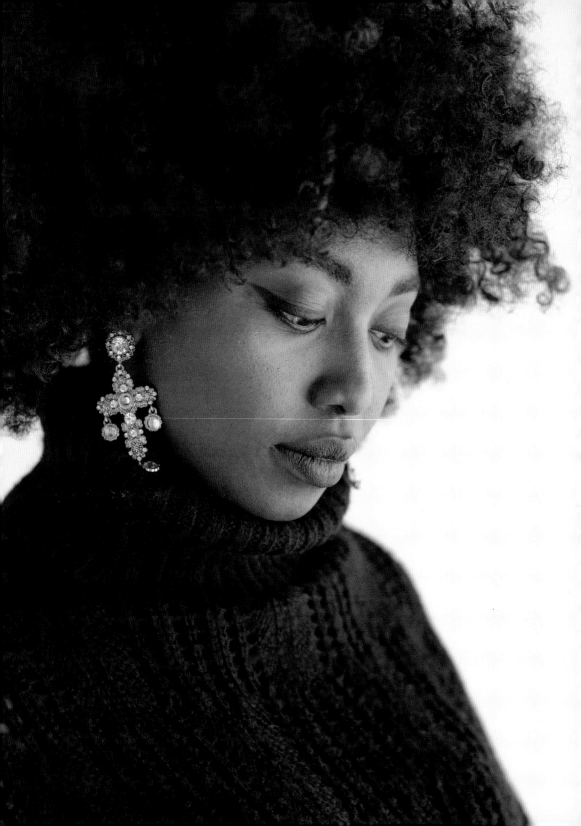

Inna Modja

'Love is vital and loving yourself is more vital still. It's important to be full of yourself sometimes – there's nothing wrong with that!'

Q. What do you regard as the lowest depth of misery?

There are many depths of misery, but I would have to say loneliness and inequality. In Mali, where I grew up, you look around you and see inequality everywhere. You see people in very difficult situations – this includes members of my own family – and what breaks my heart is that the capacity exists to address this current imbalance. Society *can* change the lives of people who have nothing, but we *choose* not to. It bothers me that, for whatever reason, nothing will be done for the sake of humanitarian reasons alone. I'm not anti-capitalism, but economic factors are more important than human factors. I see this everywhere. I'm not saying we need to overhaul society, but people need to be doing a lot more than is being done currently.

Some people need only open their tap to have access to clean water, but others walk six kilometres or more every day for clean water. It's usually women and children who do this, so that's less time in women's days to work and less time in children's days to educate themselves. I get so sad when I think of children being denied an education because of something like this. We all know that education is the key - countries will not rise and become independent if their future leaders are fetching and carrying water instead of being able to turn on a tap and return to their books. Our future is already in jeopardy, without the next generation failing to be educated.

Q. What would you change if you could?

I would change the perceptions most people have of themselves and make these more positive. I want to tell people, 'Just see yourself as you are and love yourself.' Love is vital and loving yourself is more vital still. It's important to be full of yourself sometimes - there's nothing wrong with that! Obviously, it's never good to be arrogant, but it is good to embrace who you are, accept who you are and love who you are. Because you will be able to have more love for others if you have love for yourself.

Q. Which single word do you most identify with?

Human. Whatever qualities I have and whatever flows I go through, I am just human.

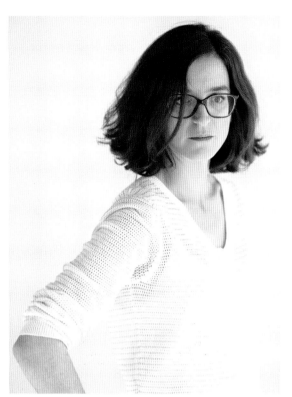

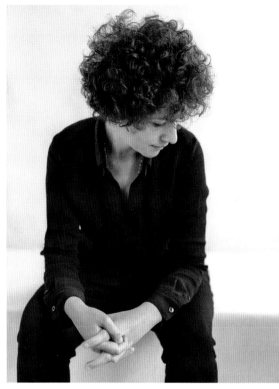

Camille Crosnier

———

Q. What do you regard as the lowest depth of misery?
I was really touched by the misery I saw when I spent three days in the Calais Jungle. I met people with histories, desires and interrupted life journeys. I met economists and athletes, people whose entire identities have been reduced to the term 'migrant.' I met a man who had travelled the entire way to Calais from Pakistan on foot.

Sasha Marianna Salzmann

———

Q. Which single word do you most identify with?
Silvia Calderoni once said in an interview that, to describe herself, she wished for a word that would transform or change its meaning every twenty minutes. I completely agree with her, and so without such a word, I'd choose 'transforming.'

'*Culot*' – nerve or courage

'Transforming'

Karen Walker

Q. What do you regard as the lowest depth of misery?
Unfairness, fear, people being angry for no reason, a lack of calmness and people not seeing the whole picture – I find the fear all this creates for others quite distressing.

Lennie Goodings

Q. What do you regard as the lowest depth of misery?
I have been very lucky, but I will say that I am devastated by the aggression – both verbal and physical – displayed in society towards women. It's devastating the number of days on which I open a paper and read that a woman has been murdered by a man in her life.

'Honesty'

'Grace'

Alicia
Garza

———

Q. What really matters to you?

I want to be able to tell my kids that I fought for them and that I fought for us. In a time when it's easy to be tuned out, it feels really important to me to be somebody who stands up for the ability of my kids – of all kids – to have a future.

The other thing that really motivates me is wanting to make sure we achieve our goals. As I was coming up as an organizer, we were told we were fighting for something we might never see in our lifetime. I'm just not satisfied with that; I think change can happen much faster, but it requires organization, and an understanding of power and how we can shift it from its current incarnation. We need to transform power, so that we're not fighting the same battles over and over again. This is what I wake up thinking about every single day. And every night when I go to sleep, I'm thinking about how we can get closer to it tomorrow.

Women inspire me to keep going. My foremost influence was my mother; she initially raised me on her own, having never expected to be a parent at twenty-six. She taught me everything I know about what it means to be a strong woman who is in her power. I'm also very much influenced by black women throughout history. I'm inspired by Harriet Tubman, not only for all the work she did to free individual slaves – which, of course, was amazing – but for everything she did to eradicate the institution of slavery, the alliances she built to do so and the heartbreaks she endured in

pursuit of her vision. And it's not only women in the United States who inspire me. In Honduras in 2016, Berta Cáceres was murdered while pursuing her vision of ecological justice and a better life for the people in Honduras being preyed upon by corporations and the United States government.

Black Lives Matter has been a big part of my activism. When it came onto the scene, there was a lot of pushback; people responded by saying, '*All* lives matter.' I think the intensity of these reactions against Black Lives Matter is a testament to how effective our systems are in isolating these kinds of issues – they make them seem as though they impact individuals, as opposed to entire communities. The all-lives-matter thing is simultaneously fascinating and infuriating to me, because it's so obvious. Obviously all lives matter; it's like saying the sky is blue or that water is wet. But, when people say, 'Actually, all lives matter,' it feels like a passive-aggressive way of saying, '*White* lives matter.'

People seemed shocked that police brutality was an issue, but I thought, 'Um, where have you been?' The police are supposed to serve all communities, but instead, they aren't accountable to black communities in the same way they are to white communities. The United States is rooted in profound segregation, disenfranchisement and oppression in pursuit of profits. And it feels like the country is being powered by amnesia.

'There is no other force in the world that is so powerful and that causes so much misery for so many people.'

Q. What brings you happiness?
My community – absolutely. This includes both of my families, blood and chosen – because my family is also my friends, the people I've been through things with. These are the people who stand with me, support me and love me. They are the people who feed me, and we just let each other be, because we understand each other.

Q. What do you regard as the lowest depth of misery?
I'd call it capitalism. There is nothing on earth that makes people as miserable, that kills people as avidly and that robs people of their dignity so completely as an economic system that prioritizes profits over human needs. Capitalism prioritizes profits over people and over the planet we depend on. There are millions and millions of people living on the streets without homes because of capitalism. And there are millions and millions of people suffering from depression and other emotional and mental afflictions because of it – because the things we are taught should drive us and make us happy are unattainable for the majority of people on this planet. Capitalism shapes every understanding you have of who you are and of what your value is. If you have no monetary value – if you can't sell something that you produce in this economy – then you are deemed unusable, unworthy and extraneous. There is no other force in the world that is so powerful and that causes so much misery for so many people.

Q. What would you change if you could?
I would start with all of the people who are suffering right now. I would give whatever is needed to every mama who is living in a car with her kids and is trying to figure out how she's going to make it another day – if not for herself then for the people who depend on her. I would give to all the people who are dying in the deserts right now, trying to cross artificial borders pursuing what they think will be a better life here in the United States – if I had a wand I'd make it so that that journey was easier and that there wasn't punishment on both sides. In fact, I would ensure that no one ever had to leave their homes in pursuit of survival – they would have everything that they needed right there at home.

The other area I would work on is within our own movements. I spend a lot of time thinking about how we could be clear about what we're up against and how we each fight it differently; I think about how we can advance our goals without tearing each other up along the way. So, if I could wave a wand, I would also change some of the suffering of organizers and activists in our movements who are tired and burned out, who feel disposable and don't feel seen.

Q. Which single word do you most identify with?
Courage. It takes real tenacity to be courageous.

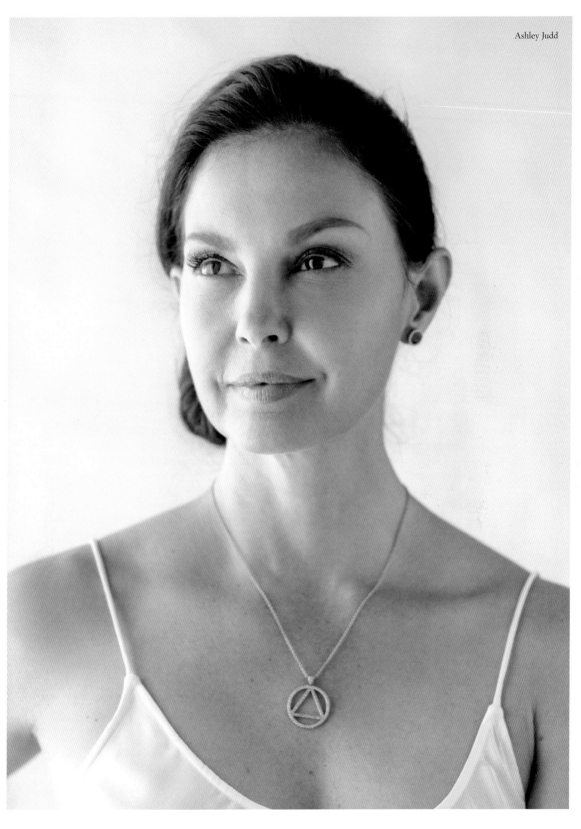

Ashley Judd

———

Q. What really matters to you?

I am a feminist. By that, I mean that I believe in dignity and equality between girls and boys, women and men. I consider the patriarchy to be just as damaging to boys and men as it is to girls and women; it's a false construct for all of us.

When I think about what has formed the person I am today – my capacities and my passions – I think not only about the totality of my lived experiences, such as being a tenth-generation Eastern Kentuckian, but about the totality of the lived experiences of my predecessors. My ten-times great-grandparents Mary and William Brewster were religious refugees living in defiance of two British monarchs; they assisted with organizing the voyage of the *Mayflower*, on which they travelled to the United States. Their kind of crusading, and devout, passionate love for – and intimacy with – God is very much a part of who I am today. My mother was pregnant with me at the time of the assassinations of Martin Luther King Jr. and Bobby Kennedy – those events imprinted on her and, therefore, on me. More than anything, though, what has formed the core of both my pain and my resilience – informed my grief and my determination to transcend my outrage so as to make it empowering for both myself and others – is experiencing sexual abuse in early childhood.

That experience of extensive patriarchal wounding shaped my neural anatomy; the very pathways of my brain have been shaped by that trauma and I have spent a good deal of my adult life either unconsciously affected, or bewildered by my inability to let go of the pain, even when I earnestly wanted to. There are more of us who experience sexual abuse than those of us who don't. Sadly, I think that coming to terms with that kind of trauma is dependent on the kinds of help people are able to access. A treatment method may be knowledge- and science-based, but if it's not accessible, it's drivel to the sufferer.

In my particular case, things changed when the pain of staying the same became greater than the pain of being willing to change. I had been using yoga, meditation and prayer as modalities to cope with the sexual abuse, but the power to really confront what happened to me came through my sister as the conduit. She had been seeking help for an eating disorder and, when I showed up to a family week, her treatment team took one look at me and recommended a twelve-step programme. Initially, I thought they were wrong to suggest it, but I was willing to do *anything* to change, and I'm glad I did. These twelve-step programmes are free and are part of a real, grassroots movement. Choosing recovery was terrifying and exhilarating, and was by far the best thing I could have done for myself and for the people I purport to love; because I cannot transmit that which I do not have. Also, through professional help, I've become a general badass. It can be abusive to highlight a problem without also underscoring a solution, so I am very thankful that today, when I talk about being a survivor of adolescent and adult rape, and of all kinds of gender wounding, I do so from a position of empowerment.

I've been profoundly influenced by feminist theologians. When I was an undergrad, I took a

'The first time I was sexually abused and I told some adults what had happened, they told me that I'd misinterpreted what he'd done and that he was a nice man.'

seminar on images of women in the Bible; it was incredibly disturbing. The experience shattered my faith and created anarchy in my family. I saw women diminished by the commodification of their sexuality. I had to look hard to find theologians willing to address the ills of the patriarchy in their writings; one such person was Sallie McFague, who wrote that God is he, she, both and neither. That is more like the God of my understanding: a God who doesn't make hard terms for those who seek her. I believe the message that the realm of spirit is broad and inclusive to all who wish to embrace it. I would say that my core identity is in the belief that I am a loved and precious child of a Higher Power; this belief supersedes all others.

I still experience patriarchal aggression – microaggressions, bombastic pride – but what matters to me now is applying my life lessons with grace and humour. I've always felt strength in the role of a crusader and that makes me feel very powerful. I've learned the lesson that it's important to connect with and listen to myself, my feelings and the sensations that I experience; only by doing this can I discover what I need. I feel that this is a lesson many boys and men need to learn, because the definitions we have of masculinity, manhood and sexuality are toxic, abusive, constraining and limited – men will come to see this if they try to connect with themselves.

Q. What brings you happiness?
My greatest happiness is seeing girls and women standing up in defiance to systems of patriarchy; it impresses me to see them doing this in ways that

must absolutely terrify them. When Julia Gillard was prime minister of Australia, the leader of the opposition said something like, 'Oh, I must be a feminist.' In response, Julia Gillard launched into a thirty-minute diatribe – in every sense of that word – in which she outlined each instance of him shaming, diminishing and ridiculing her simply for being female. She spoke from her guts – it was one of those moments when you could see that her head and her heart were connected and wide open. She went through each instance in which he had threatened and insulted her; she eviscerated him, and I loved it!

Q. What do you regard as the lowest depth of misery?
Watching the resistance to progress articulate itself so well; watching those who defend themselves against microaggressions and the patriarchy being bullied for doing so. Still, I believe that no good deed goes unpunished, so I always try to remind myself that I may not be celebrated for the choices I make, even though I feel I'm doing the right thing. And, when I see people doing the right thing and being properly received for it, I am filled with hope.

Q. What would you change if you could?
I would change the prevailing global culture of sexual exploitation and sexual entitlement.

Q. Which single word do you most identify with?
Crusader. The first time I was sexually abused and told some adults what had happened, they told me that I'd misinterpreted what he'd done and that he was a nice man. Boom! A crusader was born.

Jutta Speidel

Q. What would you change if you could?

I would send the corrupt, megalomaniacal, egocentric dictators into the desert and leave them to ruminate over their wretched lives. I would only let them return to society when they expressed remorse.

Leigh Sales

Q. What really matters to you?

The facts, in both my professional and my personal life. I believe that there is always a truth to things. People have opinions, but, at the heart of matters, there are basic facts. I find it really disturbing when we, as a society, fail to give currency to these. Everything that I do professionally is about trying to get to what the bare facts are – stripped of opinion. Perhaps that's optimistic, but I believe that if you can provide most reasonable-minded people with the facts, then they will be suitably armed to make their own decisions. When I interview people, what I aim to do is ask them those questions that I believe the average member of the audience would like to have answered. I consider it my job to be a representative for the average member of the public – I'm asking questions on their behalf, which is a privilege.

'Courage'

'Focus'

Holly Bird

Q. What would you change if you could?

I just don't get why people think they can justify certain types of behaviour. So, I would change the dishonesty and the unwillingness to question that lead to those behaviours. I can't get my head around people who think their cause is worth killing innocent people for. It all stems from how children just accept what is presented to them. They are told, 'Your religion is better than anyone else's and your way of doing things is better than everyone else's.' If we were teaching our kids to challenge those views, then everyone would get along better.

Sana Issa

Q. Which single word do you most identify with?

Resilience. Because you go through life and, no matter how many times you fall, you stand up, dust yourself off and move on. You do this, not just for yourself, but for other people as well.

'Resilient'

'Resilience'

Susan
Carland

———

Q. What really matters to you?

What matters to me most – what drives me the most – is service. But I don't believe service has to be grand; service is not only relevant on the scale of opening an orphanage, but includes those tiny acts of everyday service, whether they be to your own children or to your neighbour. Because the ultimately happy and content life is actually the life that you give away.

There's a great quote attributed to Muhammad Ali that goes something like, 'Service to others is the rent you pay for your room here on earth.' That really makes sense to me and is something that I've tried to live within myself, though I fail regularly. I'm always telling my children to look for opportunities to help, even if it's just when they see an older person struggling with a trolley in the supermarket. Because, in the end, a life of service is the only life that makes sense.

Raising my children with strong beliefs and values matters to me. I want them to be happy with who they are, but to never develop a sense of spiritual arrogance; I want them to see the core dignity in every human being and to respect that. It's not about us and them – Muslim and non-Muslim – because we are all people and can only function as a society if we respect one another. I believe that every person is potentially good, so engaging with people with that in mind allows for respect; without respect, there's an assumption of superiority – there is no dignity in an interaction like that. It's about giving people the benefit of the doubt, even when they probably don't deserve it. It's about dealing with people with compassion, even when we don't want to. The challenge is to ask yourself what you can do to try and create the society that you want to be a part of and

that you want to see flourish. We must deal with each other with compassion if we are going to counteract what is happening in the world.

I am Muslim. I had a very good experience in the Baptist church growing up, but, when I was seventeen I started to wonder why I believed what I did; I didn't know whether it was the truth, so I started looking into other religions. There was a lot of noise surrounding Islam – the typical things Westerners and non-Muslims say about it being sexist, outdated and barbaric – but I realized that Islam was in fact the antithesis of what was being presented to me. And what was at the heart of it made a lot of sense. In fact, it felt like a continuation of what I was raised to believe.

After 9/11, I definitely started to feel the burden of the international representation of Islam. I remember people saying, 'It'll have to get better soon,' but the negative representation hasn't gone away. If anything, it's escalating. But, even when I engage with people who are incredibly rude, I try to remember to give them the benefit of the doubt. I know how often I feel I've been wrong or changed my mind, so I have the awareness that other people, too, can change their minds.

Q. What brings you happiness?

It's when I feel most useful. We live in a society in which there is so much noise and so much pressure for self-promotion and narcissism: 'Pay attention to me! This is my CV!' But I find contentment in the quiet life of service, in any capacity.

Susan Carland

—

'I believe that every person is potentially good, so engaging with people with that in mind allows for respect; without respect, there's an assumption of superiority – there is no dignity in an interaction like that. It's about giving people the benefit of the doubt, even when they probably don't deserve it.'

Q. What do you regard as the lowest depth of misery?

True misery is when people have no hope, when they are in a situation they feel they cannot change. But, people can endure anything if they feel there is hope; even in situations of horrific injustice, inequality and fear, if they have hope, they will get through it. And if they don't have hope, then it's our responsibility to bring them hope.

Q. What would you change if you could?

I would change inequality. If you look at every injustice, pain or hurt, it comes from a place of inequality, of people crushing other people on a big level or small – in fact, I would struggle to find any problem in the world that didn't have inequality at its heart. If we could get rid of that, things would be so different.

Q. Which single word do you most identify with?

Hope. Although, if someone were to describe me, they would probably say 'trying' – the sense of never achieving and always failing, but of keeping going. But, the word I choose is hope – hope is a boat that we can get into when everything is difficult.

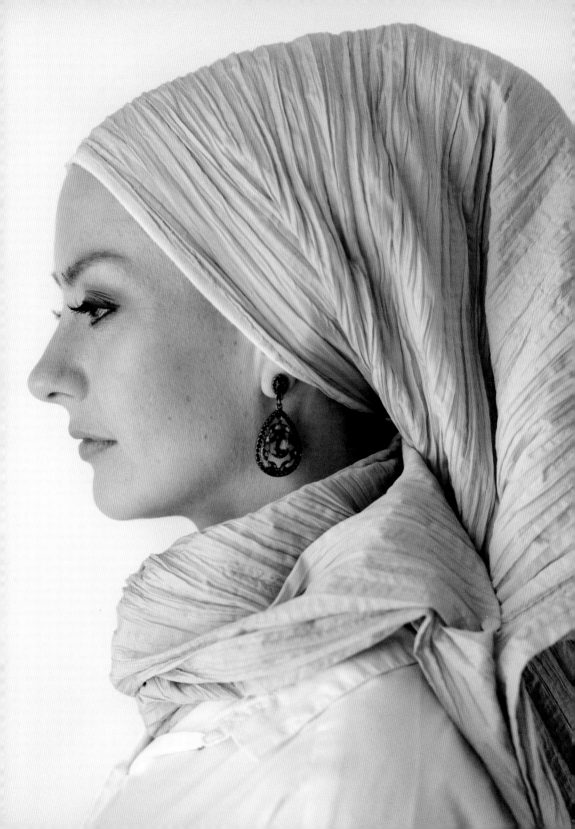

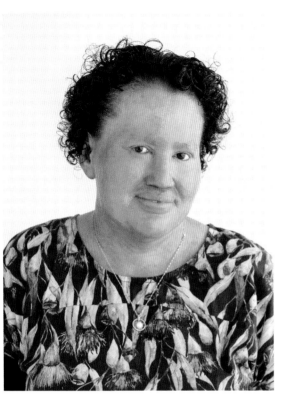 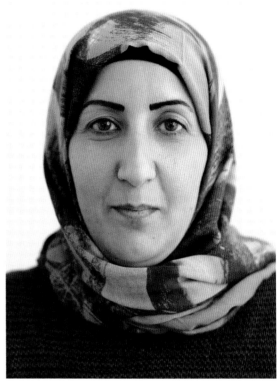

Carly Findlay

Q. What really matters to you?

I want the media to stop sensationalizing disability. It's time people like me have our voices heard, instead of having to hear our stories told by others. So, I've used my story to help influence the media and the media representation of people who look different and who have disabilities. It's important that brands like Target and Kmart in Australia have been including people with disabilities in their catalogues. It's fantastic. We've got more diversity of race and culture on mainstream television now, which is great, but there's not so much diversity around disability. Seeing people with disabilities in mainstream media really matters – it shows that we're valued, and it shows that we're seen.

Manal Ali

Q. What would you change if you could?

I wish I could go back to my country. But, as I know this will never be possible, I hope for a better life.

'Resilience'

'Freedom'

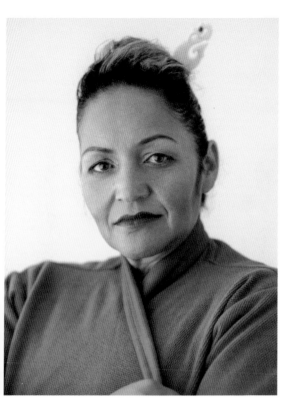

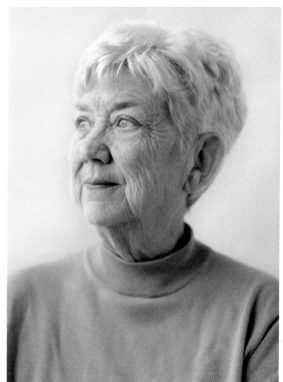

Marama Fox

Q. What really matters to you?

I joined the Māori Party to be a voice for our people. There's an old First Nations saying, 'Left wing, right wing – same bird.' These days, I say, 'Red undies, blue undies – same skid marks.' We Māori are still bearing the skid marks of colonization and of the resultant cultural genocide. They stripped away our faith in ourselves – our hope – by telling us our language was not good enough and that we were not good enough to benefit from Western knowledge. I don't think people understand what that kind of systemic abuse does to a people: to be told generation after generation that we're not good enough.

Ellen Bryant Voigt

Q. What do you regard as the lowest depth of misery?

I don't actually believe comparisons can be made in regard to suffering, whether it presents as abject poverty or acute physical pain, overwhelming grief or other forms. But since you ask me to articulate the absolute nadir, I'll say the absence of hope, when there seems no spark of possibility, however sputtering, that the present misery will ever change. The triumph of the human spirit over suffering, which a rational person knows will never end, derives from a perhaps irrational hope for the future, if not for the future of the particular one suffering then for that of others who follow, be it one's children or comrades or country or – if you'll forgive the large abstraction – humanity.

'*Whanaungatanga*' – relationship or kinship

'Stubborn'

Zainab Hawa Bangura

———

Q. What really matters to you?

Social activism is what defines me as a person. And the future – in relation to this, education is the golden key we must pass on.

I grew up in abject poverty, as my mother's only child. All my father wanted was a son, but my mother was not able to have any more children. When I was twelve, my father walked out of our lives because my mother refused to allow him to marry me off. She was an incredible feminist. She told me that, if I just took the time to understand how much work I would need to put in, there were no limits to what I could achieve. She used to say, 'When you fall, never fall on your face; fall on your back, so that you can see the sky and know that you still have a long way to go.'

After my father left, my mother couldn't afford anything, so we moved back to our village. She instilled in me this idea that I had to be educated, because that was the only way to get out of the poverty we were in. Most of the men in my mother's family had been given the opportunity to go to school, but she hadn't, so she knew what a disadvantage this was. In my final year of high school, I had to rely on a friend to pass down her old uniforms to me; another friend gave me a pair of shoes. And I would have dropped out of high school in my final year had my principal not supported me; I was a senior prefect, and she thought I was the most brilliant student, so she made a special request to the government for me to remain – she told them she couldn't afford

to lose me. Then, I was able to attend university because I received a government scholarship. My mother gave everything for me to better myself – then she died.

The traditional and cultural restrictions I experienced at the time of my mother's death changed my life. I was told I couldn't make the decision to bury her because I was a woman; I was told that I would have to find my father, bring him back to the village and await his permission. By that time, I already had a son, my own job as an insurance executive and my own car, yet I wasn't able to bury my mother. Here, I had to submit myself to the leadership of this man who left us years ago to marry another who would have his son. I had no option but to marry my partner to empower him to bury her. The blatancy of this gender inequality changed me – I knew I had to become a voice for women's rights.

At the time, Sierra Leone had a military government. I couldn't fight for women's rights under that regime, so, first, I had to fight for democracy. We rallied and I led women from the markets and villages into the streets – women like my mother. We demanded that the military leave the seat of government and return to their barracks. Once we were successful, I rose to become minister of foreign affairs. When I take stock of that time in my life, I know I learned two very important lessons. The first was an understanding of the transformative power of

'I'm working for the future of my children and of the children of Sierra Leone. I want it to be a future full of possibility.'

education; I came from a village where women weren't allowed to own land, where aunts and grandmothers were distributed as items of a man's property when he died. Yet, in a single generation, education had lifted me up beyond my mother's wildest dreams. The second lesson was that your gender and your place of birth do not determine your future. So now I make sure that every girl in my extended family goes to school and, when I look at them, I know that here we have doctors and engineers. But I know that if someone doesn't fight for them, their potential will never be known.

My mother made me believe that I could move my life forward, and now the course of our family's history is changed; it all started with a woman who had to beg for a room to stay in with her daughter, yet, today, her grandson is a lawyer who is married to an engineer. If I hadn't had that experience of exclusion when my mother died, I might today be a retired managing director of an insurance company. So, when I think about what matters to me, it is the future – and social activism is my vehicle. I'm working for the future of my children and of the children of Sierra Leone. I want it to be a future full of possibility. We must look ahead and keep moving, refusing to be imprisoned by the past.

Q. What brings you happiness?
Progress and change. Whenever I see a woman who is struggling, I ask myself what I can do to assist her to move forward and better herself.

It has been very fulfilling to watch a group of women I worked with in Sierra Leone, who have suffered appalling sexual abuse during the war, take back control of their lives – to watch them transform and rise above their suffering by helping one another.

Q. What do you regard as the lowest depth of misery?
The grand prison of poverty, and the powerlessness and hopelessness it brings a person; at times, they can believe they are not a human being. I understand the humiliation, lack of self-dignity and self-respect a person feels, and, when I see such poverty, it pains me. Because I know how my mother felt when she didn't have enough money to feed me. Wherever I go, I see poverty as having a woman's face, while power still has the face of a man.

Q. What would you change if you could?
Injustice – and the resultant lack of opportunity – because this is what creates poverty.

Q. Which single word do you most identify with?
Peace. We have too many wars raging in this world; when I look at the famine that's happening in South Sudan, I see that this is a man-made crisis. How does a country that is so fertile have rampant famine? It is caused by an absence of peace.

Zainab Hawa Bangura

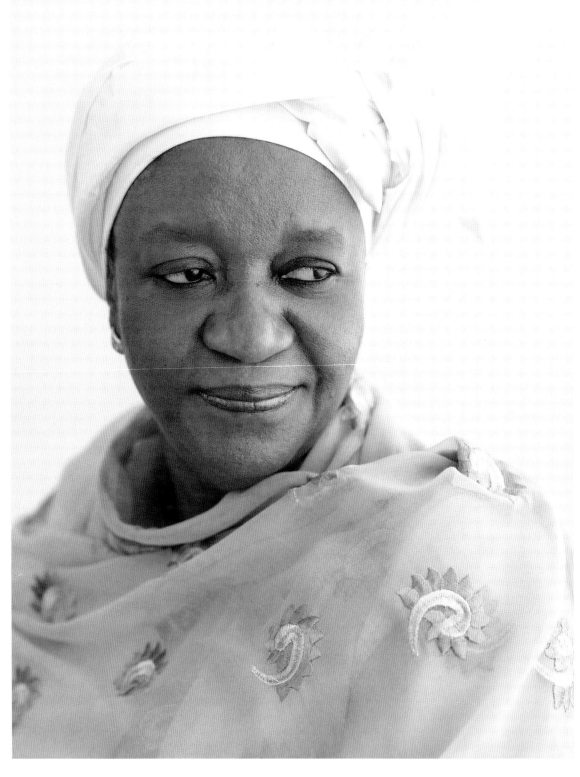

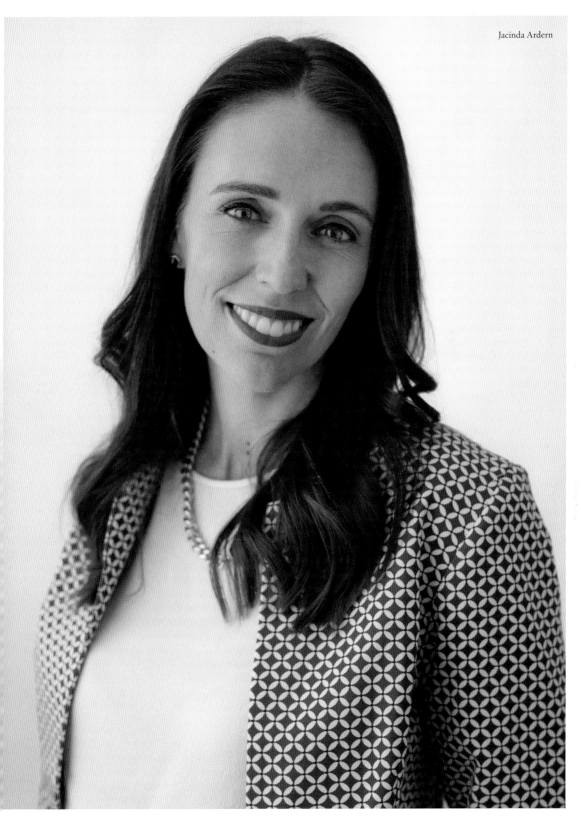
Jacinda Ardern

Jacinda Ardern

—————

Q. What really matters to you?

Empathy and kindness, because that's what can drive social change. I think these are not just sentiments, they are tools. They are what can motivate and drive you; certainly, they are two character traits that have motivated me throughout my political career. But, having been raised in a small, rural community, I also value hard work, value being mindful of the community and people around you, and I value service.

At heart, New Zealanders are incredibly fair-minded people. And, if you break some of the social challenges we face down to individual people, New Zealanders feel a huge amount of empathy at that level. I've always viewed the world this way – rather than seeing political problems as these large-scale, statistical issues and as differences between people. I often view the individual in situations.

There are so many issues we end up divided on which, if you distilled them down to a simple concept, you would find we are in fact united on. Take the issue of child poverty; sometimes you'll hear arguments like, 'Well, this is an issue of parental responsibility, is it our role to be involved?' There's a perception that, at some point, someone has neglected their duty of care. But, actually, at the heart of the discussion is a child who – whatever perception you might have of them – is blameless, who is just a subject of their circumstances. So while I might argue back that you can't talk about parental blame as long as we have a low-wage economy in which people are working yet not earning enough to survive – at its heart, we're talking about the same child. If you take a view of kindness towards that child, then this starts to change the way you might think about solving the problem. You strip away some of the blame and get back to the simple values that every child should have a good start in life and that every child should have what they need to thrive.

Q. What brings you happiness?

Having an opportunity to look out every day and see people who are finding problems and tackling them head on, whether it be a social issue, a complex business problem, or the need to innovate. I draw happiness from seeing people having the kind of attitude we value so much in New Zealand – being able to get stuck in and fix a problem ourselves – and I see the joy people get from resolving the issues they've tackled.

Particularly when I see people unexpectedly responding to need around them, I am reminded that we haven't all forgotten that we are

'There is a real perception around what it takes to be a political leader, but I hope that, over time, we can demonstrate that there are a whole range of traits different political actors can bring to their leadership.'

connected as a community. Imagine a country in which everyone is earning, learning, caring or volunteering. That's the kind of place that breeds happiness.

Q. What do you regard as the lowest depth of misery?
Selfishness upsets me, it really does, whether it be in a person's approach to the environment or to others. We're all dependent on one another in some way. Things don't tick along if we're not mindful of the world around us and are careless of the impact we have on others. So, both at a macro level and one-on-one, selfishness bothers me.

Q. What would you change if you could?
I've talked at great length about all the things I'd like to change, but now I have both the privilege and challenge of actually being able to do some of those things. If I distil it down, there are things amongst this enormous programme of work that I'd like to walk away from politics feeling we had changed. These are finally having agreement that child poverty is something which shouldn't exist in a country like ours and that we all benefit if we rid ourselves of it. And climate change. As a politician, when I think about what kind of place I want to leave the next generation, I'm very mindful of a sense of responsibility and care. What I love about New Zealand is that the idea of

guardianship, which is obviously well-entrenched in Māoridom, is imbedded in us all – the idea that the environment is something we have a duty of care for on behalf of the next generation.

Q. Which single word do you most identify with?
Kindness. Would it change the way we operate, would it change the decisions we make, if we inserted kindness into every decision we make? Kindness is that sense of being aware of the environment around you, the people around you and the community around you. This doesn't mean you can't be strong – you can be kind and strong. I like to challenge traditional views of political leadership. If you ask a group of people what their view of politicians' character traits are, they will probably come back with words like 'confident,' 'egotistical,' 'assertive' and, in some cases, 'self-interested.' There is a real perception around what it takes to be a political leader, but I hope that, over time, we can demonstrate that there are a whole range of traits different political actors can bring to their leadership. And that this doesn't mean that they are poor political leaders, rather, it means we're starting to have a political environment that's more reflective of people and society, and in which we have a range of different styles of leadership. So, I rebel against the notion that if you're strong, you are also assertive and ambitious with no regard for others.

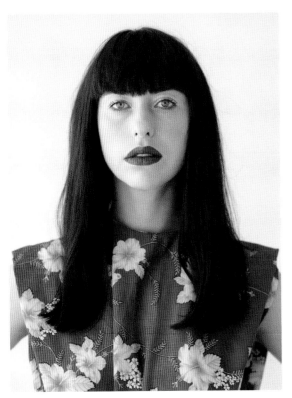

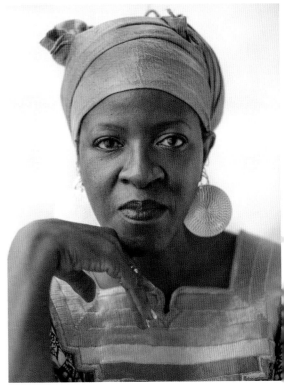

Kimbra

Q. What would you change if you could?

Myself. If you go out thinking you can change the whole world, you can quickly become disillusioned, but the only thing I can say I have real power over is myself. So, I need to ask: How can I overcome fear? How can I be a better person, a kinder person or a more loving person? And, as a musician, I feel like I'm making some kind of difference, because music – by communicating hope and love – has the ability to reach all parts of the world.

'Truth'

Mpho Tutu van Furth

Q. What really matters to you?

What's really important is that all of us – people and planet – ought to be able to flourish. Nobody can flourish in circumstances of abject poverty. Nobody can flourish in circumstances of sickness and want, or in places of war. No one can flourish when they're stigmatized, or when they're set aside. No one can flourish when they are treated as if they don't matter. We need to create a world in which all of us can flourish.

'Love'

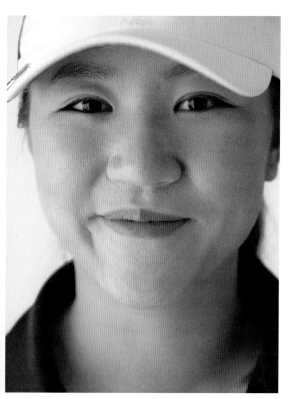

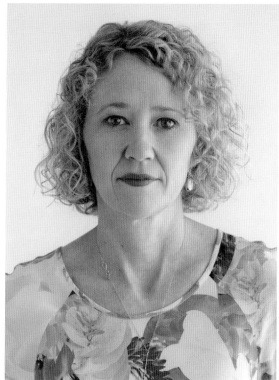

Lydia Ko

Q. What do you regard as the lowest depth of misery?

The sporting world is notoriously sexist and, historically, golf has been viewed as a men's game. A male golfer's prize money can be as much as four times higher than that of a female winner. I think, 'What? Why? We don't play fewer rounds than the guys, and it's not like we're less talented.' I hope that one day the game will be equal, because there's no reason it shouldn't be. There are so many legends who have walked this path and brilliant female role models currently on tour who have really made the game better, greater and more popular. Equal pay is the right thing to do.

'Fun'

Catherine Keenan

Q. What would you change if you could?

I would give every child the best education they could get – in the end, that would fix every other problem.

'Stories'

Jane Goodall

The future of our planet. It matters terribly to me that people are making decisions based on questions like, 'How will this help me at the next shareholders' meeting?' Or, 'How will this help my next political campaign?' People should be asking – as Indigenous People used to – 'How will this decision benefit future generations?'

When I was ten years old, I read *Tarzan of the Apes* and fell in love with Tarzan. I decided that I would go to Africa when I grew up, to live with wild animals and write books about them. Everybody laughed at me! We didn't have any money and World War II was raging, but my mother had always imbued me with the message that, if you really want something, you have to work hard, take advantage of opportunity and never give up.

It took a while for me to achieve my dream, because there was no money for university; there was just enough money for a secretarial course. I found it really boring, but I got a job in a London company that made documentary films. Then, the opportunity came; a school friend invited me to Kenya, where her parents had bought a farm. I worked as a waitress to raise money for the fare – it was jolly hard work! Finally, I was off to Africa by boat. There, I met Louis Leakey; somebody had said that, if you are interested in animals, you should meet him, so I went to see him at the Natural History Museum. As chance would have it, his secretary had just left – so, that boring old secretarial training was what enabled me to follow my dream, in some ways.

I found myself among people who could talk about everything I was interested in: the animals, birds, reptiles, amphibians, insects and plants

of Africa. And Leakey saw something in me. He offered me an opportunity to live with and learn from, not any old animal, but the one most like us – the chimpanzee. It was still a year before he could get money for this young, untrained girl who had never been to college; what a crazy idea! Nonetheless, a wealthy American businessman gave us money for six months' work. However, the authorities of what was then part of the crumbling British Empire wouldn't give permission for a young girl to go into the forest on her own, so, for the first four months, my amazing mother volunteered to come with me. After I observed tool use and tool making – then thought to be only human attributes – Leakey was able to get money from *National Geographic* for me to carry on with the study. They sent a photographer and filmmaker, Hugo van Lawick, whose early films and photographs took the story of 'Jane and the chimps' around the world, and who also became my first husband.

Finally, Louis Leakey wrote to tell me that I had to get a degree, but that I would have to raise my own money. And there was no time to mess about with a bachelor of arts, so he got me a place doing a PhD in ethology at Cambridge University. Never having been to college, I was extremely nervous and the professor told me I'd done my whole study wrong. He said that I should have given the chimpanzees numbers, not names, and that I couldn't talk about their personalities, minds or emotions, because only humans had those attributes. Back then, it was thought that the difference between humans and all the other animals was a difference of kind, but, in fact, it is a difference of degree, because chimps are so biologically like us. Finally, I was able to

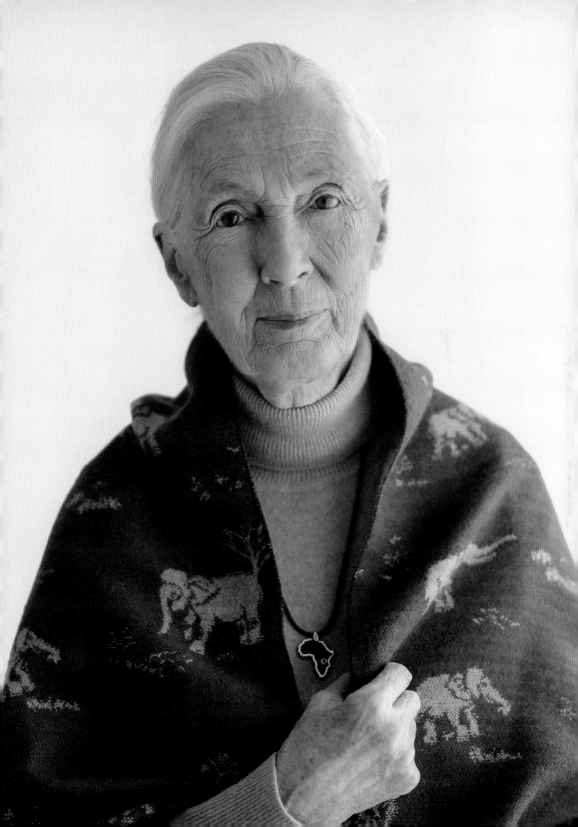

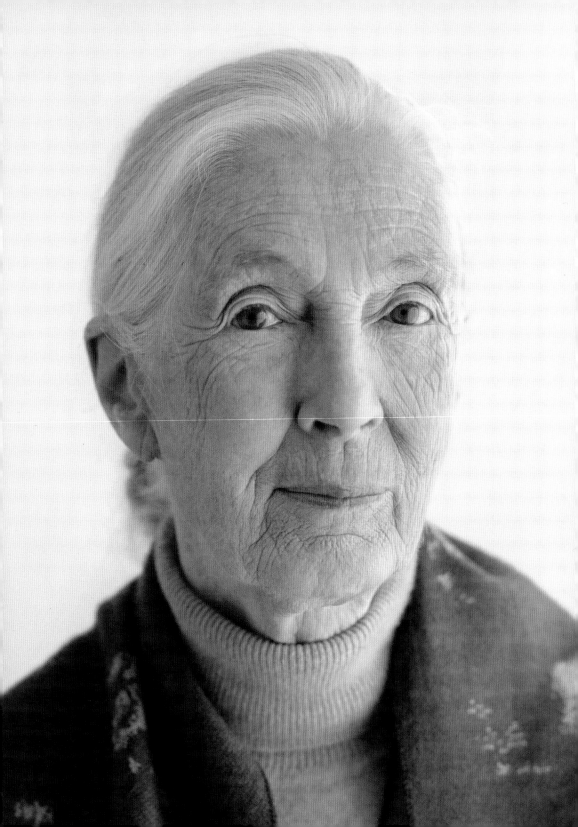

Jane Goodall

'Despite being the most intellectual creature that has ever walked . . . we are destroying the planet.'

win through and today's science has largely changed its mind.

In 1986, there was a conference in Chicago that brought scientists together from around the world to discuss chimpanzees. Everywhere it was the same: chimp numbers dropping, forests disappearing, the beginnings of the bushmeat trade and the shooting of mothers to steal their babies for sale, entertainment and medical research. I went to that conference as a scientist and left as an activist. Just like that! I didn't make a decision; it just happened to me.

So, from 1986 until now, I haven't been in one place for more than three consecutive weeks. I realized that people were losing hope, which was not surprising considering how we were harming the planet. And I realized that, if young people were losing hope, we might as well all give up. So, that began JGI, the Jane Goodall Institute, which had been started by then in 1977, so we began the Roots & Shoots programme to improve the lives of the people and gradually got their trust. I got together a bit of money and went to Africa to learn more about the plight of the chimps. That is when I realized that the people were suffering, too. There were more people around Gombe than the land could support; people were too poor to buy food from elsewhere, farmland was overused and infertile, and trees were being cut down from steep slopes. It was clear to me then, that, if we didn't improve human lives, there was no way we could try and save the chimps.

There is so much left to do. People ask, 'Why aren't you slowing down? You're eighty-three!' Well, there is so much awareness to raise. I was given

certain gifts and one gift was communication; I have to use that gift while I still can.

Q. What brings you happiness?
I love the planet, I love nature and I love being out in the rainforest.

Q. What do you regard as the lowest depth of misery?
What we're doing to the planet. It hurts that, despite being the most intellectual creature that has ever walked – the explosive development of our intellect is the main difference between us and the chimps – we are destroying the planet.

Q. What would you change if you could?
I would get our Roots & Shoots programme for youth into every school around the world, starting as young as possible. The main message of Roots & Shoots is that every one of us makes a difference every single day and we get to choose what sort of difference we are going to make. But, until you know something, you don't care about it and, if you don't care about it, you won't work to save it. On the one hand we have to reduce poverty, because, if you are really poor, you cut the trees down to try and grow food. On the other hand, we have to change our mindset; we have to measure success by something other than acquiring more money – acquiring more stuff.

Q. Which single word do you most identify with?
Hope. That there is time to turn things around. But this hope depends on us taking action - it will not be realized if we don't get together to do something. It is really important to remember that every single individual matters and has some kind of role to play, and that we can choose what sort of impact we will make, every single day.

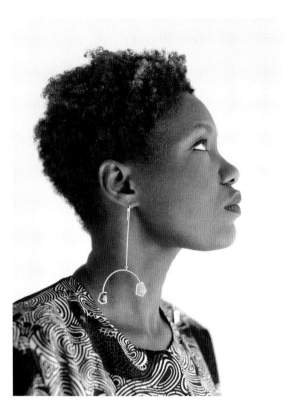

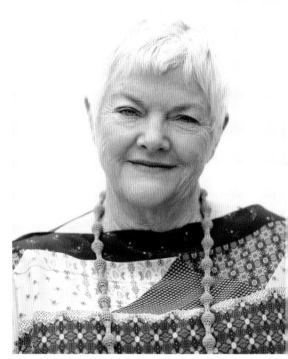

Rokhaya Diallo

Q. What brings you happiness?

Human relationships are a true source of joy
and happiness for me. It makes me happy to be
surrounded by loved ones; just knowing there
are people out there who care for me is a great
resource in the face of adversity. And I thrive on
encounters, which is one of the reasons I love my
job. My work has given me the chance to meet so
many people, and to follow their lives by making
films, documentaries and television reports. This
brings me happiness because it nourishes me both
intellectually and emotionally.

Stephanie Alexander

Q. What would you change if you could?

I would like to feel that leadership within countries
is the sort of leadership that encourages dialogue,
promotes compromise, is pragmatic, and considers
the needs and wishes of diverse groups in the
community, understanding that difference is
exciting, not frightening.

'Audacity'

'Idealism'

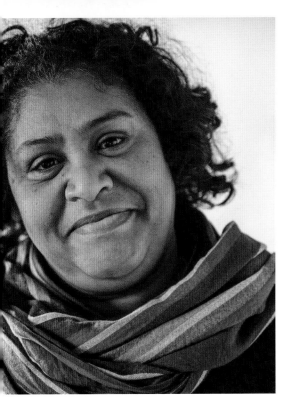

Nicky Asher-Pedro

Q. What do you regard as the lowest depth of misery?

I think being a woman in this city, Cape Town – particularly if you're outspoken and you say what's on your mind – is so tough. Men find it a challenge. They don't expect you to be 'difficult.' Being a woman in a man's world can feel like the lowest depth of misery. In this world, women are told to keep the peace and not stand up for themselves. They're told that they need a man and that they need to change to accommodate men. They're told to love men and respect men before they love and respect themselves. And as a result, women become defined by men.

'Humility'

Katarina Pirak Sikku

Q. What really matters to you?

I'm Sami and my culture matters to me. The Sami are the Indigenous People of the Scandinavian and Kola Peninsula Arctic. I didn't learn to speak Sami until I was twenty-one, because my parents had been forbidden from speaking it when they were growing up and they spoke Swedish in our home. In school, I never read about my Indigenous history, because it wasn't something that was taught. Of course, I knew about all the Swedish kings and their wars – I knew all about a history that I didn't feel a part of. When I finally got my hands on a book about the Sami, I felt seen and understood. I wish I spoke the language better, but I've made sure that my children do. Swedes are very protective of the status quo, so, although attitudes towards the Sami are changing, you can see their exclusionary attitudes in the way they treat refugees from other parts of the world.

'Tryckfrihet' – freedom of speech

Eva McGauley

———

Q. What really matters to you?

My family. I know that everyone really values their family, but I would not be the person I am today without them. I was brought up a feminist by my mum and my grandmother, so I've always had this inherent sense of equality and a desire to fight for it. I have a very politically divided family, but that's made for a lot of good conversations. My family are my support system. They keep me together, and I, them – which is why what's happening to me is so scary.

When I was fifteen I was diagnosed with nasopharyngeal carcinoma, which is a rare kind of cancer that affects one in 7 million people. I'd initially been misdiagnosed with glandular fever by my paediatrician, but when we finally found out that I had cancer I spent five months in hospital undergoing a course of really intense chemotherapy and radiation. The chemo kills every fast-reproducing cell, so the treatment affected my hair, my stomach lining and my mouth; I couldn't eat or drink because of the radiation. After the course of chemotherapy and radiation, I was told I was in remission, but three weeks later the doctors said they'd got it wrong and that I was terminal.

People think that you're going to break down when you're told something like that, then instantly have an answer when they ask you what you want to do as a result of the news. But I still don't know – it still hasn't sunk in. I don't think

it's really going to until it really *has* to. I didn't let out any emotion for a few days – my mum may have, but not around me. It was tough because we were both just trying to look after each other and protect each other. Then we all suddenly started realizing that my family is just going to have to cope without me in their lives. All of the people I rely on – and who rely on me – just took a big, deep breath in, then held it as we realized the impact this is going to have. I'm still not sure when to let that breath out.

In answer to the question, 'What do you want to do before you die?' I decided that I wanted to do what I've always planned to do with my life, but do it really fast. So, what matters to me are women's rights and combating sexual violence, because I want to give more in life than I've taken.

Growing up, I was always aware that different genders were treated differently. And I've always wanted to help people. When I was thirteen, my friends and I tottered into a feminist-club meeting at school, and came out feeling so amazing and empowered – we realized that we wanted more of it.

Before I became sick, I got involved with Wellington Rape Crisis, an organization that provides support for survivors of rape and their families. That experience showed me that I wanted to work in the sexual-violence sector,

'In answer to the question, "What do you want to do before you die?" I decided that I wanted to do what I've always planned to do with my life, but do it really fast.'

with an emphasis on prevention rather than support – I think I'm more of a politician than a counsellor. I developed a business plan for an online-messaging service that would allow survivors to message trained professionals, around the clock, who can link them up with support services in their area. I had the opportunity to speak with Jan Logie – a New Zealand member of parliament for the Green Party – about my idea, and she offered me an internship with the Green Party.

I've carried out and read a lot of research on international messaging platforms like the one I am proposing, which have proved incredibly successful, so I really think New Zealand needs one. Here, one in five women will experience a serious sexual assault in her lifetime, one in three girls will be abused before they turn sixteen and one in seven boys will be sexually abused by adulthood. This is a huge problem. Jan helped me get my business plan out there, and an agency called Help Auckland responded; they are New Zealand's biggest provider for sexual abuse survivors. We developed a fundraising page with the aim of raising NZ$50,000; after getting the message out, we reached our goal in under five months.

Q. What brings you happiness?
I really love soap operas; they are my guilty pleasure.

I very much admire Helen Kelly – the New Zealand union leader – who passed away in 2016. She was an amazing woman. The people she helped all talk about how she became like a member of their families. I'd like to emulate her and give my time, affection and love to those who need it. Because, when helping someone really pays off, that's the biggest reward.

Q. What do you regard as the lowest depth of misery?
That's tricky, because there's so much misery in the world. I'm very close to my mum, and I've always really wanted children, which I won't have, so the thing that I find hardest is seeing scenes of mothers and children being ripped away from each other in Syria. The idea of losing a child is scary – which is why what I'm going through is so hard – but, at the same time, I know that I don't have it as bad as what you see happening in Syria.

Q. What would you change if you could?
There are so many things, but can I just say world peace? That fixes them all: poverty, anger, hate.

Q. Which single word do you most identify with?
Love. For me, love is a very, very deep, meaningful and sacred thing. I make sure I say, 'I love you,' to the people I love all the time. I call my grandma, my godfather and my aunt every day before I go to bed to tell them I love them. Love is the thing that keeps me ticking.

Eva McGauley

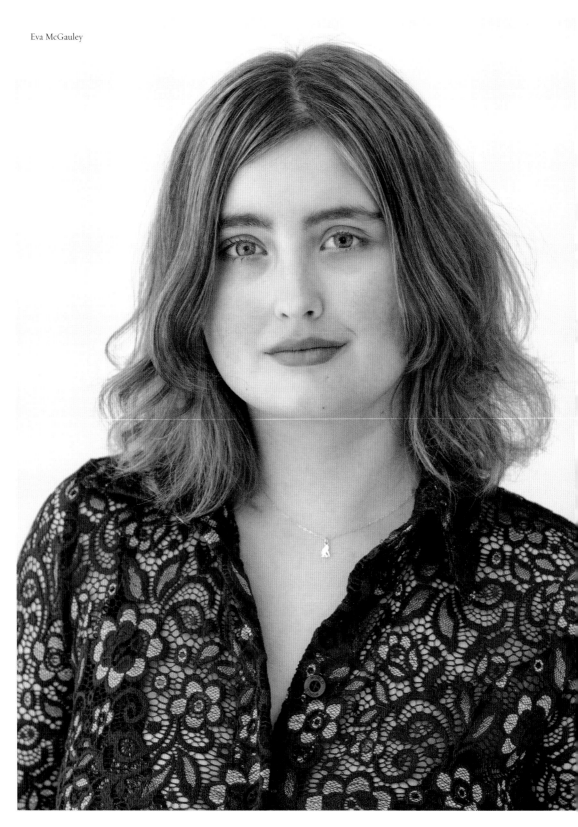

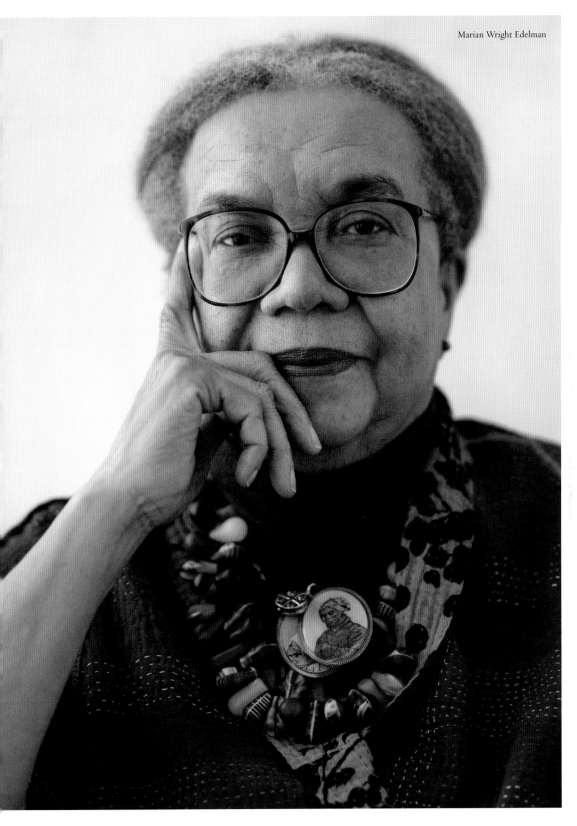

Marian
Wright Edelman

'Love'

———

Q. What really matters to you?

I have always felt like I'm the luckiest person in the world to have been born at the intersection of great people in my own family, my community and my church – my dad was a Baptist minister, and my mother was the church organizt and organizer – when history was really moving in new directions. I always had extraordinary role models, and people often asked why I do what I do. I said, 'It never occurred to me not to do what I do, I do exactly what my parents did, I do exactly what my community co-parents did, which is to serve and try to make the world better than you found it and making sure that you fight injustice.'

My daddy used to say, 'God runs a full employment economy, just follow the need, and you will never lack for something useful to do.' We were people of faith, and he made it very clear that we were put on this earth to leave it better and make sure we served people in need. When I think about the Children's Defense Fund, it was a natural progression from the civil rights movement and my Mississippi experience of the sixties. But every issue that we focus on really stems from my childhood experiences. There was a child who lived three houses down from our church and who died of tetanus when nobody knew about tetanus shots. I also remember a highway accident; we all ran out and saw it involved a migrant family that was black and a white truck driver. The

ambulance came and saw that the white truck driver was not injured. The black folk – the migrant workers – were lying there on the highway, but the ambulance drove off. I never forgot that. I cannot stand seeing ugliness or injustice of that kind.

I think that the Children's Defense Fund's work investing in children is going to be the determinant of whether this nation goes to hell or remains a world leader. Our major national economic and military security problems come from our failure to invest in an educated populace. How can it be that – as our demographics show – the majority of our children are going to be non-white in a few years, and yet over 80 per cent of black children cannot read a computer at grade-school level? This is not counting those who have dropped out of school or have been put into the prison pipeline. We are going to miss the boat to the future if we keep destroying the seed corn of our youth and failing to educate the non-white children, who are going to be the majority of our children. We have this cradle-to-prison pipeline, and we're spending three times more per prisoner than per public school pupil. That is really dumb. I get up every morning because there is a sense of urgency. The future of the country, and also our own futures, depend on what we do with children. We can't save ourselves if we can't save our children.

'I hope women will find their voice and just say, "Sorry, we have had enough," and vote these men out of power and try to build a country that is fit for our children and grandchildren.'

Q. What brings you happiness?
My children, my grandchildren, children and music.

Q. What do you regard as the lowest depth of misery?
It is unthinkable that children are dying from famine. It is unthinkable that the gun violence rate in this country for children of all ages is seventeen times worse than for their peers in the other high-income countries combined. In a nation that is so rich and has so much, the idea that children in this country are going hungry, are not being educated and don't have housing is just so outrageous. How is it that we cannot create a level playing field for every child? Every child is sacred. God did not make two classes of children.

It's an obscenity that in the United States of America – the second largest economy in the world after China – we are letting our children be the poorest age group, and the younger they are, the poorer they are. That is just intolerable. So many are faced with suffering and misery, while so few have so much. If you have got $5 billion, why do you need another billion? Why do you need more if you have got three houses, and what kind of government or Congress or political leaders continue to take money out of children's mouths? They take money that is needed for food, health care, housing, education, safe child care and early development, in order to do what? To give more tax breaks to people who are millionaires and

billionaires, and add another $54 billion to the military budget? I mean, what in the world is the matter with us?

Q. What would you change if you could?
I would lift every child out of poverty. What is it in our character that would let millions and millions and millions of children live in poverty and have hopeless lives, go off to prison and be gunned down by guns we won't control? There is something wrong with this picture, and I just hope that the boil will burst in this administration and that enough of us will begin to see clearly who we are, and that we've got to be one world or no world. That we have an obligation to pass on a better future than we currently have to our children.

I hope women will find their voice and just say, 'Sorry, we have had enough,' and vote these men out of power and try to build a country that is fit for our children and grandchildren. That is the job before us, and if we can empower our daughters and our granddaughters and our sons to do and carry on the work, then we will get there. We can't go on this way as a country, and as a world.

Q. Which single word do you most identify with?
Love.

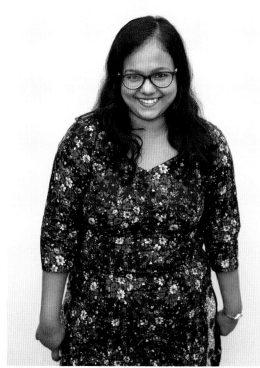

Emily Uy

———

Q. What really matters to you?

My family and my work. In 2008, we experienced major setbacks: my husband lost his job and a friend of ours caused us to lose our savings. There was no way for me to support my kids, so I moved to America to find work. I worked different jobs – making about $400 a week, which wasn't enough to send money home and still look after myself – until someone told me to become a live-in caregiver; it meant I wouldn't have to commute every day and could wear scrubs all year long when I am on duty, without having to buy new clothes for work. I also joined the Pilipino Workers Center as a way of making connections in the United States and finding a sense of belonging. They provided me with training and now I give back to them in return for what they've done for me. So, when there's a rally, I go rally. And when they are travelling to lobby for our rights, I'm there for those lobby visits – it's give and take.

'Committed'

Kakali Sen

———

Q. What really matters to you?

My sister is the most important thing in my life. When I was eleven, my mother's asthma took her life; after she died, we found out she had been working as a sex worker to earn money for the family. If my sister hadn't cared for me, I would have ended up in the sex trade too.

After my mother died, our oldest sister was eager to marry me off, but my sister – who is the middle child – protected me. But, we had so many problems in the family that I had to leave school to go to work – I suffered a lot there.

'*Dushtu*' – cheeky or precocious

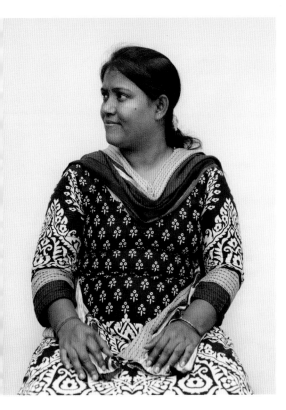

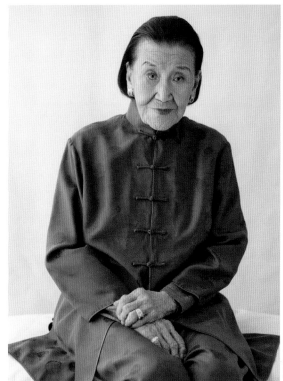

Mithu Ghosh

———

Q. What really matters to you?

What matters is my family and working hard for them. It matters that my son receives a great education that gives him opportunities in life, and I want to raise him well – to respect women.

When I was nine, I moved to Bowbazar, in Kolkata, to be with my mum and my aunty – they had been employed to do housework, but their place of work was actually a brothel in the red-light district and their boss was a madam. They ended up working in the sex trade and endured great suffering. My mother suffered and sacrificed so much to make sure I could receive an education. My aunty died when she covered herself in kerosene and set herself alight; witnessing the suffering that took her life and witnessing the pain that my mother experienced – I decided I would never work as a sex worker, no matter what.

'*Misti*' – Indian sweets or candy

Cecilia Chiang

———

Q. What brings you happiness?

Basically, I am a very happy person. I have a lot of good friends; they love me and I love them. I keep myself very busy, every day. I love all my plants; I water them and take care of them. I still cook for myself when I'm home alone. As for my health, I am fine for my age. Everybody laughs when I drink, they say, 'Wow, you are still drinking?' and I say, 'Why not?' I am happy.

'Honesty'

Linda Sarsour

Q. What really matters to you?

For me, it's very simple; I have three children and I want to live in a country that respects them in all their complexities: what they choose to do for a living, what religion they follow and what their ethnicity is. I want to live in a country that respects whomever they choose to be.

I always felt like I lived a pretty good life: I'm a Palestinian American, born to Palestinian-immigrant parents; I grew up in a lower-middle-class environment; and I went to public school. But my activism was born out of the ashes of 9/11. Seeing members of my community targeted by all levels of law enforcement in the immediate aftermath of the horrific attacks at the World Trade Center radicalized me. With my own eyes, I saw men being picked up in public, raids in my community and mothers crying at the mosque saying that they didn't know where their husbands were. I was shell-shocked that this could happen in my country, particularly knowing that a lot of the Muslims and Arabs in my community had come to the United States fleeing precisely that type of persecution and this type of police state. And I was furious. I immediately started translating for families, to connect them with legal services and help them find their loved ones. My networking and relationship building at that time was my introduction to civil rights activism. I started out by wanting to protect my own community, and then I ventured out and found that there were other communities who were also oppressed. So, more recently, I've been doing a lot of work around black civil liberties and issues pertaining to undocumented people. And, the more work I do, the more strongly I feel that there is a connection between all of our communities, that we're all being oppressed by the same state.

Racism, sexism and prejudice aren't concepts ingrained only in the minds of people, they are ingrained in America's history: we live in a country that was founded on the massacring of Indigenous People; Americans enslaved Africans here; and women were only given the right to vote within the last century. So, in order not to perpetuate racism, sexism and prejudice – in order for young people to broaden their horizons – we need to actively engage with our history and come to terms with it. We cannot teach the young blind patriotism for a country that makes mistakes; kids wave the flag and chant 'God Bless America,' but they don't understand that the flag has blood on it.

People will often say that slavery has nothing to do with them, when in fact, the existence of slavery in our history directly correlates to how we treat people of colour. And when people discuss setting up internment camps for Muslims, I wonder whether they've come to terms with the Japanese internment camps America was responsible for, because, to understand that a Muslim internment camp is a horrible thing, you need to understand the horror of previous instances of such treatment.

I was very proud to be a part of organizing the 2017 Women's March. A day or two after the 2016 United States elections, I saw a Facebook post that talked about women's rights as human rights and that made reference to many different communities. However, it did not talk about how the issue of women's rights affected the Muslim community, so I decided to comment that I thought it was a great effort and that I hoped they would include Muslim communities. The next thing I knew I was a national co-chair of the

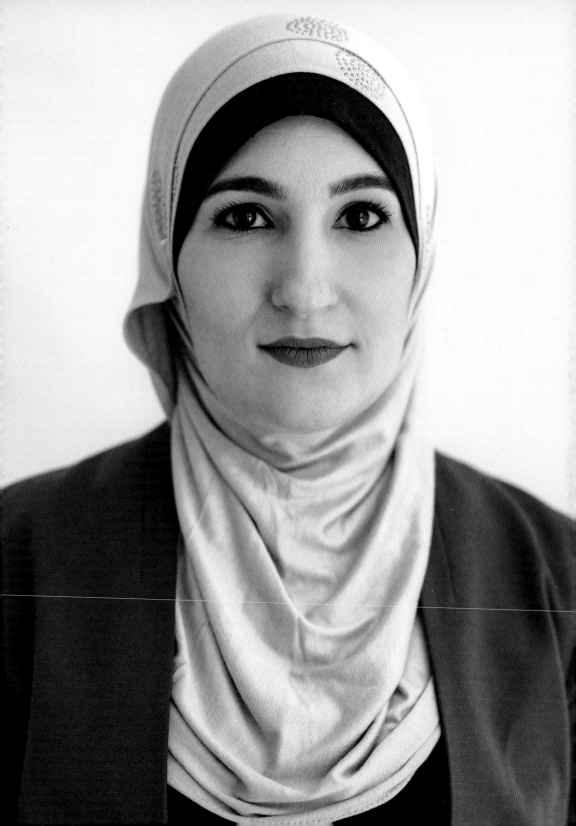

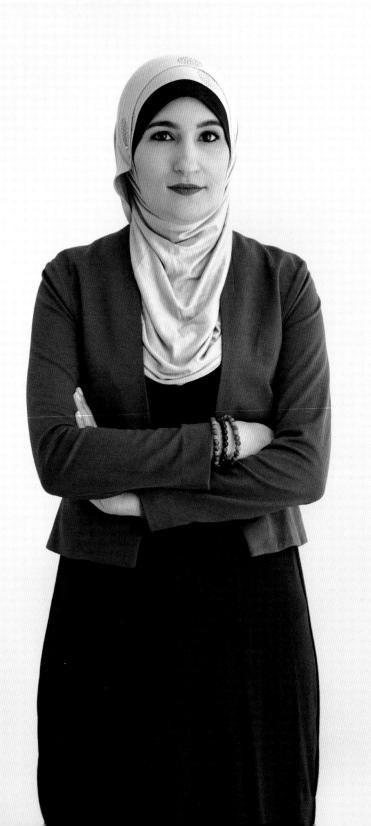

Linda Sarsour

'We need to actively engage with our history and come to terms with it. We cannot teach the young blind patriotism for a country that makes mistakes; kids wave the flag and chant "God Bless America," but they don't understand that the flag has blood on it.'

Women's March on Washington. So, I caution people against suggesting that the march was exclusive in some way; I felt gratified to be a Muslim woman in a hijab joining women from other contexts in organizing something greater than any one of us – something that a lot of people had doubts about. Although there are women in leadership roles, I've wondered whether people really believe in the true leadership of women. We are often in the back, so this was the moment to say, 'No. Women _are_ leaders. Women are capable of anything.' We planned a march for two hundred thousand people in Washington, DC, and about half a million people came. The sisterhood – the love, the compassion and the unity – was overwhelming. And it is just the beginning, a catalyst for protest and dissent under an administration like this.

I live in a country in which a lot of the people I love – people who came here to experience safety, security, respect, dignity and freedom – are not experiencing these things. But, I am hoping to help my country truly be the greatest nation on earth, a place where you _can_ be exactly who you are.

Q. What brings you happiness?
A lot of things make me happy. As much as people think I'm some angry outraged activist – which I am – I am also very content with my children and with my family. I'm content being

around people who share my values and principles. And I love New York City – I live and breathe it. It brings me joy to be in New York City and in my community out in Brooklyn. So, for me, happiness is very simple: it's beautiful people who care, and loving the things I love.

Q. What do you regard as the lowest depth of misery?
It's this dark place in which people are not able to see themselves in others: it's engaging in air strikes, it's the occupation of Palestine, it's massacres of Syrians at the hands of the Assad regime, it's the murders of unarmed people of colour at the hands of law enforcement in the United States and it's shackled pregnant women in prison. We don't treat others the way we want to be treated – somehow that's been lost across the world.

Q. What would you change if you could?
Freedom and liberation are very important, so addressing this would be my first act of change. I would love to be part of a just solution and see a free Palestine that respects the dignities of all people living there. I would end mass incarceration in the United States. We have a large prison population who are away from their families, and a lot of these people are non-violent offenders.

Q. Which single word do you most identify with?
Unapologetic.

Justina Machado

———

Q. Which single word do you most identify with?

Survivor. The best analogy is from the Olympics.
You see those really brave gymnasts doing their
floor work who fall, but have to get up and continue.
I'm sure they think, 'I want to get the hell out of
here – this is so embarrassing, this is awful.' But
they get up, keep going and finish with a bang.

Lynn Goldsmith

———

Q. What would you change if you could?

Donald Trump. And I would change the human value
system, so that love becomes our biggest prize. Your
capacity to love is what should make you important,
not your stature: as John Lennon said, 'All you need
is love.' It's that simple.

'Survivor'

'Limitless'

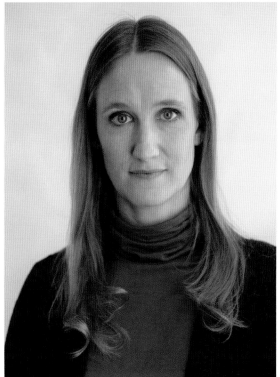

Berivan Vigoureux

Q. What do you regard as the lowest depth of misery?

The fact that three thousand Kurdish women are still imprisoned by Islamic State. Where are the powers that be? Why are they not helping us to rescue these women? Instead, the women Kurdish fighters on the front line are doing this themselves; they are extremely tough. Islamic State is afraid of them because, according to their logic, if they are killed by a Kurdish woman they will go straight to hell. These women have their own battle cries and Islamic State runs from them in fear. Men aren't as resilient as women – they retreat – but these women never leave the front line. Ever.

Kristin Helberg

Q. What would you change if you could?

I would take away the glasses – religious glasses, ideological glasses and others – through which we explain everything with a single aspect of humanity. Only by taking them off can we see each other as we are, in all of our complexity.

'Freedom'

'Open-mindedness'

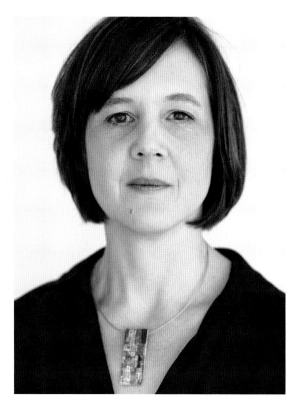

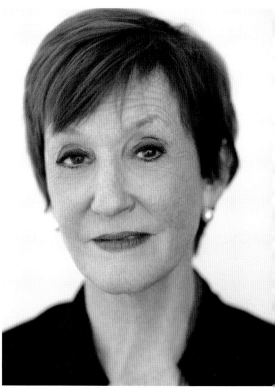

Cordelia Fine

—

Q. What brings you happiness?
Freud got it right: love and work.

Kathy Eldon

—

Q. What brings you happiness?
Happiness for me is about connecting. We are
all given gifts in life – I believe mine is the ability
to connect with an individual, to see beyond the
obvious and tap into what he or she would really like
to do and be, but may not feel courageous enough
to attempt. I believe in the power of our creative
vision and the possibility of transforming that dream
into reality. Remarkable things happen when we
focus our energy on intention, dream or vision, and
transform it into reality.

'Argument'

'Enthusiasm'

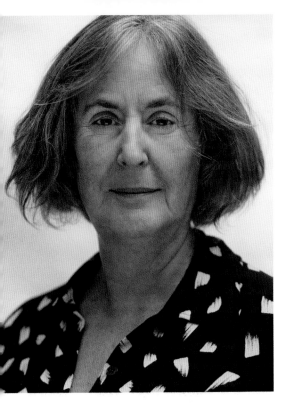

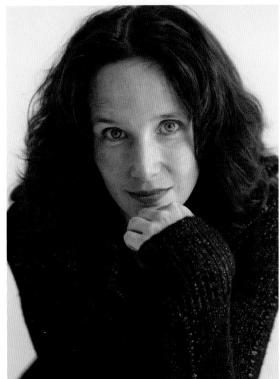

Gillian Slovo

Q. What would you change if you could?

My answer to that changes every day, but I suppose I would try and change people's feeling that those who are different from them are taking things away from them. I would like people to understand that just because you're not born in the same street, in the same city, and don't have the same colour of skin, does not make you any less human.

Hélène Grimaud

Q. What do you regard as the lowest depth of misery?

Suffering from prejudice. Sometimes people feel intimidated in the face of prejudice, thinking, 'What difference am I going to make?' But we can't think that way, because we are here to make a difference; every decision we make is literally going to change the world. And if we notice something going on, it's our responsibility to intervene. Sometimes we are not even aware of the ramifications of one act of kindness, which is why we can't be ungenerous with those acts.

'Justice'

'Empathy'

Vandana Shiva

'*Vasudhaiva Kutumbakam*'
— earth family

Q. What really matters to you?

It matters to me to cultivate more generosity and compassion in our times, to have deeper resilience to the highly irresponsible and brutal changes we are going to be living through, and to constantly find the strength to be able to respond in ways that empower everyone around me.

I am a child of these Himalayan mountains and of this valley in which I was born – I have returned here to dedicate my life to the protection of the earth and to the rights of people to live at peace with the earth. I trained in physics long ago, but it is really my work in service of the earth that has shaped my life for the last five decades.

As a young girl, I lived in the forests of these mountains. My father was a forest conservator and my mother – who had been a very high education officer in what became Pakistan – came back as a refugee and chose to be a farmer. My reading in the early stages was all based on what I found in the little forest-rest-house libraries. I was particularly inspired by a book about Einstein's writings I must have read when I was five or six – I wanted to be that kind of scientist.

Alas, there was no science teaching in the convent schools I later went to, yet I followed that dream. My parents were very nurturing and encouraging, and allowed us to be what we wanted to be. I wanted to be a physicist, but no girl was studying physics in those days; I wanted to go off to Canada, but nobody was sending their daughters off to do a PhD by themselves in the seventies. Nonetheless, my parents allowed me to do what I wanted to do, with a deep trust that I was making my own choices. So, I did a master's in particle physics and a PhD in non-locality and non-separability in quantum theory – my mind was always tending this way, because I was always dissatisfied with a mechanistic world view.

Q. What brings you happiness?

Following my conscience.

If there was any choice I made every day of my early life, it was to avoid public roles. When I was made head girl of my school, I told Mother Superior, 'I will do this work as long as I can hide. I'll do everything you need a head girl to do, but I will not run assembly, I will not give speeches and I will be invisible in the role. But anything else you want me to do, I'll do.'

It's interesting that here I now am, totally against the intentions of my childhood; I am a public figure, giving talks and writing books, all only because, at every point, I respond to my conscience. So, if my conscience tells me to speak on behalf of a person who is being kept in slavery to build a dam, I will speak; I will find my voice. Because none of this is about me.

'It matters to me to cultivate more generosity and compassion in our times.'

Q. What do you regard as the lowest depth of misery?

It hurts me to see a forest dying and to feel violence against nature - I became an activist when I saw a stream in which I had swum as a child dry up. And it hurts me to see a person wasted; it hurts to see the violation of people and the prevention of their full evolution. All around me, I see a desertification in the hearts of people, in their souls and their hopes. And I see the desertification of the planet at large, in a deep ecological sense - the planet is losing its capacity to support life. This outrages me, so I channel that rage into finding creative alternatives. In this, quantum theory is always alive in me; the seed has a potential, the diversity has potential, the land has potential and all this gives me joy; full evolutionary potential expressed in people gives me joy.

Q. What would you change if you could?

First, I would get rid of this cooked-up construction of people who destroy the world whilst hiding behind a corporate form. A corporation is a total construct - the East India Company was something written on paper for three hundred merchant adventurers - and yet, a big part of the problem today is that absolute power is in the hands of a few people through the corporate form. Corporations should dissolve, and people should take responsibility for their business, rather than externalizing liability via a limited-liability corporation.

Secondly, I would do what I'm doing anyway: work to protect the commons that are vital to humans living ecologically on this planet. Because I believe everything related to life is a commons - not just for humans, but for all of life. These commons - plants, biodiversity, seeds, rivers, land, atmosphere - cannot be privatized. Privatization means making profits out of depriving others and destroying the commons, because you don't have to pay the consequences. But, if I have to manage my river as a commons, I'll make sure it's not polluted. And, if I have to save my seeds and pay the consequences if those seeds are not fertile next year, I'll make sure they're fertile.

Thirdly, I would introduce deep ecological, food-literacy and gardening education into every school, so every child knows what the earth is about, what the soil is about and that they have in their hands and in their minds the capacity to work with the soil to provide amazing food.

Q. Which single word do you most identify with?

I've chosen a phrase, *Vasudhaiva Kutumbakam*, which is the Sanskrit for 'earth family.' Vasudhaiva is one of the one thousand names for the earth; in India, everything - the sun, the divine goddess - has one thousand names.

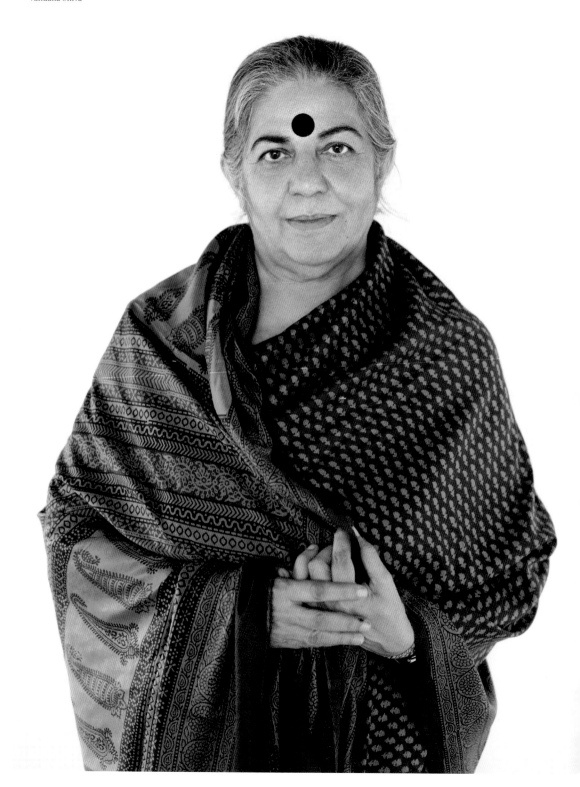

Vandana Shiva

Ivy
Ross

———————

Q. What really matters to you?

What really matters to me is living my truth and being exactly who I am on the inside, on the outside. Being genuine is so important to me in terms of living a life that is fully mine; it's about acknowledging my values and refusing to compromise on them. I've had several experiences where, after giving a talk, young women have come up to me saying, 'I want to be like you!' And my response is always, 'No. You want to be like *you*.' That's a lesson – a gift – I feel I can pass on.

People – especially women – should not let anyone tell them how they should live their lives. My father was the designer of the Studebaker Hawk and I always wanted to be like him. But, when I told him I wanted to follow in his footsteps, he said, 'Ivy: marry someone rich, become a schoolteacher and have your summers off.' It crushed me, and although now, I appreciate that he wanted to spare me from the kind of suffering he'd experienced because of his work, it felt like I was being robbed of my dreams. My mother says that's the day I went into competition with my father! I suppose I did, unconsciously. I thought, 'I'll show you I can live my dream.' No one should compromise themselves – their dreams or their truths – for anyone else; I feel I've been fearless in that respect, and my father triggered that in me.

I became a jewellery designer because I knew I had to be creating with my hands. When I was twenty-three, my work got into museums and my ego was satisfied. That was such a gift; some people spend their whole lives pursuing that kind of success, but when I achieved it, the high lasted for about three weeks and then I realized that life is actually about the journey, about the process of creating versus the end result. Life is too short to ignore that.

I stumbled into the corporate world by accident. Eventually, I was running the design and product-development departments for a wide range of companies, including Swatch, Calvin Klein and Mattel. One of the greatest instances of living my truth came when I was at Mattel in charge of designing and developing all of the toys for girls. Two of the typical buzzword phrases that the chief executive officer had put in an annual report were 'innovation' and 'teamwork.' I had studied what I call 'the technologies of the sacred' – sound, light and colour, along with the power of connection and psychology – and I realized that it was time to implement what I *believed* could work in pursuing Mattel's goals of innovation and teamwork.

Team creativity comes from trust and being in resonance with each other, but, when I looked at my team, I realized that they didn't know each other at a deep level to create the trust, nor were they on the same wavelength. I'd been studying sound and vibration for thirty years as a hobby, so I brought in my sound teacher to discuss some options about how to use the power of sound to connect the team into the flow state when we needed to create together. We got twelve volunteers from my team to sound out their voices. We recorded their vocal ranges with the objective of finding a place where all of the twelve voices overlapped. We took that fundamental frequency and embedded it in music – in octaves up and down. When we would brainstorm ideas, I would play the CD in the background. After a short period of time each day, our brains would entrain, spiralling to new places and ideas together. An independent creativity test administered both before and after

'People – especially women –
should not let anyone tell them
how they should live their lives.'

the team worked in this way, showed that I had increased creativity by 18 per cent. I had taken my beliefs in the power of sound and music, put them into action, and united us. The ideas and products that were generated from this alternative way of working were so successful that I won the chairman's award for sustainability. It was such a validation for embracing fearlessness.

When I think about the benefits of female involvement in the corporate world, I think of this project. Feminism, for me, isn't just a woman's cause; it's about embracing the female principles that exist in everyone. It's about creating the space for others to be who they are and allowing their talents to emerge. It's about collaboration and trust rather than control. It's a generalization, but I think men are more individualistic and competitive, which is why I'm excited that we are getting more women into technology. Women ask different questions and have different perspectives than men do.

Emotion and intuition have roles to play in decision making, so I think a little bit of EQ to balance IQ is something every business can benefit from. We have incredible minds in Silicon Valley, but what we're lacking is heart; I'm interested in technology that amplifies our humanity, rather than removes us from it.

Q. What brings you happiness?
Being in a state of awe and wonder, which, to me, is when my ego is diminished in the face of something greater than myself: that could be the beauty of a sunset, standing in front of a magnificent piece of art or feeling the love between one another.

Q. What do you regard as the lowest depth of misery?
The destruction of the natural world and the disappearance of entire species. Life is an embodied network. We are a part of a community composed of relationships. There is no separation between humans and nature. By killing nature, we are killing ourselves.

Q. What would you change if you could?
I would love for us to go back to the time before our egos developed – or to before we got things so wrong that we decided to separate ourselves from collaboration with each other and with the world. Today, we live separately from nature and we live separately from one another – that separateness is the cause of so much negativity. One of my favourite books as a kid was Horton Hears a Who! by Dr. Seuss. It has hugely influenced my life. There's a fundamental lesson in it, that together we can do anything. In the story, only when all the tiny Whos of Whoville joined together holding hands, making noise could they prove their existence. They would have been destroyed if they had not all cooperated, as they were too tiny to be seen. But together, they made a loud enough noise to be heard – I would love to see each corner of society included in the global discourse and have every aspect of life connected.

Q. Which single word do you most identify with?
Imagination. In the long run, it's imagination that brings us knowledge. Because, if you can imagine it, you can make it happen.

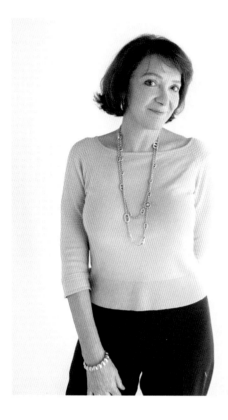

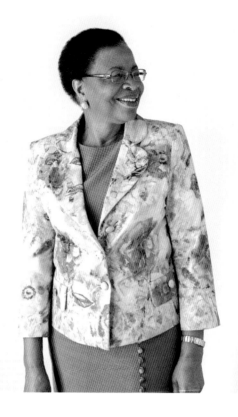

Dominique Attias

Q. What do you regard as the lowest depth of misery?

The world's indifference. When people are dying in places that have no oil, we stand back and watch – that kind of injustice is unbearable; it makes me angry and that anger fuels me.

Graça Machel

Q. What do you regard as the lowest depth of misery?

It's when a human being becomes dehumanized to the point of being unable to recognize the humanity of others. Yes, there are people in desperate situations who are capable of anything when they're looking for something to eat. But, if you give them a loaf of bread, you will see their humanity – it has not been killed. There are people living in abundance, however, who have managed to kill their own humanity and who therefore are not able to recognize it in others – they're not able to recognize suffering. That is the absolute lowest depth of misery.

'Tenacity'

'Service'

Gail Kelly

Q. What would you change if you could?

Education for girls – indeed, equality for girls – is a huge area requiring change. As we know, there are many, many countries around the world – and particularly in developing nations – in which girls have serious challenges with regard to equality, and don't have the educational access and support that they need. But we shouldn't overlook the developed parts of the world, in which girls also have many challenges; in some respects, these may be subtler, but girls in the developed world equally don't have access, opportunity and equality in the same way their brothers may have.

'Optimism'

Rebecca Odes

Q. Which single word do you most identify with?

Creativity: it's the word I've connected with since I was a kid – it was part of needing to find a name for why I was different to people around me. It's still what I feel makes me, me.

'Creativity'

Yene Assegid

Q. What really matters to you?

The biggest lesson that I've learned – and it's a hard lesson – is having the courage to be authentic: to be yourself. Everybody has a gift, so whatever it is, just be it and own it. Society doesn't foster this attitude, though. Instead, it tells us to be apologetic for our authenticity if we don't align with this or that expectation. But I say, 'No. You are beautiful the way you are. You matter just the way you are.'

My family moved to Belgium in the mid-seventies, when the revolution in Ethiopia was starting up. It was hard, because no one explained to a nine-year-old why we were being transplanted. Of course, I knew something was happening when I noticed more and more people wearing black back home; this was because people were being executed and assassinated, and people were disappearing. Before we left, we sold everything. A week before our flight I was asked to open the front door of our home and, when I did, all I saw was the muzzle of an automatic rifle – but it didn't compute; soldiers were coming to our house, searching for weapons or for anything that would associate us with the previous regime. When we left, it was less of a goodbye and more of a funeral, because it was goodbye forever. I went from being a child to a small adult over the course of one flight. We landed in Amsterdam en route to Brussels, and all I remember is that the scent of the air was different. When we got to Brussels, there was no sun, no garden, and no community. There were eight of us: my mum, dad, uncle and the five children. My parents had less than $10,000 and no jobs. Everything that we were, was gone. Everybody who knew who we were, and who we could be, was gone. What happens when you take away someone's identity?

You're no longer anybody. You're an immigrant – a number. When you go to government offices, you go to the counter where the 'other' goes. You stop walking around flamboyantly, and you make your life as discreet as possible. I wasn't conscious of this at the time, but, intuitively, I decided that I had to create something for myself – and it's a lifelong effort to transform this situation into something positive.

What matters to me now – in my work as a trainer and coach – is to look at how I can support people in opening up their gifts. Not many people outside Africa think much of Africa, and I often wonder when Africans will be able to travel for work or education or pleasure. When will we be able to travel because we choose to and not because we feel like we must leave the continent in order to survive? When will we be able to live with the kind of facility and dignity that so many others in the world have? Young Africans must ask themselves: what can they, as the next generation, do to make sure that our grandchildren have those things? How are their lives going to matter? What will they *do*? What will they leave behind? The answers, I believe, are in opening their gifts in service to others. Young Africans must embrace who they are and then be the best versions of themselves.

I still feel like an outsider, but a professional outsider. Being an outsider is actually a gift; you belong everywhere because you don't belong to anywhere and you're not in any box. Somehow you become more human because you know how it feels to not be from 'here.' You become more humble, but bold at the same time. You become kinder and also less tolerant of prejudice. It makes

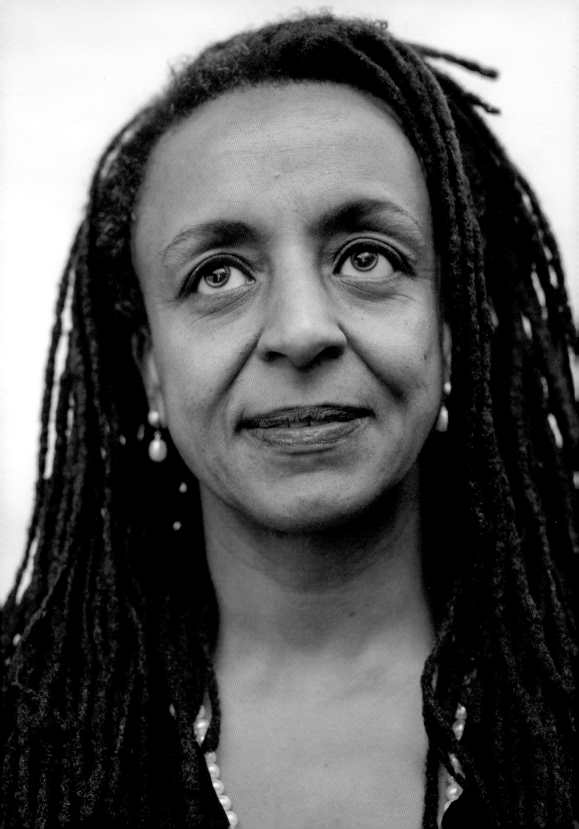

'It matters to me that I'm real with myself and with the people I love; it gives me the courage to follow my heart.'

something very special in you. So, it matters to me that I'm real with myself and with the people I love; it gives me the courage to follow my heart.

Q. What brings you happiness?
I am happy to wake up in the morning – just happy to be around. And I'm grateful for the friends and family that I have.

I pray. For me, God is not necessarily a religious God, but rather a spiritual being of the greatest possible universal expression of love. Sometimes I pray and I say, 'Please don't send me any more challenges right now. I need a summer break!' In hindsight, though, I am grateful for the challenges that I have, because it's through challenges that we grow into our humanness.

Q. What do you regard as the lowest depth of misery?
What brings me misery is when we, as humans, step lower in our thinking. Misery is when we are made less than who we are: for example, when we expect less of ourselves or when we expect less from another person. Or when we label. It's important to me that we are able to look at others as an expression of the universe – or of God – and to not be reductive of another's identity. If we can

look at everyone through a lens of knowing that they are an expression of the greatest spirit, then we'll know that we are not more than them and that they are no more than us.

Q. What would you change if you could?
I would bring about awareness. I wish people would act in the consciousness that the creator – the divine, God or whatever it is that you believe in – is right there with them, always. Would people say what they say if they knew God was listening? Would they do some of the things they do if they knew that God, this being of love, or of positivity, was watching? I think they wouldn't. And what that is, really, is just awareness of God and of God's presence within each of us; awareness would help us to be kinder, to be more tolerant, to be more understanding and to be more forgiving of ourselves and others.

Q. Which single word do you most identify with?
Gratitude. I am grateful for everything I have, especially in the knowledge that there is always a chance that things could become worse. Sometimes we can also have gratitude for what we don't have; maybe, in not having it, we are being spared from some other trouble.

Esther Duflo

Q. What do you regard as the lowest depth of misery?

It's the contempt the rich sometimes have for the poor. Why is there so much hatred for the poor? There's no explanation other than an express intention to hurt people who are already vulnerable. I can't imagine what it must be like to have nothing and be surrounded by jeering rich people.

Sophie Blackall

Q. What really matters to you?

The fact that we are in this world *together* – that we are all connected. We live precariously on this fragile planet and, ultimately, that is the thing that we share more than anything else: the land we live on, the climate, and the world we will leave for our children and grandchildren. Australia and the land are very much a current that constantly runs beneath everything I do. We have this ancient landscape with its Indigenous People; we are still newcomers to the country and to the land.

'Evidence'

'Story'

Karen Mattison

Q. What brings you happiness?

The thing that I love doing, and in the end have made a career out of, is connecting people. I think it's an incredible thing to do. When you put two people together – whether it's someone who needs a great dentist or somebody looking for a job – that's where real magic happens.

'Possibility'

Renée Montagne

Q. What would you change if you could?

I would transform people so that they are able to see the 'other' as something valuable, beautiful and desirable to know. For the most part, at the heart of what's wrong is the fact that people don't see each other. And, as a matter of fact, people have memories that are a little too long. They nurse bad feelings, often against those who are close to them: the Shiites and Sunnis, the Northern Irish and the Irish.

'Passionate'

Nicole Tung

—

Q. What really matters to you?

More than anything else, it's the people I love. But it's also the people I have yet to meet, who share the goal of human decency with me; there's something about sitting down at a dinner table with people you've only just met – who invite you into their homes to share their food – and finding a connection with them.

In my work, what matters is truth. I always knew I wanted a job that allowed me to travel. While I was at university, I went on a spring break trip to Bosnia. I'd been reading a lot about the conflicts in the Balkans, and I met a woman who had been widowed by the Srebrenica massacre in 1995. These experiences compelled me to pursue journalism; I'd always been interested in history, so journalism felt like a way to write history's first draft.

I started out doing mostly metropolitan news coverage in New York, but, when the Tunisian revolution started – off the back of the Arab Spring – I had to see what was going on. In 2011, I made it to Tahrir Square in Egypt; it was exhilarating and I felt very privileged. I went on to cover Libya when Gaddafi was overthrown; it was outside a courthouse in Benghazi, with thousands of people chanting in unison about having achieved freedom from Gaddafi's regime, that my work as an international reporter solidified. I went on to cover the Syrian Civil War, which is what I've been doing for the past several years.

It matters that people connect with my photos and that the stories I tell are accurate; I want to be able to explain complex issues through my images. But, the more I see of conflict, the less I understand it. War is a place for extremes – it's about how people lose humanity, and also how they gain it. I have witnessed some horrific things, but also the most heroic acts performed in the most terrible of situations. I've seen people risking their lives to save others with no regard for themselves. War and conflict are as old as humanity, they're almost inherent to being alive. But, although conflict needs to exist to create change or move something forward, I'm not interested in the people in power who start conflicts. Rather, I try to focus on people who are the most vulnerable, who deserve to be heard and who are often sidelined by those in charge.

There are two sides to being a conflict journalist. One is very selfish: it has to do with the exhilaration – the rush, the adrenalin – of being on the ground, where the action is happening. You feel so alive and so present, with every emotion heightened. This is dangerously addictive, so you have to constantly be aware of what you're getting involved in and of how deep you want to go. The other side is noble: ultimately, you're there for the vulnerable – for their stories. It's such a privilege when people give you access to their lives – you have a responsibility to bring their stories to whomever is willing to listen. You hope that some sort of change will follow, that, by showing the human side of conflict, you encourage people in positions of power to use their influence positively.

We go into this profession knowing the risks – we're under no illusions – but our responsibility to

'I have witnessed some horrific things, but also the most heroic acts performed in the most terrible of situations.'

tell the truth is more important than the danger. Today, those who are neutral in situations of conflict – the journalists – are being murdered for wanting to tell the truth. We have become targets. But you know what? That makes me even more driven, because, otherwise, we will all be silenced. As human stories go unheard, the world will continue in ignorance of the suffering on the ground – and that is something to fight against.

In a way, this work is a mission in defiance of those who want to silence journalists. When James Foley was killed and the footage of his execution was shown in the news, so many people questioned what he'd been doing in Syria; having to defend his decision was so infuriating. You don't get to ask that question about my friend, who risked his life to bring you a story he cared about – of people he felt needed to have their voices heard.

Q. What brings you happiness?
I find happiness in nature, in being able to step away from everything that's going on in the world – and in my head – and feel peace.

A few weeks ago, I was standing outside an internally displaced people's camp in Iraq; it was full of people fleeing Mosul. I heard this woman cry out and saw that she was embracing a little ten-year-old boy. It was her son – she hadn't seen him for two years because she'd been outside Mosul when Islamic State took over and she couldn't get back home. The woman was in a state of the most extreme joy; they were both crying and the boy seemed so in awe of being

able to see his mother again. It's moments like this that you really live for.

Q. What do you regard as the lowest depth of misery?
I'm not a parent, so I can only imagine what the pain must be like, but one of the most difficult things to witness is parents losing their children. So, too, it is very difficult to see children – especially young children – losing their parents and not comprehending what has happened.

I often ask myself why a certain thing is happening, but I never have an answer. It is very easy to become disillusioned and frustrated with humanity because of all the suffering we create for each other. I don't think there *is* an answer, though; we just have to be strong and continue working to tell the world about what's happening.

Q. What would you change if you could?
There just needs to be more equality. So much subjugation is carried out by men that I wish more women were in power. Would there be war if women were in power? Maybe, but I would hope not. There is something nurturing about women that I've seen all across the world. Women tend to be more practical and have a different approach to problem solving, so I certainly think the world would be more peaceful. In any event, we need to create some kind of counterbalance to the testosterone.

Q. Which single word do you most identify with?
Hope. I hope for tolerance and for respect.

Diane Wright Foley

Diane Wright Foley

'Mercy'

Q. What really matters to you?

There's so much that matters. It matters to me that, for whatever moments or days I have left on earth, I can do God's will, truly. The largest piece of my strength has been my faith in a very loving and merciful God – I know that God was very much with my son, Jim, to the end of his days.

It matters that I can follow the message of love and mercy, and that I can make a difference for the likes of American hostages and independent journalists who are trying to give a voice to people who have none. That's become very important to me – to make a difference for those who need help.

Jim was a remarkable young man. Throughout his life he really cared about the underdog. He was always interested in people who were different from him or who were from a different culture. He did a master's in journalism, then became a conflict journalist. He was very taken up by the hope in the Arab Spring; he'd been in Libya shortly before he went to Syria, so he had an understanding of what it meant for people to seek freedom. Within a month of Jim's execution, I felt compelled to start the James W. Foley Foundation; it just felt like he had so much work left unfinished. The foundation serves to advocate for hostages – particularly Americans who go into conflict zones – because at the time of Jim's death we didn't receive much support here in the United States. Few protect freelance conflict journalists. They are out there on their own.

The work that I'm doing with the foundation is incredibly important to me because I feel our world desperately needs to know the truth; it needs to hear the voices of those who otherwise would not be heard. How else can we become a better society? Jim had a deep understanding of this; he realized how vital the voice of the people is to our democracy and to any goodness in the world. And goodness matters, because I think one of the most frightening things is the opposite – the feeling of hatred and division. That's so destructive to our society, and the world.

As Jim was a unifier, we have supported the international Alliance for a Culture of Safety – ACOS – which is a historic collaboration between media, NGOs and freelancers. We are trying to foster a network that brings together the resources of the many wonderful journalist-oriented NGOs in the world – the Committee to Protect Journalists, Reporters Without Borders – and media companies, whereby they are able to

'I feel our world desperately needs to know the truth; it needs to hear the voices of those who otherwise would not be heard.'

focus on protecting freelancers in conflict zones. There are a lot of good people in the world, so it's just a question of bringing them together to pursue the good cause. We're very hopeful.

Q. What brings you happiness?
Happiness is everywhere. I'm very blessed. I'm blessed with a wonderful husband and four beautiful children. Our grandchildren are the biggest gift, particularly our youngest; he's one-and-a-half years old and is named after Jim – he's the most beautiful child. I have a beautiful mum, too, and I love nature. I've been blessed – there's a lot of suffering in the world and I've just tasted a bit of what many people go through in a much worse way.

Q. What do you regard as the lowest depth of misery?
The hatred. It's the hatred that would treat someone like our son so horribly for all those years, torturing then killing him in such a brutal way. That kind of hatred is hard for me to understand and is so frightening to me – it's just the lowest place a human can be. As people, we have the power for good or for bad; we have the power to be merciful and loving, or to really destroy one another.

Q. What would you change if you could?
The only way we can change is just one person at a time – each of us trying to do the next right thing, trying to be forgiving and merciful to people who may have offended us or really hurt us deeply. We're all just people and we all make mistakes.

I also think it's important that people who are trying to do good in the world come together and stand together. I wish there could be more collaboration. Jim was held with eighteen Western hostages; all of those people came from countries allied with the United States, yet those countries didn't work together to get this group of nineteen hostages out. Each country did its own thing. That is sad because, if we'd come together, we would have had some idea of what we were facing and what true tragedy was ongoing in Syria. And we could have been a lot stronger. I believe in convening people to discuss issues and I deeply believe in a loving God – that is essential for me to continue.

Q. Which single word do you most identify with?
Mercy.

Christine Parker

Q. What do you regard as the lowest depth of misery?

Around the world, I see that divisiveness based on gender or sexual orientation has permeated all facets of society. It's really sad that we are still having conversations about inclusiveness. New South Wales announced its second female state premier recently – an incredibly capable individual – and I found it fascinating that she was asked questions about why she was single and childless, and about whether this would have any impact on her work. In this day and age, I found that incredibly disappointing. But I take heart in the great progress we've made over the years and in the groundswell of individuals and communities that really want to make a difference, and that want to celebrate what's right as opposed to what's wrong.

'Passionate'

Rosie Batty

Q. What really matters to you?

My work as a campaigner and advocate against family violence, particularly towards women and children. This work is a direct result of my son, Luke, being murdered by his father in 2014; that was a final act of power and control – of revenge – that totally changed my life.

'Courage'

Lara Bergthold

Q. What would you change if you could?

I've been thinking about the difference between equality and equity: equality gives everybody the same thing and says, 'Make with it what you will,' whereas equity understands that some people need a little bit more to enable them to stand on the same ground as others. If the world could better understand why equity is so important, we'd see a lot of things changed and relieved. On a different scale – and it's related to equity – young women must be raised with the power and belief that they matter as much as young men. Until that's changed, we aren't ever going to see the world the way we wish it to be.

Eryn Wise

Q. What really matters to you?

The United States will never acknowledge that a genocide has happened in this country – it is consumed by self-assuredness. But somebody, long ago, decided to survive, so that I could be here to have these kinds of conversations. So, my existence is their resistance. I don't think most Americans will *ever* see me. But I see me, and that's a lot better than my mother's generation. So many Indigenous People are lost to us, because they were told they didn't exist; as a result, they stopped seeing themselves. This is why I look at myself in the mirror every morning and say 'I see you.' And I tell the kids I work with that I see them too. We're going to have to make one hundred thousand times more noise if we are going to be heard, but I'm here to help them scream.

'Loyal'

'Resilient'

Embeth Davidtz

'Kindness'

When I think about what has profoundly influenced my life, the two moments that come to mind are having children and being diagnosed with breast cancer at age forty-seven. There are profound differences between my life before and after motherhood, and my life before and after breast cancer.

Raising kids in this day and age is a truly difficult thing to do. Of course, I want my children to be happy, but that's not always a requirement; rather, it matters that they be on the right path. Trying to find and keep them on that path is really important to me as a parent.

The planet is also very important to me, and it's fundamental that I'm not contributing to ruining it. In everything I do, I'm consumed by the question, 'How do I leave this world a better place?' Answering this is becoming more and more difficult, however, because the world seems to be degenerating, and I do wonder whether I'll have the feeling of the world being in a better place in my lifetime.

It matters to me that I'm talking to women about breast cancer – not only about experiencing it, but also about the results of treatment. Many women struggle with the idea of still being able to own their femininity after going through a baptism of fire like breast cancer; this has been a very interesting journey for me and not always a comfortable one. When I was first diagnosed, I remember feeling an enormous amount of shame; breast cancer felt like something dirty, and, for a long time, it wasn't something I wanted other people to know about. The first time I had to appear in front of others with really short hair,

everyone thought I was trying something edgier. I told them, 'Oh, I just felt like a change.' But, whilst I just wasn't comfortable shouting from the rooftops that I had breast cancer, it also didn't feel like I was being authentic by hiding it.

Then, a job on the television show *Ray Donovan* came along that required nudity in a love scene. My immediate thought was, 'I only have one nipple!' I decided to get a prosthetic one and sent a photograph of my nipple off to have one made. I figured I could put it on and cover the scar with makeup, and everything would look all right. But, as we started to discuss the character more deeply, I began thinking more about my body. I realized that I had a choice: I could hide the map of who I am and nobody would be any the wiser, or, I could reveal this map and be a woman who can still be a lover *and* a compelling character. It felt a bit like taking the lead but, to be honest, it also just felt like the right thing to do. So, we did it; I showed myself as I am, and it blew up. There was a massive outpouring from survivors, families of victims and advocates. It was overwhelming. I hadn't really *done* anything – I certainly didn't set out to serve the greater community – I just wanted to be honest.

I'm so glad I did it, though, because the experience has given me purpose. So many women have told me that, when they saw the scene, they felt beautiful, unjudged, strong in their sensuality and sexuality, and able to reject the labels associated with their scars. I had never thought of myself as ugly after breast cancer, which is why it was so important to me to convey a confident, well-put-together woman in a sexual light – to not have her scar dictate that she was less of a woman.

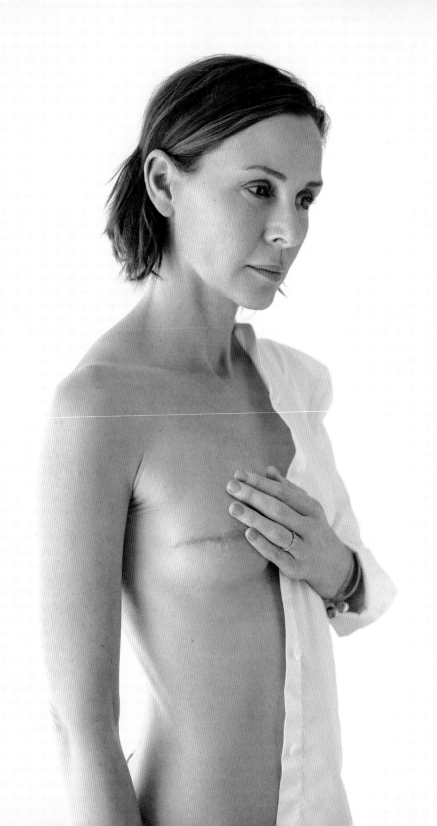

Embeth Davidtz

'Many women
struggle with the idea
of still being able to
own their femininity
after going through
a baptism of fire like
breast cancer.'

I did worry, though, that some of my children's friends might see the show and talk to them about it; they were at the age where you don't really want your parents to stand out in any way. So, I carefully told them what I had done and why. The discussion happened after the show had aired and when people were beginning to respond, so I told them that I really thought what I had done was helping others. I showed them the correspondence I had received, and they saw the value in it. In time, I hope they will feel proud.

Q. What brings you happiness?
My dogs, my cats and my chickens. My children, too, bring me great happiness and I have a really great partner; I got married later in life, and that feels like it was a smart decision for me. I lived in South Africa for many years, so being in Africa makes me happy. I love being in nature: the sound of birds, swimming in the ocean and gardening. It's the small things that bring me the greatest pleasure.

Q. What do you regard as the lowest depth of misery?
My immediate response to that is personal: the lowest depth of misery for me was day three of

chemotherapy. But, that's not the lowest depth of misery; there are people who, on day three, have absolutely no hope of recovery. So, the lowest depth of misery may be being told that there is no hope for you – being told that there is, in fact, no room for optimism.

Q. What would you change if you could?
I would end suffering. When I think of children struggling to survive in war-torn countries, or living in circumstances of poverty or abuse, I just want to rush in and protect them; I think of my own children, who are so fortunate, and I want to take everything that the world is throwing at the disenfranchised children and chuck it back!

Q. Which single word do you most identify with?
Kindness. The word encapsulates everything about how I want to live my life. I felt so optimistic about the United States twenty-five years ago, and now I long to feel that way again; I wish that we could get back to human kindness – if we could hold on to kindness, even just for an hour every day, things would be better.

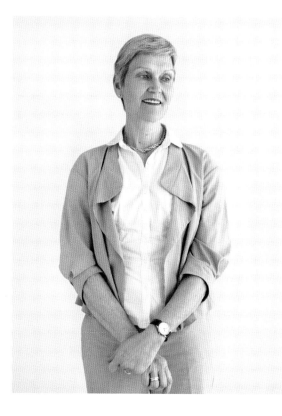

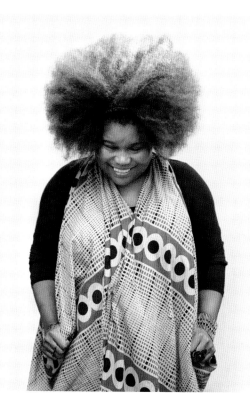

Adele Green

———

Q. What would you change if you could?

I would banish hunger, poverty, intolerance, greed
and cruelty.

In my field, I would change the overall focus from
cure to prevention. Good health ultimately flows
from a very sound social structure, but a lot of
people are impotent because of overarching cycles
of exploitation and poverty that aren't going to
change until we have a more just society.

'Love'

Audrey Brown

———

Q. What brings you happiness?

I would say the place and time when I am most
happy is when I'm watching a thunderstorm in the
dark, or playing swords with my nieces.

'Kindness'

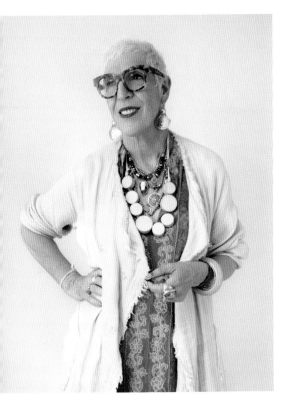

Ronni Kahn

Q. What brings you happiness?

I find happiness in seeing the smiles of the people who work for me – people who've found purpose and meaning through their work for my organization. I didn't ever intend to be an inspiration to anybody, but it turns out that people find something about what I've done meaningful. And that's priceless.

Molly Biehl

Q. What brings you happiness?

Some of my happiest moments have been a result of difficult moments, of realizing that the magnitude of joy can, and does, far outweigh the painful things in my life. I'm grateful for difficult experiences, because they allow me to delve very deeply into myself and remember the positive things: my family, my successes. In a wider sense, the potential I see in young people brings me happiness; it makes me feel optimistic to see them seeing themselves as contributors, particularly in such a confusing time.

'Love'

'Power'

Chimamanda Ngozi Adichie

Q. What really matters to you?

A friend of mine once told me that everything I care about, I care about passionately; I don't think it was necessarily a compliment!

At the risk of sounding like a beauty-pageant contestant, I care about justice. I believe that my purpose is to be a storyteller and, because of this, I believe that I feel things in a very particular way – certainly far more intensely than other members of my family. When I see that which is unjust, my reaction is strong, and what I feel inspires what I write.

I grew up in the shadow of the Biafran War. I didn't experience it, but my parents did; both my grandfathers died in the war. Despite no one wanting to talk about it, the war was very present, and I was the child who asked endless questions – every family has that one child. I wanted to understand the story of who we were and how we came to be in that situation of conflict.

I'm often asked whether anything specific occurred in my past to make me into this fierce feminist, but there was nothing seminal; I just see myself as having been a child who always wanted to understand. As a storyteller and a person who creates, I have always felt slightly removed from my world; I have always felt that I am watching everything and am never entirely present. That has given me the ability to notice; very early on in my life I noticed that the world is very unfair to girls and women. I wanted to understand the justification, but I've never found one. I suppose that, in wanting to understand why certain things were a certain way, I wanted things that were bad to be better – that's still something I want. As a little girl, I always questioned being told, 'Oh, our culture forbids that.' I saw the unfairness even in small things; I was told that I couldn't go to the local masquerades at night, because only boys could do that. That's when I realized how important it was to be an individual, because allowing people to be individuals and judging people as individuals is a way to combat gender expectations.

I left home when I was nineteen to go to college in the United States, which was a decision that changed the trajectory of my life. My parents are relatively progressive people, and I had been protected from a lot, so it was at university that I did my growing up: the culture I grew up in was outward looking and cosmopolitan, but also very traditionally Igbo.

It's very difficult to talk about one oppressive institution without talking about the others. I often like to joke that I don't choose the days on which I am black, the days on which I am a woman and

'Very early on in my life I noticed that the world is very unfair to girls and women. I wanted to understand the justification, but I've never found one.'

the days on which I'm both. I experience being black and being a woman, and being a black woman, every single day.

Class is something that has become prominent in my life, because, unlike these other two categories to which I belong, it's a category in which I actually experience privilege – and it's made me understand how complicated privilege is. There is a certain level of access I have that I haven't really earned, but which I benefit from rather happily. This makes my determination that we get rid of unearned privilege even stronger. Here in America, for example, it is impossible to talk about race without talking about class, because there is a very strong sense that race is class. And I can't talk about gender without referencing race and class, because the gender pay gap is also an issue of class.

My writing matters to me. It's hard for me to talk about who inspires me or who influences me because, on the one hand, the writer in me is reluctant to know the answer – I want my influences to be unconscious, otherwise I may feel like I am copying someone. On the other hand, though, I just don't have an answer – everything I've read up to this point must have influenced me: the history of the Catholic church, the rule of the Nazis, Enid Blyton . . .

Q. What brings you happiness?
My family and my friends – the people I love. For me, family is broadly defined; it's not just the people with whom I share blood, it's the people with whom I share love. Following them, it's my work. I love that I can write and, when my writing is going well, it is a source of happiness. When it's not going well, that's often a trigger for depression – but that's what my family is for.

Q. What do you regard as the lowest depth of misery?
As opposed to experiencing an absence of love, I would say that it's being separated *from* love and being separated from loved ones. It is when you are trapped in a situation that you cannot change and you're cut off from your people – that's the lowest.

Q. What would you change if you could?
I can't pick just one thing; I would eliminate all forms of gender, racial and religious injustice. The issues are their own, independent issues, but they cannot be analysed in isolation from one another. It's very complex and is always a work in progress for me – the issues are connected and they are not, but, however strong their connection to one another is, they've got to go!

Q. Which single word do you most identify with?
Human.

Chimamanda Ngozi Adichie

Gabourey Sidibe

Gabourey Sidibe

Q. What really matters to you?

When I think of the things that have shaped me, the first would be my parent's marriage. My mother is American and my father was Senegalese; they got married so that my father could get a green card. They eventually fell for each other – or settled for each other – and had children. But I don't think I got to see a real, loving relationship as a child, so I don't know what that looks like from the inside.

Being in school was also very formative. I went to a school in the Lower East Side of New York City, where most of my classmates were Puerto Rican or Dominican; about 4 per cent of us were black. Being one of the 4 per cent – who also happens to be round, who also happens to be dark – had a real effect on me; sometimes for the better, sometimes for the worse.

What shaped me more than anything, though, was becoming an actor. I had thought I would grow up to be a therapist and had started studying psychology. I loved discovering the inner workings of the human psyche, and I wanted to be a part of exploring that. My whole life I'd watched my mom, who is a singer, pursue her art, and I thought it was too hard for me to do. But I was completely wrong; my first-ever audition was for a film that was called *Push* at the time, but which most people know as *Precious*. I auditioned on the Monday, was hired on the Wednesday, and a year and a half later I was the eighth black woman in history to be nominated for an Oscar for Best Actress. Having all that happen to me at twenty-five years of age shaped and rocked me; it's completely different to what I thought I'd be doing and I'm still very surprised every day. But I hope having studied psychology helps my acting because, even when you're an actor, the purpose of playing a role is to get behind a character – to get behind the thinking of a person and make it real. And that's what psychology is, to me.

Today, my happiness and my comfort – being able to love myself and see that I am deserving of love – really matter to me. I think that's an issue a lot of women battle with, and I think women of colour battle it a little more. Because there is this school of thought that, as a black woman, you're supposed to be strong, a survivor, superhuman – that you have to put everyone ahead of yourself and that there's no room for selfishness.

I like the thought of the strength of a black woman, but I also want to be able to think of myself. I know that sounds really selfish but, without kids or a husband, it's something I can afford to be at this stage of my life; I can be 100 per cent selfish and worry about my own happiness, my own sanity, my own emotions and my own comfort. Prioritizing myself – at least not prioritizing others above myself – is really something I want my life to be about.

'Being able to love myself and see that I am deserving of love – really matter[s] to me. I think that's an issue a lot of women battle with, and I think women of colour battle it a little more.'

Q. What brings you happiness?

I find happiness in odd sorts of things; I love seeing a hummingbird or a butterfly, doing my own nails, reading a good book or discovering a good show. Those things bring me joy. And I definitely don't think happiness is something that will come to me, rather, it's of my own making. I can't hitch my expectations for joy to someone else. Happiness won't come from relationships outside of myself – if it did, my happiness would end when relationships did.

Q. What do you regard as the lowest depth of misery?

I always say that there are billions of people on the planet, so there are billions of ways to be a person. By that logic, though, there are a billion ways to suffer. I've known my own personal suffering, but I know it doesn't compare to the suffering of people living in third-world countries or fleeing their countries to escape persecution.

From my own small, privileged point of view, however, I'd have to say that the worst kind of suffering is when you're struggling alone and all you can see, feel and understand is darkness – it's when there is no light, everything is harsh and all you want is a way out, but you can't find it. It's when a person is imprisoned by their own brain, by their emotions. I say that's the worst, because that's the suffering I understand; sometimes it can feel like that kind of suffering isn't real compared to what others are going through, but it is.

Q. What would you change if you could?

I would change the stigma attached to reaching out for psychological help. Having some time to talk to a therapist – someone who doesn't know you personally and isn't really involved in your life – can be so liberating, because they don't have a stake in you. Just being able to talk to someone with whom you don't have to worry about monopolizing the conversation is key.

I think this has the potential to benefit the entire world, because, once we all reach a level of emotional intelligence, we will be forced to acknowledge each other's humanity; it would force us to be kinder and it would force us to explore the greatness that can come from within. Developing one's emotional intelligence and working on one's self is working towards good energy – and that's contagious. If we were all allowed to be sensitive, we would make a better world; if we were allowed to have emotions, to talk about them and fix them when need be – which is the most important part – then this world would be a safer place.

There are a billion ways to make this world better, but I would say that sound, global mental health is a good start.

Q. Which single word do you most identify with?

Happy. The word sometimes sounds foreign to me, because I don't say it enough.

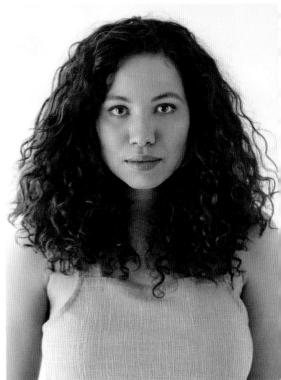

Véronique Vasseur

Q. What really matters to you?

After my mother died, I decided to finally do something that really mattered to me. So, I entered La Santé Prison in Paris. I became part of a very particular, extremely violent world. I really loved the place and its residents, but it was a world completely apart, with its own absurd codes. So much could have been done to improve it – with very little effort and no extra resources – that I decided to write a book about it. The response was incredibly violent because, when you take on the prison administration, it's as if you are attacking the police. I was supported by the medical team and, of course, by the detainees inside the prison. I have a whole suitcase full of letters from inmates and their families, and also from more furtive sources, like the prison chaplains. My book triggered a commission of inquiry – the prison couldn't hide any more.

'Sincerity'

Jurnee Smollett-Bell

Q. What would you change if you could?

I would make sure that children have a safe start, a healthy start, a fair start, an equal start, and that they are never violated. I think so many issues are caused by people being violated in their childhood. It doesn't have to be this way.

'Vessel'

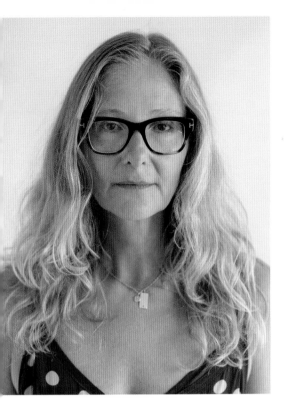

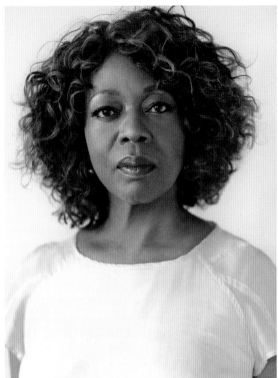

Eva Orner

Q. What really matters to you?

Telling stories, exposing injustices and educating people matters to me. When I produced *Taxi to the Dark Side*, I was constantly asked what motivated me. So, at the age of thirty-eight, I confronted that question for the first time. Three of my four grandparents perished in the Holocaust, and I remember 'Never Again' being a very strong message in the Australian Jewish community of the seventies and eighties. But, at the same time, I was seeing Cambodia falling apart on the news. Being a precocious child, I asked, 'Isn't it kind of happening again? It's close to us and we're not doing anything about it!' It really struck me, and I grew up wanting to do something that mattered. The work is hard, but I try not to carry it with me. I try to see beauty. Because living well matters to me, too: going to the beach, being in the sun, cultivating meaningful friendships and having love in my life.

'Kindness'

Alfre Woodard

Q. What brings you happiness?

I do enjoy being around my comrades – my fellow artists. I feel that we're in the human business; we're recreating a human action. We're bringing people to life and telling the stories of how they intersect. This is my way of paying rent in the world. Since we first stood up on two legs around a fire, there have been those who told the stories and kept the lore, who held up the mirror; it increased the well-being of the tribe. Now, we're recognizing that we are a global tribe. I'm making a product, and I want to know where it's landing. I've got to be concerned about that family sitting there in front of the TV. Do they have health care? Is anybody hungry? Will that girl be bullied at school? Will she be touched by the neighbour? I think an artist has to understand that. We can name it activism, but, to me, we're in the people business – and it's part of a whole.

'Joy'

Sarah Beisly

Q. What really matters to you?

People, and my relationships with them, matter to me. It's important that each of my family members feel valued: my kids, my husband and our family back in New Zealand. What matters is learning what it means to love my family, to stand with them in their suffering and to celebrate with them in their joys.

My family extends to the family that my husband and I are building with our business, The Loyal Workshop – we don't want to operate it like a standard business, rather, we operate like a family.

One of the things that radically altered the way I make decisions was meeting Jesus. Getting to know his priorities by reading the Bible shifted my priorities. Jesus was concerned for the marginalized; over and over again, we see him give his time to a woman he values who has been pushed to the edge of society. When society is telling her she is nothing, he acknowledges her dignity and tells her that her life has value; I realized that, if I claimed to follow Jesus' teachings, then concern for the marginalized needed to be important to me as well.

I studied business, but I was never interested in making money for myself; I was always examining how business can be used to empower the marginalized or to provide opportunities for the poor. In 2002, when I finished my degree, I visited Kolkata with a bunch of mates, and we met up with mutual friends who were providing alternative employment to women trapped in the sex trade. Something in me came alive – I believed in what they were doing, because it was why I had studied business in the first place.

The slavery that continues to exist in today's world is a human-rights atrocity. There are currently so many women trapped in the sex trade, and the vast majority of these women have not chosen this profession – they are tricked, they are stolen. The stories of how women end up in the red-light district are common enough: girls grow up in a poor household, with a lack of education and opportunities; traffickers – whom the girls often know – go around the villages and offer work in the city; and, when the girls get to the city, they are sold to a brothel and locked up in a disgusting room the size of a single bed. They are repeatedly raped, forced to see customer after customer after customer. They're told that, having started this line of work, they are bad women – that no one else will take them now and that that is their lot. Slowly, they start to believe this. The psychological abuse is so intense that it gets to a point where the doors are unlocked and the girls won't leave, because they are trapped in their minds. There is a daily rent for their room, so they need to see enough customers to meet that amount; for anything they need above that, they need to see more customers. The women's bodies are commoditized for men's enjoyment, but, as they age, they are discarded. Society has rejected these women because they're deemed worthless, and then the red-light district rejects them too. As they get older they struggle to afford the room and struggle even more to earn money for food. It gets to the point where they can't sustain their life anymore; many end up becoming madams because there is nothing else for them.

When I saw all this going on in Bowbazar, I couldn't believe it was happening in my lifetime – I knew I would never be able to justify doing

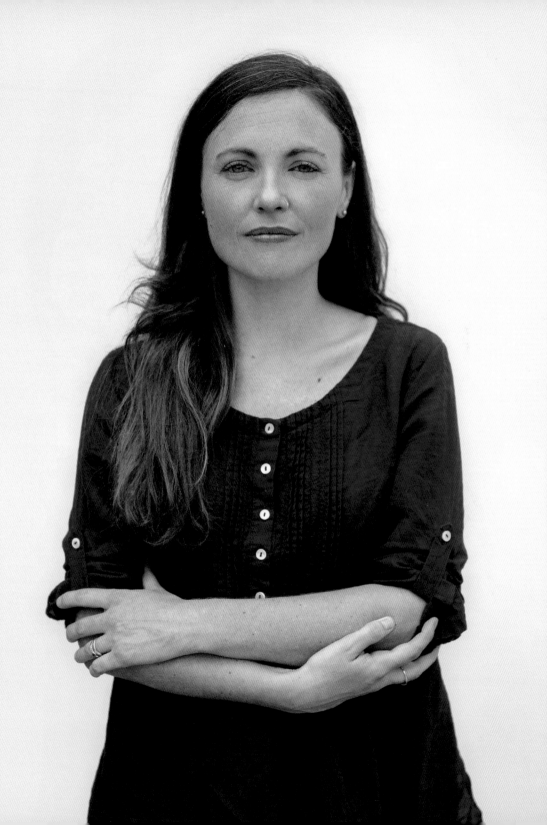

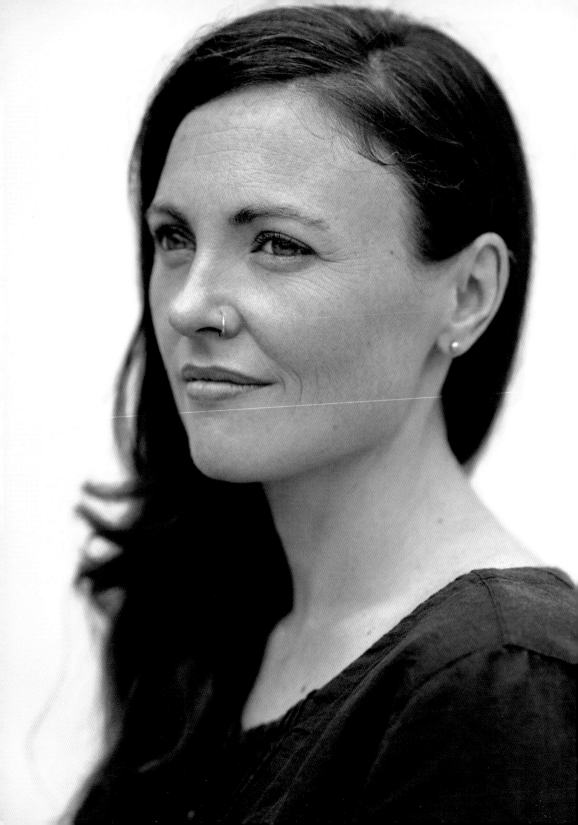

Sarah Beisly

'It's important to me that I spend my days on this earth wisely; I don't want to squander the freedom that I've received, and I want to use it to help more women find their freedom.'

nothing about it to my grandchildren. In 2014, we set up The Loyal Workshop, which is perched on the edge of the red-light district and offers employment to women who have been trapped in the sex trade. Most of these women are in their mid-thirties – they have reached that point where life is no longer sustainable. When we started, we just did brothel visitations to build up a rapport and trust with the women; we wanted to show ourselves to be friends who wouldn't betray them. Building this trust takes time. We speak a lot about what it would look like for them to fight for their freedom. We let them know that, when they're ready to leave, we're here to offer them work in a for-profit business in which the products speak for themselves and aren't contextualized by the stories of our artisans – there is a lot of pride and dignity in that.

So, it's important to me that I spend my days on this earth wisely; I don't want to squander the freedom that I've received, and I want to use it to help more women find their freedom.

Q. What brings you happiness?
One thing that brings me joy is watching my children laughing and giggling together, when they are being totally silly, ridiculous, childish, innocent and playful.

Another thing that brings me a lot of joy is seeing the transformation in the lives of the women who work for us. When I first meet them, they are trapped in hellish situations, but I have the privilege of witnessing them move from that point to becoming a part of a family in which they belong and are accepted for who they are, and for who they can become; their posture changes, they start to stand upright, they look us in the eye, they start to crack jokes – they start to believe. We have a mantra here at the workshop, 'Your life has a lot of value; my life has a lot of value.' You can see them start to believe that it's true. What greater joy is there than witnessing this transformation take place in front of our eyes?

Q. What do you regard as the lowest depth of misery?
I have not seen a lower form of misery than a girl being sold into the sex trade and forced – against her will – to work as a sex worker for years and years. Can there be anything worse than to be repeatedly abused on a daily basis and to really believe what society is telling you – that your life has no value?

Q. What would you change if you could?
If people treated every single person with the dignity and respect that they deserved – regardless of the colour of their skin, their gender, their caste, their background or their sexual orientation – this world would be a much better place.

Q. Which single word do you most identify with?
Love.

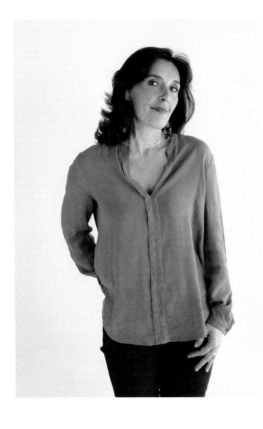

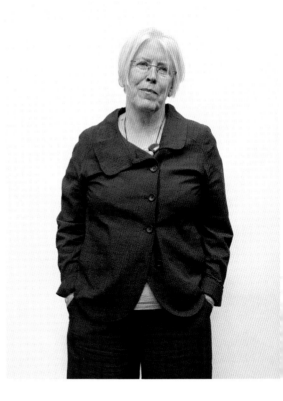

Laure Hubidos

Q. What really matters to you?

I would define myself as a woman with a strong sense of commitment. This goes way back, to when I lost my mother at age four. This was incredibly difficult, least of all because her death was initially hidden from me. It meant that I had to cope with questions of loneliness and death from a young age; I had to come to terms with solitude and developed what amounted to a philosophy of life: a commitment to always choosing life above everything else. Questions of solitude, weakness and suffering were naturally always on my mind, so, the commitment that defines me today – and that is growing stronger and stronger with age – has always been with me; I have always been committed to being close to people who are the most vulnerable and left out. All people matter to me, but those who matter to me most are the unhappiest and the most fragile.

'Commitment'

Mary Coussey

Q. What really matters to you?

My number-one issue is equality, and a lot of my life has been concerned with that. When I was a child, I once saw a black woman being abused by a passenger on a bus. It upset me tremendously; she was obviously used to that kind of treatment, because she didn't react. My first job was as a personnel officer in a factory; if they thought I'd recruited too many black people, the union would approach me and tell me to stop. At another job, I was told to put a red dot next to the names of black people applying for work to 'alert' certain foremen. That kind of blatant racism infuriated me and is why I went to join the Race Relations Board.

'Equality'

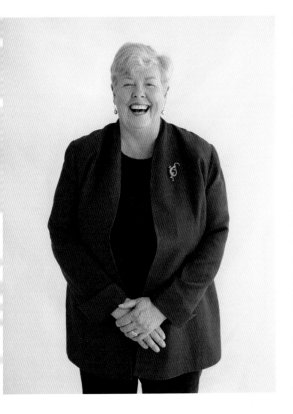

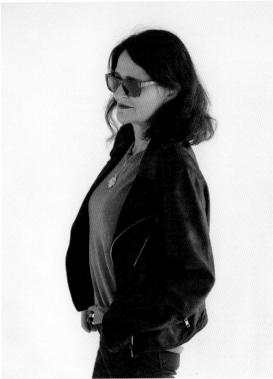

Christine Nixon

Q. What would you change if you could?

The way we treat each other. It would make such a difference if people treated other people decently and fairly. Achieving fairness and equity requires system reform – it's not so much the people who need to reform. One of the things I wouldn't do is want to change women and minority groups. Rather, those who have access to power should be the ones to change and recognize that we would just be so much better off as a society – as communities, families and individuals – if we had better fairness and decency, and were not treating people harmfully. We've got to be ambitious. On occasions it's not appropriate to say that you're an ambitious woman, but I am ambitious – not for me, but for what could be done.

'Power'

Miss Tic

Q. What would you change if you could?

Although I am a person who writes on walls, I would stop walls – whether physical, geographical or mental – being built. I draw on walls to make it possible to see beyond them.

'Subversion'

Callie
Khouri

'Joy'

Q. What really matters to you?

What matters to me most, as a human being, is that the people I experience on a daily basis feel loved. My personal relationships with my family, with the people I work with and, generally, with the people I am around are really important to me. I want the people near me to *know* how important they are to me – to know that they are appreciated.

Beyond that, I will never stop trying to make it clear that inequity is inhumane – in every single circumstance. If this world is going to survive, we have to recognize this. We cannot look out and see strangers. Because there is no room for 'them' – it *has* to be 'us.' I feel this is the overriding message of almost everything I say or do. I was thirteen when the women's movement was really getting fired up, in the seventies. That's when I started realizing – looking around – that I couldn't see women in positions of power. For the first time, I felt that things for women were limited and this upset me to my core. I became aware of how women were talked about and to, and I was incensed. There was an inequity in the way women were treated and in what was expected of us – there still is.

Although the inequity wasn't something that was happening in my household, I could witness it anywhere I looked. Funnily, my father – whom I lost when I was sixteen – is the cause of and support for my feminism. I was really lucky that he was such an open-minded human being; he is the first person who ever talked to me about abortion. He was a doctor and would probably be called a conservative Republican – but he was pro-choice. He had seen the result of back-alley and botched abortions early in his career, and he found these barbaric. He thought that if someone had made the decision to terminate a pregnancy they should be able to do so safely, no matter their age. He said a twelve year old who's decided to terminate her pregnancy has had something horrible happen to her – whether she knows it or not. Such a girl shouldn't have to find a solution to her problem with the support only of her twelve-year-old best friend. We don't want youngsters deciding how to confront this issue, and we certainly don't want them – or a woman of any age – in the hands of unethical, untrained people. I had no idea about back-street abortions and the context in which they occurred, but my dad made sure I knew. He was a great man.

When I was sixteen, I picked up *Ms. Magazine*. I discovered Gloria Steinem speaking words that could have come out of my own mouth. That's when I knew I had to be working to change the way the world looks at women. I *had* to illuminate people. In this world, we have right and left, top and bottom, in and out – one doesn't exist without the other. And yet, with men and women, half are treated as second-class citizens. I'm not going to rest until that changes.

Ordinarily, I need to have a gun to my head to sit down and write; I love finishing a piece, but getting

'I was thirteen when the women's movement was really getting fired up, in the seventies. That's when I started realizing – looking around – that I couldn't see women in positions of power.'

to the finish line has always been difficult. When I got the idea for *Thelma & Louise*, however, I knew I had to write it and finish it. It always had a life of its own. I would wake up in the middle of the night to write a scene – that certainly hasn't happened subsequently. I felt very strongly that it was meant for women. I could say, 'This is something I want to see. Don't you?' I wanted to watch a movie in which the women weren't objects, like they were in the forties. Those roles were ridiculous and made me not want to be a woman. I wanted to watch something that did. So, I guess *Thelma & Louise* was an answer to something I was looking for; I didn't know other women would experience it as intensely as I did, but I'm happy they did.

The movie was about two women breaking out of a box, and finally having every constraint removed by their actions and mistakes; they got bigger and bigger and bigger until the world was too small to hold them. The film was on the cover of *TIME* magazine, which was amazing, and it got glowing reviews, but it also got some really angry responses, especially from some of the male critics and social commentators. A lot of men found it incredibly threatening. I can remember the first time someone described it as 'man-hating.' I thought, 'How? How is this man-hating when it is just a reflection of how the world is for women? This is just how it is; there's nothing unusual about it. The only thing unusual is that she shot the guy! If the gun had been in the man's hand it would have been so unremarkable

that it wouldn't merit comment.' I also thought, 'Wow, this film is really going to take the lid off this thing; we're *really* going to have to have this conversation now. We're going to need to talk about what hating is and then about what women-hating is.' All the men were villains? No, they weren't. And anyway, all villains are men in movies about guys. But apparently women aren't allowed to write male villains, at least on-screen. That's an insane double standard.

Q. What brings you happiness?
Dogs.

Q. What do you regard as the lowest depth of misery?
Realizing that the resting state of the world is one of unfairness. There's so much darkness, violence, fear and poverty, and it's hard not to lose hope. We live an existence that was chosen for us by politicians.

Q. What would you change if you could?
If I could change one thing about human nature, I would change the propensity for violence.

Q. Which single word do you most identify with?
Joy. It's what I wish all of us could experience. We don't need to experience joy all the time, but it's important to know the real heights of emotion, and I do think joy is the overriding purpose of being a human on this earth.

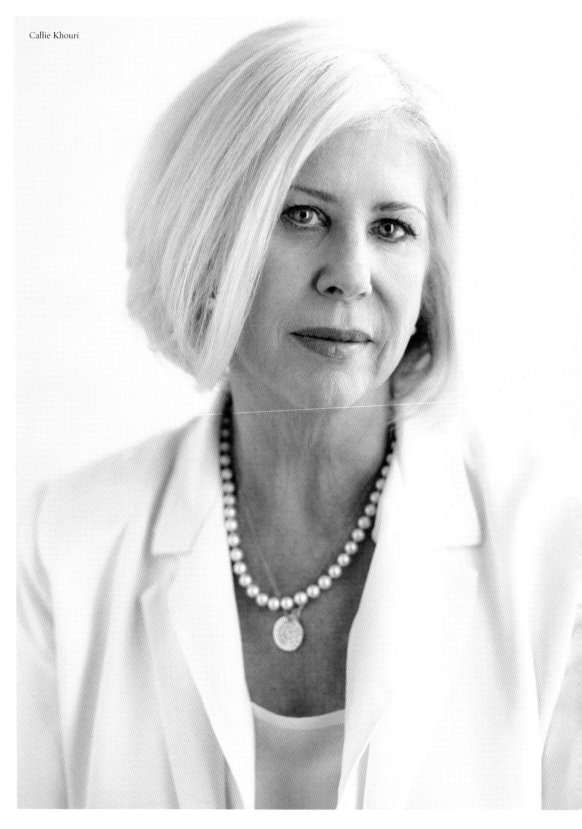
Callie Khouri

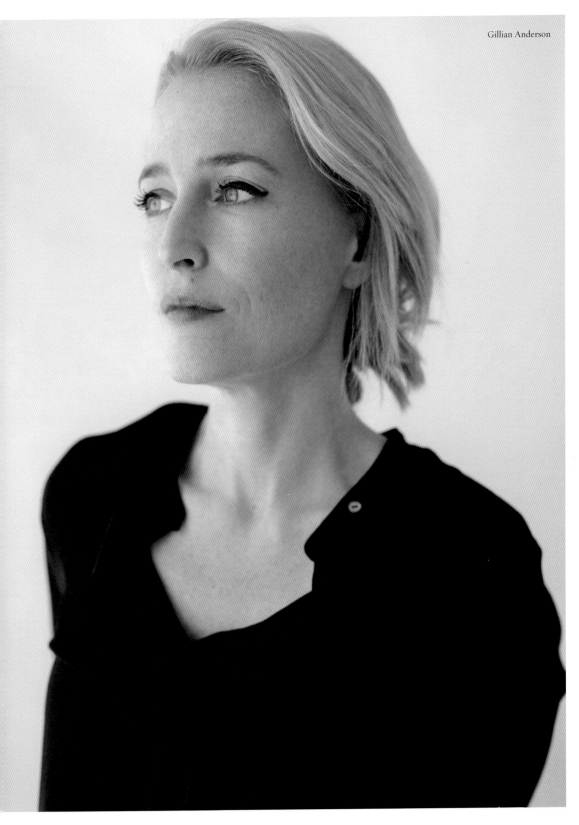

Q. What really matters to you?

I'm learning that my state of mind needs to matter to me the most. As I have grown older – as I have experienced hormonal changes and lost the certainty of the faculty of my mind – I have come to realize how vital this is to anything else I put my attention to. I have spent a lot of my life putting things before my state of mind, whether it be my career, my family or my work. I find it really, really hard to not put other things first. But what I've started to learn is that I am useless to my children if my mental state is fragmented and not grounded. Part of putting my state of mind first is about meditation and yogic practice. It's about remembering the important things in life every morning and connecting to gratitude. As a woman soon to be in her fifties, if I don't do this the stress level has a hugely negative impact on everything else that is important to me.

Despite growing up in white, middle-class America and white middle-class England, there have been various times in my life when I have felt depths of despair, hopelessness, anxiety, fear and panic, and have felt entirely alone. The contrast of this experience, in the enormous luxury of the life that I have been born into compared to so much of the world – I say luxury even though oftentimes my parents were wanting for money – has made me want to be of service, in any way, shape or form.

I feel the intensity of the responsibility of privilege. The greatest gift is the empathy for other human beings that is born out of whatever adversity one experiences in life. People are so brave – there is so much courage and perseverance. Yet, if it's hard to find courage and perseverance even in my privileged life, then where on earth does it come from in those *without*?

I have an empathy for outsiders. When I was growing up in London, England, I was an outsider; even though I spoke with a British accent, my parents were considered Yanks. Yet, when at age eleven I moved from 1970s London to the small Republican town of Grand Rapids, Michigan, I was also an outsider; on the one hand, America represented sunshine and hamburgers, happiness and wealth and extended family, but on the other, Grand Rapids was a small town – I had a funny accent and on a deep level I never really felt like I belonged there. I didn't feel like I fitted in at all. So, I moved from being separate in one country to being separate in another country.

These versions of rejection were part of my fight against the world. The rebelliousness in my teens was me kicking against a feeling of not belonging, even though, ultimately, part of me didn't want to belong. I've always been a fighter. I think my stance is naturally a warrior stance. But the softer side of me – or the side of me that is interested in human connection, human kindness, acceptance, equality and justice – comes from knowing the other side.

'Truth can be a terrifying thing, but the more courageous individuals are, the more that courage spreads – it amasses.'

One of the things that I've been concentrating on recently is having the courage to tell the truth. There's something inherently liberating about that. It's about being true to oneself. We are reaching a time when it's becoming more and more important – especially for women – to create definite intolerances towards that which is not our truth. And this can spread; it is contagious. I hope that there can be a global movement of unearthing one's truth, one that enables real change to happen, in both small and big communities around the world. Truth can be a terrifying thing, but the more courageous individuals are, the more that courage spreads – it amasses. And the ripple effect is potentially what will save us.

Q. What brings you happiness?

The greatest sense of joy and happiness that I have experienced is the result of mindfulness and meditation; I am able to open my gaze onto the world – see the sunset and the trees – and come from a place of compassion and kindness. And my children are what I love the most and what bring me the most happiness. But I have come to know that, even if they are in joy, if I have not connected to joy myself, it is very hard for me to recognize and honour it in them.

There is also joy in human connection. The minute I come out of myself and place myself on an equal footing with another human being – no matter what the circumstance – in that minute, in that meeting of humanity, there is no more separation. It is unity. The thought of that unity being able to exist in the world – that there are organizations, communities or individuals whose goal is to build a foundation for it – gives me a sense of hope, and a greater sense of joy and possibility.

Q. What do you regard as the lowest depth of misery?

Hopelessness. When I think of the word 'hopelessness' I think of the lowest, basest level of despair. It is enhanced by a sense of aloneness in the world or a sense that there is no way out, that there is nothing left, that there is no hand to reach for, no connection, no faith. This can be felt by somebody sitting in a penthouse in Manhattan or it can be felt in a refugee camp in Syria. A state of hopelessness is potentially the worst state to be in; it is something that can be universally connected to. And what solves it is connection – it's another human being reaching out and saying, 'I understand. I get you, and you are of value.'

Q. What would you change if you could?

I would make kindness a part of every human interaction.

Q. Which single word do you most identify with?

Sorry. This is because I have a need to say sorry to myself – and to forgive myself; I have a need to say sorry to people in my life with whom I have not connected or whom I have caused harm. And I have a desire for the action of 'sorry' to be spoken in the world.

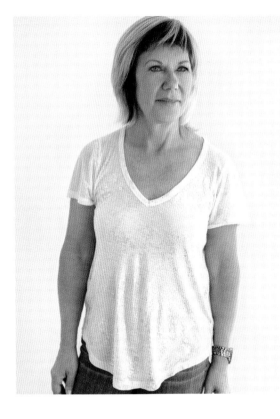

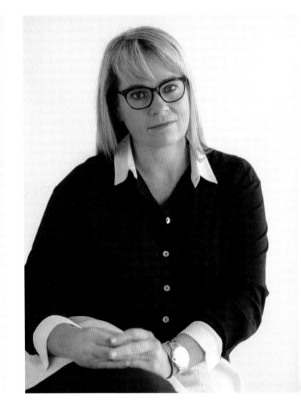

Jude Kelly

Q. What would you change if you could?

If I had a magic wand, I would change the very deep-rooted idea that men and women aren't equal. Almost all theologies have this idea that there is a male, divine creature, and that down from him comes creativity that imbues males with a final, separate and more powerful existence. At its most primitive, this idea begins with the question, 'Well, who is physically stronger?' It is the strongest, therefore, who can literally dominate. You can see in the desire humans have to create status how the idea of 'men versus women' came about. It's obviously complex and, when it goes back thousands and thousands of years, it is very hard to deconstruct. So, I would just eradicate the whole thought process and start all over again with the idea that men and women are marvellous and equal. I would love to see what would happen if we could do that, and I am optimistic that we are at least considering this idea of equality.

'Imagination'

Zelda la Grange

Q. What really matters to you?

Humanity is all that matters – period. If we can acknowledge and respect each other's humanity, we will be able to see that we have more in common than sets us apart. If we can focus on that, we can achieve anything. Everyone on earth craves respect, and it's by respecting our enemies that we make them our friends. The biggest lesson Nelson Mandela taught me is that it's when we are able to remove ideology from consideration that we can connect with one another.

'Empathy'

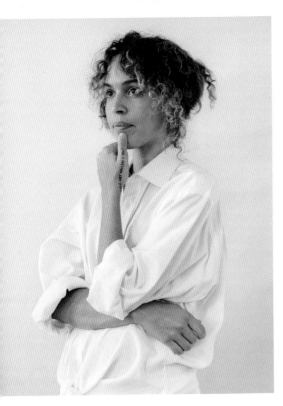 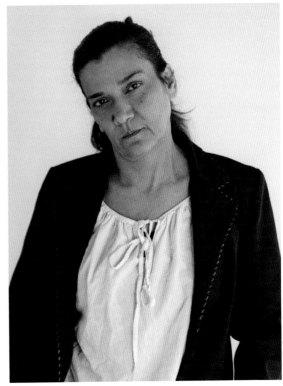

Cleo Wade

Q. What would you change if you could?

It's hard to pick one thing; as Gloria Steinem says, the issues of our world – especially those of the most marginalized people – are linked, not ranked. But, if I could change anything, it would be to plant a little flower inside everyone that incentivized them to know the world can change and to effect that change.

Nadia Remadna

Q. What do you regard as the lowest depth of misery?

I'm saddened by all of these young people who have no dreams or hope, young people who are filled with hatred of France and of people from different backgrounds, young people who prefer to have their brains blown out in Syria or elsewhere. I can't help wondering, 'What have we passed on? Where did we go wrong? And what could have been done about it?'

'Moon'

'Equality'

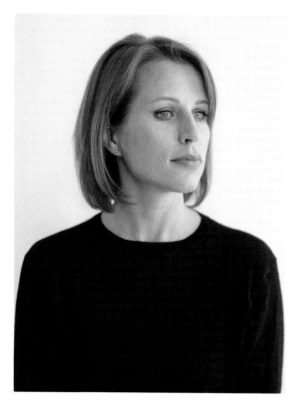

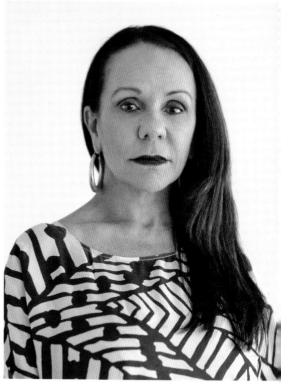

Josefine Cox

Q. What would you change if you could?
I would try to diminish social inequality between people and genders, and guarantee equal access to all the world's wealth. Also, I would try to provide better access to education, clean drinking water, medical care, resources and public infrastructure. I believe the world is a big, colourful family; if one family member isn't well, it is the duty of the other family members to support them.

Linda Jean Burney

Q. What really matters to you?
What matters to me is that we in Australia, as a nation, grasp the art of truth telling. Until we do that, we'll never come to terms with the past and how great we can be as a nation. And we'll never walk together. We've made enormous strides in that area, but there is still so much to do. What drives me, many other Aboriginal people and our fellow travellers – because there are many non-Aboriginal people who are part of our journey – is the sense of injustice around the shocking history of colonization and the treatment of our people.

'Courageous'

'Empathy'

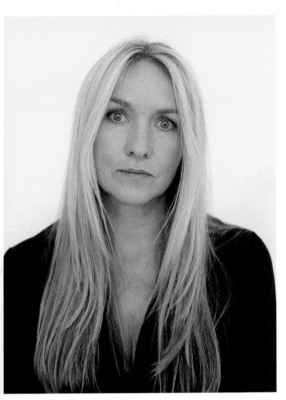

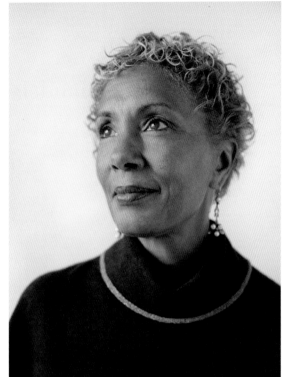

Collette Dinnigan

———

Q. Which single word do you most identify with?

Yes. Most of my life, I've had dreams and have followed them, so 'yes' means, 'Let's try!' – even if you fail, you will have learned something. Whereas, if you say 'no,' it's an iron doorstop – it's not progress.

Deborah Santana

———

Q. What brings you happiness?

I find joy in being still, and in reading the works of people who have overcome personal strife to manifest good and live in their power. Two years ago, I finished my master's degree in women's spirituality. It was life-changing to read the multi-cultural and multi-dimensional voices of women who identify their socio-cultural, spiritual and philosophical lineages without the oppression of patriarchy. The idea stuck with me that activism can either be brash – *against* others – or it can be gentle – *for* others and standing your ground. My own activism is informed by indigenous wisdom. I call myself a 'spiritual activist' – my causes are illuminated and given foundation through prayer. The peaceful, healing energy of meditation brings me to a state of happiness.

'Yes'

'Gratitude'

Winnie Madikizela-Mandela

Q. What really matters to you?

So many things matter so much to me, in my strange type of life, that I wonder how to actually answer that question. All my life, I've been a politician, made so by the circumstances of my country. I never planned to be a politician, but the policies of South Africa's previous government and its brutality compelled almost each and every black person to become one – every black home was really a political institution. I got caught up in the quagmire, and I then became one of the freedom fighters on the front line of the struggle for our people.

The African National Congress is my family. I have known nothing other than the African National Congress, for whom I am a member of Parliament. If I woke up tomorrow and I was no longer a member of the African National Congress – although I was originally a social worker – I don't know what I would be; it never even occurred to me that I would be anything else other than a fighter for the liberation of my people and my country.

Q. What brings you happiness?

I have the greatest wealth; I may not have dollars, but my grandchildren and my great-grandchildren are the best thing God has ever given me – I live for them today. And at the very mature age of eighty, they are a complete joy. I don't know how I would get along each day without them, because they bring me so much happiness. They've compensated for all the years of struggle and they've healed a lot of my wounds. Because of them, I have learned to forgive the painful past and remember that we all belong to the family of humankind. Otherwise, I would have been so scarred; I don't think I would be alive if

I didn't have this wealth of my grandchildren and great-grandchildren. And I'm hoping to become a great-great-grandmother very soon!

Q. What do you regard as the lowest depth of misery?

The patriarchy of society; in South Africa, women are not only culturally oppressed, but are oppressed by their past. During the apartheid era, women were of the lowest rung in society. And they were the least educated. The traditional belief was that you only educate a boy, because a girl is going to get married and take her brains away from the family – we have the extraordinary situation of the *lobola* bride-price custom, whereby families exchange wealth in the form of cattle. In apartheid South Africa, there was no point in educating women; the laws of the country at the time made it impossible for women to be women – we were regarded as children and, literally, nobodies at all. As women, we were regarded as cannon fodder, because our husbands, brothers and uncles perished in the apartheid prisons. South Africa was a police state – like Nazi Germany.

I remember an extraordinarily painful part of my life, when I was banished. I was living with my youngest daughter, Zindzi, in Johannesburg, though she was at boarding school in Swaziland. The apartheid government made it their business to arrest me whenever my children returned from school – this particular time when Zindzi came back, I was removed from Johannesburg and banished to this remote little village of Brandfort. The laws at the time were that if you were banished or banned by the apartheid regime, you were not to communicate with more than one person at a given time. The interpretation by

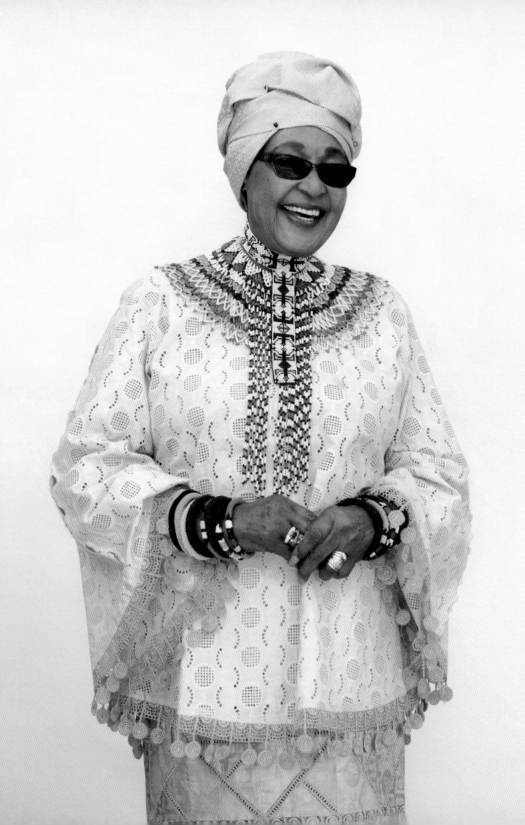

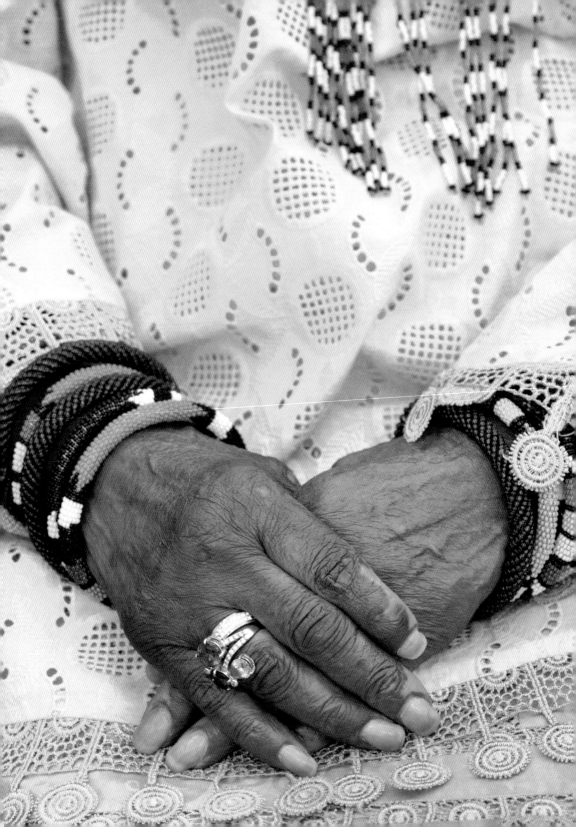

Winnie Madikizela-Mandela

'It is a serious problem that women must prove that they are equal. How odd is that? Men would not be in this world without women.'

the police of the law of the time was that, given that I was banished, my Zindzi could not have visitors, who would have been little children; she was barely twelve years old. I had to make an application to the regime to allow Zindzi to have children to come and play with her in the premises to which I was banished. To my horror, I was told by my lawyers that I couldn't make that application because by law a mother had no such rights – I was not her guardian. Only her father was her guardian and he was in prison on Robben Island at the time. The lawyers had to fly to Cape Town and apply for a visit to see Zindzi's father on Robben Island simply so he could sign documents to allow me to apply for Zindzi to have other children enter the premises to play with her. Those were the laws of the country at the time.

It's still a struggle to uplift the lives of women. As a result, our generation and the generation that followed us are still not as educated as our men; we're still fighting for total equality.

Q. What would you change if you could?
I would like a global situation in which women were equal to men, in all aspects. A situation in which it isn't strange that in an old democracy

like America, someone like Hillary Clinton would want to be president. The fact that she is a woman is somehow remarkable, even in the twenty-first century – she has to prove to certain people that she, as a woman, can do the job, and this is the case globally. I think that patriarchy really is an international cancer.

Even the African National Congress only began to accept women in 1943. It is still very difficult for South Africa. We're battling, right now, to understand the concept of power, and that it does not reside with men only. Were we to put up a woman candidate for the presidency when the current term expires, it would be a fierce battle, as there are still quarters within male circles that believe that a woman cannot lead a country.

It is a serious problem that women must prove that they are equal. How odd is that? Men would not be in this world without women. We are their biological passage. They cannot avoid being mothered by us, and we are very proud of the fact that we are that biological passage for humankind.

Q. Which single word do you most identify with?
Peace.

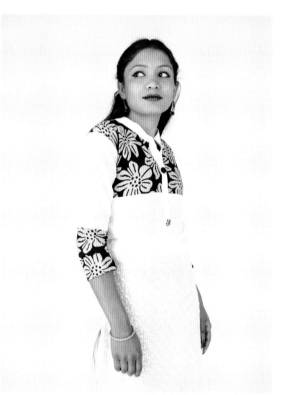

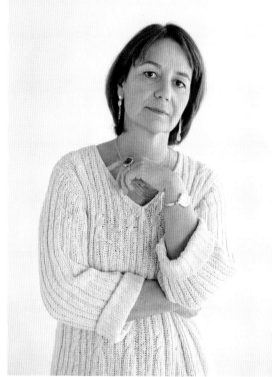

Sapana Thapa

Q. What really matters to you?

Love, trust and cooperation among people. These are the values I wholeheartedly believe in and that I want to promote in my life and in my work.

Trust is difficult for me personally; when I was seven years old, I was sent to Kathmandu by my parents to study and to look after my grandmother. It was a sad time, but my grandmother showed me love – she is the most beautiful person and kind. She paid for me to go to school, and now I support her.

Clémentine Rappaport

Q. What brings you happiness?

I get a lot of satisfaction from my work, which, in many ways, is political as well as medical. It brings me joy that I'm not alone in my commitment – that I have a team who share my values and goals. I also find joy in the moment when a child becomes able to access language; many children who are suffering just don't speak, so, when a child is able to articulate who they are and what they're going through, they are effectively joining the world.

'Performer'

'Perseverance'

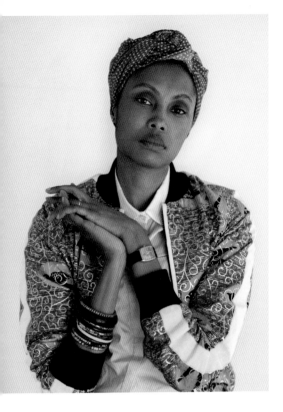

Imany

Q. What brings you happiness?

I feel very happy when I hear my sixteen-month-old baby talk and laugh. When I'm on stage I feel happy, too, because I am completely myself and that person is received by the people who come to watch me. When I was fourteen, I picked up a book by Simone de Beauvoir. Back then, my family was still very traditional: my mother was a good housewife, raising good daughters, and she told me that I had to be the perfect wife. But, when I read that book, it was like a slap in the face – it was the first time I'd heard a woman's point of view like this and it was the beginning of who I am today. It was the first time I realized I was the master of my own destiny. I realized my life was somewhere else, even though I didn't yet know where that was.

'Stay'

Zoleka Mandela

Q. What do you regard as the lowest depth of misery?

One of the most difficult things that I've come to accept is how I failed my daughter as her mother. I lost my daughter Zenani in a drunk-driving accident in 2010, and, unfortunately, at the time I was still quite heavily into addiction. I wasn't with her when she died – when she needed me. I had been so dependent on drugs and alcohol for so long in my life that it was difficult for me to be the mother that she deserved, or for that matter, the mother any of my children deserved. Now, I just try and live my life knowing that I'm staying clean every day and ensuring that I do things that would make Zenani proud of me.

'Hope'

Roxane
Gay

Q. What really matters to you?
Loving what I do and being proud of the work I put out into the world.

A lot of who I am is a product of how I was raised. I'm a first-generation American, born to Haitian parents – that context absolutely informed and shaped who I am. My parents would always talk about how we were free – about how our ancestors were free – and I think that went a long way towards giving my brothers and I confidence to do what we're doing today.

I have had the writer's bug since I was four. My fascination with writing is just something that's always been a part of my personality – part of who I am. My love of stories is just *there*. I love observing people and forming those observations into something more.

I definitely see a very important role for myself as a black, female author, which is not a perspective we often see in popular culture – even in fiction. I have a platform that, historically, not a lot of people like me have had. It's an exciting time right now – both as a reader and as a writer – because there is an increasing plethora of new African American voices and of voices within the African diaspora. Yes, the numbers are still small, but suddenly I feel like there are more than three authors I can talk about; now, I can quote writers from Algeria and from the Dominican Republic. There's a long way to go, but it's been a spectacular elevation.

I always took myself seriously as a writer, even when no one else would, even when I had no idea how I was going to finance my life with writing. But, I never intended to contribute to the feminist discourse in the way I have – that was never part of my agenda, I just liked to write. I am a feminist, though, and I have been since before I knew what feminism was – I just had a very clear sense of right and wrong. What happened with *Bad Feminist* was so unexpected; the book wasn't conceived as a collection, rather, I wrote those essays individually. When they were consolidated, I was going to call the work *What We Hunger For*, but my publisher thought that was too many words! It's incredibly gratifying to see that so many women are gravitating towards my thinking about feminism, to this idea that it's important to recognize that we can't be perfect feminists and that that's okay.

Other than my work, what matters to me is being a good person to the people in my personal life. At the end of the day, my friends are the people who have always been there for me – so, honouring those relationships is incredibly important. These are the people who have loved me through my best and worst, and I would choose those relationships over just about anything.

Q. What brings you happiness?
I don't know; I'm still looking for it. Writing makes me happy and reading makes me happy.

'I have had the writer's bug since I was four. My fascination with writing is just something that's always been a part of my personality – part of who I am.'

Being with my best friend – that feeling of being with the right person, at the right time, in the right place – makes me happy.

And privilege. Being able to do whatever it is I feel I need to do with my free time; having free time to relax makes me happy, and I'm very conscious that that's an immense privilege.

Q. What do you regard as the lowest depth of misery?
I think inequality is still the biggest problem – and the biggest sadness – in this world. We live in a world of plenty, yet there are billions of people who are suffering and who are going without. You don't have to look far; inequality and suffering are everywhere, and it feels like there's no solution. People seem very unwilling to confront and address inequality, and that's distressing, because I can't see an end in sight.

Growing up in the United States, then going to Haiti for the summer, I learned the difference between relative and absolute poverty. No matter how much money you have in Haiti, the poverty is so intimate – right there, everywhere you go. It's unavoidable. In many ways, that's a good thing, because then you can't willingly avoid it – you *have* to reckon with it. I have never forgotten the first time I went to Haiti, seeing homeless people clambering over our car for a dollar and knowing we could only hand out so many dollars. You really have to confront your privilege when

you go to Haiti to hang out on the beach at Club Med – this had a profound influence on me.

I don't believe in utopia – I'm a realist – so I know inequality will always exist, but the current scale is breathtaking. And it's so avoidable! Yet the people with the power to effect the kind of change we need are unwilling. It's frustrating and it's a disgrace that we have people in this world – particularly in the United States – who go hungry and without health care! How is that possible? These are basic human rights.

Q. What would you change if you could?
Absolutely no doubt in my mind on this answer: a year of male silence. No speaking from men for a year: 'Shush! No more talking. It's okay; just look pretty.' That would be so good. I think it would be wonderful to just let women run things for a year; I don't know if we would do any better, but let's try it! We've tried everything else and, at the very least, it would go a long way. It would be so grand!

Q. Which single word do you most identify with?
Fuck. It can be used in so many ways. I'm sure there are fancier options, but that's not me. I love it because I identify with it on so many levels. And I love how it starts out soft and ends hard.

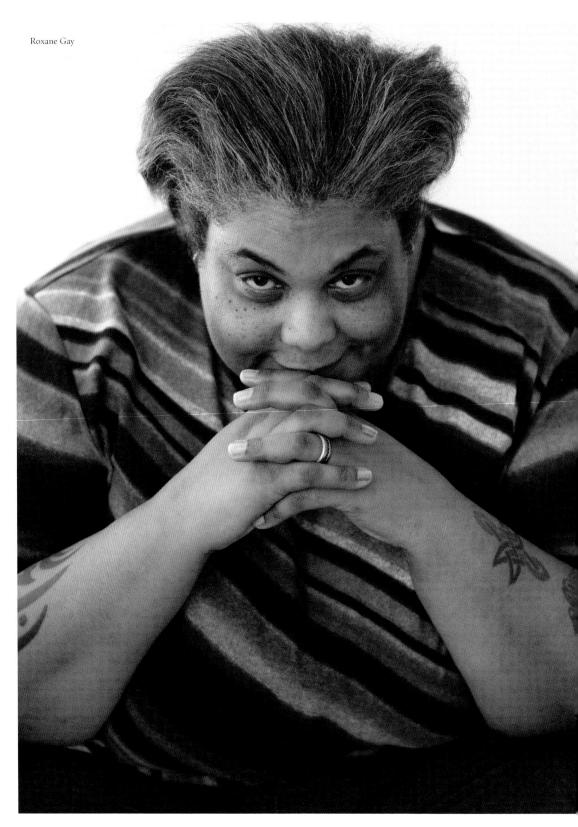

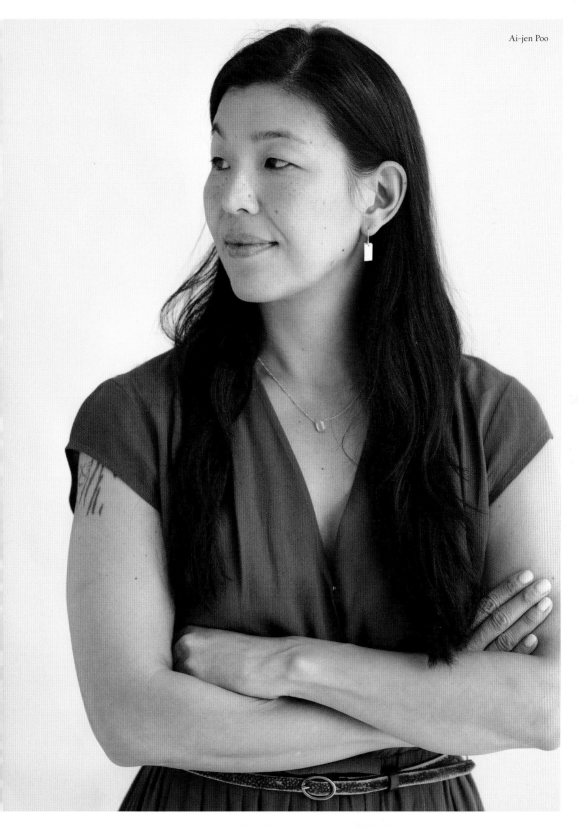
Ai-jen Poo

Ai-jen
Poo

'Dignity'

Q. What really matters to you?

Dignity: as the writer Atul Gawande says, 'You may not control life's circumstances, but getting to be the author of your life means getting to control what you do with them.'

So, it matters that my grandmother, who is ninety-two and who cared for me from when I was six months old, should be able to live well and with dignity, on her terms. Workers like Mrs. Lee, who is my grandmother's homecare worker, are critical; Mrs. Lee allows her to live in her own apartment and get the support she needs to go to church, to the doctor and to play mah-jong with her friends. Mrs. Lee is a huge piece of the puzzle that allows for that dignity. And Mrs. Lee should also have dignity at work: the ability to take pride in what she does, to know that her work is valued and respected, and that she will be compensated so that she can care for her own family. If we really enhanced dignity - this notion of what it means for everyone to live with dignity and work with dignity - we'd be in a good place.

If you think about what domestic workers do, this work is probably some of the most important work in our economy. Domestic workers go to work in our homes every day and take care of the most important aspects of our lives: our kids, our aging loved ones and our homes themselves.

I grew up watching my mother and my grandmother do that work inside our own home in addition to working outside the home - taking care of everyone and everything all the time. I always thought all of that work was really undervalued. What's more, if you look around in the immigrant community, there are very few work options for women. A lot of immigrants have risked their lives - left behind professions, families, traditions and cultures to give their children more opportunity in the United States - so the stakes are incredibly high for them and they've invested quite a bit in being here. Most immigrant women end up in one form of low-wage service work or another, but, despite how important this is to so many families, it is some of the most undervalued work in our economy. So, it's really important - not only for the workers themselves, but also for all of the families who count on them - to really uplift the value and the dignity of this work, and make it more sustainable for everyone.

Women - particularly immigrant women - are caught in the crosshairs of a lot of the attacks of the Trump administration. Many people don't realize that three-quarters of all undocumented immigrants in this country are women and children, and that most of these women are working in the domestic work setting. Some of the recent data shows that domestic work is the profession with the highest concentration of undocumented immigrants of any workforce. There are a high number of vulnerable women;

'I fundamentally disagree with the notion that, somehow, there is not enough beauty, resources, joy and connection in the world for all of us.'

they are isolated, because this work has been undervalued for so long and because immigrant women are on the frontlines of many of the enforcement efforts – the raids, the deportations, the targeting – of this administration.

Q. What brings you happiness?

All the things that we have been able to achieve and receive recognition for as a movement have been achieved through the power, courage and hard work of thousands of women: domestic workers, nannies, housecleaners and caregivers who sacrificed a day's pay to travel to state capitals to lobby and share their stories, to march with millions of other women, to negotiate, take risks and assert their dignity. It makes me happiest to see these women – who are sent messages from every direction that they are not fully workers, not fully human or not fully citizens – stand up in their power and assert the value of their work, and the dignity with which they do it.

Q. What do you regard as the lowest depth of misery?

There's a very powerful narrative that is dividing the United States in really toxic ways – it is the thing we have to transform. It has to do with notions of 'us versus them' and with a scarcity mentality. I fundamentally disagree with the notion that, somehow, there is not enough beauty, resources, joy and connection in the world for all of us; it is a notion that is turning

us against each other. This kind of division is creating a toxicity that is incredibly destructive. It is really terrifying to watch it rise in new ways. I know people say it's always been there, but it seems like we're adding to it. Yes, the kerosene was on the ground, but it wasn't necessarily on fire – and now we're lighting matches.

Q. What would you change if you could?

I would probably make care an organizing principle in our economy. I would try to reorganize our economy so that care in all of its forms – care for neighbours, care for family, care for children, care for elders, care for friends, care for co-workers – is a fundamental principle in every arena of civic and economic life. I would want us to have all the support we need, so that the caregiving relationships in our lives would be upheld as some of the most important and valuable. People who provide care would feel recognized and valued, and be able to support their families. We would utilize care as a way of reinventing our relationships and our structures of value – it would change everything.

Q. Which single word do you most identify with?

Dignity. My grandmother, who is my heroine, embodies dignity, so, in some ways, it is my north star.

 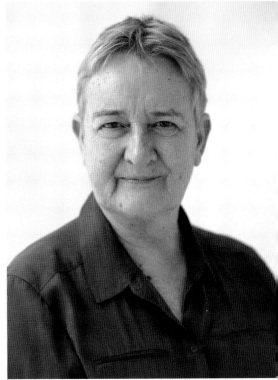

Hodan Isse

Q. What really matters to you?

Justice – more than anything; I think that justice will go a long way towards solving the problems we are faced with. And, when I look at the root causes of most of what vexes the world, I find that these are a lack of inclusion and a lack of justice.

Justice includes within its definition service delivery, freedom of speech and the voices of each individual. A woman in a rural area who is poor, malnourished and sick has no voice in this world, when in fact her voice should be the loudest of all. Instead, she is almost like an untouchable. Justice also includes a fair distribution of resources – at present, global resources are mismanaged in that they are exploited for the benefit of the few. I'm very grateful for what God has given me, but I'm always reminding myself of the fact that he's given me too much; I think more people should be doing this.

'Unity'

Marilyn Waring

Q. Which single word do you most identify with?

Integrity. When I left parliament I wondered what I was going to do with myself. I went to see a very highly placed recruitment agent, and he said to me, 'I've gotta be honest with you, Marilyn. With respect to the private sector, you're just too hot to handle.' That was one of the best compliments I ever had. I thought, 'Cool, let's keep it that way.'

'Integrity'

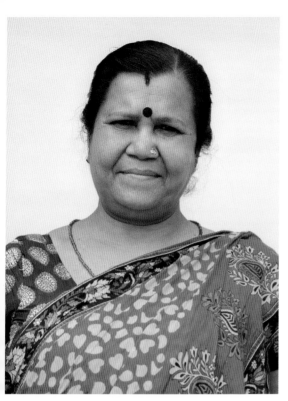

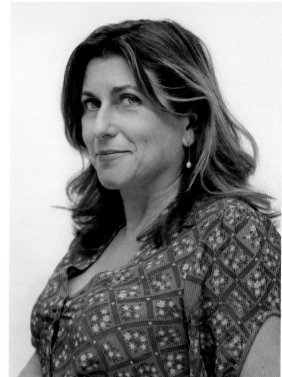

Balika Das

Allison Havey

Q. What do you regard as the lowest depth of misery?

The suffering I've experienced was when I was working in the sex trade; working in a brothel room is the lowest form of suffering. The lowest points were when horrible men would come to my room – drunk or under the influence of some drug – and do awful things to me, abuse my body. You can survive going without food, but to survive the brutalization of your body every day is very, very difficult. Not every woman survives.

Q. What really matters to you?

Work has always been extremely important to me, and I feel very intensely about engaging in something that I really love. I'm now working full time as a co-founder of The RAP Project, which is something that I am immensely proud of. We're in over a hundred schools and we've reached twenty-five thousand teens. With the early sexualization of nine, ten and eleven year olds, I feel very strongly that parents need to talk to their kids about sexting and hard-core porn. They might not feel comfortable doing this – I myself wasn't five years ago – but it's happening. Erotica might be natural, but hard-core pornography is not, and we don't want young men who are victims of this – nor young women – to think that it's a lovemaking manual. We're about healthy, consensual, respectful sex.

'Manu' — the name of my son

'Optimistic'

Isabel Allende

'Generosity'

Q. What really matters to you?
It's people – women especially. I have been a feminist – a feminine feminist – all my life, and my main mission has been to care for women; I have a foundation that works for the empowerment of women and girls.

Justice matters to me.

And stories – I love to listen to people's stories.

Q. What brings you happiness?
Love, romance, passion, sex, family, dogs, friends – all that brings me happiness.

Q. What do you regard as the lowest depth of misery?
On a universal level – speaking outwardly – I would say that there are many depths of misery, but the worst is probably slavery. When you are a victim of absolute power and are living in constant fear, that is the worst.

On a personal level, I would say that the lowest depth of misery is when something happens to your child and you have absolutely no power to control it. It is when your child is behind a door and you don't know what someone is doing to her – when you have no say, when you can't be there and when you can't even touch her.

My daughter, Paula, had a rare genetic condition called porphyria, which my son and my grandchildren also have. It is manageable and should not be lethal at all. Paula took very good care of herself but, when she was newly married and living in Madrid, she had a porphyria crisis. She went to the hospital, and they f**ked up the whole thing: they gave her the wrong drugs so she fell into a coma, then they didn't monitor the coma, then they tried to hide their negligence. For five months, I lived in the corridors of the hospital waiting for them to bring my daughter back to me, and everybody kept promising that she would open her eyes and recover.

She suffered severe brain damage. By the time they admitted this and gave me back my daughter, I decided to bring her back to the United States. She was married, but her husband was a young man who couldn't take care of her. I told him that, in her condition, she was like a newborn baby. I said, 'Give her back to me.' He did – that's something that I will always be grateful for. I was able to bring her back to California on a commercial flight – today that would be impossible, but this was before 9/11. I sectioned off a part of the plane, and we flew with a nurse and all the necessary equipment. But how do you come into a country with a person who can't apply for a visa? We came to Washington, DC, where Senator Ted Kennedy sent two people from his staff to wait for me at the airport – I don't know how, but they got us in. When we got to California, we went directly to the hospital.

After a month, it was absolutely certain that Paula wasn't going to react to anything. She was in a vegetative state, so I brought her home and decided that I would take care of her – because that's what mothers do. I created a little hospital in the house, and I trained myself – we had her there until she died.

That experience, culminating in Paula's death, changed me completely. It happened when I turned fifty, which is the end of youth. Menopause followed, so it hit me at a moment when I was

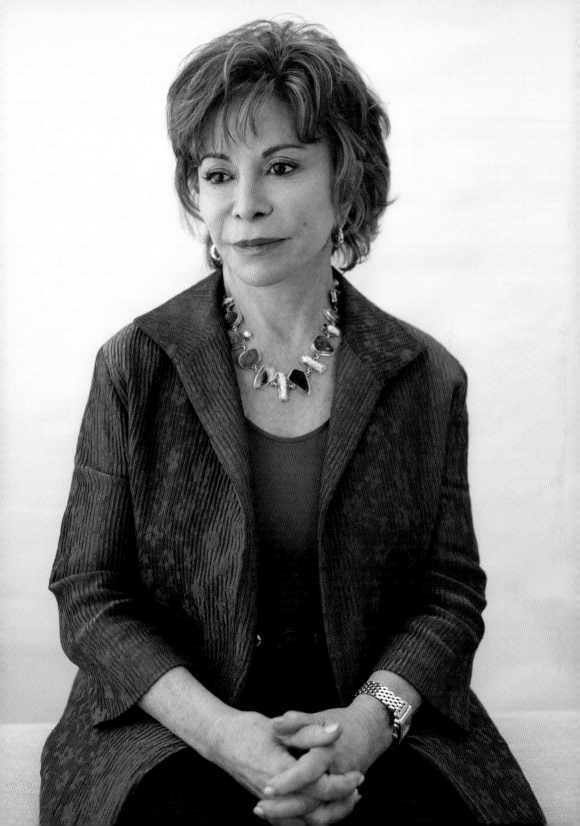

Isabel Allende

ready to change, to finally mature. Up to that point, I had been an internal adolescent. It made me throw everything that was not essential in my life overboard. I let go of everything. With Paula, for example, I let go of her voice, of her charm, of her humour. I cut her hair short, then, eventually, I let go of her body and her spirit, then everything was gone. I learned the lesson that I am not in control. People have this idea that we come to the world to acquire things – love, fame, goods, whatever. In fact, we come to this world to lose everything. When we go, we have nothing and we can take nothing with us.

Paula gave me many gifts: the gift of generosity, the gift of patience and the gift of letting go – of acceptance. Because there are things you can't change: I couldn't change the military coup in Chile or the terror brought about by Pinochet; I can't change Trump; I can't change the fate of my grandchildren; I can't change Paula's death; I can't even change my dog!

Now, no matter what happens, it is nothing by comparison to the experience of Paula's death. I loved my husband intensely, for many, many years, but two years ago we separated. When people wanted to commiserate, I thought, 'This is not even 10 per cent of what I went through with Paula.' Nothing could be so brutal, to me, at least. It gave me freedom, in a way. It gave me strength and an incredible resilience I never had before. Prior to that, many things could have wiped me out.

Q. What would you change if you could?
I would change the patriarchy – end it! All my life, I have worked towards a more egalitarian world, one in which both men and women are managing our global society – a place in which feminine values are as important as masculine values.

Q. Which single word do you most identify with?
Generosity. Years ago, my therapist said that I had very low self-esteem. He told me to go to ten people and ask them to write five things about me – whatever they wanted. It was a very difficult thing to request from people; it seemed like an exercise in vanity and narcissism, but I did it. Everybody mentioned generosity as my first trait, so maybe there is something true in that.

The mantra of my foundation is, 'What is the most generous thing to do?' This is because of my daughter. She was a very special person and a psychologist. Whenever I was going through something trying, she would ask me what the most generous action I could take was. She used to say, 'You only have what you give.'

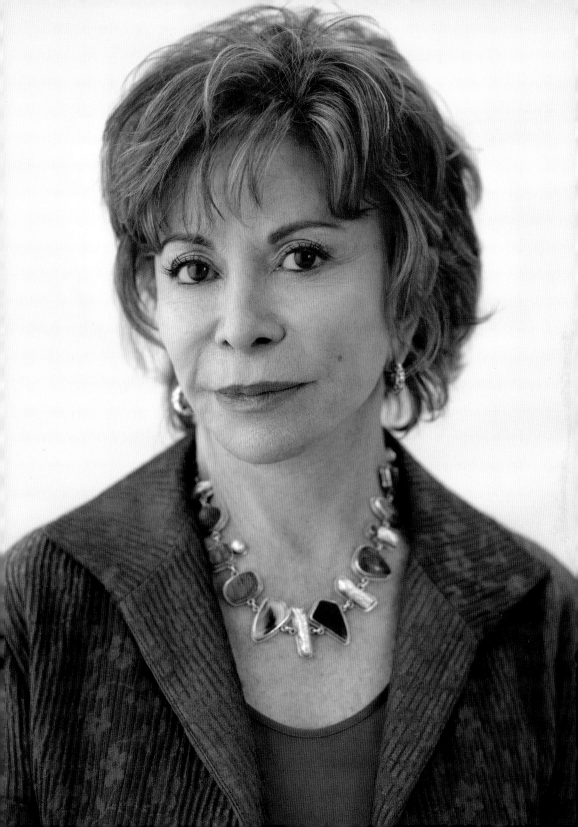

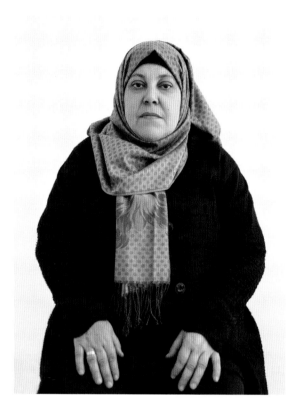

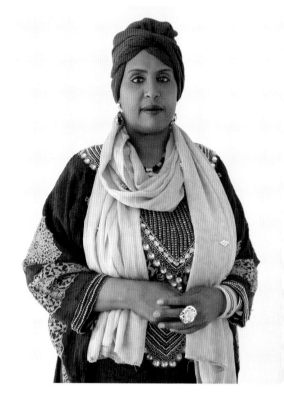

Ghada Masrieyeh

Q. What do you regard as the lowest depth of misery?

The context I live in is very uncertain – in fact, every day our existence feels unstable. I am always afraid of tomorrow. I am always afraid of war breaking out and of how that will affect my children: Where will they go? Will we be able to stay together? We are living in extremely difficult circumstances, with little access to clean water and constant power cuts.

Hibo Wardere

Q. Which single word do you most identify with?

Compassion. Recently, when I was meeting with communities who had given up FGM, I met a woman who was an ex-cutter; it took me half an hour to compose myself, because all I could see was my own cutter's face on her body. After I had spoken to the group, I saw this ex-cutter coming towards me. I felt I was going to crumble as she hugged me, but, somehow, I felt I had to hug her back. I did. We sat down to talk about her life, and she spoke about being married off to a forty to forty-five-year-old man at age eight, then to a fifty-five-year-old man at age twelve. She became a cutter because her mother was a cutter – it was a generational thing. She told me that, when her own daughter was cut by her mother, she nearly died inside.

'Life'

'Compassion'

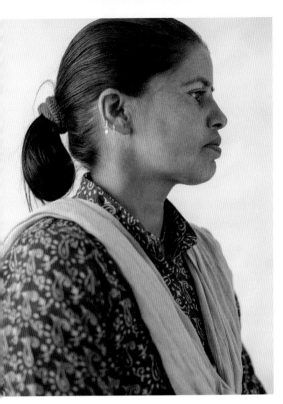

Ambika Lamsal

Q. What really matters to you?

My two daughters are more important to me than anything else; I don't care about my own life or my own future – only about them. I was married at the age of thirteen and had two children by the time I was seventeen. One month after my second daughter was born – when my eldest was two – my husband died. I'm told my mother died when I was five, although I know nothing about her, and my father died the year I married. So, I was left to raise my children alone. After my husband died, his family did not look after us – they did not want to support a young girl with two children.

Maggie Beer

Q. What brings you happiness?

Happiness is love, music, food and making a difference.

Creating the kind of pleasure that people get from eating my food is a great joy. I love to cook and I love to share; there is a warmth and generosity of the table that forms such an amazing part of your life if you love food. I love having people around me who want to be there, too – people who are really interested in food, life and what we can do to make it better.

'Education'

'Excitement'

Maria
Shriver

Q. What really matters to you?

The most influential person in my life was my mother and the most influential person in my mother's life was *her* mother. The role of mother is the most important role I have – it completely outweighs my professional life. I am the mother of both young women and young men, and I want them to be raised the same way. I want them to experience, then pay forward, love and compassion for humanity – equally. My passion in life is humanity; within that is the understanding that women and men must be recognized as equals. But, women cannot be empowered at the expense of men, just as men cannot exist without empowered women. My goal is to empower all those who are disempowered, so that we can all be speaking the same language. Even though our brains are very different, we all have the same souls and the same hearts, and we all want the same things.

This equality is something I want all my children to feel very strongly.

Beyond my children, my family and my friends, it is my faith and my work that define me. Becoming a journalist was a natural fit for me, because I approach the world with tremendous curiosity. I'm fascinated by people and their stories – by how they got to where they are and by what they had to endure along the way. I'm constantly trying to find a story in everyone's life.

I am also passionate about working to find a cure for Alzheimer's disease. When my father was diagnosed with it, I had to watch the smartest human being I had ever met lose their mind, in real time. That experience made me incredibly curious about what goes on in the brain and about how Alzheimer's can affect such a finely tuned instrument, to the point that the sufferer no longer knows the function of a fork. So, I started teaching myself about Alzheimer's. Like everyone else I talk to about the statistics, I was shocked and curious to discover that women are far more susceptible to the disease than men. I decided that I could be someone who sounds the alarm, who lets women know they are at risk and galvanizes people, internationally, to find a cure. It has become my mission to get women to think about this and to empower their minds, with a view to saving them. I hope this will, in turn, empower their entire lives. When women put their minds to anything, the possibilities are endless, so I believe women *can* be galvanized to save others and themselves from losing their minds. My passion has always been to empower women – emotionally, physically, mentally, spiritually and financially – and so it really does feel like all my work has led me to this moment; Alzheimer's disease impacts all those areas of both a woman's life and of the life of her family, because women are at the centre of their families.

I believe that every person is inherently good and has the ability to foster change, inspire change and create change. This starts with the self; I believe that change starts within and ripples out from

> '**I believe that every person is inherently good and has the ability to foster change, inspire change and create change.**'

there. It's very easy to look around and decide that there are no good people, but, if you open your eyes and your perspective, all of a sudden you'll find them. You may have decided that someone is terrible, but, given the opportunity, that person may prove you wrong. When we open our minds, we are finally confronted by truths that force us to re-evaluate our beliefs.

It's easy to scare people and divide them, but it takes a true hero to talk about peace. We need examples of good, evolved and awakened leadership, in every country in the world. Of course, we want more women in leadership roles, but there are many progressive male leaders who are also true examples of compassion and empathy. Pope Francis talks about a revolution of tenderness – messages like that can bring about incredible change and can inspire millions of people.

Q. What brings you happiness?
My children bring me tremendous happiness, as do my friends and being in nature. And the simple things; chips and guacamole make me happy. Beyond this, seeing other people happy and witnessing acts of kindness – the actions of those trying to make the world a better place – makes me happy; I'm always reminding myself to direct my gaze towards the good, and away from the negative, evil, divisive and cruel.

Q. What do you regard as the lowest depth of misery?
Loneliness and feeling disconnected from what's going on around you. It's miserable to not feel that you are making a meaningful contribution; I have great empathy for those who grow old and feel they are not needed by society or that they've been alienated from their families.

Q. What would you change if you could?
With my magic wand, I would create the cure for Alzheimer's, so that people could be as physically healthy and mentally strong as possible, for as long as possible.

And I would try to promote peace instead of fear, kindness instead of cruelty and compassion instead of power. There seems to be a lot of violence and anger in the world right now – I know that's been the case forever, but it feels more pronounced now. Maybe we're just more aware of it, but it definitely feels like it's encroaching on our mental and spiritual space a lot more. I'd also ask the media to report more on all the good that *is* being done, rather than on repeating the same old negativity that seems to sell.

Q. Which single word do you most identify with?
Love.

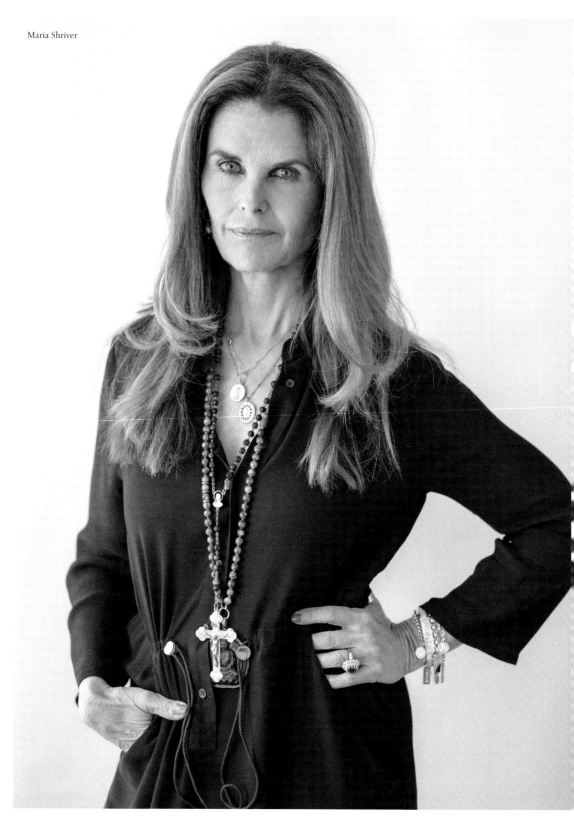
Maria Shriver

Laura
Dawn

Q. What really matters to you?

The most important thing to me right now is the world that I'm going to leave for my daughter, Mona. When she was born, everything shifted. Now I see everything through the lens of making sure that she has a good life. There's a deep delight for me that I'm able to give her some of the things I wasn't given, in the form of support from an early age. But, I'm also aware that she is walking into a world that is deeply troubled. Before my daughter was born, I described myself as a radical feminist, but I don't think I truly was one until she was born.

The way that women and girls are devalued worldwide has become the most pressing issue to me. I think finding ways to reinvent culture and to address systemic sexism – which is really the white patriarchy that's been in control for most of history – is vital to our survival as a species. If we don't have more feminine principles and leadership, and more values of communication, cooperation, collaboration and consensus building, we won't be able to address very dire and direct threats like climate change.

I did a study, called *Men*, that I'm hoping to make into a film. It's about testosterone and how it acts in homogenized groups of male leadership. It's about looking at what happens when you just have men at the fore of the political, financial, religious and cultural systems of the world. Historically, these systems were – and, let's be honest, still are – run by men: mostly white men. The continuation of this could be the end of us, because it's one of the reasons we've had such intractability around climate change. In a closed system of male-dominated leadership,

men's testosterone and cortisol levels rise, which produces a really negative cascade of effects. It produces an acute focus on short-term threats and a very long-lens focus on long-term threats: so terrorism feels very, very immediate, but climate change – which is much more likely to be the bigger catastrophe – is put off. Men also fire dopamine and serotonin when they engage in conflict, so in these situations they exhibit much more risk-taking behaviour.

Women have a somewhat different leadership style, so, when you inject a tipping point of 30 per cent women into a ruling system of men, the entire group changes biochemically – communication, collaboration and consensus-building become more possible.

My big theory is that, if more women were involved in the leadership of the world, in every country, we might see less war and more action on some of the direst threats. There are studies that bear this theory out; the countries that have the most progressive policies towards women generally have more women in office and in business. These countries also have the highest gross domestic products, they have the highest happiness indices and they have the lowest incidences of war. The countries that have the most repressive policies towards women are in endless cycles of war and tend to be doing very, very poorly.

The backbone of feminism is that people should be treated equally; what I call radical feminism is an awareness that feminism is connected to racism, xenophobia and class – it's all connected.

'The way that women and girls are devalued worldwide has become the most pressing issue to me.'

And men can participate in radical feminism. They need to be our allies. I'd say a good place for men to start is by looking at how they speak about women when they are not around. The 2016 United States election has shown us that misogyny is still very much alive and that there's still massive resistance to equality. The author Rebecca Traister makes the point that the entire American economy was built not only on slave labour – which is something we're all aware of – but also on the free labour of women. We have an entire economy that, for many, many decades, was propelled by men at work.

This entire system doesn't work without someone at home taking care of the family, doing unpaid labour. A lot of the work that has historically fallen to women – the care of a household, the care of children, the care of the elderly – is unpaid labour. And this won't do anymore. It's time to look at more aggressive ways of addressing the power imbalance.

Q. What brings you happiness?
Spending time with my family makes me the happiest: just me, my husband, Daron, and Mona making up songs, giggling, taking a walk or doing something fun. Showing Mona the world is so much fun.

I have a little mantra; I believe that every act of creation is an act of love. So whenever I see someone participating for the forces of love, I get very moved by it. Sometimes, reading the news feels like an onslaught of negativity, but the truth is that the human race gets a little less violent every year. We get a little better all the time. And

the arc of the moral universe is long, but it bends towards justice. It makes me so happy when I see someone choosing creativity – choosing love – and trying to spread that in the greater service of everyone.

Q. What do you regard as the lowest depth of misery?
To me, there's one deepest misery – it's violence. Yes, we all have to die, and at some point we all realize this. In my case, although I knew about death, I don't think I actually realized that it would happen to me until I was around ten – I remember being overwhelmed with the pain and fear of that realization. So, seeing as we all live with this existential knowledge of our own demise our whole lives, why would we choose to murder each other?

There's a kind of violence, too, in not sharing the bounty of this world. We live in a world where the resources are vast – there's plenty to go around for everyone. No one needs to go hungry; there's not a shortage of food, there's a shortage of the will to get food to people who need it. This is part of why I did the *Men* study: trying to get to the root causes of violence and trying to figure out how human beings could evolve into a less violent species.

Q. What would you change if you could?
I would put more women in charge. I'm not naïve enough to think that this would fix everything, but I think it's worth trying – because it's worth noting that at no point in history have we tried it.

Q. Which single word do you most identify with?
Love.

 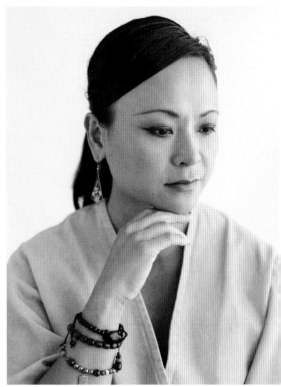

Kanchan Singh

Q. What would you change if you could?

The job that I have is about driving women around to keep them safe from being accosted, so I would make this world safer for them. Wouldn't it be nice if women needn't fear being accosted or assaulted as they are going about their lives?

'Safety'

Pauline Nguyen

Q. What do you regard as the lowest depth of misery?

Pain is inevitable, but suffering is a choice and not having the freedom to let go is miserable. I see so many people who have been unable to choose the story that gives them peace, so they take a painful event, put more lenses and more filters on it, until it becomes misery and they suffer needlessly. This absence of consciousness causes people to suffer needlessly, because of the stories they've created and the layers of meaning they've piled onto those stories. All this becomes a rock they are chained to.

'Freedom'

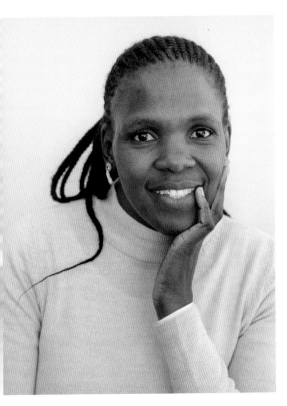

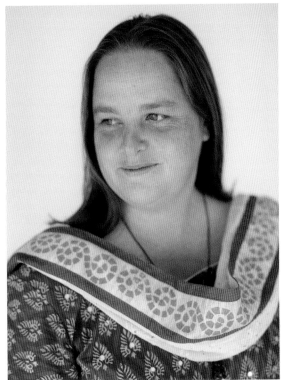

Nokwanele Mbewu

Q. What brings you happiness?
What also makes me happy is seeing children getting better. When I first started with the Mentor Mother Programme, I met three girls on a home visit. They were living in a shack that didn't have proper walls – the walls were made of plastic. Every night, this guy was coming over, opening the home and taking a child to rape. I thought about those beautiful girls every night until they were removed by a social worker and taken somewhere that I knew they would be safe. It makes me happy to see positive change; I see so much misery in this job, but when I see things change for the better I feel such joy. The women I work with have such capacity for strength, and watching them realize that makes me so, so happy.

Bec Ordish

Q. Which single word do you most identify with?
Gratitude. If we focus on the things that we have instead of things we don't have, we cannot feel any negative emotions.

'Care'

'Gratitude'

Jody
Williams

Q. What really matters to you?

What matters to me is finding sustainable peace through justice and equality. That means redefining security and distinguishing it from national security, which just provides for the security of the state's structure; it isn't really about taking care of people. We need to ensure that structures of power focus on human security, on making sure that the needs of individuals and communities are met by governments – that's their job!

If everybody had access to basic health care, decent housing and a job worthy of the name – one for which they're paid enough to actually survive - the world would be much less stressed. Power struggles would be shaped very differently. It makes me angry that those subscribing to the realist school of thought – the Henry Kissingers – think that people who talk about peace are wimps who don't understand the realities of power and are tree huggers who wear Birkenstocks. It's not that way at all: I hate Birkenstocks, and I do understand the realities of power! That's why I want to shift the focus away from the power of the state and onto the state providing for the people it is supposed to be providing for. That's what drives me and fills me with righteous indignation.

Personally, what really matters to me is that at the end of each day – even if I have been a bitch or haven't put my best foot forward – I can look in the mirror, straight into my own eyes, and know that I am doing the best I can to make the world a better place for everybody: even for people I don't like! When you win a Nobel Prize, you don't become Mother Teresa – there are people I can't stand and that's the reality. There are 7 billion people on the planet, but although I may not like everybody, I do want the world to be good – even for those I dislike. If I didn't, then I'd really just be a member of a political party. You have to be driven for the greater good of everyone – I am, so I feel very happy about that.

Q. What brings you happiness?

Being inspired; not by the famous names that I encounter, but primarily by those that are unknown. I chair the Nobel Women's Initiative, which I helped form in 2006; we came together to use the influence and access to resources that we have because of winning the peace prize to support and shine a spotlight on the work of grassroots women's organizations, to enhance what they're trying to do in their countries and bring them into a larger network. Some of the women that I have been privileged to meet through that work, and some who I would call friends, just blow me out of the water. On days when I just want to stay in Vermont and never leave my house again, I think of them.

There is something that has moved me tremendously recently. I joined my sister Nobel Prize winner Rigoberta Menchú for the last week of a trial in Guatemala, after years of avoiding Central America – I'd been avoiding it because, despite eleven years' work, we had been unsuccessful in stopping United States intervention in El Salvador and Nicaragua.

In 1982 and 1983, in northeast Guatemala, fifteen Mayan K'iche' women – who couldn't even speak Spanish - were held as domestic and sex slaves in an army garrison that had been built for rest and recuperation leave for soldiers who needed some fun after going out massacring. After the women's

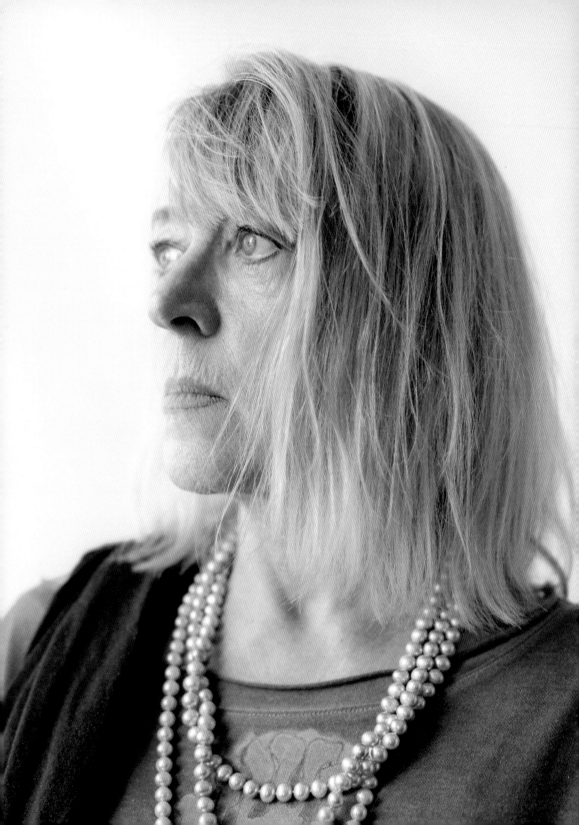

'It makes me angry that those subscribing to the realist school of thought – the Henry Kissingers – think that people who talk about peace are wimps.'

ordeal ended, they were vilified as prostitutes and what happened to them wasn't acknowledged. They started talking through their trauma with each other, and over time, with the support of three Guatemalan NGOs, they decided to bring charges against the man who had been the head of the garrison and the man who had been the head of the vigilante paramilitary self-defence group. It took about six years for the case to get to trial.

When we met with the women before the judgement, they could not look us in the face – they barely looked at each other. They had their hands up almost in supplication; it was like looking at ghosts. They said they were doing this because they wanted justice and because they wanted to make sure that it didn't happen to other women and children. I was blown out of the water listening to them. And they freakin' won! They won the case! It was amazing. When I think of inspiration, I think of women like that.

People have become caught up in 'self-actualizing,' but I just think, 'Get up off your ass and actualize for people who really need help!' I have my own emotional issues, so I'm not unsympathetic, but I don't believe that learning how to get in touch with your inner being will make you able to help the world. The obsession with self in this country

makes me sick, especially when you compare it to those women in Guatemala, who have absolutely nothing, and yet had the courage to pursue a case that is precedent-setting in the entire world; it's the first time a country has tried sex as a war crime in its national courts. And they won. That makes me happy.

Q. What do you regard as the lowest depth of misery?
People who have no hope. People whose lives have been so crushed that they just move through life and don't live life. The opportunity for a full life has never been given to them, or has been taken away from them – I just can't imagine it.

Q. What would you change if you could?
The big thing would be to make people care about the planet. When I hear an owl in the middle of the night it just makes me so happy – I wish people understood that connection.

Q. Which single word do you most identify with?
Fuck, probably! It's a noun, a verb, an adjective and an adverb – I love it. When I first said it at home – when I went away to college – my parents were horrified, of course. My mother, who's eighty-six, begs me not to use that word in public because – this cracks me up, I just adore her – it tarnishes my Nobel image. But it's who I am.

Sara Khan

———

Q. What really matters to you?

Countering radicalization is one of the key challenges of our time, especially as we are seeing children as young as ten fall victim to extremist world views. Our failure to address and resolve this issue is only exploited by the populist far right, in its promotion of an 'us versus them' narrative that sees Muslims as the enemy. Islamist extremists also, of course, promote an 'us versus them' world view. The middle ground that advocates for shared values and a common humanity is increasingly under threat, so we need to defend that middle ground – that is what I seek to do with the work I do.

'Humantiy'

Lisa VeneKlasen

———

Q. What really matters to you?

A sense of belonging. It matters that I make sure people feel part of something larger. We live in an individualistic world that keeps people from connecting with each other, when what really gives us meaning is being with others, as part of something greater than our selves. My community of family and friends certainly gives me a strong foundation, and I am always wanting to bring people in to be a part of it.

'Subversive'

Claudie Haigneré

Q. What do you regard as the lowest depth of misery?

I may be saying this because I'm a doctor, but I think the depth of misery is suffering – in all forms. There is pain in physical suffering and then there is moral and intellectual suffering that we endure when we are alone, when we experience injustice and helplessness. Such suffering, of every kind, causes us to give up. It makes us want to exit this life that is making us suffer, or it makes us feel our suffering is so unfair – such an undeserved punishment – that we are pushed to extremism and violence of the kind we are seeing today.

Caster Semenya

Q. Which single word do you most identify with?

Ubuntu. It has a lot of meanings, but, for me, it is about acknowledging the basic human dignity of every person. I am a reflection of those around me – I am defined by them. It is about being respectful of others and being received with respect.

'Curiosity'

'*Ubuntu*' – humanity

Alexandra Paul

Q. What really matters to you?

My identity: I'm an actor, an athlete and an activist - these represent my job, my health and my soul.

When I was twelve, I read this quote: 'When in doubt, do the kindest thing.' It's my guiding principle - you can't really go wrong with it. So, when I wasn't getting a lot of work in my forties and I had to decide what to do with myself, it had to be something to do with alleviating suffering for animals and for people. I don't know if my wanting to help others is selfless, because it gives me meaning and purpose. A lot of people give love and support to their children; I don't have children, so I try to put that kind of energy into my activism.

I've concentrated on animal rights, working to release animals from factory farms and to stop testing on animals. I work with an organization that negotiates with laboratories to release dogs that are being experimented on. As a vegan, it matters to me that animals have full rights. This means that no one is eating them, wearing them, experimenting on them or caging them. Animals suffer too and should be able to be free.

I also have a career as a health coach now. Helping people to get healthy and fit, and to feel good about themselves, matters to me.

Q. What brings you happiness?

I'm in love with my husband. We've been together for twenty-one years, and he's amazing - he's just so wonderful and supportive of me.

I also find happiness in my activism. I volunteer with an organization called Food Not Bombs - we cook vegan meals and serve them to the homeless. There are fifteen of us who cook for about a hundred people. Most of us aren't cooks, but we manage to put together an amazing meal. We engage with the people we serve; these are people with passions and dreams. The social aspect of being together with all these people makes me happy.

Q. What do you regard as the lowest depth of misery?

The lowest depth of misery is being imprisoned - whether you're an animal or a human, whether it's an actual cage or not being free to love who you want. In the world today 25 billion animals are confined and exploited, and 45 million people are enslaved - that, to me, is hell.

Q. What would you change if you could?

Here in America a lot of women take it for granted that we have gender equality - we don't. The word 'feminist' is a dirty word, and it shouldn't be. Women's pay is seventy cents on the dollar here compared to men, and on top of that we do most of the work around the house, while raising kids.

I remember screen testing for a female lead role in a television series in which the male lead had already been cast. They were also looking for the

'In the world today 25 billion animals are confined and exploited, and 45 million people are enslaved – that, to me, is hell.'

second male lead. I found out from a friend who had seen the budget that the female lead was to be paid less than the second male lead – and none of the guys who were up for that second lead had the credits that I had. None of them. But it had already been decided that they were more valuable than I was. And that sort of behaviour is not changing.

So often, I notice women apologizing for the smallest things. Just coming towards you along the street they'll say, 'I'm sorry,' and step aside. Men never do that. Women are apologizing just for taking up space, and I don't know if that's changing fast enough. I don't think women are enabled to make demands the way men are; men are raised differently. Young boys aren't discouraged as much as young girls, and so girls are raised with an inherent lack of self-efficacy – they are taught to question themselves and are not encouraged to go out and be messy and loud.

In my high school years, my voice was tiny. When I started acting, sound people would always say, 'Speak up, Alexandra, speak up!' But I didn't know how to – it didn't feel authentic to speak up and to speak in my power. A lot of girls go through that. Girls in America are taught that we should be nice and shouldn't be loud. Of course that affects us as we get older. Maybe we perpetuate things like pay disparity because we don't demand the way men do – but to demand *anything* is very hard for a woman.

So this is what I would change if I could. Perhaps it starts with empowering girls and women through education. Every woman should have access to education as long as she wants it. In tandem with that is educating boys and men on the value of women.

Something I care deeply about is human overpopulation – it is one of the most important issues facing our planet. Getting the population down to 2 billion through humane means is essential, and it's an effort which is interconnected with so many other issues. Suddenly, solutions to crises like economic disparity and climate change become visible. And I think the number one way to stabilize the global population is to empower women. If women were wholly empowered, we would choose to have smaller families – because it's normally women who end up raising children. In societies where men have so much power over women, there tend to be larger families because it's a sign of machismo to have more children and they are not a burden for men.

Q. Which single word do you most identify with?
Compassion. I like that it has the word 'passion' in it. To me, it means kindness in action.

Ruth Bader Ginsburg

Q. What really matters to you?

Two things: my work and my family. But I wouldn't put one before the other.

In terms of my family, the best decision I ever made was my choice of life partner: my late husband, Marty Ginsburg. We met when he was eighteen and I was seventeen, and he was the only young man up to that point who cared that I had a brain. He was my biggest booster, and we had fifty-six wonderful years together.

I also had wonderful in-laws. My mother-in-law's secret to a happy marriage was, 'It helps sometimes to be a little deaf.' I've followed that advice, not only in dealing with my dear spouse, but also with colleagues throughout my career; so, when I hear anything that is unkind or thoughtless, I just tune it out.

I received wonderful advice from my father-in-law, too. My daughter was fourteen months old when I started at Harvard, and I worried about balancing my responsibilities. My father-in-law sat me down and explained that, if I didn't think I could manage my studies, I had the best reason in the world for dropping out. But, he said, if I did want to do it, then I would have to pick myself up, stop feeling sorry for myself and find a way. So, at many turns in my life, I have asked myself, 'Is this something I really want?' And if it is, I find a way to do it.

My success in law school, I attribute largely to my daughter, Jane. My life was balanced, whereas most of my contemporaries were consumed by their studies. Our babysitter worked eight-to-four, which allowed me to attend classes and read law books during the day. At four in the afternoon, I went home; then, it was Jane's time. We went to the park, played silly games and I sang – I wouldn't dare sing to anybody except my children! After Jane went to bed, I was eager to get back to the books. So, each part of my life was a respite from the other.

My own mother, who died when I was seventeen, impressed on me the importance of independence. In those ancient days, most parents of girls wanted them to find Prince Charming and live happily ever after. But my mother wanted me to fend for myself. She thought being a high school history teacher would be a good path for me; she never dreamed of me becoming a lawyer, no less a judge!

It was when this country experienced the Second Red Scare, in my college years, that I became interested in the law and in doing something to keep our country in tune with its most basic values – like the right to think, speak and write as one believes, and not as a 'Big Brother' government thinks.

Then, later, I had the enormous good fortune to be alive, and to be a lawyer, in the early sixties when the women's movement was coming alive in the United States. What we achieved later, in the seventies, would have been impossible at any time earlier, because society wasn't yet ready for that change. By the seventies, however, most people's thinking in terms of what life should be like for women had changed.

'My own mother, who died when I was seventeen, impressed on me the importance of independence.'

I was also the beneficiary of a change brought about by President Jimmy Carter. When he became president in the mid-seventies, he took one look at the federal judiciary and realized that they all looked like him; they were all white men. President Carter realized that the federal bench wasn't representative of all Americans and was determined to appoint members of minority groups to it – back then, women counted as a minority group! He was only in office for four years – so he never had a Supreme Court vacancy to fill – but he literally changed the complexion of the United States judiciary through his appointments; he appointed twenty-five women as trial judges and eleven as Court of Appeal judges – I was one of the lucky eleven.

I have enjoyed everything that I have done in the law, but I think the job I now hold is the very best a law-trained person could have. Our mission is to do what the law requires and what is just, and we have tremendous job security, because the Founding Fathers were wise enough to protect the independence of all federal judges.

Q. What brings you happiness?
I'm satisfied when I feel I've done my job, when I've written an opinion that is as good as I can make it. And my growing family is my happiness; I get endless joy from my children, Jane and James, and from my four grandchildren and two stepgrandchildren.

Q. What would you change if you could?
We have advanced as a society, but there is still a long way to go, so I would have society buy into the notion that daughters are to be cherished as much as sons. I don't want daughters to be held back by artificial barriers, rather, they should be given the opportunity to grow, aspire and achieve according to whatever talents they have. That is my dream for the world; I am convinced that we will all be better off when women and men are truly partners in society at every level.

When I started at Harvard, in 1956, they had only been accepting women for five years and I was one of nine women in a class of five hundred. There were no anti-discrimination laws back then, so they installed women's bathrooms in only one of the two teaching buildings. If you had an exam in the one building and needed to go to the bathroom, you had a problem; but we didn't complain, we just accepted that that was how it was. And there were law firms that wouldn't interview women. They'd say, 'We had a lady-lawyer once and she was dreadful.' Justice Sandra Day O'Connor worked without pay for four months to prove her worth to a county attorney in California. Of course, he found out in short order that she was worth more than all the men put together!

Q. Which single word do you most identify with?
Notorious. A young woman made a Tumblr account out of my dissenting judgement in the *Shelby County* case. She told me I had become The Notorious R.B.G. – totally understandable! The Notorious B.I.G. and I were both born and bred in Brooklyn, New York, so we have *that* in common.

Jodi Peterson

Q. What really matters to you?

I'm working very hard to try and close some gaps, to allow our community to successfully transition out of homelessness. A topic that's very important to me right now is helping those who are homeless get their identifications back. Many people who come out of the system – whether it's prison or foster care – end up homeless, with no way to actually say who they are. They can't do anything: they can't get a job, they can't drive a car and they can't apply to live anywhere. So they end up on the street. All this tends to lead to quite a bit of recidivism – because people have a will to survive, but if they can't do it legally, they're going to do it illegally.

'Family'

Caroline Paul

Q. What really matters to you?

When I first became a firefighter, I knew people doubted my physical strength. But what soon became clear is that they doubted my courage too! I began to realize that we don't expect bravery in women; in fact we encourage fear in our girls from an early age.

'Unruly'

Gillian Caldwell

———

Q. What do you regard as the lowest depth of misery?
I'm horrified by the greed that drives so much behaviour – at the 'profit at any price' mentality that some big corporations and individuals demonstrate in their collusion with governments, and by pay-to-play politics, whereby governments are delivering for private gain, rather than for public good. I am horrified by the collateral consequences of this greed. In January 2017, Oxfam reported that eight men now own the same wealth as the 3.6 billion people who make up the poorest half of humanity – it's preposterous. It's sad, too, because a lot of research demonstrates that wealth and power don't correlate with a sense of satisfaction and joy.

Amy Eldon Turteltaub

———

Q. Which single word do you most identify with?
Gratitude. Having been to the depths of sorrow – feeling the pain of losing my brother in such a horrific way – I feel grateful to now be so joyous.

'Integrity'

'Gratitude'

Divya
Kalia

————

Q. What really matters to you?

I want to ensure that women in India benefit from an equitable distribution of jobs and also benefit – in whatever profession they are in – from the same honour and respect men receive in pursuing their professions. And I want to ensure that women are not discriminated against when they come forward to do the kind of work society believes is reserved for men.

India is a very religious country, but, although I am a Hindu, my religious inclinations are not very strong because, early on, I was introduced to a lot of literature by my communist grandfather. When I was seven or eight, my mother had to undergo a very dangerous operation that she was told she might not survive. Watching her going through her illness instilled a fighting spirit in me; I decided that, if she could fight when everything was completely out of her control, then I could do the same in my own life. It made me fiercely independent; I completed a master's degree in economics, then went on to work in the field of analytics.

Being a married Indian woman and trying to also pursue a career means that you have to fight twice as hard; when you're single, you need only look after yourself, but, once you get married, you are expected to take principal responsibility for the care of the entire extended family - that is a cultural value placed upon you. When I married my husband, our families joined, and I was expected to focus on everybody in that bigger family. As a wife, you get up in the morning, clean the house, make the breakfast, prepare and pack lunches, then go out to focus on your work knowing that it is not only *your* livelihood but the family's you are pursuing. And,

if someone in the family is not well, you have to take the day off to take them to the doctor. When you are married, travel for work also becomes difficult, because, in India, we are so emotionally connected to our kin that being away from home introduces a disconnect with our family. But, I have been extremely lucky in that my family is very understanding and supportive of me – not everybody is so lucky.

My husband and I were both doing well professionally, but we quit our jobs to pursue our own venture, Bikxie. Delhi has terrible road congestion that can last for hours; we used to spend four to six hours a day travelling but would see bikes zipping past our four wheelers and think, 'That's not fair!' And because there is no organized transport that operates from the Delhi metro stations, people end up spending four times the cost of their train ticket on travelling the last mile from the station to work. I used to tell my husband, 'I wish there was a taxi service on motorbikes!' and he thought this was a great idea. That's when we conceptualized the bike taxi. I told my husband that, as a woman, I might not feel comfortable sitting behind a male driver because I might bump into him if he braked; culturally, that wouldn't be acceptable to me. Our state, Haryana, is also infamous for incidences of molestation in cabs, so, if I wasn't comfortable, how could I expect other women to be?

We decided to employ women pilots for our bikes, to ensure that women commuters feel safe and to create employment for women. We also provide pepper spray to our pilots to ensure that they and our travellers are not subjected to anything untoward. We've now been operating for

Divya Kalia

'Being a married Indian woman
and trying to also pursue a career
means that you have to fight
twice as hard.'

over a year and, fortunately, we've not faced any
issues of that nature. When we started we had
ten male and five female pilots, and now, because
the response has been so phenomenal, we are
catering to three cities.

We have sometimes gone around with our
female pilots to get a sense of their day-to-day
experiences. One day, a call came in for a female
pilot to pick up a young girl and take her for
tuition. We went home with the girl and spoke to
her mother, who, because it's not safe for a girl
to travel alone, used to drive her daughter to the
tuition herself. It was utterly heartwarming when
she told us how confident Bikxie made her feel
about her daughter's safety.

Once Bikxie becomes really successful, it's my
dream to start other ventures through which
I can ensure that women in India have access
to an equitable distribution of jobs and are not
discriminated against because of their gender.
Watching women come out of their houses
and breaking the stereotypes really matters to
me – it's so liberating! And they break those
stereotypes not because they're encouraged to,
but because doing so just makes sense to them.

Q. What brings you happiness?
I absolutely love cooking and experimenting
with food!

Q. What do you regard as the lowest depth of misery?
It's something I feel would upset most women:
the feeling of helplessness that comes from not
getting sufficient education or support, which
keeps you dependent. This is why my husband
and I feel so proud to have been able to generate
employment for both men and women; they
feel more financially independent and they have
choices. We don't restrain anyone from taking
on a job for us part-time, which allows them to
study or work in parallel; this means that a lot
of our women pilots are studying. This is great,
but there are a lot of smart people out there who
aren't educated or empowered enough to do what
they're meant to – for these people, misery is the
helplessness that comes from not receiving the
right life orientation at a young age.

Q. What would you change if you could?
I would provide a global, moral- or values-based
education system. There is a difference between
literacy and education; of course we need to
improve literacy globally, but we also need to
make sure that people are in the right frame of
mind. Violence, racism and gender discrimination
won't go away until we have a universal education
system that helps children understand, from a
tender age, that they need to be accommodating
of others.

Q. Which single word do you most identify with?
Morals – without them nothing else matters.

Amy Stroup

Q. What brings you happiness?

One of my favourite subjects in high school was humanities. One day, our teacher walked in and wrote, 'What's the difference between happiness and joy?' on the board. I was gripped by a stream of consciousness and wrote that happiness is the cheapest emotion, because it's like weather to me – there are several minutes of sunshine, then cloud eclipses the warmth and it's freezing. That's happiness – it's never constant. Joy, on the other hand, feels far more sustainable; joy is not fleeting and it's something I find in the simplest things. It brings me joy to see a man respecting a woman, to enjoy a good dinner or to see someone do something excellent. Those little things are moments of happiness, too, but I think joy is the emotion that you can actually *experience*. It's transcendent and creates the narrative you need when you receive the worst news – a narrative that tells you you'll still be all right, even when you feel you won't be.

'Resilience'

Nadya Tolokonnikova*

Q. What do you regard as the lowest depth of misery?

Observing misery hasn't ever helped anyone. What helps is action – moving forward – and breaking through your own fears.

*Pussy Riot represents all women; the photograph may, or may not, be Nadya Tolokonnikova.

'Siberia'

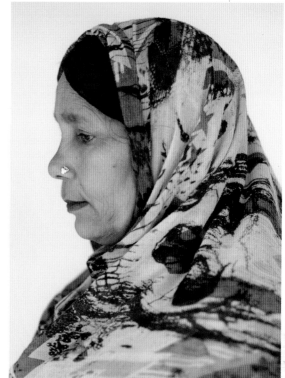

Monika Hauser

———

Q. What would you change if you could?

I am changing something now; my colleagues and I are taking our competencies, capabilities, inner strengths and conviction that together we are strong, and using them to engage structures that perpetrate gender injustice. We are supporting survivors medically, psychosocially and legally. We support them through income-generating projects that allow the women to earn their own money and avoid relationships of dependence. I recently met one of our first clients again. When we first met, she hadn't wanted to go on with life. Now, she has started a self-help group in her village for women who aren't receiving external support and is a beautiful, strong woman. It's a wonderful story.

Sabila Khatun

———

Q. What do you regard as the lowest depth of misery?

I don't know – I'm a sad person, and sadness sees only sadness.

Being with a man who abuses you is devastating. When I see fathers, mothers and children all together, I feel sad, because I didn't have that life and I couldn't give that life to my children.

'Persistent'

'Family'

Bobbi Brown

Q. What really matters to you?

Everyone wants to be confident, and a woman is confident if she feels comfortable in her own skin. So, first of all, it matters that I am able to teach women how to be their best selves. Empowerment has always been my message, both through my company and in life. This doesn't mean trying to be someone you are not, but it may mean that if you put on a little eyeliner and mascara, or a little blush, you feel good. And if you take care of yourself, you take care of everyone.

I fell in love with makeup when I was a young girl in the Jackie Kennedy era. I fell in love with beauty and makeup watching my mother put hers on – she was so gorgeous.

Nothing that I was either taught or learned growing up in Chicago set me up for what I'm doing, but everything I do brings me back to something or someone in Chicago. We were taught hard work, and we were taught giving back. My entire life, I have been someone who cares about other people – this is not because I was told to do it, it is because I watched my family doing it. Today, I will be sitting in business meetings and will think about my grandfather Poppa Sam, who came from Russia. He was a role model for me in the way he handled his business; he was constantly working, always paying attention to the details and caring about his customers.

My career started after college, where I got a degree in theatrical makeup; I had gone into theatrical makeup because I knew I didn't want to go to beauty school – I wanted a regular college degree. It was an inter-disciplinary major that I had to put together myself, and it is why I am here today – because college was not about the rules, it was about creating your own destiny and being an entrepreneur of your life. When I left college, I did the most important job that anyone could do: I waited on tables. It taught me a lot – that I could take care of myself and could pay my rent, and what it's like to be in the service industry.

Later, I moved to New York, where I thought I would do some fashion work on the side while I got my movie career going. But I did one movie and hated it; it really wasn't for me. So, I started pounding the pavement and being hired as a freelance makeup artist working in magazines. It was the eighties, and the makeup was artificial everything: pale skin, contouring, overdrawn lips and eyebrows. I either wasn't good at it or didn't like it, so I started to do makeup that just enhanced someone's natural beauty. I think it's because I love the way people look without makeup.

Starting a company as a new mum, not getting enough sleep, was definitely a challenge. I remember talking to editors on the phone – telling them how to stay fresh when leaving the

'Empowerment has always been my message, both through my company and in life.'

house in the morning – while my son was literally puking on me. But you kept it cool, because back then you didn't talk about having kids. It wasn't cool in the fashion industry to even have a life outside of fashion. I think I probably had a little bit to do with the change of attitude – that you can actually have a life outside of the fashion industry – because that was always really important to me.

When I launched Bobbi Brown Cosmetics, I knew I needed to make foundation that actually matched skin, and not just white skin – everybody's skin! I knew there was a hole out there because, when I was a makeup artist, I could never find colours that worked on people's skins; I always had to go to theatrical makeup stores to buy yellows and blues to fix all the makeup. That's why, over all the years in my company, whenever we would have meetings to decide what to discontinue based on what sells, I refused to get rid of the darkest foundations even though these were not top sellers.

For me, everything has to make sense. It makes total sense that, when a woman comes to the counter, she needs to get a foundation that matches her skin – it's not that complicated. I figured out early on that blush should be the colour of your cheeks when you pinch them, that the pencil should be the colour of your brows and that the most beautiful lipstick is the colour of a woman's lips. To me this was common sense;

it was not brilliance and it wasn't some 'Aha!' moment, it was just what needed to happen.

Q. What brings you happiness?
It's pretty simple: having a happy marriage, having amazing kids, having great friends, being able to be incredibly creative and take a lot of risks, and working with a team of people that have my back. We have a lot of fun and that makes me happy.

Q. What do you regard as the lowest depth of misery?
The hardest thing in life is when people don't have their physical or mental health; if you have your health, there is always hope.

After that, I would say not having an education. If you are educated, in whatever way it is, you have a future. This doesn't mean everyone has to go to college; you could be educated by being an apprentice or by going to trade school. It doesn't matter which form it takes, I just wish that everyone could get an education.

Q. What would you change if you could?
Free health care and free education. Honestly, I couldn't choose between the two.

Q. Which single word do you most identify with?
Authenticity. To me, there is nothing better than when a person is exactly who they are.

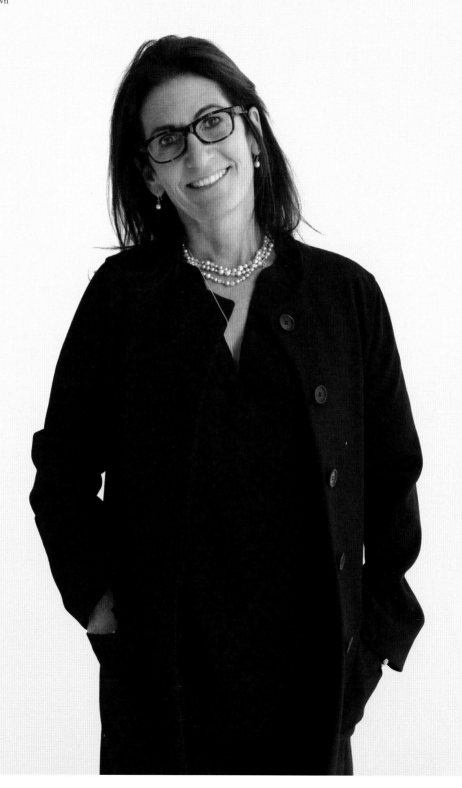

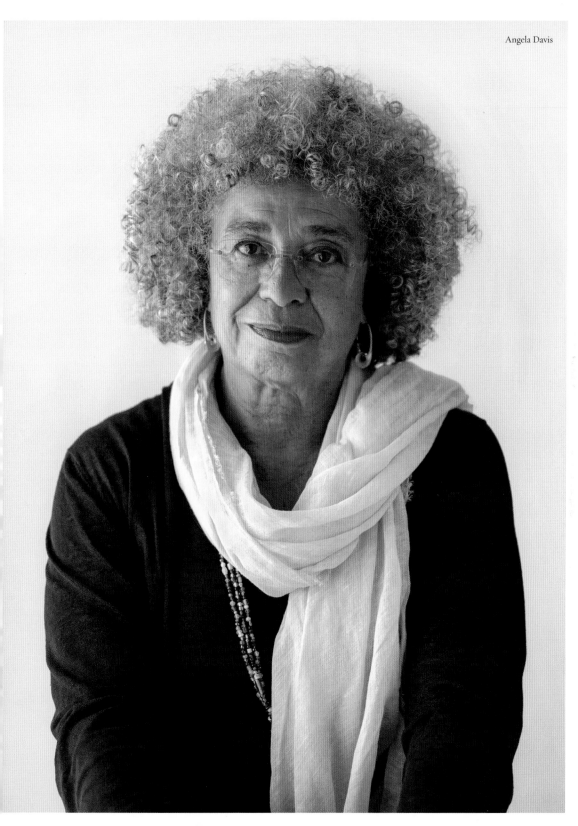

Angela Davis

Angela
Davis

——————

Q. What really matters to you?

The same things that have always been important to me: justice and equality, and opposition to capitalism. I have been active in campaigns that are designed to emphasize the importance of equality among human beings, whether this be racial, gender, political or economic equality. There is no hierarchy of problems, rather, they are all interwoven, intersecting and interrelated.

My mother was a political activist and she was a very powerful influence in my early life. When I was eleven, I was involved in an interracial discussion group in our church; the building was subsequently burned down because white and black children were engaging in discourse with one another. I left Birmingham when I was fifteen years old, to finish high school in New York City. My school was very progressive; many of the teachers had been blacklisted in the public-school system, so I was exposed to Marx and Freud. I went on to study philosophy under Herbert Marcuse and came to subscribe to his view on critical theory. All of these experiences formed the person I have become.

Beyond this, I would say that the major influences in my life have been movements – movements of vast numbers of people. What started out as the freedom movement – now better known as the civil rights movement – is associated mainly with figures like Martin Luther King Jr. and Rosa Parks, but I was also very much influenced by the rank-and-file participants of that movement. I knew the four young girls who were killed in the 16th Street Baptist Church bombing, in September 1963, and that was a major turning point in my life. I became

a member of Advance, which was affiliated with the communist party, of which I then also became a member. And I became active in the Black Panther Party. This has all been in aid of justice and equality.

Recently, I have focussed on issues that emanate from the vast numbers of people who have been imprisoned in the United States, by what we call the prison-industrial complex; 25 per cent of the world's prison population and a third of the world's female prisoners are imprisoned in the United States. This is the work I am most passionate about today. I've been thinking about this process of imprisonment for a very long time – in 1970, I myself was arrested and spent some eighteen months in jail and on trial. I have learned to see this movement as an intersectional one, because it is very much related to struggles for equality and education, certainly to the campaigns to end racism and sexism. I have come to the conclusion – together with the many comrades, friends and others who have worked around this issue – that it really can't be fixed. There is no way to reform the prison system. How sad this is, when the very history of the prison system is a reformative one; the concept of prison was introduced as a humane alternative to existing forms of punishment, which were corporal and included the death penalty. So, we now say that the prison system must be abolished. Abolitionists argue that – as opposed to assuming that you can create a more effective penal system – you should ask a different question: What does society have to look like in order for it not to have to depend so heavily on imprisonment, policing

> 'We have someone in an elected office who assumes it is possible to return to a period before we made strides towards ending racism and many other evils.'

and other forms of security that are grounded in violence? The answer is that we need to be focussing more on free education and on free healthcare – including free mental healthcare. In the United States, the three largest mental institutions are jails in New York, Chicago and Los Angeles. We say, don't fix the system, fix society, so that we are not so dependent on putting people away and using modes of violence. My views on this are very much informed by my belief that, in order to achieve any of the major goals of social justice, capitalism has to be the target of our analysis. And that, eventually, this system will have to be dismantled.

My views on feminism – the anti-racist feminism with which I identify – are integrated with my socialist outlook. Mine is a Marxist-inflected feminism that calls for social justice for everyone and requires us to think about the interconnectedness of all our social justice struggles. There can be no end to racism unless we simultaneously envision an end to sexism, as well as an end to the pollution of the planet. The struggles of black people are interconnected with the struggles of Indigenous Peoples and the struggles of Muslims, as Islamophobia is very much linked to racism as it is evolving today. Feminism provides us with the tools to understand the interconnectedness of these issues and struggles.

I am interested in emphasizing the need to make our work international, particularly here in the United States where even progressive leadership emphasizes American exceptionalism and represents the United States as the centre of the world. I spend a lot of time in Australia and am affiliated with an organization there called Sisters Inside; I have learned a great deal from that experience – especially from Aboriginal people – so, I would like to see us exercise more humility and be aware that we have so much to learn from people all over the world.

Q. What brings you happiness?
It is seeing that people are capable of coming together across the borders and lines of division that are designed to keep us apart – I am most filled with happiness when the prospect of bringing people together is fulfilled.

Q. What do you regard as the lowest depth of misery?
Donald Trump. I would never argue that history is inevitably progressive, because often we experience setbacks, but now we have someone in an elected office who assumes it is possible to return to a period before we made strides towards ending racism and many other evils. It makes me sad and very angry.

Q. What would you change if you could?
I would end capitalism. Wealth should not be concentrated in the hands of the few, rather, it should be social wealth; and education has become commoditized, to the point that the cost of so many institutions – even public ones – is prohibitive.

Q. Which single word do you most identify with?
Justice. Justice for all, that is indivisible.

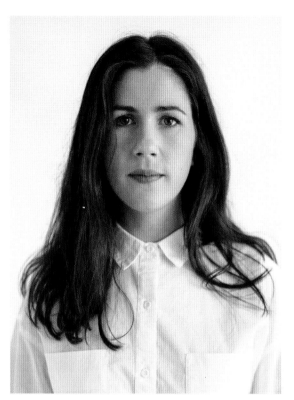

Becky Lucas

Q. What really matters to you?
People being able to have a voice. Everyone has a story and has something to say. It's important that everyone is able to speak up and be heard, and that their stories are valued. It matters to me that people learn how to listen to one another – that we move away from individualistic consciousness, towards a place of empathy.

'Failure'

June Steenkamp

Q. What really matters to you?
The [Reeva Rebecca Steenkamp] foundation gives me a reason to go on, a reason to live and to move forward; helping other people is what my life is about now – this has helped me a lot. But violence against women is not an easy thing to stop, and it's escalating every day – the examples are endless, and sometimes it feels like there is so little justice for these women. Nonetheless, I hope we can change the world; until I take my last breath, my life is going to be about trying to save other women from losing their daughters; it's going to be about trying to help others so that they don't have to go through what I went through and what Reeva went through.

'Death'

Georgie Smith

Q. What would you change if you could?

Our community is our responsibility. If our community is to be a success, we must aid its progress. Therefore, we cannot turn our backs on those who are not thriving; if we lift them up, we lift up their entire community. The same applies, too, to the environment; we shall not flourish as long as it is not flourishing. So, let's shift the thinking around what community is and the individual's role in community. For too long, we have been taught to look at what we can gain from situations, rather than what we can bring to situations. The consciousness is there, now let's act – with love!

'Gratitude'

LaTanya Richardson Jackson

Q. Which single word do you most identify with?

Love. We just opened the Smithsonian's Museum for African American History and Culture in Washington, DC. As we went through the museum's history galleries – from the shackles of slavery, through Jim Crow and the Brotherhood of Sleeping Car Porters – everybody kept saying, 'God, those first galleries are hard.' But I said, 'Oh, no, you can't look at it like that; you've got to look at the love.' We are still here, and it's love that brought us here – without it, we could have just lain down and died. It wasn't fear that kept us going, because you can't create from fear. It had to be the relationships between the people – the love.

'Love'

Elif Shafak

Q. What really matters to you?

It matters a lot that the art of storytelling transcends all existing boundaries; it reminds us of who we are as human beings and of what we share together. For politics and politicians, there is always a distinction between 'us' and 'them,' but for a writer there is no us and there is no them – there is only human beings, equal and one, everywhere.

I am an introvert by nature, as I guess all writers are. Our task is based on loneliness. Writing is a very lonely job, and it thrives upon solitude – you have to go into your imaginary cocoon. Throughout my very nomadic teenager years, writing was the cement that kept the pieces of me together, the existential glue that served as my sense of continuity. Even in my motherland, I have felt like an outsider, in certain ways. An insider – outsider: I was enough of an insider to understand the people, to love the culture and to feel attached to it emotionally; I was enough of an outsider to view things through a critical glance. But it's fascinating to me that the art of storytelling allows a writer to connect with people. You connect, understand and empathize with people you've never met before – it's almost a transcendental journey. So, even though it is a very lonely job, you end up feeling connected to thousands and thousands of people, East and West, regardless of class, race, nationality or religion.

The sisterhood is a concept that really matters to me. I was born in France, but I came to Turkey with my mother. At that time, in Turkey, it was very unusual for a woman to be a divorcee. Being raised by a working, single mother had a huge impact on me and my personality. I was also raised by my grandmother, though, so I

experienced two very different women as my primary caregivers. My grandmother was more Eastern; she was very spiritual and traditional. On the other hand, my mother was more Western; she was secular and urban. Nonetheless, I saw the sisterhood – the solidarity – between them.

Women's rights are crucial. I cherish stories, but I'm also interested in silences – in the things we can't talk about. I'm interested in political, cultural and sexual taboos. In my work, I like to think that I try to give more of a voice to the voiceless and to bring those who have been pushed to the periphery back into the centre. This matters to me. It's more important than ever that we all become activists: women *and* men. LGBTQI rights are as important as women's rights, and I see these two sets of rights going hand in hand. They can't be detached, because they're basically fighting the same kind of discrimination: the patriarchy and a sexist society. How can a woman be happy under the patriarchy? Turkey is a country that is very patriarchal: very masculine, sexist and homophobic. I certainly can't be happy in those circumstances, but I also believe that men can't either, especially young men whose dreams and ideals don't conform to what traditional masculinity expects of them and who want to break those clichés. On the subject of Turkey, I'm half pessimist, half optimist. History is non-linear; sometimes it marches backwards, and Turkey is regressing at a bewildering speed. They are making mistakes that their ancestors made five generations ago.

We have seen a decline in democracy, in human rights and in freedom of speech, and, as societies tumble down into authoritarianism, populism

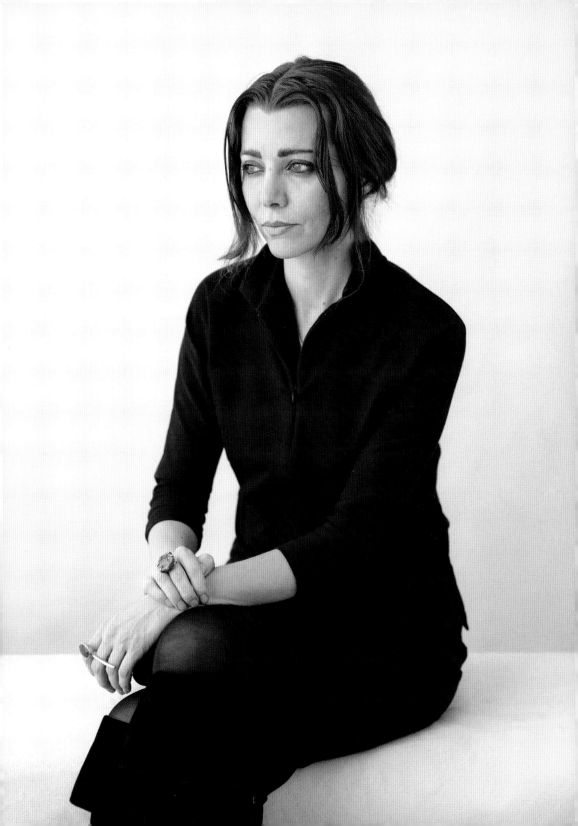

Elif Shafak

'Even under the harshest of circumstances, women, sexual minorities and minorities of all backgrounds are amazingly active, vocal, visible and dynamic. They are not passive victims. They are alive and full of dreams, and they are a huge inspiration to me.'

and fanaticism, women have a lot more to lose than men. This is why women need to speak up louder and bolder in the public space. And I believe it can be done – I'm very Gramscian in that regard: pessimism of the intellect, optimism of the will. Even under the harshest of circumstances, women, sexual minorities and minorities of all backgrounds are amazingly active, vocal, visible and dynamic. They are not passive victims. They are alive and full of dreams, and they are a huge inspiration to me.

Q. What brings you happiness?
Writing, reading and stories – being in that world of imagination. I love words; sometimes just playing with the alphabet – with letters – can be a source of happiness. I also think there are small acts of happiness in our lives that can mean so much and that are, therefore, by no means small. And motherhood has been an amazing journey.

Q. What do you regard as the lowest depth of misery?
There is so much misery and so much pain in the world. Perhaps one of the biggest sources of misery is seeing how we, as human beings, fail to learn from the past. Our collective memories are short and flimsy – Turkey is certainly a society experiencing collective amnesia. When you don't face and learn from the mistakes of the past, you can't really grow up. I'm not talking about living in the past, but about acknowledging it. Many societies are experiencing collective amnesia. This is why it is essential to keep activism alive – we can't take a single thing for granted. Even in

Western, liberal democracies, nothing can be taken for granted. This includes women's rights, LGBTQI rights and freedom of speech – we need to care about, and put some effort into, keeping these things breathing and alive. This is a crucial time in history, a point at which more and more people are realizing that we are sliding backwards into old habits. We need more international solidarity and greater global consciousness. If we are not aware, we might end up making the same mistakes our grandparents made once upon a time. Memory is a responsibility.

Q. What would you change if you could?
I am very concerned about inequality, about the gaps that have so many repercussions. I mean economic and social inequality, but also cultural inequality and cognitive gaps. There are some very advanced lifestyles around the world and yet, in each of those places – or not far away from them – there is still hunger and poverty, and girls not being sent to school. I worry about the increase in the number of child brides, which is happening in my motherland as well; many Turkish men are marrying Syrian refugees as second and third wives, despite polygamy being illegal. We need to start seeing ourselves as global souls, to whom inequality is the problem of all, not some.

Q. Which single word do you most identify with?
Storyland. It's the one place where I feel totally free, fully myself, in harmony with the multiple voices inside my soul.

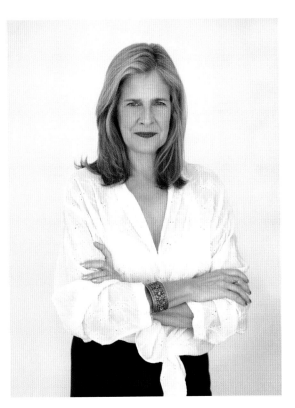

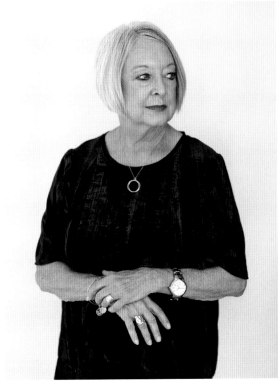

Dana Gluckstein

Q. What really matters to you?

My aunt, Jeanette, who died of lupus when I was thirteen, was my deep inspiration and mentor. She taught me that it's not the material in this world which matters, but our inner light and our inner radiance. She was a very holy person who lived in a truly crippled body, but her energy transcended that body. So I, too, focus on the inner. I try – through my work and also in my life – to be a steward for voices that need to be heard. And I try to be present.

Linda Biehl

Q. What do you regard as the lowest depth of misery?

Being ignored. The Truth and Reconciliation Commission process in South Africa might not be considered very effective, but the process of healing – the process of justice – is about being heard. And that is immeasurable.

'Dignity'

'Tolerance'

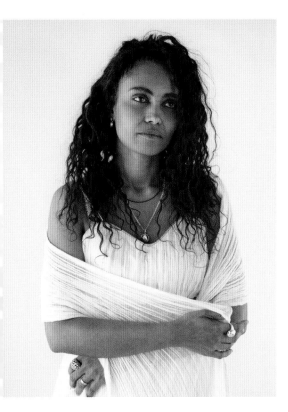

Sergut Belay

Q. What really matters to you?

Family, health, work and happiness. Up until five years ago, I was living with my mother, my husband and our children in Ethiopia. But, when my husband was imprisoned by the government – as a political prisoner – I skipped the country. I came to Sweden, via Kenya, without my children; suddenly I was an immigrant and I was alone. The Swedish government were amazing, though; they gave me a place to live, food and money. I was placed with six other women from different countries, which was good for me, because I needed to be around people. I have learned so much from these women. In fact, I've learned a lot since coming to Sweden, especially how to live with a whole new weather system!

Amber Heard

Q. What do you regard as the lowest depth of misery?

I can say that – having narrowly survived what I can only hope and imagine are the very depths of my own personal capacity to feel pain – there is some intrinsic worth to the experience; not to the pain itself, but to the surviving of it. You can never win a battle if you've never picked up a sword or been cut by one. And the truth is, if you have never experienced pain, loss, failure or destruction, you can never know what it is to survive, succeed, live and thrive. And you most certainly won't be able to help someone else who is in the throes of that kind of experience themselves.

'Kindness'

'Bravery'

Nicole
Avant

Q. What really matters to you?

It's funny: the way people speak about their grandmothers – Jewish, Middle Eastern, Russian, African-American – you'd think they were all the same woman. When the world is unfair, grandmothers stand fiercely combating the strife caused by racism, sexism, and other forms of hate with radical love and acknowledgement.

During the Gulf War, I asked my own grand-mother, who was knitting blankets to send to the troops, why she was doing this. She answered that she wanted them to know that someone was thinking of them; it didn't matter that she didn't know them personally. Her investment in others, known and unknown, is my foundation, and it informs my love for my friends and family, as well as my calling to help those in need. Showing yourself respect, love and kindness, and turning those principles into actions – extending them to the world around you – is how we march humanity forward.

Q. What brings you happiness?

Waking up with my husband and our dogs, and being healthy and able to experience the world.

The ocean and the beauty of nature bring me great joy.

Q. What do you regard as the lowest depth of misery?

Self-loathing, and a refusal to take responsibility for one's own energy.

Also, people who are intentionally cruel, who enjoy seeing others fail or thrive on hurt that results from gossip and slander.

Q. What would you change if you could?

I'd see to it that all people lived safe, healthy and abundant lives. Young girls everywhere would have access to quality education and would have the freedom to live up to their full potential. When we deny women and girls an education, we hurt them for life and maim their entire communities.

Q. Which single word do you most identify with?

Yes!

Nicole Avant

Vidya Balan

Q. What really matters to you?

What really matters is being authentic to myself in every moment, and I would like to see every woman doing the same; we are all living by certain set standards – living to fulfil certain role obligations – and are always putting others before ourselves, but I want women to be empowered to feel, do and say whatever they wish, without pressure, fear of judgement or consequences.

In India, there is often discrimination between girls and boys, from the moment we are born. However, my sister and I were brought up in a very egalitarian atmosphere – perhaps because it was just us two girls. We were brought up to be very self-assured women. Our parents gave us the freedom to be who we wanted to be and to do what we wanted to do, and our home environment was very protective; in my parents' eyes, my sister and I were the most beautiful, the smartest and the brightest human beings.

It wasn't until I stepped out into the real world that I developed body issues. I was a very fat child, and, when I left my safe space, I came face to face with a lot of judgement that I had been kept away from – it's shocking that people are willing to use so many different parameters to judge a person by. But, when I came home, I felt secure; I didn't feel less than anyone else, than someone who was thinner or brighter – or who was a boy.

Nonetheless, I could see the difference between my family and my friends' families. I could see brothers being given more leeway than their sisters; the boys could go and get girlfriends, for instance, but the girls didn't dare. Those things bothered me a lot and informed my belief that women should not be prevented from living their lives on their own terms.

Q. What brings you happiness?

It makes me extremely happy to see anyone living their life on their own terms. In India, the social conditioning runs very deep and the family bond is very, very strong. At times we all limit ourselves because of the expectations our families have of us – we don't want to do anything that might topple the apple cart or overthrow the status quo.

There are parallel realities in India. Mumbai is the kind of city in which you can live your dreams. People come here from all over the country and fall in love with the place. In Mumbai, a girl can live her life on her own terms and with whomever she wants.

But in other parts of the country, people's struggles are very different; in a lot of small towns and villages, girls can't live their lives on their own terms. Because of a lack of resources, many families are faced with choosing which of their children to send to school. This means girls are discriminated against when their brothers are prioritized, but they cannot stand up to their fathers and speak their minds about wanting to go to school. And even when girls *are* sent to school,

'I want women to be empowered to feel, do and say whatever they wish, without pressure, fear of judgement or consequences.'

many drop out because there are no toilets for them to use; this remains a reality for so many girls, although our current government is doing a great job of addressing sanitation issues. I travel a lot in my work as an actor and as an ambassador for sanitation, and I'm happy to say that I see changes happening in these small towns and villages – girls are slowly gathering the courage to demand education as a right for all, rather than as privilege for the few. I also see a growing awareness that people have the right to live life on their own terms – this fills me with joy.

We are in a better place than we were ten years ago; many educated men believe themselves to be liberated and support their wives working, but I'll hear them say things like, 'She's doing so well; I've allowed her to succeed.' Excuse me? Who are you to allow anything? This is a clash between intent and conditioning, of course, but it's positive that men who are exposed to the issue of equality are part of the dialogue. It troubles me, however, that a lot of men are removed from these discussions. There are men who rape and there are men whose attitudes towards women are sometimes worse than rape. I see this a lot, and I find it very distressing.

Nonetheless, I see women in Mumbai becoming more outspoken about the issues facing them, whether that be body shaming, unfair judgement or crimes against women. It's incredible that women are saying, 'Shut up! You have no right to judge me, and, even if you think you do, I don't care, because I don't hear it!' As women, we are no one's property and our lives are ours. We can't be told what to do and are going to live our lives exactly the way we want: we will pursue our desired professions and will be single for the rest of our lives if we want to. It makes me very, very happy to see more and more women starting to feel that we are no less than those who would put us down – in fact, we are better than them.

Q. What do you regard as the lowest depth of misery?
The lack of empathy; the world has become so intolerant. When I look at the leaders being elected around the world, I see in them a reflection of the fact that we are moving backwards to a space of exclusivity. People don't want to open themselves up to others; there is a definite 'us' and 'them' in which you can see the lack of empathy. We don't have to agree on everything, but it shakes me to the core when people rule out the possibility of another's opinion.

Q. What would you change if you could?
I know it's slightly utopian, but I would love for everyone to be accepting of everyone else.

Q. Which single word do you most identify with?
Love.

Elisabeth Masé

Q. What really matters to you?

Freedom, human rights and justice. When I die,
I want to have the feeling that I did what I could and
have no regrets about that. My mother always said,
'You can't lose something if you don't give up on it,'
and that's something that informs my life.

The refugee crisis is something I care deeply about.
I wanted to contribute in some way, but at the same
time not in a manner that was fleetingly charitable –
like giving money or food. So, I decided to bring
one of my artworks of a dress to life. I brought
seven German women and seven female refugees
together to embroider this piece. We stitched our
stories together with a red thread, which, to me,
was a symbol of solidarity. Together, we made
something beautiful.

'Tolerance'

Elida Lawton O'Connell

Q. What do you regard as the lowest depth of misery?

I met – and lost – my first husband during the war,
when we were both covering stories. I was pregnant
with my first child at the time. Losing my husband
was the closest I've come to giving up. I thought,
'That's it. I'm going to die. I don't want to eat. I just
want to die.' But, I knew I had to continue. As hard
as it is, you have to keep moving until you can start
breathing again. Eventually, someone you talk to will
make you smile. I've learned never to give up. I've
had so many bad things happen to me, but I know
I've done good things in my life – when you meet a
man you saved as a boy, and compare that to your
sadness, it's completely eclipsed.

'Trying'

Dianna Cohen

———

Q. What really matters to you?

At this point in my life, my artwork and my work with Plastic Pollution Coalition are inextricable. I was born in the sixties, so I grew up with a lot of awareness about the environment. As a depression baby, my father was taught to save and reuse every single thing. Another thing that influences me is my mother's death from a kind of breast cancer that is oestrogen receptive; we now know that most cancers are oestrogen receptive and that chemicals that are used to make plastics – phthalates and bisphenols – are endocrine disruptors that function like synthetic oestrogen.

'Community'

Alexandra Zavis

———

Q. What do you regard as the lowest depth of misery?

The mother who has to watch her baby waste away from hunger because she herself is too hungry to produce milk. Or the father clawing away at rubble because a bomb has landed on his house and he doesn't know whether his family is alive or dead. Too often, it seems the cost of our wars falls heaviest on those who play no part in them but have the misfortune to live in their midst.

'Resilience'

Dolores Huerta

———

Q. What really matters to you?

My mother was a feminist and a businesswoman; she was charitable, soft spoken and gentle, and she set the philosophy for all our family. She taught us that you have to help people you see in need, that you have an obligation to help them even if they don't ask for your help. And she said that, if you do help people, you don't expect a reward or compensation for the help you are giving them, because, if you expect someone to give you something back, that takes the grace away from the act.

Q. What brings you happiness?

It brings me happiness to see people taking power, to see them working together and taking collective action, thereby developing leadership. We are seeing the end result of the work we are doing.

Q. What do you regard as the lowest depth of misery?

It makes me sad to see that people do not engage. People have the power, but they choose not to exercise it. I think that, for a lot of people in our society, there's too much leisure and entertainment; many people are so hooked on their cell phones or video games that they aren't coming out into the world and seeing what's really going on around them.

The other thing that makes me sad is seeing so many people who are homeless in our society. It is a disgrace to our government that we have so many empty houses but so many homeless people. It is a disgrace that we in America – one of the richest countries in the world – can't house our people, or give them free medical care and free education like other countries do. It is greedy corporate control of our government that is depriving people of a decent education, of decent health care and decent shelter. It's a sin to have people making multimillion-dollar salaries while other people can't afford to live on what they earn. It's not only wrong, it's almost evil.

There is a terrible ignorance in our society that comes from a lack of education – the kind of ignorance that racism, sexism, homophobia and prejudice against immigrants comes from. Who built this country? First, it was the Native American slaves. It was African slaves who built the White House and the United States Capitol; it was people from Mexico and Asia who built the railroads, tilled the farms and built America's infrastructure. These are the very people who are now looked down on; immigrants and people of colour did all this work, yet racism is systemic and endemic in our society.

Q. What would you change if you could?

Right now, there's a very strong intent to destroy labour unions – and labour unions are workers. Organization is absolutely important because, when we are not organized, it's very hard to reach people. But when we are organized, we can communicate, we can talk to each other and we can become educated on issues. When we have an organization, we can all move together and take actions together to make the changes that need to be made. In all my work, over six decades, we have been able to make a lot of positive changes, but, in order to do that, you have to be able to mobilize and put pressure on the politicians. And, you have to make sure you can elect the right people to get the kind of representation you need. But, you can't do all that if you don't have organization.

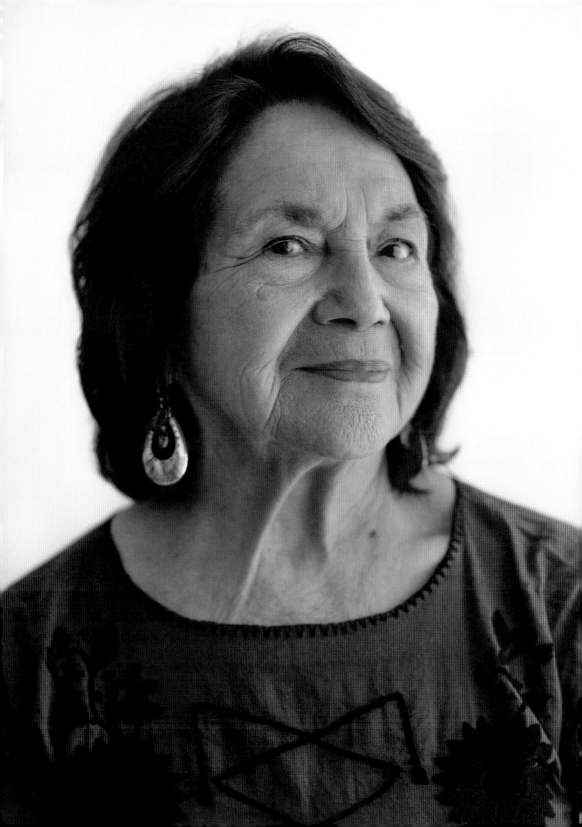

Dolores Huerta

'It takes courage to step out of your comfort zone and take on challenges even when you don't know exactly what the outcome will be and when you know that, when you start doing work to change things, you are going to be criticized.'

Consider the 2016 election – specifically, where the blue states were. What did the blue states on the West Coast – Washington, Oregon, California – and on the East Coast – New York, New Jersey, Vermont, Connecticut – all have in common? They had organized labour! Workers in those states are organized, so they can act together, especially when it comes to the political realm. But in those places where labour unions don't have organization – the South or the Midwest – too much power has been taken away from working people, so they can't really organize; they have been hamstrung.

All of this lack of organization and lack of education results in the kind of president we ended up with in 2016. The only way out is to vote bad politicians out of office. But Republicans are putting in voter-suppression laws. In California, you can register to vote on your cell phone and people are automatically registered when they get their driver's licence. But, in Wyoming, you have to go down to the courthouse – between nine a.m. and five p.m., Monday to Friday – to be able to register to vote. So, they put up all these obstacles, and as a result we have a democracy that is not functional, because people aren't able to participate by casting their vote. They are trying to make voting more and more prohibitive for people, which is how they keep control. I like to quote the words of the Spanish philosopher José Ortega y Gasset, who said that if you don't have an educated citizenry, all you end up with is a government ruled by the greedy and the powerful.

People have the power to make change, but they don't act on that power. We have to instil in them the understanding that we are the majority – we are the ones who pay the taxes, we are the ones who elect people to the legislative and congressional offices. All government staff work for us – we pay *their* salaries with *our* taxes.

Q. Which single word do you most identify with?
Courage. It takes courage to step out of your comfort zone and take on challenges even when you don't know exactly what the outcome will be and when you know that, when you start doing work to change things, you are going to be criticized. You have to have the courage to continue despite those criticisms.

We all have to take responsibility to have a more representative government by voting. If we do not do this, no one will do this for us.

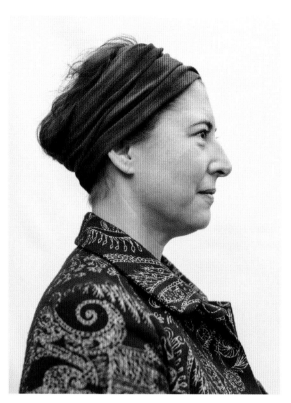

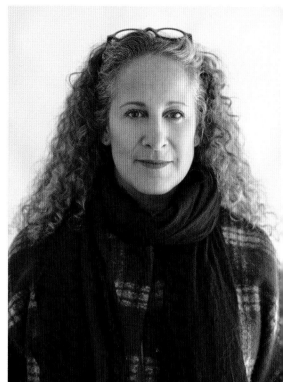

Safia Shah

———

Q. What really matters to you?

Being positive and generous matters to me. I don't think there's any place in life for negativity. I've never seen it do any good whatsoever. It's one of the most limiting emotions one can have, and I've seen it ruin perfectly good people.

Gina Belafonte

———

Q. What would you change if you could?

I would go back in time to when we started our human evolution and inhibit our feeling that one thing, or person, needs to be better than another; I would ensure the development of an understanding that there are enough resources for us all. I would make the experience of living equal for all of us: men, women and the differently abled. We would all sit in a space, probably a circle, where we have the opportunity to make a contribution and to communicate, which would give us collective understanding and the ability to identify the best way forward.

'Invent'

'Peace'

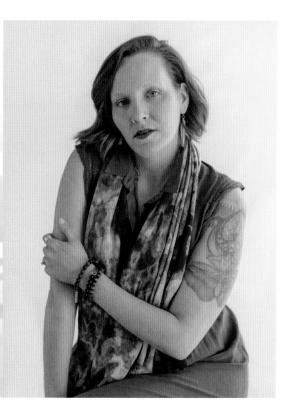

Dana Donofree

Q. What would you change if you could?

I want to see a day when we are living without cancer. I hope to close my business in twenty years because there won't be a need for me anymore!

Valerie Van Galder

Q. What really matters to you?

Mother Teresa said, 'Do small things with great love.' I've seen the effect tiny gestures of kindness can have. Just emailing somebody who has messaged our Facebook page and saying, 'Hey, you're not alone. We're listening, and we feel your pain,' can actually make a difference.

'Vibrant'

'Laughter'

Danielle Brooks

‘Manifestation’

What matters to me most is telling stories that move us forward as a society – telling stories that help people better understand one another.

I was in my first church play when I was six years old, but, when you're that young, you don't understand how you're affecting others. Everyone kept telling my mother that I was good, so from that moment on she found all of these different programmes for me to attend. I was transferred to arts school in middle school, then again in high school; in high school, I discovered my love for theatre, and I came to understand its power to change people's lives – it definitely changed mine.

In my senior year at the South Carolina Governor's School for the Arts and Humanities – I had just been accepted to Juilliard, so the school was always making me perform monologues when donors visited – I performed an August Wilson monologue from *The Piano Lesson* for about twenty women, who all happened to be white. I was terrified. But all these women were able to relate to Berniece's story, the need to convince her brother of the mistake he had made by selling their piano, an heirloom that had so much family history in it. The women all told me how they'd been moved, and that was the moment when I realized the power of art – how transformative it is. Everyone can find a way to relate to it. That's when I decided I would use my gift to help others become more free. In return, it does the same thing for me. This is why I feel so strongly that we have to pour our resources into arts education; it allows people to experience the arts and, through them, to feel seen and heard. Because it's important to give voices to people who feel like they don't have one.

In this world, most of us are operating in our own little circles, but, when I had the chance to tell Berniece's story, I realized the potential for arts to help us relate to each other. There is so much hate and opposition in the world – I'm right, you're wrong – so what we really need is to be able to relate to each other's stories. I feel *Orange Is the New Black* is so powerful because all of the characters are written off as criminals – as the lowest of the low – but you come to understand how each of them landed in prison. You see that most of them were operating out of love: stealing for their children, selling drugs to support their husbands or whatever else it might be. They were trying to do more, be better and to provide. When you take a step back and appreciate that these are people's mothers, sisters, daughters and lovers, you start to break down the judgement about who they are.

I do think that there are micro-aggressions black actors experience – I experienced them myself when I first started on *Orange Is the New Black*. Some people deem my character, Taystee, ghetto or unkempt, because she is incarcerated and says whatever she wants. And they have reflected that on me. I've stepped into interviews where the first questions are, ‘Are you trained? Where did they find you?’ Yes, I'm trained! I spent four years at a conservatory studying this craft. Yet, I don't

'In the twenty-seven years that I've been on this earth, a core lesson has been being able to identify self-hate. When you don't love yourself enough, or you don't feel like you have a reason to live, that's misery.'

necessarily hear those questions when my white contemporaries are being interviewed about their characters. I was at a fancy event recently, and a very distinguished black woman, who is in the business, told me she'd only realized my background after she recognized me in *The Color Purple*. She said, 'I thought they found you on the street or something.' I felt that was disrespectful to me as a human being, because she didn't have the imagination to believe that I could be greater than just the character I was playing.

People can be so close-minded in their beliefs, but I feel acting creates room for people to change – to see things differently as they get to know a character and then the person behind it. My mother is a minister and my father is a deacon, so I grew up in the church, and my family can be very homophobic. But, because they've engaged with the work of my colleagues Laverne Cox and Samira Wiley – and then with the women themselves – they're able to look at life a little differently than they had been taught to. I think that's a beautiful thing. What I've learned from my mother and her journey with faith is that it's okay to leave room for more love.

Q. What brings you happiness?
Doing what I love. When I'm centred and have inner peace, that brings me happiness. There are so many distractions that can throw you off balance, but, when I can take a moment to live outside of my insecurities and be fully in the moment, I find a true appreciation for life, health and the beautiful people around me.

Q. What do you regard as the lowest depth of misery?
Self-hate. I know I have a lot more to learn, but, in the twenty-seven years that I've been on this earth, a core lesson has been being able to identify self-hate. When you don't love yourself enough, or you don't feel like you have a reason to live, that's misery. Not all, but a lot of, self-hate we cause each other. In some way, our self-hate is all connected: whether it's somebody who's been abandoned by their mother or somebody who can't provide for her child. We affect one another; the minute I run into somebody, their energy moves my energy, and vice versa.

So, I think it would help if we all took a second to focus on loving ourselves. If I'm not operating out of a place of love for myself, how am I supposed to spread love? A drug addict who spends time with drug addicts is most likely going to do drugs, whereas, if they're going to AA meetings and hanging around people who are clean, that's probably the direction their life will take. I feel it's the same when it comes to loving one's self: we have to surround ourselves with the same vibrations.

Q. What would you change if you could?
I would change how we view money; greed is a powerful demon and it runs the world. I think the way we view money is ugly.

Q. Which single word do you most identify with?
Manifestation. We have the power to manifest whatever we want, if we believe.

Danielle Brooks

Meryl Marshall-Daniels

'Heart'

Q. What really matters to you?
Q. What really matters to you?

I have a deep drive for peace, for a place of quiet within myself.

My career has been all over the place, but, at the core of it, I would describe my role as that of peacemaker. The night Martin Luther King, Jr. died, I was taking a class called 'What it's like to be black in America.' I remember a member of the black student union saying, 'We know what we have to do in *our* community, the rest of you figure out what *you* have to do.' At the time I didn't know how profoundly that would influence me, but, as result of that experience, I eventually became a facilitator. Having worked in law, in television and with non-profits, I've always been at the heart of conflicts, so in my early fifties I trained as a mediator and my work now is really about attaining that inner peace by overcoming conflict.

People think of conflict as this crisis moment, but, in truth, conflict starts long before that – the crisis is merely the eruption. I would therefore say that we cannot avoid conflict, because in most cases it already exists. At its core are our internal issues. We live in an extraordinary time, a very treacherous time; the 2016 election in America brought out the worst in people, and it has posed some essential questions. The levels of misogyny and racism that have been uncovered, which exist in such a pervasive fashion, are now out there for everybody to know about. Those emotions are running free. In a way, it's a gift for those who wanted to believe that these issues

no longer existed; we've been disabused of that dangerous assumption. The sacrifice of civility and the unwillingness, or inability, to have dialogue around difference has really intensified. This is really frightening, because it means that we're on a precipice. And if we're not careful, we could destroy ourselves in the process.

People in America have always assumed that democracy is so incredibly resilient. People believe that the will, the heart and the passion of the American population is extraordinary; even though we have this incredible belief in individualism – which has been a deep value – we also have the Horatio Alger myth that anybody can make it. But a lot of those dreams and a lot of those precepts are being undermined. Our economic system of capitalism and our concept of democracy have become confused. They're not one and the same. And unless and until we do some hard work towards understanding how they intersect, or don't – understanding how they support each other, or don't – we are going to live on this precipice. There are a lot of people who are no longer optimistic and who no longer have hope; the biggest danger to humanity is to feel hopeless and helpless.

It's so important, in conflict, to understand what you care about deeply and what is being affected. Conflict often presents itself in a way that is not representative of what the issues are, so

'There are a lot of people who are no longer optimistic and who no longer have hope; the biggest danger to humanity is to feel hopeless and helpless.'

the real challenge of conflict resolution is to be able to understand what is driving us. Once this is revealed, the potential for resolution is great. But without that honesty, without that ability to really uncover the interests you are trying to pursue or protect, resolution is not possible. So, acknowledging and expressing your deeply held feelings is crucial – because acknowledgment and expression, by their very nature, change conflict. Once you understand what you're trying to protect or pursue, the relief that clarity brings gives you a vocabulary, or choice, that was totally invisible to you when you were acting unconsciously – out of instinct – and behaving out of fear of this unknown element. That is how we obtain peace among ourselves and also within ourselves.

That quiet, peaceful place matters to me, even on a smaller scale. I've always been an extrovert, so, because I was so engaged with the outside world, without realizing it I failed to attend to aspects of myself. I've discovered that it's important to cultivate the very diverse aspects of myself. I've learned that in the darkness – in the pain – is where my passion also lives, so avoiding those dark feelings is actually hazardous to my growth, to my development and my joy; I've come to understand that passion in life requires engagement with all aspects of who I am.

Q. What brings you happiness?
In the outward world, I find happiness in the

potential for change, for growth and development. I came into this world as a lawyer – I was raised by a lawyer – so I knew about battle. But what has emerged in the world during my lifetime is this understanding about how reconciliation can be such a powerful tool, and that we have a deep yearning for connection and relationships. If we can find a way to be human – to share our humanity – the opportunities to create magnificence exist every day.

Q. What do you regard as the lowest depth of misery?
Being helpless in the face of suffering. I feel overwhelmed by the agony and the suffering of others. I can't live in that space, so I have to turn to optimism – and yet, I have discovered over and over in my life that sometimes helplessness just needs to be shared. It needs to be witnessed, but it can't always be fixed. That's been a brutal realization – that my optimism is sometimes not helpful. Increasing my capacity to witness and encourage the voices of pain has been a deep learning in my life. But one has to hope that through expression there can be transformation.

Q. What would you change if you could?
The ability to listen: I would make it safe for people to listen to themselves and to others.

Q. Which single word do you most identify with?
Heart.

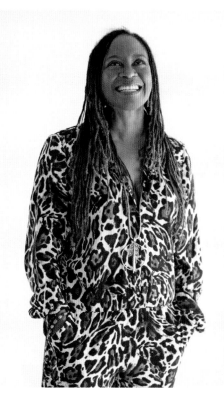

Pamela Novo

Q. What really matters to you?

My husband and our baby. And being an educator, because I do see parents who have somewhat neglected their children. That filters down into the child – it becomes apathy. In instances like that, you try to support the child and instil certain values in them – sometimes it works, sometimes it doesn't, but it makes me happy when I am able to help a child become enthusiastic about education. I use myself as an example to kids of how to continuously engage with learning; when I started school, I didn't speak a word of English. I remember standing in front of my entire class, unable to simply say, 'Teacher, can I go to the toilet?' I peed myself, which was incredibly embarrassing. So, when my kids say that they can't believe this, because my English is so good now, I tell them it's because I kept learning and kept reading.

'Perseverance'

Tracy Gray

Q. What really matters to you?

Justice. When I was five, I saw a mentally disabled girl being locked in the schoolyard by a group of boys. I can remember how deeply it affected me. In fact, it's an experience that birthed everything I do, think and feel today about fairness, equality and justice.

'Laughter'

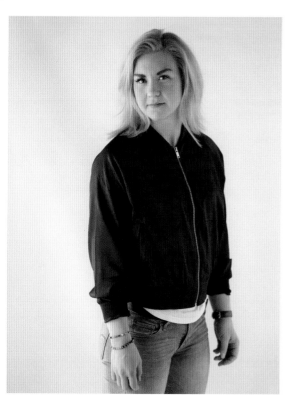

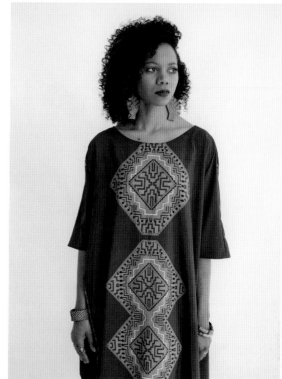

Elin Rova

Q. What really matters to you?

It matters to me to feel good – that my life is worthwhile and that I can cope with the challenges that come my way. I want people around me to feel the same way; I wish that all people were happy and well. My mother is a nurse and has had the greatest impact on me. Watching her, I grew up always wanting to help people, to share in their happiness at overcoming whatever obstacles they are facing. That's part of the reason I became a nurse. I work in the emergency department, so I have seen a lot of death. You put your mask on and you become a stone, but it's very difficult to cope when you see a child's body. Now, I'm training to be a midwife, because I think the moment at which a child is born is the greatest on earth. It inspires such joy and is something I want to be a part of.

Tabitha St. Bernard-Jacobs

Q. What would you change if you could?

I would create a system that requires every single human being, at a certain age, to live a year in somebody else's life. Most people who hurt others do so because they don't, or aren't able to, see the humanity in others.

'Sunshine'

'Relentless'

Aminatta Forna

Q. What really matters to you?

I've devoted my life to trying to help people move towards the understanding that we are more alike than unalike. I find it baffling that people cannot see this; I find it sad that we concentrate far too often on differences and not on similarities.

One of the discussions that is engaging writers at the moment is whether we can write people across race or across gender. I'm often asked, 'You write male characters: how do you understand men so well?' I always say, 'Because I don't think they're any different.' I do think they have differences of experience, though. One of these is that men are much freer to move through the world than women are, because they don't have to think about their own personal safety to the constant extent that women do – they don't have to fear rape so much and are not seen as victims in the way that women are. But despite these differences of experience that can lead to differences in behaviour and ways of thinking, fundamentally, I don't think men and women are different. And I feel exactly the same about people of different races and cultures.

There are reasons why patterns form. I'm often asked another question, and it always irks me. It starts like this, 'Coming from two such different cultures – Scotland and Sierra Leone . . .' I will often say to the interviewer, 'Have you ever been to Sierra Leone?' They'll say, 'No.' So I say, 'How do you know they're so different?' The two countries are actually strikingly similar. Let's take my grandfathers in my Scottish and my Sierra Leonean families: they were both not happy with my parents' marriage; both are tall, thin, very athletic men; one is a Scottish Presbyterian and the other one is a Muslim, but both are very

religious; both are highly patriarchal; and both had a tendency to indulge me as a child. These two men, from different places in the world, were – to me – almost exactly the same. If you can see that, then you can see that people are the same; but the presumption of difference that arises simply because we are talking about different colours and different continents, is where we start to go wrong.

We are all connected. I've always wanted to tell stories, because stories are how we come to understand the world. What fascinates me about stories – what drives me to write – is looking at the interconnectedness of things. That's why I moved from non-fiction to fiction: because you can construct worlds in which connections can be demonstrated. They say that non-fiction reveals the lies, but only a metaphor can tell the truth. In *The Handmaid's Tale*, which came out in the mid-eighties, Margaret Atwood pinpoints exactly how rights can be rolled back; she describes how an American elite manages to regain power by vilifying Muslims. And look at where we are now. A writer as great as Margaret Atwood can join the dots and create understanding. That's what writers do.

Q. What brings you happiness?

I have the good fortune to have happiness as a resting position; I'm generally happy unless something I see makes me angry. It's a good way to be. What makes me *happier* is food!

Q. What do you regard as the lowest depth of misery?

I think to be without hope must be the depth of misery. I am fortunate enough that I have never actually experienced the depth of misery, so I

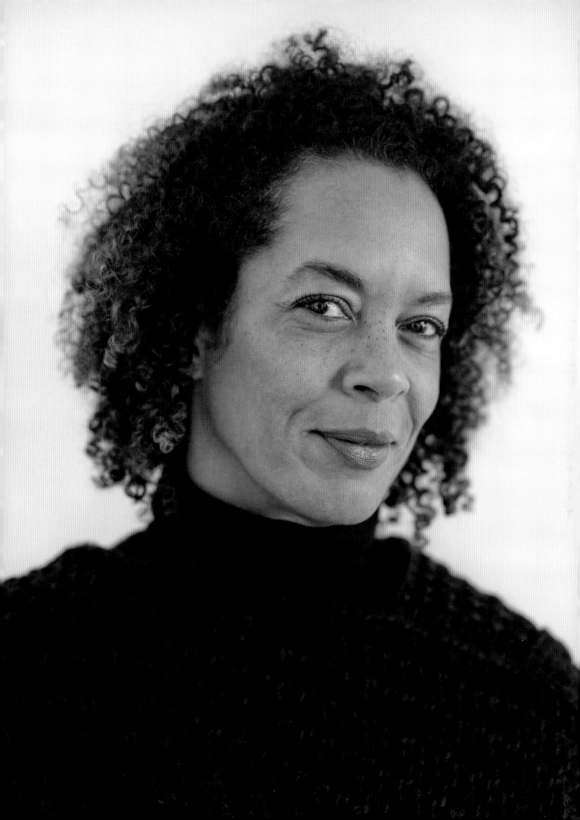

Aminatta Forna

'I've devoted my life to trying to help people move towards the understanding that we are more alike than unalike. I find it baffling that people cannot see this; I find it sad that we concentrate far too often on differences and not on similarities.'

can't imagine what that is like. What I would say is this: the thing that makes me saddest and angriest is human cruelty, the capacity of one human being to be cruel to another. I do believe that human beings are innately capable of cruelty. I believe we belong to the animal world, and I don't believe that there's anything that elevates us beyond that – apart from the fact that we *are* more sophisticated. We are more intelligent, and, therefore, we have the capacity to organize ourselves into societies that do not rely on alpha-dom, muscularity, bullying, the scale of numbers and mob rule. We can organize ourselves in ways that mean one human being doesn't have to force another to submit to them. That is possible. So the refusal to strive for it is what makes me most frustrated and angry.

Q. What would you change if you could?
Actually, it isn't up to me to change anything – because I really, genuinely believe that change begins within. What I try to do is get people to see the world in a different way: to reverse the gaze, to see how they look to somebody else, to look towards something that hasn't been seen before. The only thing that needs to change in the world is a quite tiny shift of perspective. It comes back to the idea that you only have to see that people are

more like you than unalike. That's really the only thing that has to change.

I do believe that sometimes people can be wilfully blind. So you have to engage with them to the point where you can pull off their blinkers and actually encourage them to see what is there. Although there's been a rise in monoculturalism, humans are not naturally monocultural. In fact, it takes a lot of work to blinker differences. It requires a Slobodan Miloševic or an Islamic State kind of mentality to say, 'Cultures are distinct and people are different from each other.' And what is behind this? Just follow the money: it's a cover story in order to acquire power and wealth.

Q. Which single word do you most identify with?
Resilience. It is the courage to endure. We have this saying in Sierra Leone – typically delivered quite dryly – that goes like this: somebody will say, 'Aw di bodi?' meaning, 'How are you?' In response, people will sometimes say, 'Ah fol don an git ap.' It means, 'I fall down and I get up again.' The fact that this response is almost always delivered with a smile – in a place like Sierra Leone, one of the poorest countries in the world – means something to me. That's what I call resilience.

Marita Cheng

Q. What really matters to you?

I'm always asking whether I'm doing enough to fulfil my potential. My mother worked as a kitchen hand and put all her money into extracurricular activities for my brother and me. She wanted us to have as many experiences as possible.

'Hope'

Julie Taymor

Q. What brings you happiness?

My work, and everything that matters to me in it, brings me happiness. As do my other half, my dog, my mother and my friends. And being on the beach; beautiful places in nature bring me tremendous happiness.

I'm happy when I see people accomplish something – seeing them at their best instead of their worst just awes me. The word 'awe' is very important, because awe is hard to find – especially in a world in which technology has become so primary. I know people think technology connects them, but it also brings out the worst in people. Everybody becomes smaller – more downturned – until they live inside themselves and are not outward anymore; I really prefer an open, connected, outwardness in human beings.

'Transformation'

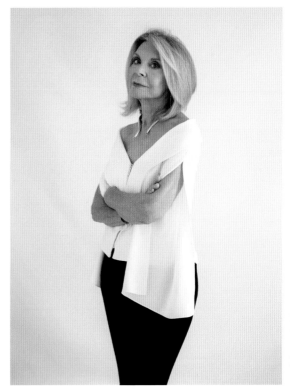

Pearl Tan

———

Q. What do you regard as the lowest depth of misery?

Hopelessness. I think that the news cycle these days makes viewers feel like they can't add anything that will help resolve a given situation. People feel hopeless, like what is happening around them cannot change, and so they come to view systemic problems as being set in stone. In response to this hopelessness, it is so easy to spiral downwards and remain in a slump, and that is misery to me. What drives me is the determination not to stagnate is that place; I may only be one person, capable only of doing many little things, but that doesn't mean I shouldn't be doing them.

Carla Zampatti

———

Q. Which single word do you most identify with?

Optimism. I'm a great optimist; I really believe that the spirit of people will win through. I would like everyone to have a greater sense of optimism, because it's the only thing that you can rely upon.

'Learning'

'Optimism'

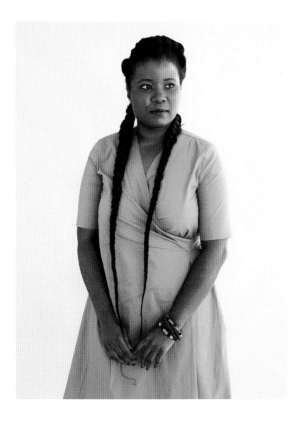

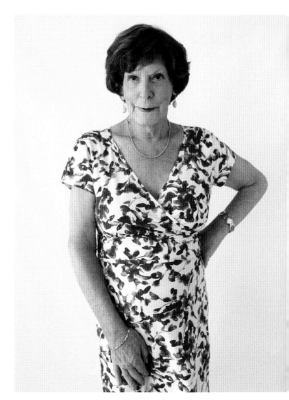

Santilla Chingaipe

———

Q. What really matters to you?

We need people to realize that when someone is suffering somewhere, it isn't that person's problem alone – it is *our* problem that we *all* need to find a solution for. I think my generation believes that others have fought for freedom and that now is the time to revel in equal rights – but it's not. In many ways, we're regressing. However, I believe that in understanding others, there is hope.

Rosemary Jones

———

Q. What really matters to you?

I was born Robert Anthony Jones. I went to an all-boys boarding school in Dorset, which I absolutely hated. The only good thing about it was the headmaster's daughter, whose name was Rosemary – I took my current name from her. She was gorgeous. All the boys wanted to sleep with her, but I just wanted to be her.

When I had fully transitioned, I felt like a pig in muck; it was like walking on the clouds. I was liberated. I didn't have to be on guard, worrying about whether anyone would notice anything. Being able to express the truth – to express myself the way I wanted to express myself – felt gorgeous.

'Joy'

'Elegance'

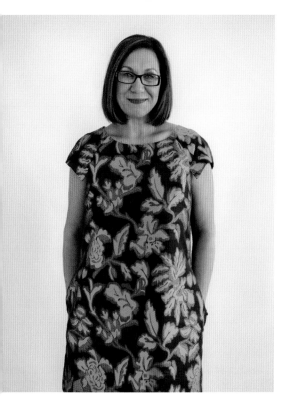

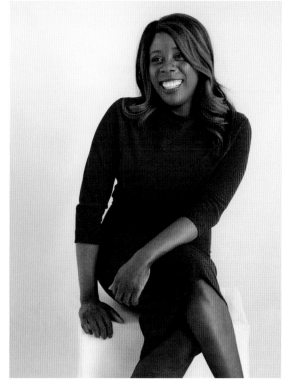

Anita Heiss

Kaylin Whittingham

Q. Which single word do you most identify with?

Hope. Because I'm hopeful on every level: I hope I'll meet Mr Right; I hope that one day the racial hierarchy won't exist; I hope that one day teachers won't have to be forced to include Indigenous perspectives in a classroom; I hope that we don't have to keep explaining why it's important to have an Aboriginal acknowledgement of country, that people can understand it's just how it's been done for tens of thousands of years; I hope that in years to come our Indigenous young people aren't leaving school with low literacy levels; I hope that at some point an Australian government actually acknowledges that what's happened in the past is the reason we're stuck where we are today; and I hope Donald Trump doesn't last!

Q. What brings you happiness?

I'm still searching – I don't think I've quite found happiness as yet. But I am optimistic; there are moments, things and people that bring me joy.

I find happiness in helping others find that, yes, there *is* a way; inspiring, empowering and engaging others to believe in themselves, to believe that they, too, can accomplish.

'Hope'

'Automony'

Jessica Gallagher

Q. What really matters to you?

Being happy and living in the moment; I know that if I'm doing the things that I love, then my life will take care of itself and opportunities will present themselves. And spending as much time as possible with the people that I love matters.

In relation to sport and my career, what matters is surrounding myself with good people who really make it all worthwhile. Standing on top of the podium for Australia is an incredibly special moment, but there's a whole tribe of people who are involved in that process. So, although I participate in individual sports, you get to share it with so many others – it's those relationships with people that really matter the most to me.

Q. What brings you happiness?

When I was younger, I had the ability to experience life with full vision, but, when I was seventeen, I was diagnosed with a rare, degenerative eye disease. That has been one of my biggest challenges. I'm now legally blind, so I find pure happiness in the simple things: in the fact that I haven't completely lost my sight, in the fact that I can have time with my family and friends, that I have a roof over my head and that I have the opportunity to do the things that I love, which are my greatest happiness. I'm very fortunate that, despite the challenges I've faced, I still have the ability to choose the life that I've always dreamed about. Being able to have that

perspective is really important, and it means that moments as simple as walking down the street on a nice sunny day to get a coffee with a friend make me really happy, although they are essentially simple.

My brother and I grew up with a single mum, who worked really hard to provide for us. I idolized her; the challenges she went through gave me the skills I have today – especially the resilience, persistence and courage to move forwards. I think the uncertainty of my diagnosis hit my family harder than it did me – they experienced a lot of pain coming to terms with the fact that I had this life-changing condition. We didn't know anybody who had a disability, let alone low vision.

For me, it was a matter of accepting that I couldn't change my situation. Yes, it threw up the uncertain question of what my life would look like, but at the age of seventeen you're trying to figure that out anyway! It was about trying to accept and acknowledge that there were things I was never going to be able to do, and using the strengths and the skills that I did have to create my own path, regardless of the fact that I had low vision. I look at life as a series of moments, and, in any given moment, I get a choice of how I want to perceive a situation. I'm always trying to take away the positives from a situation, but I know that if the outcome is negative I'll be able to learn from it.

'I find pure happiness in the simple things: in the fact that I haven't completely lost my sight, in the fact that I can have time with my family and friends, that I have a roof over my head and that I have the opportunity to do the things that I love, which are my greatest happiness.'

On my journey, I've learned that knowledge is power, so I love that I can now give back to young children who are recently diagnosed with, or were born with, low vision or blindness. I'm able to share my experiences and the fact that I have been able to overcome all of the challenges I've faced. I love that I can pass my knowledge on to others – to help them learn – but I find it incredibly humbling when my story helps someone find inspiration. It can be really empowering for people to receive advice from someone in similar circumstances, because it helps them move past the challenges they're facing.

Q. What do you regard as the lowest depth of misery?
It really breaks my heart that so much of our global blindness is preventable and avoidable, but is not avoided because people can't afford to see an optometrist or get a pair of glasses that may only cost ten dollars. That level of inequality, whereby so many people in this world don't have the ability to live the life that they've dreamed about, is misery, and is why I'm so passionate about things like eye health.

Q. What would you change if you could?
I would create equality of opportunity. I would give people the ability to live a good life, be free and safe, have a roof over their heads and afford food – just those simple, basic things that the majority of us take for granted. The helplessness and inability of people to choose the directions of their lives really saddens me.

Q. Which single word do you most identify with?
The one word I would identify with is trust; it's the very essence of my life as a vision-impaired Paralympian. When I'm ski racing, I ski with a guide at over one hundred kilometres an hour. We wear headsets, and I have to trust that he gives me the right communication. It's the same when I'm on a tandem bike: I have to trust that the person steering the bike knows where they're going and what they're doing. If you can truly trust people, then authenticity and honesty come easily – through these, you are able to develop deep relationships with people.

Trust, for me, even lies in approaching a stranger for help in something as simple as walking down a street when you can't read signs or see steps. It takes a lot of courage, because you have to trust a complete stranger. I gain a real sense of optimism every time I ask for help, because I've never had an experience in which my requests for help have been refused. Whenever I'm struggling, there's always someone willing to help. It's a special moment, and suddenly you're bonded with a complete stranger. It may only last a moment, but it gives me such optimism.

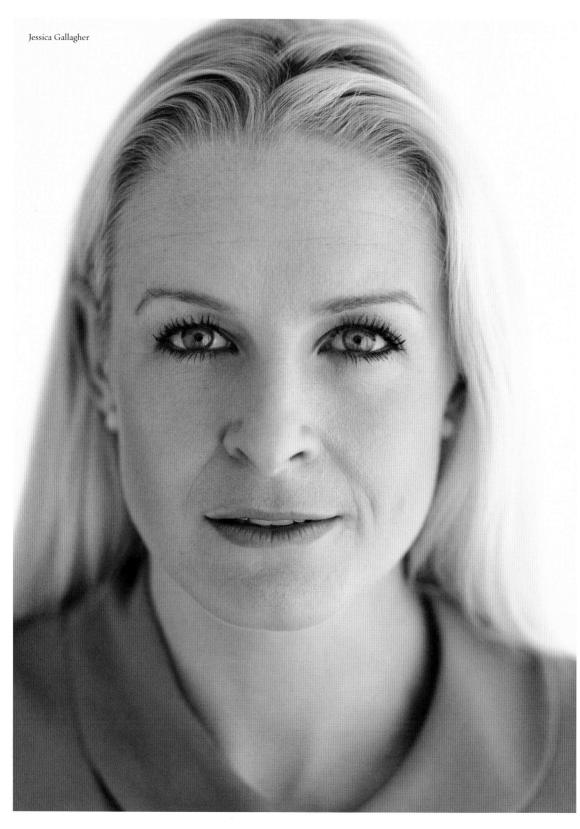
Jessica Gallagher

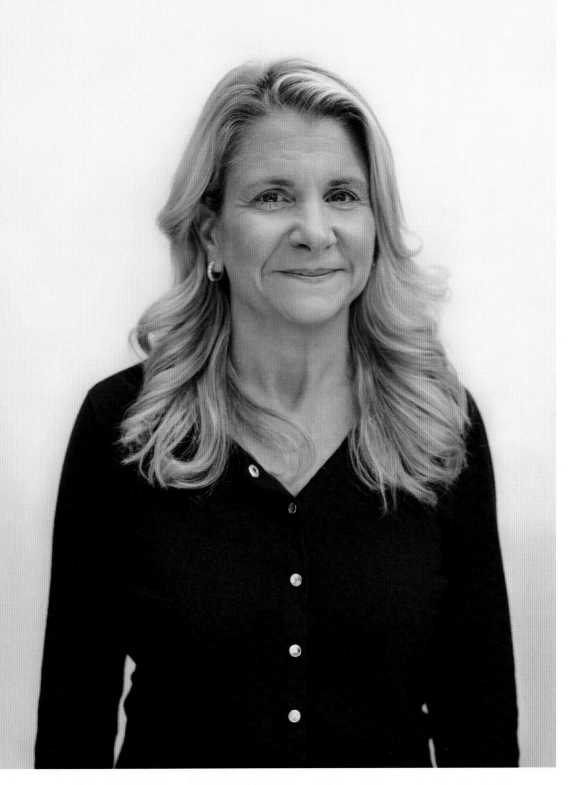

Deana Puccio

Deana Puccio

———

Q. What really matters to you?

My advocacy work for young women and victims of sexual violence. New York in the seventies was not a safe place, so growing up I had this feeling of wanting to make a difference. I was lucky enough that God gave me a brain, that I had a supportive family and was able to go to decent schools. For me – as an individual and as a woman – I knew I'd been given a lot and I wanted to give something back. I became a lawyer because I wanted to become a prosecutor, specifically to work with victims of sexual assault. This has defined who I am and how I view the world vis-à-vis women and violence.

Most women I talk to have been subjected to some sort of sexual assault or harassment – or worse – some at a very early age. In my first job before law school, a senior male colleague asked me for something. When I told him I couldn't help he said, 'Well, if you don't do what I say I'm gonna undress you.' I laughed it off, but the next thing I knew his arm was around me as he unzipped my skirt. I was mortified. But when I went to my boss – a woman – she shooed me out of her office saying, 'Boys will be boys.' I knew then that, with all of my advantages, I had to do something to help women who didn't have the options I did.

When I was pregnant with my first daughter I was working on a case involving an impoverished family in Brooklyn. My victim was a sixteen-year-old girl who had been raped. She'd been manipulated and groomed by a guy who was much older. She ended up becoming pregnant from the encounter and decided to keep the child. The perpetrator took a plea because we would have his DNA. It was a relief, because trials can re-victimize the victim. And sometimes you go through a trial and the rapist gets off because of one juror with misogynistic, sexist views. One day, after the conviction, I came back from court to find a gift at the front desk. The victim's mother had knitted me a baby blanket. For her to buy that wool, to find the money and to take the time and effort to knit that was worth more than any pay cheque, any fancy present or any expense account. Of all the baby gifts I've received – whether a Tiffany rattle or the like – the only gift I've kept and that will stay with me forever is that baby blanket, knitted for me twenty years ago by a woman in a housing project, because I helped find justice and peace for her and her daughter.

Doing things like that is what's important in life. If you can affect one person's life, then you've made a difference. How many of us can say that we've really affected someone's life? And if you can act locally, then the potential exists to make a difference globally.

I'm mother to three teenage daughters; worrying about their safety has been a hugely significant

part of my life. Because of this, I started a sexual-awareness programme called The RAP Project with my friend Allison Havey. Its purpose is to educate young men and women about sex and sexuality. Professionally, it's one of the most important things I've done. It is so easy to make misogynistic comments, to participate in 'locker-room talk' or laugh at a rape joke. But we often tell young men that, if they are ever tempted to do so, they should first picture their mother, their sister or their grandmother being talked about in the same way. Their reaction is usually one of disgust. We then ask them to question why the woman they are objectifying deserves any less respect than those women in their lives do. As they acknowledge that all women are entitled to be treated with the same amount of respect and decency as their mothers, sisters and grandmothers, the process of change continues.

Q. What brings you happiness?
My three beautiful daughters. And my husband: I have a wonderful, loving partner of twenty-seven years. He is one of the most amazing people in the world and he's a proud feminist. He doesn't judge anyone. And helping young women – and now young men – makes me happy. I also love to cook; I'm Italian and Lebanese by ancestry, so to be feeding people across my kitchen table filled with family, love, friends and wine is my greatest sense of happiness.

My work has also made me very happy. When I made the decision to go to law school it was specifically to make a difference for women, so I feel extremely lucky to have been able to do that.

Q. What do you regard as the lowest depth of misery?
Having any of my children unhappy or ill. I want my daughters to be happy and confident. I want my daughters to have the confidence and self-esteem to reject society's warped standards – those societal pressures for girls to be perfect that have led to increases in eating disorders, suicide rates, self-harm and depression. I don't want my daughters to experience things I've experienced in my life – I don't want them to ride a train and be subjected to the sight of men masturbating in front of them. I want the world to be a better place for them than it was for me twenty-five years ago. But I don't think that's the case – I think the world's actually worse.

Q. What would you change if you could?
Injustice. I'd want to change economic injustice and gender injustice, to achieve an even playing field, where we treat everyone with dignity and respect, the way we actually want to be treated ourselves.

Q. Which single word do you most identify with?
Loyal.

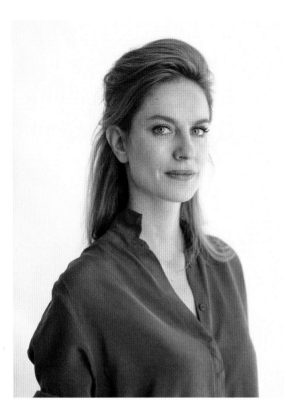

Julia Leeb

———

Q. What would you change if you could?

I wish people could recognize the destructive power of their impulses and counter them. I also wish people could communicate better. Some of the greatest atrocities in this world are unknown to us, because they are occurring in remote places like North Korea or the Congo. We look at these places from afar and say that we can't understand why certain things are happening. But, there's always a reason, and most often it's very conventional: someone feels misunderstood or like they have been unfairly treated, or that their pride and honour have been offended. But, the reality is that it's very easy to stop a conflict at its inception – if people could communicate better, I think they would see this.

'Creativity'

Jane Caro

———

Q. What would you change if you could?

I would try to get rid of shame. In my view, every human being can be redeemed; it's important to condemn behaviour and opinion, but never the person who has behaved in a certain way or who has opined something foolish, or even hateful. For example, people will call certain politicians liars. But no one person is 'a liar' – we all tell lies. No one person is 'a sexist' – we are all sometimes sexist. No one person is 'a racist' – we are all sometimes prejudiced and bigoted. When you recognize this, suddenly it stops being 'us and them' and becomes just 'us.' It's that connection and 'us-ness' that I'm after.

'Connection'

Hlubi Mboya Arnold

———

Q. What really matters to you?

Although my name is a Xhosa name, it defies
the archetypal Xhosa woman because it means
'different kind of girl.' I interpret it as representing
strength, unity, passion and love of one another, and
that interpretation informs my work as an activist.
I'm a feminist, but I don't believe in the exclusion of
men - I believe in the inclusion of all. In terms of
gender equality, the work is all about breaking the
glass ceiling. There are so many double standards in
the corporate environment and there is still so much
violence in the workplace – this is not limited to
physical violence, it can be something as 'simple' as
marginalizing women.

Nahid Shahalimi

———

Q. What do you regard as the lowest depth of misery?

There have been difficult moments, but aren't
the lows and highs the beautiful thing about life?
When the Shah – the last king of Afghanistan – was
overthrown in 1973, everything changed. The war
took my father away, and life became a living hell
for us; being rich and female, without a male head
of the family, became a curse. We had enough
wealth for everyone, but some relatives were like
hungry wolves waiting for my dad to die; I saw
people turn into monsters for whom only money
mattered. We left Afghanistan because of the war,
but mainly because it was very dangerous for us as
women. We left with nothing; we walked over the
mountains, with nothing to eat or drink for five days.
This robbed us of our childhoods, but it also made
us strong. We had already hit bottom rock, so, what
else was there? Death?

'Love'

'Resilience'

Geena
Rocero

———

Q. What really matters to you?

Justice: I want everyone to have the same opportunities to pursue their dreams. I was just a young trans girl, growing up on a little island of the Philippines, who had a dream – I imagined something bigger for myself. And here I am: I live in New York City, I offer my voice for my community and I'm meeting world leaders. But, I don't forget where I've come from, and I have such gratitude that my dream has come to pass.

In the Philippines, we have a long-held tradition of throwing a fiesta for the birthday of a particular saint; I was always drawn to the singing and dancing contests, and to the transgender beauty pageants. When I was seven, I remember standing there watching these beautiful trans women, thinking, 'Wow, that's me!' For the first time in my life, I found that I could identify with this particular representation of humanity. I realized that I wasn't alone, and I started dreaming of becoming like these women. It was the first time I felt valid – the first time I felt that all the things that had been going on in my head since I was five could actually be real. It was the moment I realized there was a place in this world for me to inhabit.

When I was fifteen – again, I was at the pageants – the pageant manager approached me and offered to pay for my registration and garments to wear. She told me she would take care of me and that I could be her daughter. It opened up an entirely new world for me. For the next two years of my life I was immersed in this world, travelling around the Philippines with people like me: wonderful, creative, loving people. We found community in each other in a country where – although we were seen – we were not included. And we found empowerment through each other; this was

particularly important because, although we were culturally visible, we weren't politically recognized. We weren't recognized as women – on many of my official documents I'm still listed as male.

Fashion was one of my dreams, so I moved to New York City to become a model. It was a completely different experience, because there weren't a lot of trans models – there still aren't. For about a decade, I worked, but hid who I was. Worrying about whether anyone would find out my history gave me great anxiety, because all of the trans women who had come before me lost their careers when they came out. But, I felt like I wasn't fully myself at work or with the people I surrounded myself with. Then, I just decided to share my story and did a TED Talk; I decided it was time to share my pride in my journey as an immigrant, trans woman of colour. It changed my life. People ask me why I did it; I think I felt a sense of purpose that was greater than my fear. And declaring the fullness of my humanity and femininity to the world opened up so many opportunities. The greatest has been being able to listen to people's stories. I'm so aware of my privilege and would never want to speak for anyone, so it matters that I'm engaging with the complexities of people's experiences, so that I can share them with the world. Producing has given me the ability to take ownership of the trans narrative; for the longest time, people have taken away our control of our own narratives by telling our stories through their own lenses. That's changing and will continue to change.

Visibility of the trans community is an important component, but it is only one aspect of realizing equality. There is a very complex, empowering

Geena Rocero

'I want everyone to have the same opportunities to pursue their dreams. I was just a young trans girl, growing up on a little island of the Philippines, who had a dream – I imagined something bigger for myself. And here I am.'

relationship between changing policies and changing culture – those two things work hand in hand. You can't change a culture without effecting specific policies that will empower trans people. Equally, you can't talk about changing policy without changing culture. Trans people need to have access to employment and inclusive health care practices – to the things that we need as humans. But, even with the progress that is being made on the issue internationally, we are constantly being pushed back into the closet. Now, more than ever, we need to embolden people by unapologetically living our truth.

I'm aware of how lucky I am to live this life, but I'm also aware that the journey hasn't ended. It keeps going, and it keeps evolving. Justice, for me, is about the freedom to be yourself, the right to self-determination and the ability to express yourself in the world. That should be everyone's lived experience.

Q. What brings you happiness?
Where I was born and raised, creativity was a privilege; we didn't have much money, so creative outlets weren't prioritized. Being able to express myself creatively makes me happy – I value the inner workings of my mind and what it can imagine.

Q. What do you regard as the lowest depth of misery?
Not having the ability to dream. It was being able to dream of a life that was better than the one I was born into that allowed me to be myself. But some people don't have the privilege of dreaming because their thoughts are consumed by survival – and that is the biggest misery. To be able to dream is to be able to envisage how you can change the course of your life.

Q. What would you change if you could?
Bruce Lee once said, 'Be water, my friend.' I want us to embrace this notion of the spiritual essence of fluidity, in order to truly understand that we're all in this together. I grew up in a place in the world where everything was very restrictive; I was surrounded by a rigid, traditional, Catholic environment – the Philippines is the only country in the world in which you can't get divorced. But, when I came to New York, I began to realize that life is made up of so many different components. So, I wish people could adopt as their resting stance a fluid mindset and a fluid attitude when engaging with issues of any kind. Because, how are people going to develop their universal understandings of culture, religion or class if they remain rigid in their beliefs?

Q. Which single word do you most identify with?
Gratitude.

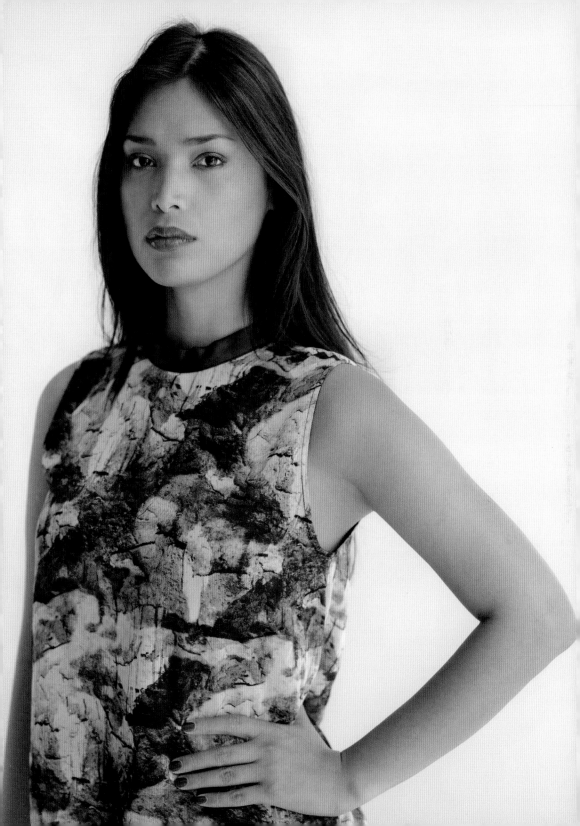

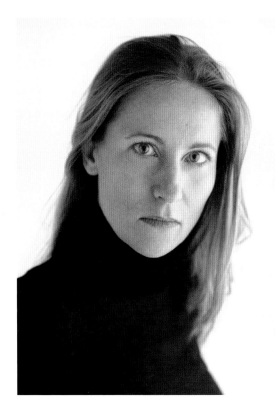

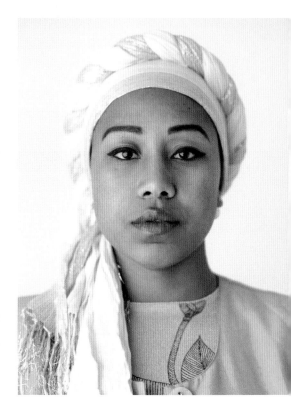

Véronique de Viguerie

Q. What would you change if you could?
The thing I would change would affect only half of humanity; it would be great if men could fall pregnant.

In some places, when a woman doesn't live up to expected perfection, she dies. But, if men could get pregnant, this would remove the burden so many women bear of having to be perfect. Here, I'm thinking specifically of honour killings, where it's considered that, because a woman is giving birth to the next generation of her family, she is carrying its honour. So, when she displays imperfection, this is considered dishonourable and she is killed. If men could fall pregnant, they would never subject one another to the same standard.

'Fighter'

Yassmin Abdel-Magied

Q. What would you change if you could?
I wish that I could get people to feel empathy at scale. Part of the reason so many injustices go on for so long is that people just don't care. There are so many stories about New York City that people can even name some of the city's streets, but we don't have that level of understanding of the stories of people living in Syria, Lebanon or Sudan. We don't know those worlds or the people in them. But, if we did know those stories – if they were familiar to us – we would be able to feel empathy. And, I think the way we get there is through storytelling. I've recently started to believe in the power of popular culture, because I see the potential storytelling has to change hearts and minds. As people develop non-threatening relationships with characters, something unfamiliar can become normal – that's a gateway.

'Unexpected'

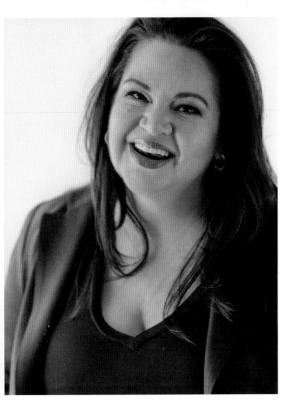

Christy Haubegger

Q. What do you regard as the lowest depth of misery?
Solvable problems: hunger, lack of water, inequities in the distribution of the basic things we need to live a life of dignity. Somehow, we have both an obesity and a hunger crisis in this country – but both issues are solvable. And not solving these issues is immoral.

Andrea Mason

Q. What do you regard as the lowest depth of misery?
I'm very much committed to making a difference in the area of intimate-partner domestic relationships. When these relationships are strong and healthy, they form the basis for strengthening other relationships within families. Aboriginal women are incredibly resilient and I see in them a willingness to take the necessary steps towards ensuring their safety. Where a woman is seeking help, it should always be given, and there is also a lot of early-prevention work that needs to be done. This involves talking to men and boys about the impact and trauma of violence, and about how they can lead lives that are free of abuse. I can't speak for them – that's their work to do – but I can encourage men to make the space their own and then use it to encourage other men to engage.

'Wonder'

'Courage'

Ruchira Gupta

———

Q. What really matters to you?

Dignity and justice. I firmly, firmly want fairness. I understand that inequality exists and that there will always be inequality in some form or another – someone will always be richer, someone will always be whiter – but I still believe we can make this world a fairer and more equitable place.

So, what matters, is my work to end inequality.

About twenty-one years ago, when I was working as a journalist, I was travelling through Nepal and came across numerous villages with very few women between the ages of fifteen and forty-five. I started asking the men I met why this was. Most were sheepish and some were very hostile, but a few told me they were all in Mumbai, which was fourteen hundred kilometres away; I couldn't understand how these women had gotten there from these remote Nepali villages, so I decided to find the answer. It changed my life – I discovered a supply chain stretching to Mumbai's brothels.

The supply chain involved local village procurers, transporters, corrupt border guards and lodge keepers across the border in India. The lodge keepers would lock these girls up for several days, and beat them, starve them and drug them, until their spirits were completely subjugated. The girls would then be sold to pimps in Mumbai, Kolkata, Bihar and Delhi. Prices were negotiated based on beauty; fair skin was premium, being voluptuous was premium, as was being docile and young – the youngest girl I met who had been trafficked was seven. These women were then locked up in

rooms with iron bars on the windows and brought out every night to see eight to ten customers. Girls and women were being chewed up and spit out by the system, and, although the prostitution was all in plain sight, the extent of the network was invisible. I had covered war and famine, but nothing like this kind of intimate and deliberate exploitation of one human by another, the violence of a fifty-year-old man on top of a ten-year-old girl. I decided to tell the world about it.

I made a documentary, *The Selling of Innocents*. I interviewed twenty-two women who found the courage to tell their stories. They spoke about how they were pulled out of school or sold by their fathers. They told me about how, when they escaped to a police station, the officers would return them to their pimps and tell them it was too late for them to be redeemed – that they were devalued and should accept their destiny. These women were beaten black and blue, their bodies were developing diseases and they were being forced to have abortions. I felt rage, anger and sadness – and I started to realize that reporting wasn't enough.

The women would later tell me that I saved their lives, but we saved each other's. I was shooting in the brothels without any protection for myself; one day, I was talking to these twenty-two women in a room when the brothel manager appeared at the door with a knife – these places are tiny wooden houses with narrow staircases and twenty rooms to a bathroom, and there's

'I still believe we can make this world a fairer and more equitable place.'

nowhere to run. The manager told me I couldn't be filming. The women surrounded me in a circle in that little space and said he would have to kill them all to get to me. That was the moment I was transformed, because I thought I was saving them, but they saved me.

I went back to the women I had interviewed, and they asked me to start a not-for-profit organization. I told them I wasn't a lawyer or a doctor or a social worker – I had no idea how to run a not-for-profit – but they told me I could help them because of my English and access to networks. We set up Apne Aap, which means 'self-action' – this is a reference to the individual needing to help themselves, but is also about women coming together to help womankind. Fifteen years in, we're now twenty thousand members strong. We have a voice, we influence policy and we march in a great battalion for women's rights. When the Delhi bus rape happened, we marched to parliament. The women of our organization have overcome their shame, guilt and fear, and we are now sharing their stories with politicians – we have convinced them to classify trafficking as a sexual offence.

When we started, those twenty-two women said they had four dreams: schooling for their children, so that they didn't end up in the trade; a room of their own with a door they could lock, so that they and their children would be safe; a job with a steady salary in a clean office; and justice. Today, children are working in jobs that they never would have had access to otherwise and are supporting their mothers. Sadly, the original twenty-two women are no longer with us. They have all died from various things – AIDS-related complications, suicide – but their dreams live on in their children.

Q. What brings you happiness?
Friendship: I love sitting with my friends and talking about 'the possible.' I love entering into people's stories and standing up for justice.

Q. What do you regard as the lowest depth of misery?
I've seen so much of it that it's hard to define what that would be. In my film, there was a nine-year-old boy who slept on the floor of his mother's room in the brothel; when she had customers, he would either look for another room to sleep in or would have to sleep on the street outside next to a heap of garbage. And, I've seen women who were raped with foreign objects. I thought violence was the lowest, but then I met a girl sold by her father – the man who should have protected her. So, I'm afraid I don't know what the lowest depth is; I don't know why people want to hate more than they want to love.

Q. What would you change if you could?
I would remove Donald Trump from office like a puff of smoke – poof!

Q. Which single word do you most identify with?
Freedom.

Ruchira Gupta

Alice
Waters

Q. What really matters to you?

My immediate answer to that is the obvious things: my family and friends, and cooking. And it's cooking *for* my family and friends, with all of us gathered around the table.

Beyond that, what matters is that we preserve and take care of the land that sustains us. Humanity needs to remember that we are a part of nature.

I grew up in a lower-middle-class family, so we never went out to dinner. My mother – who wasn't a particularly good cook! – used the produce from the 'victory garden' we had out back; it had been planted to provide fruit and vegetables during the war. My entire childhood was spent out in nature. My three sisters and I were always climbing trees, running around, sledding in the snow, walking in the rain – you name it! That made a very big impression on me, and I'm still passionate about being outside and in nature.

When I was nineteen, I went to France, then on to Turkey and Greece – my travels engaged me with food I had never seen or tasted. France had a very slow food culture at that time; you'd go to the market twice a day, and children would come home for lunch – I fell in love with that way of life. The first cookbook I owned was written by Elizabeth David, who had also been very changed by a trip to France many years before. She was probably the biggest cooking influence in my life.

I went to school at Berkeley, in California, then went on to study the Montessori method of teaching in London, yet teaching wasn't for me – I just didn't have the patience, but there was a lot about the Montessori method that made a lot of sense to me. It's very much about opening up your senses: tasting, smelling, seeing, listening, touching. In our world today, we're so closed off to these things because we're not asked to work with our hands – it's seen as too much of an effort! Even cooking has been closed down by the fast-food culture we live in, yet cooking is a key way of opening up your senses. So, in my opinion, Montessori fits in perfectly with edible education.

I started the Edible Schoolyard Project because I want to foster a new kind of relationship with food. I want children to be edibly educated, to know about nourishment and sustainability, and to be able to put these skills into practice in their own lives. I believe that is an incredibly empowering experience. And I believe we're winning them over! We're not telling them what to do, we're just creating something irresistible.

We have a demonstration site and learning lab at Martin Luther King Jr. Middle School in Berkeley – for twenty-one years we've been developing a model for edible education with the school administrators. We work with sixth, seventh and eighth graders – about a thousand students a

'I want children to be edibly educated, to know about nourishment and sustainability, and to be able to put these skills into practice in their own lives.'

year – and it's been amazing watching them learn, and watching their brothers and sisters coming through after them. I believe I can say that we have made a big impression. For the past five years, we've been reaching out internationally to find similar projects that have a garden or a kitchen or a school-lunch programme that supports organic farming. We have five thousand five hundred partners on our website right now, and those are only the organizations who have added their names to our community – so I know this is happening everywhere. And connecting with community is fundamental to a holistic approach to existing on this planet. All this matters, and is incredibly fulfilling.

Q. What brings you happiness?
Cooking for people and creating spaces for connection – food is such a great context for meeting new people, so connecting people over a meal makes me happy.

Connecting people committed to slow food makes me happy, too. I am the vice president of Carlo Petrini's slow food movement, an alternative to fast food that promotes regional, sustainable, seasonable cuisine. I have the opportunity to meet people from the 156 countries that are members of Slow Food International – it's like being in the underground and passing on secret messages: 'Do you know this person in Vermont?' 'Have you

heard what they're doing in South Africa?' 'Have you met so-and-so from Iceland?' Being a part of that 'counterculture' makes me so very happy.

Q. What do you regard as the lowest depth of misery?
It's being really disconnected from nature and from real food. Both of those are a hunger as real as the hunger for food. It's shocking that we don't know how to – indeed, can't – feed ourselves; it makes me want to cry.

Q. What would you change if you could?
First and foremost, I would change public education, because with young children I think you have a great opportunity and a real possibility of fostering a healthy approach to food. We want children to begin life with a set of values that are essentially human values: taking care of the land, taking care of each other and nourishing themselves – this influences the way they will be for the rest of their lives.

For me, education needs to be hands-on, where you're learning by doing. Whether it's a math class or it's an art class, every class should give children the possibility of using their hands, of being out in nature and developing models in the real world, rather than being a sterilized, isolated place like in a university.

Q. Which single word do you most identify with?
Determined: I am driven!

Emma Davies

Q. What really matters to you?
It matters that I remind myself to be present and
not to miss anything, that I accept everything as it
comes – whether for good or ill – and that I am ready
to act. When I was thirty-five, I had breast cancer,
which was quite a gear-shift in my life. I'm one of
the very lucky ones; I came out of it with more than
I went in with. There is something very powerful
about all the minutiae of life falling away.

Jessica Grace Smith

Q. What would you change if you could?
I would give everyone a sense of individual
accountability, which would then lead to a
communal accountability for our actions.
People need to take responsibility for what they
are consuming and for the ethics of it. Because
everything we do is a vote for the world we want
to live in.

'Joy'

'Restless'

Pia Sundhage

———

Q. Which single word do you most identify with?

Teamwork. In football, individuals come together to become a great team and to bring out the best performance in one another. I would like to see the same in Sweden. A lot of people come to this country, but I don't think we embrace difference; we want everybody to be Swedish, and that's foolish.

Sharon Brous

———

Q. Which single word do you most identify with?

Hope. So often, the reality of the world pulls our gaze down to the lowest common denominator – to the worst of human behaviour and instincts. This dulls our imagination, makes us forget what could be and live instead paralysed by what is. One of the great spiritual challenges today is reclaiming an ethos of aspiration, a sense of hope and possibility.

'Teamwork'

'Hope'

Ruth
Reichl

―――――――

Q. What really matters to you?

Kindness is probably the most important thing in the world; it's something that can inform your life, or not. I've never felt the importance of kindness more than when I became the editor of *Gourmet* magazine; I realized that I could either be one of those hard-driving, difficult, hard-to-please bosses, or I could try to make the lives of the sixty people who were working for me better. Kindness is the thing you want to keep front and centre in your life all the time – there must be a hundred times a day that you have a choice of being a bitch or being kind. For me, it's about making those choices all the time and always erring on the side of being kind. The older I get, the more important I think that is.

Q. What brings you happiness?

The act of making a beautiful meal makes me happy. For me, there is nothing quite as wonderful as thinking, 'Who's going to come to dinner tonight? What can I cook that will give them enormous pleasure?' In today's world, where we're so busy, so rushed, and always feeling pressured and fraught, the one place where we take time to slow down is at the table. I love watching everyone relax and start really paying attention to each other. That's one of the joys of being a cook.

One of the things that shaped my world as a child was my mother's bipolar disorder. There were a lot of ramifications attached to this, but one was that she was taste blind; she couldn't taste when food was bad, so she fed people poison. As a child, I learned very quickly to taste very carefully, and I cooked a lot. But the thing that was so important about my mother being bipolar is that she woke up every morning not knowing who she was, how she was going to feel and what she was going

to do. I woke up every morning – and still wake up every morning – grateful that I'm not her and grateful that I'm sane. I learned early on that it is a blessing just to be a sane, ordinary person who can count on herself. That shaped everything else in my life.

The author Ann Patchett was interviewing me about my books and said that in every author's work, no matter what they're writing about, there is a buried message that gets repeated over and over again. That's true. The secret to life runs through all of my books – it's learning to find joy in ordinary things. You can spend your entire life in despair, because there is a lot to be despairing about and there are terrible things happening to people everywhere. But at the same time, it behoves us to learn to take joy in the smell of coffee in the morning and the feel of rain on our faces. There are as many reasons to be happy as there are to be unhappy – you can choose to be either one. So I literally find joy in the sound of water boiling in the kitchen or the colour that emerges when you peel a peach – there's a sunset hiding under there. One of the reasons I love food is that it is such a ready source of joy, if you pay attention. Working for the likes of Condé Nast, you live this very big life; you meet famous people, and have clothes, cars, jewels and money. But none of it matters. You can find as much joy in a piece of bread and butter. To me, that really is the secret to life.

Q. What do you regard as the lowest depth of misery?

Because I'm a food person, it's hunger. Here in America, one in eight children goes to bed hungry every night. It's horrifying, given that we are in the richest country in the world. It really hurts me.

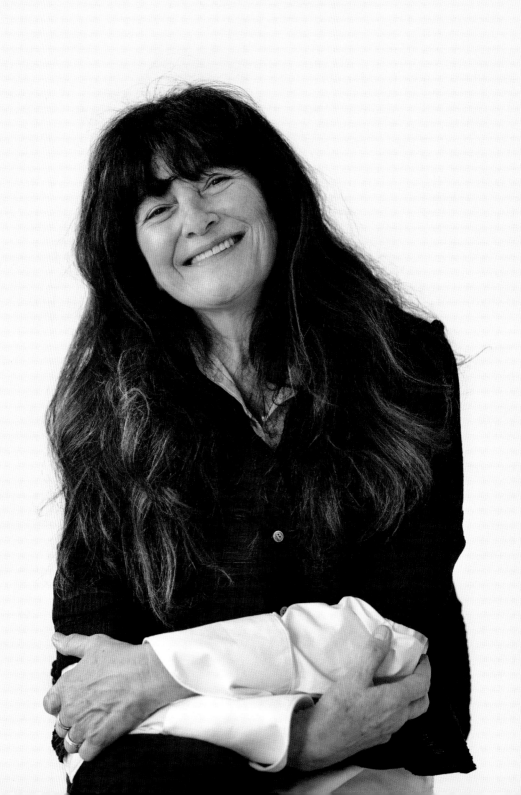

Ruth Reichl

'There must be a hundred times a day that you have a choice of being a bitch or being kind.'

There's plenty of food in the world for everyone, and it's all a problem with distribution. I really believe that one of the reasons government exists is to give people the basic necessities in life, and food is certainly the most basic of basic necessities. It really horrifies me that, as we become more scientifically adept, we still can't manage to feed the world – looking at people who go hungry makes me crazy.

Q. What would you change if you could?
Gender inequality is probably the most egregious inequality there is. Who would believe that today we still see women who have no rights at all; who want to learn to drive but are completely subservient to their husbands. Half the world is being robbed of all their potential, and we need to stop that.

I would also stop climate change; the devastation that we've created today was unimaginable thirty years ago. We know climate change is going to make people hungry and it is completely man made. We're probably too late to stop it completely, but if I could, I'd get us, as a world, to all pull together and say, 'We will not put up with this anymore; we really need to make a change here.'

Q. Which single word do you most identify with?
Generosity. It's a really important quality; every time someone tells me I'm generous, I just find myself beaming.

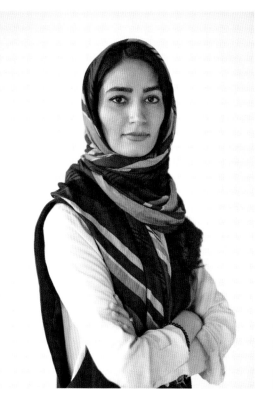

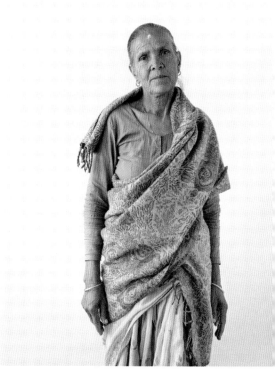

Fereshteh Forough

Q. What brings you happiness?

I wake up every morning and am very conscious that I have a mission: to help people by empowering them. Every single step I take towards that goal makes me happy. It feels amazing when I see our students' tweets, their pictures, and the codes that they are writing – they are embracing the opportunity to empower and develop themselves, and that makes me joyful. Knowing that I'm contributing to empowering women in Afghanistan by educating them in the field of technology makes me happy, because they are being enabled to learn something. And not only that, it also shows people around the world a positive story about Afghanistan.

Januka Nepal

Q. What brings you happiness?

I'm glad for the opportunities the children in my family have, because, when I was a child, there were no schools – I have never studied, and I don't know how to write; if I have to sign something, I do it with my thumb. But my 'grandson' and 'granddaughter' are going to school, so when they study hard and perform well, that makes me very happy.

'Visionary'

'*Sukha*' – happiness

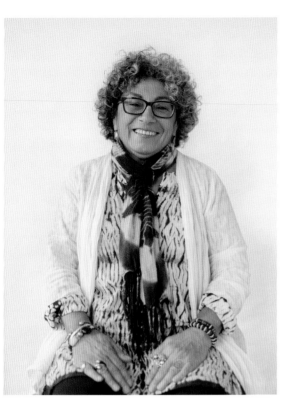

Katherine Acey

———

Q. What do you regard as the lowest depth of misery?

Being ignored. The Truth and Reconciliation Commission process in South Africa might not be considered very effective, but the process of healing – the process of justice – is about being heard. And that is immeasurable.

Sarah Outen

———

Q. What really matters to you?

It was my father's death that prompted my decision to row solo across the Indian ocean in 2009. I had been thinking about rowing an ocean, but had wanted to do it with other people, because I had no concept of going solo. But dad died quite early on in the planning phases, so, at his funeral, I told everybody I wanted to make the journey solo in his memory, to use it as a way to get through the grief and do something positive for others by raising money for charity.

'Compassion'

'Energy'

Suha Issa

Q. What really matters to you?

The sense of satisfaction I get from seeing young people achieve their goals. I work as an English teacher in Beirut; in the mornings, I teach secondary-school Palestinian students at a United Nations agency, and lately I started working with primary-school Syrian refugees in the afternoons. Having my children look up to me and seek my advice – particularly now they've started their careers – matters to me as a mother.

My Palestinian teenage students are despairing because of the constraints placed on them by the Lebanese government; my role is to support them in their aspirations. This is their only chance to get out of this misery and suffering – out of *everything*.

CCH Pounder-Koné

Q. What do you regard as the lowest depth of misery?

The lowest depth of misery is when you cannot see the possibility of hope, when you don't believe in any part of yourself. It's that place where there's no one in your life to tell you that they see you, that they love you or that they appreciate you and would miss you if you were gone. I have never been to that precipice, and I find it difficult to understand, but I do believe it is misery.

'Individuality'

'Moon'

Mariam Shaar
———

Q. What do you regard as the lowest depth of misery?

Being outside your country of origin and being unable to return – that makes me sad, and I believe all Palestinians feel this way. To be classified as a 'refugee' is not something that I am comfortable with – I don't like that word or what it means in practice. But what makes me sadder still is the life that each of us lives in the camps – this is not a humane existence. We live in very bad conditions.

'Persistence'

Patricia Grace King
———

Q. What really matters to you?

Being present – this is tied to having had, and recovered from, cancer; I had five months of chemotherapy, then a double mastectomy. There were elements that just sucked, but, in some ways, it was a blessed time. When we were in the middle of it, my husband said, 'Well, this is just what we're doing right now; later on we'll do something else.' This was a great way to think about it, because it helped me assess what I could take away from the experience; everything can change wildly and no moment is permanent.

'Gratitude'

Nomvula Sikhakhane

———

Q. What really matters to you?

I believe people deserve to be loved.

And I feel that mothers should always put their daughters first – they are the most precious things in life. Mothers should take care of their daughters and look after them. If a daughter says something is wrong, then something is wrong – a mother should believe her.

After my mother found out about all the horrible things that my stepdad was doing – and she had the proof – she still decided to go with the guy. It broke me for a long time. I used to be very bitter, angry and grumpy. I was angry at the world and always used to question, 'Why does life have to be this way?'

But as I grew older and went on to high school I told myself: 'I'm not going to let what happened to me make me a victim. I'm going to be strong and overcome it.' But it wasn't easy. I was angry and when people spoke about my stepdad's abuse I'd break down and cry. Eventually I said, 'I have to be strong and I have to keep going – I'm not going to be a victim of what happened to me. I'd rather have a bright future and be something big.' Even though what happened is not something that I can erase, I can change the way it makes me feel and be a happy person. Because there's nothing that beats happiness. There's no point in staying mad and questioning something you cannot change. But you can turn the negative into a positive. And,

so far, I think I've done that; I've accepted what I can't change and made something positive out of it. I've learned to be a happy person and to let go.

Even though I was still a bit angry when I went to live with my grandmother, as life went on I realized that there was a lot that I should be grateful for. I realized that what was happening was probably a blessing, that I should accept that blessing and embrace it. There are great things in my life: not everyone gets a chance like I did. Not everyone has people like Sahm and Claude who are willing to take them on, do things for them and put them through school. Most of the time, if someone does something like that, they want something in return. But Sahm and Claude don't.

Q. What brings you happiness?

The happiest time of my life was when my granny told Sahm what was going on – she worked with my grandmother. Sahm started buying me things, which is how she came into my life. I'd never actually received so many nice things or had someone doing nice things for me. Sahm taught me how to read and so much else. It was just so overwhelming, but in a nice way. To me, Sahm and Claude are a mother and a father.

Today, my happiest moments are when I walk into a kitchen and start work. My granny used to cook where she worked and, when I didn't go to school because of my stepfather's trial, I'd go

'After my mother found out about all the horrible things that my stepdad was doing – and she had the proof – she still decided to go with the guy. It broke me for a long time.'

to work with her and watch her cook; her being busy – moving around the kitchen – touched me, and I told myself, 'This is what I want to do when I'm done with school.'

Then, when I was in Grade 7, my aunt and I were walking around Randburg – we were on the way to apply for college for my cousin – and saw HTA, the school where I later studied culinary arts. I told my aunt, 'This is the school I want to go to. When I'm done with everything, this is where I want to be.'

At first, when people asked me what I wanted to do, I had doubts. But, eventually, I realized that if you're going to do something that doesn't make you happy, then there's no point in doing it. I felt that being a chef would make me happy, so, when people asked me what I was going to do, I started answering, 'I want to be a chef. Because cooking makes me happy.'

When I'm in the kitchen I feel happy. And when you serve someone food and you see them smiling, it says something to your heart. You see that you're bringing change to someone's life because they're smiling and they're happy about a meal.

Q. What do you regard as the lowest depth of misery?
It makes me sad that, after everything that happened to me, my mother still got the man that hurt me out of jail. That still breaks my heart, to the point that I feel I should never forgive her for it. I'm her daughter, at the end of the day, and most mothers would do anything in order for their daughters to not have to go through something like that. But it's like my mother didn't care. Besides that, however, there's nothing I feel that I should complain about; I have a complete life and I have everything I need – life is beautiful.

Q. What would you change if you could?
I would change situations in which children go to bed hungry. I believe that no child should go to bed with a hungry stomach.

Q. Which single word do you most identify with?
Love. I picked love because of Sahm. She has given me so much love – something that my mother failed to do. Sahm showed me that you don't have to be a mother to someone to give them love. Skin doesn't mean anything – it's what's in the heart that really matters. At one point I was angry that I didn't get love from my mother, but when Sahm came into my life she filled that void. I decided that my mother could go on with her life and I would go on with mine: because I have someone who's playing that role. And I have Claude playing the role of a father, and the love of my grandmother as well – I think love goes a long way.

Sahm
Venter

Q. What really matters to you?

What matters to me is integrity and sincerity.

And I love communication and telling stories; I became a journalist because I wanted to communicate what was happening under apartheid. The highlight of my entire career – the pinnacle – was Nelson Mandela's release. I was lucky enough to be outside the prison on that day. We waited and waited – it was a very, very hot day – then all of a sudden we saw this grey hair, with a halo behind it, and this fist in the air. It was him! I just stood there. I couldn't believe that he was finally out. Everything I had witnessed – about people being killed and the horrible violence – all seemed far away.

All these years later, it's really important that we stay true, as a country and as a world, to the values that we held high at our best moments: democracy, freedom, integrity, humanity, sincerity. These values are all underpinned by humanity. You cannot have a system like apartheid if you have humanity, because apartheid was the absence of humanity, in its crudest form. And human beings kept that system alive – it wasn't a machine, it was people. We have to always be very true to our values and hold on to the good people in the world. We have to nurture them. And we must make sure that we don't ever let that spirit die. Too many people forget about those things and get too caught up in materialism in their own lives.

They forget too quickly. We have to remember where we come from, and we have to judge where we are now in that context – because we can so easily slip back into the worst moments of our lives if we're not vigilant.

This needs to happen throughout the world – South Africa's not the only country in the world that's ever had bad things happen. Most countries have something terrible in their past or are still experiencing something terrible. We're all in it together as a human species. We don't live in isolation, especially not today with all the globalization; if we had had social media in the past, I don't know that apartheid would have lasted as long as it did.

Q. What brings you happiness?

I love hearing good news, whether it be about someone I know or someone I don't know. I like to hear about people's good news – that things have come together in their lives or in their careers. It can be little or it can be big, but I am so happy when I hear that people are succeeding in what they are trying to do.

For example, I know a family whose mother died. The small children were left behind and their aunt took them in. But she could not get them registered because the mother hadn't registered their births – and if you aren't registered, you can't

'It's really important that we stay true, as a country and as a world, to the values that we held high at our best moments: democracy, freedom, integrity, humanity, sincerity. These values are all underpinned by humanity.'

get access to anything. Quite a lot of effort was put in and – after they had been pushed from pillar to post – all of a sudden they met the right person who sat down with the aunty and said, 'What surname would you like them to have?' It all came together and now they exist – they can function in the world. That's pure happiness.

And I was very happy when Nomvula got accepted into chef's school; I think we both cried.

Q. What do you regard as the lowest depth of misery?
Cruelty. It's extremely difficult to be aware of any type of cruelty, whether it be against women, children, men, animals – any type of life. Cruelty is unspeakable; it should not be tolerated. I can't even hear about it. In fact, I cannot even listen to news programmes on radio and television about some cruelty that's happened. I cannot hear it; I have to turn it off or turn it down. When we're talking about cruelty, we can talk about abuse – physical abuse, emotional abuse – which happens all the time in the world and in this country particularly. It drives me crazy.

Q. What would you change if you could?
I would let everybody have equal quality education. Everybody. As a right. Everybody needs to be paid properly for their work; nothing should say that if you're pulling a big pile of recycling around you shouldn't get enough money to live in a house with electricity, water and food. Everybody should have free and easy access to good-quality social services. And there should be no national borders, so people could move around the world wherever they want and just settle down, raise their families and be happy.

We're not there yet with gender equality, either: not just in South Africa, but in the world. Women are still second-class citizens, and I don't really see all that much change, here or anywhere else. Some countries can be held up as beacons because they've got really special laws and have been at it longer than we have, but South Africa is a deeply sexist society. The slogan always used to be 'Fighting for a non-racial democratic South Africa,' then some people added 'a non-sexist South Africa.' Ours is a very patriarchal society. I'm talking about in every sphere of life, including corporates. I recently had conversations with women who believed that it was okay for some big corporates in this country to tell women how to dress. I was completely shocked. I thought, 'Try and make me wear heels, and I *will* go to the Constitutional Court.' Because it's insane.

Q. Which single word do you most identify with?
Gratitude. I am very grateful for my life: my family, my friends, my car, my job, my house, my roof, my hot water, my electricity. And for the fact that I am able to help people from time to time.

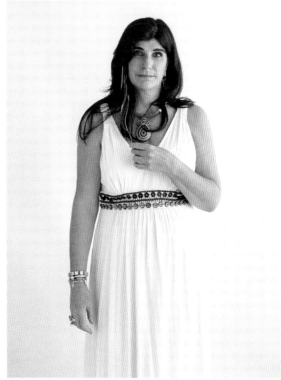

Zamaswazi Dlamini-Mandela

Q. What really matters to you?

We need to look after each other as human beings and take it upon ourselves to make the world a better place. My grandfather's call to action when he retired many years ago was that he'd done his bit – both my grandparents have done their bit – and that it really is up to us, as a world, to make the world a better place. My grandparents have got us somewhere that is just remarkable, but, if we do not continue their work, it would be very easy for us to go back.

Joanne Fedler

Q. What would you change if you could?

I'd start everything from the beginning again. Our difficulty is that the table has already been set. We're limited by what exists. Given that, I'd revolutionize the way we value things in our world. I'd switch everything we currently chase with kindness, service, generosity and humility. I'd swap consumerism with the stories of the meek, soft-spoken, humble warriors of this world. Less noise, more listening to each other.

'Love'

'Service'

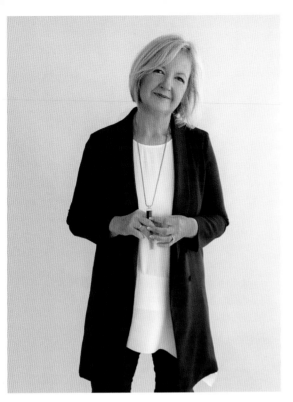

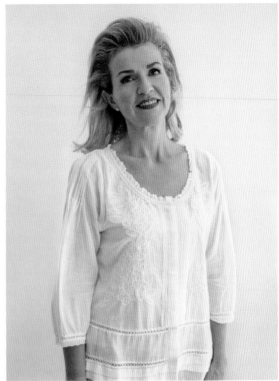

Jan Owen

Q. What brings you happiness?

My happiness is tied up with my purpose of
unleashing the next generation – I can't imagine
doing anything else. Beyond this, I believe there
are three currencies operating in life: power, which
is represented in government; money, which is
represented in business; then there's love, which is
represented in community. I've utilized all of those,
but the currency of love is my happiness.

Anne-Sophie Mutter

Q. What really matters to you?

When it comes to music's potential, Europe is
the perfect example of its application. There are
so many different concepts and perspectives on
life, religion and culture in Europe today, and, with
everyone living in such close proximity to one
another, these different perspectives are mingled.
In this context, music is the only language we can all
really share, the only language that, when 'spoken,'
can be understood by us all on an emotional level.
When we sing songs and play music, we are able
to interact on a level that is totally natural; whether
there is a celebration or we are mourning, the one
thing we have in common is that our rituals are
all imbued with music. And for children, music
is a school of life: it teaches discipline, listening,
teamwork and leadership.

'Generosity'

'Passion'

Miranda
Tapsell

———

What matters to me is that art teaches empathy. When people see the way others live their lives, their perceptions change. I love being an artist because I saw what *The Sapphires* did to a non-Indigenous audience: it appealed to people across the board – grandmothers, mothers, daughters – who were able to relate, not just to the era, but also to the timelessness of the story. Young girls loved the film because, like them, the characters were young women trying to achieve their dreams and find their way in a very uncertain world.

Art might not save lives – it might not cure cancer – but it is powerful. It allows people to walk in the shoes of those who are marginalized and disenfranchised. Non-Indigenous people have come up to me and taken my hand, saying, 'Thank you so much for *The Sapphires* – you have no idea what that story meant to me.' This helped me really understand the power stories have to put people into someone else's shoes and allow them to understand what it means to live that person's life. This made a big impact on me, because I have to talk about race a lot.

My mum raised me to be very, very proud of my heritage. I choose to identify as being Aboriginal and am asked about this quite a lot. I'll gladly tell people that I'm Aboriginal, but this seems to be quite divisive. I'm not sure what makes some people think that my pride in my heritage equals a hatred for non-Indigenous people. I don't hate non-Indigenous people, I'm just aware of a system that supports non-Indigenous people and that fails to support the more vulnerable, which includes Indigenous People.

I love storytelling because it gives the most vulnerable a voice. The media doesn't tend to shine much light on Indigenous issues from an Indigenous perspective: if it does, this is very rare. While there's been a lot of conversation in Australia on the topic of Indigenous Peoples, I still feel as though I'm expected to choose a side. Yes, there has been a lot of progress – I didn't grow up having to fight the battles my nan and my mum did, in terms of getting the vote and becoming citizens – but I don't feel as though I should have to choose.

I was a child when John Howard was prime minister of Australia; he was in power from 1996 to 2007, and was quite conservative. The implication I got from his politics was that he didn't believe that the Australian government owed an official apology to the Stolen Generation. From 1869 to 1980, Aboriginal children were forcibly removed from their mothers. He questioned the legitimacy of these claims and refused to acknowledge the damage that had been done to Aboriginal families over decades. While I'd never been taken from my mum, if I had lived in the sixties – born to my Larrakian mother and my non-Indigenous father – that would have been my fate. So, to me, hearing our own prime minister ask why an apology was important was like hearing him ask, 'Why do you

> 'Art might not save lives – it might not cure cancer – but it is powerful. It allows people to walk in the shoes of those who are marginalized and disenfranchised.'

even need to exist? Why are you here? Why are you making us feel uncomfortable?'

For most of my life, I have had to justify why I choose to call myself Aboriginal. The title, and all the issues surrounding Aboriginal people, seems to make people uncomfortable. Becoming an artist made me realize that, when people see me in a different light, they can actually like me! People who aren't Caucasian have had to survive by fitting into an existing structure – they're only given the chance to assimilate. No one should have to live that way. Australia needs to encourage integration, because everyone should be able to define themselves the way they choose, without judgement. To be shamed for not blending in is something I just can't agree with.

Q. What brings you happiness?
Being around my friends and family brings me happiness, because I'm one of those people who can't hold things in and they help me overcome hardship.

Being able to use the platform I have makes me happy. I am a very privileged woman, and I've been given an opportunity to use the media in whichever way I can to shed light on the issues that Indigenous People, and other marginalized groups, face.

Q. What do you regard as the lowest depth of misery?
I have to admit that I found 2016 really hard and I think a lot of people found it hard as well;

a tribalism was starting to form among many people who identify themselves as white, and I was starting to see more and more people who look like me being shut out. It frustrates me that we now live in a time in which people are more concerned with words than with their effect. When someone like me points out racism - that someone has felt hurt, degraded - people would rather analyse language and sentence structure to determine whether there has in fact been an incidence of racism. I'm sorry, but that's a waste of my time and it's what brings me misery.

Q. What would you change if you could?
I wish I could change the way people thought, the way they see the environment and the way they treat it, and I wish I could change the way people choose to continue to disenfranchise Aboriginal people. But the thing that gets me up out of bed every day is thinking, 'No, I will continue to be strong and continue to say the things I believe in the media.' That's what gives me hope.

Q. Which single word do you most identify with?
My word is 'brave.' Bob Marley said, 'You never know how strong you are until being strong is the only choice you have.' That resonates with me, because sometimes when I know that something needs to be done I just take action, then look back and go, 'Oh, I didn't realize how brave I was.' To me, those actions are what bravery is.

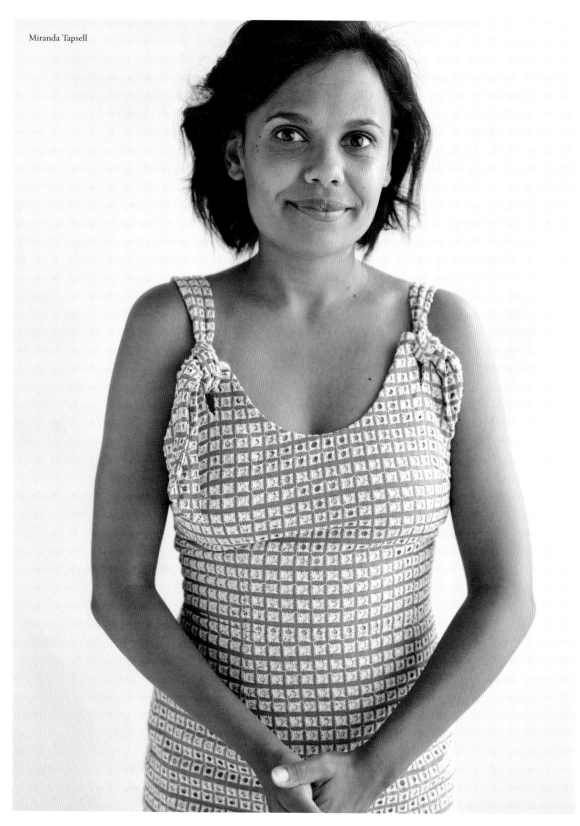
Miranda Tapsell

Louise Nicholas

Q. What really matters to you?

I advocate on behalf of survivors of sexual violence and their families, because what happened to me cannot be allowed to happen to anybody else.

I am a survivor of child and adult rape, perpetrated against me by members of the New Zealand police force from the age of thirteen through to nineteen. For many years, I stayed silent; I covered up what had happened because I blamed myself and carried a lot of shame.

The policeman who hurt me from the age of thirteen was a family friend and had a high standing in our community. I was absolutely petrified that people would find out, because I thought my family would hate me for it. I tried to take my own life – this wasn't about finding an easy way out, it was about protecting my family from the shame of what was happening to me. But I did find the strength to lay a complaint. My family and I never had the criminal-justice system explained to us, though, and not understanding what's happening with those processes can really tip a child survivor over the edge.

I've been through the process of the criminal-justice system seven times in my life; each outcome, bar one, was that the men who hurt me – and so many other victims as well – were acquitted. That experience defined me. My anger grew in the face of this level of abuse; my

contribution towards ending this kind of violence is to get out there and be the voice for those who stay silent.

Now I work alongside the New Zealand police. I help train them, and I support them in their work with survivors, particularly through the criminal-justice system. That process is brutal, so I support survivors through the process. I try to empower them to find courage and strength – these qualities are in all of us, and we can find them if we're given an opportunity to do so. Sitting in the witness box is not like retelling a story – rather, you actually relive what happened; a lot of survivors describe this as an out-of-body experience, because, in order to not be hurt again, you need to be outside of yourself.

In New Zealand, one in three women will be sexually abused before the age of sixteen; many of these women will never disclose their experiences. And, for those who do, it may be decades before they disclose what has happened to them. I try so hard to encourage and empower them. It's not about having to go through a process – it's not about having to go to the police or court – it's about empowering these women to be who they want to be. And it's about the fact that their voices are important – no more silent survivors. Silence is a killer, on so many levels: the suicide rate of survivors is too high, and, when you sit with prisoners – peel back their levels of anger – often

'It's like going from the dark into the light, knowing that you have done all you can do for yourself. Once you walk into that light, all the evil, putrid, horrible stuff sitting in your soul is gone . . . That light is the beginning of a new life.'

the root cause is that they, too, were subjected to sexual violence.

The most important thing is that children need to be encouraged to speak, especially within families; we need to ensure that they have a safe person to go to if anything bad happens. A lot of my survivors – especially the young girls – quite often say, 'I don't want him to go to jail; I just want him to stop hurting me.' That's all they want. So, it's about helping them navigate their pathway to healing and showing society that victim blaming is unacceptable. People don't necessarily speak out straight away and society needs to not judge them for that; society just needs to be willing to listen.

Q. What brings you happiness?
My family; my children and my two little granddaughters.

The biggest joy I get is seeing a survivor come to the end of her journey. Having seen her at her darkest, having walked alongside her through whatever she's going through, it really is like how human beings slowly stood up to walk in the evolution of man! That's what I see in the survivors I work with – that moment when they hold their heads up high and are so darn proud of achieving something they never thought possible. And that thing is: 'I talked.' It's like going from the dark into the light, knowing that you have done all you can do for yourself. Once you walk into

that light, all the evil, putrid, horrible stuff sitting in your soul is gone. That's something a person can only do for themselves; and that light is the beginning of a new life.

Q. What do you regard as the lowest depth of misery?
It's when you are continuously banging your head against brick walls: the government's brick wall, and society's brick wall in the form of all this victim blaming, in the form of this rape culture we've got and the attitudes that come with it. Every day you're fighting to change attitudes, those rape myths like 'She shouldn't have been drunk' or 'She shouldn't have been wearing that.' In actual fact, it's as simple as understanding that men just shouldn't rape. It's that simple. Just don't rape. Don't hurt our girls.

Q. What would you change if you could?
I would have everybody personalize the experience of sexual abuse, because, when people understand the effect it has on a family and the potential effect it could have on them, that's when you start seeing change. We just need our men to understand that all you have to do is ask and listen – all you have to do is be respectful of us as women. We need to teach our young men that they don't need to hurt people.

Q. Which single word do you most identify with?
Attitude. If you change attitudes, you've got a pretty cool world to live in.

Lisa Congdon
———

Q. What would you change if you could?

So much pain in the world comes from fear of difference. So, if I could change one thing, it would be to make people recognize that our differences – skin colour, sexual orientation, gender identity, religion – are actually our strengths.

'Resilience'

Lavinia Fournier
———

Q. What brings you happiness?

The families I work with have brought me joy. These are unfortunate families who have very little to live on; they spend their days in the street scavenging materials to recycle, but they are incredibly joyful. They laugh about their problems and are full of joy. Their victories are what make me happy: when a father is overjoyed to find work, when they receive government assistance or when they find housing after months of struggle.

'Humanity'

Shami Chakrabarti
———

Q. Which single word do you most identify with?
Empathy. It informs my thinking and my work.
We lawyers call it non-discrimination and equal
treatment, but, as people, we call it empathy.
It applies in many intimate spheres of love and
friendship, and it applies in the greater social
context as solidarity.

Florence Aubenas
———

Q. What do you regard as the lowest depth of misery?
I find it most difficult when I feel like a voice
crying in the wilderness. For instance, we see
headlines with dire warnings about all of today's
environmental issues all the time. However, we
can write all the articles we want, shout ourselves
hoarse asking what kind of world we are going to
leave for future generations, receive all the front-
page coverage we want, but the articles won't be
read and the message won't be heard. Yes, we
know that sooner or later people will realize what's
going on and be forced to take action. But, until this
happens, there is almost no point and this makes
me despair. Why are we unable to see the truth and
know what should be done about it? It makes me
terribly sad that I still haven't found the answer to
these questions.

'Empathy'

'Vivant'

Margaret Atwood

Q. What really matters to you?

An impossible question! It's too hard to definitively decide what matters to me – because so much does.

I think that *when* you were born is very important, because it determines what was going on when you were ten, when you were twenty and so on. It defines what is within your living memory and what is – on the other hand – in the land of legend. I believe there is a huge gap between the lived memories of the depression kids, the war kids and then the baby boomers – those are *very* distinct generations. Equally, anybody born in the year 2000 doesn't even remember the Vietnam War – it is a mythical thing to them that was long, long ago and far away – and they can't envisage a world without cellphones. For them, World War II is way back there – it is like people in 1880 thinking back to the Battle of Waterloo.

I'm a war kid. In the fifties, when I was an early teenager – it was an impressionable age – *1984* had just come out. The Cold War, Stalin and Russia were very much on people's minds. If you had a fear in that period, it would have been of being blown up by an atomic bomb, followed closely – in the case of women – by a fear of getting pregnant. Because there was no pill in that age, sexual politics were really quite different then. The fifties was a decade in which the prevailing ideology was to get women back into their homes and tell them that they wouldn't be fulfilled unless they had four kids, an open-plan house and a washer-dryer. Women's jobs were to make life happy for others and get rid of their selves. Luckily – because Canada was a cultural backwater – that message wasn't being pushed in our magazines. My parents were very egalitarian and keen on the outdoor life.

I grew up without electricity or running water, which gives you a whole different mindset. I had few material possessions; at first, this was because of the war, and after that, my parents simply weren't interested in such things. Other girls complain about having been put into a frilly dress; I complain about missing out on that. So, I drew dresses! I spent my time drawing, then reading and finally writing.

My writing is important to me. I tried my hand at writing romance stories when I was sixteen, because they paid the most. No-go – that was not going to happen. Then, I thought I'd be a journalist – until my parents invited one to dinner. He said I'd just end up writing the ladies pages and obituaries, which some people say I've done anyway.

I'm very proud of my work. It's unique to see something like *The Handmaid's Tale* take on a new aura of urgency in a time when various state legislatures move towards phasing out not only women's reproductive rights, but their health rights. What is the plan here? All of it is pretty frightening and it doesn't only affect our women – because you can never change the condition of women without offering things for men.

Apart from my writing, I invest myself in conservation issues, freedom of expression and women's rights; since I take the radical view that women are human beings, I consider women's rights to be a subset of human-rights issues.

Q. What brings you happiness?

The pursuit of happiness was always a bit of a red herring, because happiness in itself is not a

'I grew up without electricity or running water, which gives you a whole different mindset.'

goal – rather, it is a by-product. So, doing things that you really want to do, being with people who you really want to be with and pursuing goals you find worthwhile will probably bring you happiness along the way.

But, happiness is quite often a matter of inheritance, I'm sorry to say. Some people are more cheerful than others, and some people battle depression all their lives – it's a chemical thing. I'm congenitally rather cheerful, and with all the dire things I write about, you would think I would be very depressed all the time. But that's not the case; dark things don't consume me, and I am generally an annoyingly chirpy person – which can be very irritating to other people when the news is quite gloomy.

Q. What do you regard as the lowest depth of misery?
The lowest depths of misery and suffering are certainly being experienced by people right here and now on this planet. Human beings have been imagining hell for a great many centuries, and they have done a pretty good job of creating it. What we have difficulty with is creating heaven.

Q. What would you change if you could?
The most important thing right now for us as a species is that we must avoid killing the oceans. If we kill the oceans, our oxygen supply will plummet. The blue-green algae and marine algae make approximately 60 per cent of the oxygen that we breathe; were the oceans to die, the oxygen supply would become a lot more skimpy. A great number of people would die, and the rest would become very stupid. Our brains would be functioning at about the level of somebody on the top of Mount Everest. How well are people unable to breathe enough oxygen to function going to get on at that point? Yet, we have advanced technology, so the thought of allowing the oceans to die is terrible.

If I could wave a magic wand, I would let the oceans be de-acidified. And I would let all the plastic be taken out of them. Plastic is a hard issue to get around, especially when you think of how many things in our lives are now dependent on plastic parts, including our phones, our computers, a lot of the parts of our cars and the things in our homes. We really need to find a solution to what happens to those plastics long term.

I am annoyingly chipper, but that doesn't mean there is ground for hope. I think that most people have hope built into them, because a species without hope built into it wouldn't last very long. So, we keep hoping for the next breakthrough, which keeps people working at the next breakthrough – if we didn't hope, we wouldn't do it.

Q. Which single word do you most identify with?
And. It means there is always something more.

Märta, Karin, and Linnéa Nylund

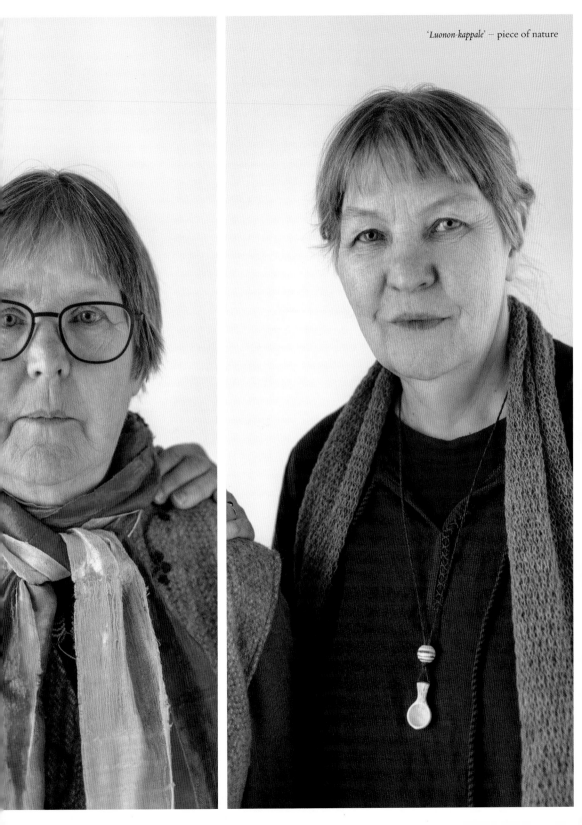

Biographies

Inna Modja

Inna Modja was born in Bamako, Mali. A musician, singer, songwriter and visual artist, Modja has released three albums: *Everyday Is a New World*, *Love Revolution* and *Motel Bamako*. A vocal women's rights activist and a survivor of female genital mutilation, Modja works to denounce and de-legalize the practice.

Camille Crosnier

Camille Crosnier was born in La Rochelle, France. After graduating from the Lille Graduate School of Journalism, Crosnier became a journalist with Radio France and then the French commercial radio network RTL. In 2015, Crosnier joined Yann Barthès' *Petit Journal*, today known as *Quotidien*, an independent broadcast on French television and one of France's top talk shows.

Sasha Marianna Salzmann

Sasha Marianna Salzmann was born in Volgograd, Russia. In 1995, she emigrated to Germany, where she studied literature, theatre and media at the University of Hildesheim, and screenwriting at the Berlin University of the Arts. An award-winning dramatist and essayist, she was editor of *Freitext* – a German culture-and-society magazine – from 2002 to 2013. Salzmann became artistic director of Studio Я, at Berlin's Maxim Gorki Theatre, in 2013. She co-founded the New Institute for Dramatic Writing in 2014, with the goal of encouraging debate by bringing the social importance of the arts back into the public consciousness.

Karen Walker

Karen Walker CNZM was born in Auckland, New Zealand. She launched her eponymous fashion label in the late 1980s and showed at New York Fashion Week for twenty consecutive seasons from 2006 to 2016. Today her work is sold worldwide. Walker is committed to responsible, ethical sourcing, and her company partners with the African production company Artisan.Fashion to produce accessories of social significance. In 2004, she became a Member of the New Zealand Order of Merit, and, in 2014, she was made a Companion of the New Zealand Order of Merit for services to fashion design.

Lennie Goodings

Lennie Goodings was born near Niagara Falls, Canada. She is the publisher at Virago, the British trailblazing feminist publishing house that was established by Carmen Callil in 1973. Goodings has worked at Virago, which is now an imprint of Little, Brown, since 1978. She is the author of the children's book *When You Grow Up* and was a contributor to the 2013 anthology *Fifty Shades of Feminism*. She is married with two children.

Alicia Garza

Alicia Garza was born in Carmel in California, USA. She is an activist and organizer based in Oakland, California. In 2013, Garza co-founded Black Lives Matter (BLM), an ideological and political organizing network campaigning against anti-black racism and violence. In 2016, she and her two BLM co-founders were recognized in *Fortune*'s World's 50 Greatest Leaders. Garza is the director of special projects for the National Domestic Workers Alliance. She is also an editorial writer, whose work has been featured in publications including *The Guardian*, *The Nation*, *The Feminist Wire*, *Rolling Stone* and *Huffington Post*.

Ashley Judd

Ashley Judd was born in Sylmar in California, USA. She holds a master's degree in public administration from Harvard University's John F. Kennedy School of Government, where her paper, Gender: Law and Social Justice, won the Dean's Scholar Award. She is working towards a PhD at the University of California, Berkeley. A Golden Globe and Emmy Award – nominated actor, Judd is also a feminist social-justice humanitarian. She has served on the boards of the International Center for Research on Women, Population Services International, Apne Aap Worldwide and Demand Abolition, and was appointed a goodwill ambassador for the United Nations Population Fund in 2016.

Jutta Speidel

Jutta Speidel was born in Munich, Germany. She attended film school before embarking on a successful and award-winning career as an actor in film, theatre and television. In 1997, Speidel founded HORIZONT, a non-profit organization for homeless children and their mothers. She has received numerous awards, including the Prix Courage Woman of the Year Award in 2004, the Order of Merit of the Federal Republic of Germany Cross in 2005, the Bavarian Order of Merit in 2011 and the Bavarian Medal of Europe in 2017.

Leigh Sales

Leigh Sales was born in Brisbane, Australia. She holds a master's degree in international relations from Victoria's Deakin University and a bachelor's degree in journalism from the Queensland University of Technology. A journalist and author, Sales is the recipient of two Walkley Awards: for radio current-affairs reporting, in 2005, and for broadcasting and online interviewing, in 2012, and she was made a Member of the Order of Australia (AM) in 2019. Since 2011, Sales has hosted *7.30*, the Australian Broadcasting Corporation's television current-affairs programme.

Holly Bird

Holly Bird was born in Rochford in Essex, England. She attended Elam School of Fine Arts at the University of Auckland, New Zealand, before becoming a communicator in the New Zealand Police in 2009. Following her return to the United Kingdom, Bird became a member of the UK Police Service in 2013. Also a martial artist, Bird became a British kickboxing champion at the World Fight Sport and Martial Arts Council Championships in 2016. She holds a black belt in Shotokan karate, and is a qualified instructor.

Sana Issa

Sana Issa was born in Beirut, Lebanon. When she was fifteen

years old, her family married her to a man twenty years her senior; when she left her abusive husband, her family ostracized her. In 1982, Issa – a self-taught English speaker – began volunteering to guide aid workers and journalists visiting Beirut's refugee camps; this led to employment at *Newsweek* magazine's Beirut bureau and was the beginning of a twenty-five-year career in international journalism. In 1993, Issa moved to the United Kingdom, where she completed a master's degree at SOAS University of London. In 2016, Issa founded Agrabah Media.

pp. 24–27

Susan Carland
————

Susan Carland was born in Melbourne, Australia. A writer, sociologist and academic, Carland completed her PhD in the School of Political and Social Inquiry at Monash University in Melbourne in 2015. Her research and teaching focus on gender, sociology, terrorism and Islam.

p. 28

Carly Findlay
————

Carly Findlay was born in a small town in rural Victoria, Australia. Born with ichthyosis, a rare genetic skin disorder, she advocates for a more inclusive attitude towards media portrayals of people who are disabled and who are living with facial differences. She holds a masters of communication from Melbourne's RMIT University and a bachelor of e-commerce from La Trobe University, also in Melbourne. A blogger, writer, public speaker and appearance activist, Findlay was named one of Australia's most influential women in the 2014 *Australian Financial Review* Westpac 100 Women of Influence Awards.

p. 28

Manal Ali
————

Manal Ali was born in Damour, Lebanon, to Palestinian parents. She was born in Damour refugee camp and now lives in Beirut's Bourj El Barajneh camp. Ali works with Soufra, a catering social enterprise, established by the Women's Program Association. Soufra employs women from Bourj El Barajneh to produce Palestinian dishes that are sold outside of the camp.

p. 29

Marama Fox
————

Marama Fox was born in Hamilton, New Zealand. She has taught at Māori-language immersion schools aimed at fostering an understanding of Māori language, culture and wisdom, and in public secondary schools. Fox was an advisor to the Ministry of Education before being elected to the New Zealand Parliament in 2014; she is co-leader of the Māori Party.

p. 29

Ellen Bryant Voigt
————

Ellen Bryant Voigt was born in Chatham in Virginia, USA, and lives in Vermont. A teacher and writer, Voigt is the author of eight collections of poetry, including *Messenger: New and Selected Poems, 1976–2006*, which was a finalist for the 2008 Pulitzer Prize, and two collections of essays on the craft of poetry. In 2015, she was awarded a MacArthur Foundation fellowship.

pp. 30–32

Zainab Hawa Bangura
————

Zainab Hawa Bangura was born in Yonibana, Sierra Leone.

She holds a bachelor's degree from Fourah Bay College in Freetown, Sierra Leone, and advanced diplomas in insurance management from the University of London and Nottingham University. She was Sierra Leone's minister of foreign affairs and international cooperation between 2007 and 2010, and minister of health and sanitation between 2010 and 2012. She was the United Nations special representative of the secretary-general on sexual violence in conflict from 2012 to 2017. Bangura has received numerous awards for her social activism, including the Reagan-Fascell Democracy Fellowship and the National Endowment for Democracy's Democracy Award.

pp. 33–35

Jacinda Ardern
————

Jacinda Ardern was born in Hamilton, New Zealand. She holds a bachelor's degree in communication studies in professional communication from the University of Waikato. In 2008, Ardern became a member of the New Zealand Parliament. In 2017, she became leader of the New Zealand Labour Party and Leader of the Opposition. In October 2017, Ardern was elected Prime Minister of New Zealand. She is Minister for National Security and Intelligence, Minister for Arts, Culture and Heritage, and Minister for Child Poverty Reduction.

p. 36

Kimbra
————

Kimbra was born in Hamilton, New Zealand. Her debut album, *Vows*, was released in 2011, and her second album, *The Golden Echo*, was released in 2014. Kimbra's collaboration with Gotye on 'Somebody That I Used to Know' won record of the year and best pop duo/

group performance at the 2012 Grammy Awards. Kimbra has twice travelled to Ethiopia in support of Tirzah International, a global network of grassroots movements that works to combat poverty, exclusion from education, modern-day slavery, HIV/AIDS and violence against women and girls.

p. 36

Mpho Tutu van Furth
————

Mpho Tutu van Furth was born in London, England. She is a preacher, teacher, writer and retreat facilitator, and is an Episcopal priest. Shortly after her marriage to Marceline van Furth in 2016, she handed in her licence to officiate in the South African Anglican church, as it does not permit its priests to marry same-sex partners. Tutu van Furth is canonically resident in the USA. She is the daughter of anti-apartheid activists Archbishop Emeritus Desmond Tutu and Leah Tutu. Tutu van Furth was the founding director of the Desmond and Leah Tutu Legacy Foundation, which is dedicated to supporting projects and initiatives that promote peace and reconciliation for the flourishing of people and the planet.

p. 37

Lydia Ko
————

Lydia Ko was born in Seoul, South Korea, and grew up in New Zealand. In 2012, at the age of fifteen, she won the Canadian Women's Open title, making her the youngest-ever winner on the Ladies Professional Golf Association (LPGA) tour. In 2015, she became the world's number-one-ranked woman professional golfer, the youngest person ever to do so. Ko has achieved fourteen wins as a professional player on the LPGA tour, an Olympic silver medal at the 2016 Rio Olympic Games,

was named the LPGA's 2014 Rookie of the Year and 2015 Player of the Year, and was 2016 Young New Zealander of the Year.

p. 37
Catherine Keenan

Catherine Keenan was born in Perth, Australia. She holds a doctorate in English literature from Oxford University, and is a former journalist, arts writer and literary editor. In 2012, Keenan co-founded the Sydney Story Factory, a not-for-profit creative writing centre for marginalized young people. In 2016, Keenan was named Australia's Local Hero at the Australian of the Year Awards.

pp. 38–41
Jane Goodall

Jane Goodall DBE was born in London, England. She is a primatologist, conservationist, author and environmental activist, and holds a PhD in ethology from Cambridge University. In 1960, Goodall began living with and studying chimpanzees at Gombe Stream National Park in Tanzania. She is the founder of the Jane Goodall Institute for Wildlife Research, Education and Conservation, and of Roots & Shoots, a global environmental and humanitarian education programme for young people. She became a United Nations Messenger of Peace in 2002 and was made a Dame Commander of the Order of the British Empire in 2004.

p. 42
Rokhaya Diallo

Rokhaya Diallo was born in Paris, France. A journalist, award-winning documentary filmmaker and activist, in 2007 Diallo co-founded Les Indivisibles, an organization that uses parody and humour to break down racism. In 2012,

she was awarded a COJEP prize for her work against racism and discrimination. Diallo is the author of seven books, including *Afro!*, which was published in 2015. She has directed four documentaries, including *Not Yo Mama's Movement*, which investigated police brutality. In 2016, Diallo was highly commended by the European Diversity Awards in the Herbert Smith Freehills Journalist of the Year category.

p. 42
Stephanie Alexander

Stephanie Alexander AO was born in Melbourne, Australia. She has been owner-chef in several restaurants – including, for twenty-one years, Melbourne's acclaimed Stephanie's Restaurant – and is the author of fifteen books, among them *The Cook's Companion*, which has sold more than five hundred thousand copies. In 2004, she established the Stephanie Alexander Kitchen Garden Foundation. In 2014, Alexander was made an Officer of the Order of Australia for distinguished service to education and as an author, having previously been recognized for services to the hospitality and tourist industry, and the encouragement of apprentices, in 1994.

p. 43
Nicky Asher-Pedro

Nicky Asher-Pedro was born in Cape Town, South Africa. As a teenager she became involved in the anti-apartheid struggle and later worked in radio. She is a social worker, activist and journalist for The Big Issue magazine, a non-profit organization that empowers unemployed and marginalized adults.

p. 43
Katarina Pirak Sikku

Katarina Pirak Sikku was born in Jokkmokk, Sweden. She is a First Nations Sami woman. She graduated from Umeå Academy of Fine Arts in 2005. Her exhibition, *Nammaláhpán*, at the Bildmuseet contemporary art museum in Umeå, was nominated for the Dagens Nyheter Culture Prize in 2015; the multimedia exhibition was the result of Pirak Sikku's ten-year study into the racial and biological nature of the Sami peoples. Her work has also been shown at Korundi House of Culture in Finland, Grafikens Hus in Sweden, Museo de Arte Moderno de Medellín in Colombia and the Árran Lule Sami Centre in Norway.

pp. 44–46
Eva McGauley
1999–2018

Eva McGauley was born in Wellington, New Zealand. Raised in a strongly feminist environment, McGauley became a member of the Wellington Rape Crisis centre at the age of thirteen. In 2015, at age fifteen, she was diagnosed with nasopharyngeal carcinoma, which was subsequently confirmed to be terminal, and after undergoing several treatments of chemotherapy and radiation she passed away in 2018 at the age of nineteen. McGauley dedicated her teenage years to supporting young victims of sexual violence, having had several friends who are survivors of sexual assault, and was an intern for the Green Party.

pp. 47–49
Marian Wright Edelman

Marian Wright Edelman was born in Bennettsville in South Carolina, USA. A graduate of Spelman College and Yale Law School, she was the first African American woman to be admitted

to the Mississippi Bar. In 1968, she became counsel for the Poor People's Campaign, initiated by Martin Luther King Jr. In 1973, she founded the Children's Defense Fund, a not-for-profit child advocacy organization of which she remains president. Edelman's work has been widely recognized; among many awards, she is a recipient of the Albert Schweitzer Prize for Humanitarianism, a MacArthur Foundation fellowship and the Presidential Medal of Freedom.

p. 50
Emily Uy

Emily Uy was born on the island of Cebu, in the Philippines. She immigrated to the United States in 2008. Uy is a cancer survivor and full-time caregiver, specializing in working with patients in hospice care who are suffering from the effects of a stroke or cancer. She is a member of the Pilipino Workers Center in Los Angeles, California, a non-profit that serves Filipino workers and their families.

p. 50
Kakali Sen

Kakali Sen was born in Kolkata, India. At the age of fourteen, she began working twelve-hour days, seven days a week, in a jewellery factory. Sen now works as an artisan at The Loyal Workshop, and lives with her older sister in a red-light district of Bowbazar, Kolkata.

p. 51
Mithu Ghosh

Mithu Ghosh was born in Murshidabad, India. At the age of nine, she moved to Kolkata to live with her mother and aunt, who were working in the sex trade. Ghosh left school at fourteen and, after selling rotis for several years, now works as an artisan for The Loyal Workshop.

equality and the environment – and the founder of Navdanya, a movement that works to protect the diversity and integrity of living resources in India; she is a board member of the International Forum on Globalization. Shiva's published works include *Biopiracy, Stolen Harvest, Water Wars* and *The Violence of the Green Revolution*.

Ivy Ross

Ivy Ross was born in Yonkers in New York, USA. A graduate of New York's Fashion Institute of Technology and of Harvard Business School, her metalwork features in the permanent collections of twelve international museums, including the Smithsonian American Art Museum. Ross has been a senior executive in creative design and product development with companies such as Swatch, Coach, Calvin Klein and Mattel. She is a vice president, head of design and user experience for hardware products at Google.

Dominique Attias

Dominique Attias CLH was born in Tunis, Tunisia. She holds a master's of law from Université Paris II Panthéon-Assas and a post-graduate degree in clinical psychology and psychopathology from Université Paris 8. Attias lectures at a number of French tertiary institutions and has held offices in several French legal associations as well in the Louis Chatin Association, which works to defend children's rights. In 2011, Attias was made a Knight of France's National Order of the Legion of Honour.

Graça Machel

Graça Machel DBE was born in Gaza, Mozambique. She is an African stateswoman, a former freedom fighter and Mozambique's first minister of education. She is the widow of Mozambican president Samora Machel and of former South African president Nelson Mandela. Among numerous awards, Machel has received the United Nations' Nansen Refugee Award and is an honorary Dame Commander of the Order of the British Empire. She is the founder of the Graça Machel Trust and several other organizations through which she advocates for women's economic empowerment, food security and nutrition, education and good governance.

Gail Kelly

Gail Kelly was born in Pretoria, South Africa. She began her banking career in South Africa in 1980, before moving to Australia in 1997. In 2002, Kelly became the first female chief executive officer (CEO) of a top-fifteen ASX-listed company – St. George Bank. In 2007, Kelly was appointed CEO of Westpac Group. Since retiring from Westpac in 2015, Kelly has been engaged in a variety of roles, including with CARE Australia, an international organization that works to combat global poverty, with a particular focus on the empowerment of women and girls.

Rebecca Odes

Rebecca Odes was born in West Orange in New Jersey, USA. She earned a bachelor of arts degree from Vassar College, studied art at the School of the Art Institute of Chicago and holds a master's degree from the Interactive Telecommunications Program at New York University. In 1996, she co-founded gURL.com, the first major website for young women. She is the co-author of four books for women and girls, including the bestselling life-guide *Deal With It!*. In 2013, Odes co-founded Wifey.tv

to create and curate media by and for women.

Yene Assegid

Yene Assegid was born in Addis Ababa, Ethiopia. At age nine, at the beginning of the Ethiopian Civil War, she and her family emigrated to Belgium. Assegid later studied in the United States, gaining a PhD in transformative leadership from the California Institute of Integral Studies. She now works for The Shola Company, providing coaching and training in leadership development, team building and personal development.

Esther Duflo

Esther Duflo was born in Paris, France. She has degrees in history and economics from the École Normale Supérieure, Paris, and a PhD in economics from the Massachusetts Institute of Technology (MIT). She is a professor in the MIT department of economics, and a co-founder and co-director of the Abdul Latif Jameel Poverty Action Lab, a network of researchers whose mission is to reduce poverty by ensuring that policy is informed by scientific evidence. In 2009, she was awarded a MacArthur Foundation fellowship. Duflo is a co-author of the award-winning *Poor Economics: A Radical Rethinking of the Way to Fight Global Poverty*.

Sophie Blackall

Sophie Blackall was born in Melbourne, Australia. She earned her bachelor's degree in design with honours from the University of Technology in Sydney before relocating to Brooklyn, New York, in 2000. Blackall has illustrated more than forty children's books, including *Finding Winnie*,

for which she won the 2016 Randolph Caldecott Medal. Her 2012 MTA Arts and Design subway poster was displayed in trains throughout New York City. Blackall has collaborated with UNICEF creating artwork for immunization advocacy in the Democratic Republic of the Congo and India, and with Save the Children, promoting children's literacy in Rwanda and Bhutan.

Karen Mattison

Karen Mattison MBE was born in Liverpool, England. She began her career in the public and charity sectors, but realized after having children that career progression in part-time roles was significantly limited. In response to this, she first co-founded Women Like Us, to support women with children to find quality part-time and flexible work. She then co-founded Timewise, which is dedicated to unlocking the flexible jobs market in the United Kingdom. Mattison was made a Member of the Order of the British Empire in 2010.

Renée Montagne

Renée Montagne was born in Oceanside in California, USA. She is best known as the co-host, from 2004 to 2016, of the National Public Radio's flagship news programme, 'Morning Edition.' She graduated from the University of California, Berkeley, with a degree in English, and began her award-winning journalism career at an independent community radio station in San Francisco, KPOO, which dubs itself 'poor people's radio.' Montagne travelled to South Africa in 1990, arriving the day Nelson Mandela was released from prison, and covered the nation's transition to democracy up to President Mandela's inauguration. She has worked extensively in Afghanistan since 9/11.

pp. 74–76

Nicole Tung

Nicole Tung was born and raised in Hong Kong. She graduated with a double major in journalism and history from New York University in 2009, and has since worked as a photojournalist. Tung freelances for international clients that include *The New York Times*, *The Wall Street Journal* and *TIME* magazine, and her work has received numerous awards. Since 2011, Tung has been reporting on the civil war in Syria, where her friend and colleague James Foley was killed in 2014.

pp. 77–79

Diane Wright Foley

Diane Wright Foley was born in Keene in New Hampshire, USA. A former community health nurse and nurse practitioner, Wright Foley now runs the James W. Foley Legacy Foundation, an organization she co-founded in 2014 following the kidnapping, torture and murder of her eldest son James (Jim) by Islamic State. She is committed to American hostage return and safety for freelance conflict journalists, and to unifying such global efforts.

p. 80

Christine Parker

Christine Parker was born in Auckland, New Zealand. Trained as an accountant, she holds postgraduate qualifications in human resources management, leadership and quality management. In 2011, Parker became Group Executive, Human Resources, Corporate Affairs and Sustainability at Westpac Group. She is a governor of the St. George Foundation, a not-for-profit organization that helps disadvantaged children, and is a director of Women's Community Shelters, which works to establish new short-term emergency accommodation facilities for homeless women and children in New South Wales, Australia.

p. 80

Rosie Batty

Rosie Batty was born in Laneham, England. She moved to Australia in 1988. In 2014, her eleven-year-old son, Luke, was murdered by his father. Batty works as an advocate and campaigner against family violence. Her work was recognized with a national Pride of Australia Medal for courage in 2014, she was named Australian of the Year in 2015 and was made an Officer of the Order of Australia (AO) in 2019. Her memoir, *A Mother's Story*, was published in 2015.

p. 81

Lara Bergthold

Lara Bergthold was born in Boston in Massachusetts, USA. She has a master's degree in public policy from the John F. Kennedy School of Government at Harvard University. Bergthold is a principal partner at RALLY, a communications firm that works towards influencing how people think about and respond to political and social issues.

p. 81

Eryn Wise

Eryn Wise was born in Albuquerque in New Mexico, USA. She is a Native American woman of the Jicarilla Apache Nation and Laguna Pueblo People. She is an organizer for Honor the Earth, a not-for-profit that works to create awareness and support – both political and financial – for Native environmental issues and sustainable Native communities. In 2016, Wise became a leader and media coordinator for the International Indigenous Youth Council, campaigning against the Dakota Access Pipeline at Standing Rock Indian Reservation.

p. 82–85

Embeth Davidtz

Embeth Davidtz was born in Lafayette in Indiana, USA. She obtained a master's degree from Rhodes University in Grahamstown, South Africa. Davidtz has appeared in numerous films, including *Matilda*, *Schindler's List*, *Mansfield Park*, *Bicentennial Man* and *Bridget Jones's Diary*, and in television programmes that include *Californication*, *Mad Men* and *Ray Donovan*. She was diagnosed with stage-three breast cancer in 2013 and underwent chemotherapy, immunological treatment, lymph-node removal surgery and a mastectomy. Davidtz has been in remission since 2013.

p. 86

Adele Green

Adele Green AC was born in Cairns, Australia. She studied medicine, then epidemiology at the University of Queensland and at the London School of Hygiene and Tropical Medicine. She is a senior scientist at QIMR Berghofer Medical Research Institute in Brisbane and at Cancer Research UK, Manchester Institute and Manchester University. Her focus is on researching skin cancer and melanoma causation, prevention, management and prognosis. In 2004, Green was made a Companion of the Order of Australia for service to medical research, to public health and to leadership in the wider scientific community.

p. 86

Audrey Brown

Audrey Brown was born in Kliptown, South Africa. Inspired as a child by journalists such as Maud Motanyane and Don Mattera, she obtained a bachelor's degree in journalism, African history and politics from Rhodes University and a master's degree in journalism from the University of Wales, and is now a broadcast journalist with the BBC World Service. Brown has been particularly influenced by her mother, Beatrice, a fierce Catholic divorcee; her beloved uncle, Gene; and the fact that she is the only girl in a family of five children.

p. 87

Ronni Kahn

Ronni Kahn was born in Johannesburg, South Africa. She emigrated to Israel in 1970 and then to Australia in 1988. In 1994, she founded event-planning business Ronni Kahn Event Designs. In 2004, Kahn founded the food-rescue charity OzHarvest and was instrumental in changing legislation that had prevented potential food donors from donating their excess food. In 2010, Kahn was named Australia's Local Hero at the Australian of the Year Awards, and in 2012, she was awarded the Tribute Award for Innovation, Entrepreneurial Skill and Contribution to the Community at the Veuve Clicquot Business Woman Awards.

p. 87

Molly Biehl

Molly Biehl was born in Santa Monica in California, USA. She holds a master's degree in sociology, as well as a bachelor's degree in political science, with an emphasis on international relations. When her sister, Amy, was killed while working in South Africa in 1993, Biehl and her family – including her mother Linda Biehl (p. 172) – established the Amy Biehl Foundation Trust to focus on personal development, job skills development and income-generating opportunities in South African communities. Biehl has served as an executive director for the Amy Biehl Foundation and is a contractor in the health care industry.

pp. 88–90

Chimamanda Ngozi Adichie

Chimamanda Ngozi Adichie was born in Enugu, Nigeria. A graduate of Eastern Connecticut State University, Johns Hopkins University and Yale University in the United States, Adichie is an award-winning writer whose work has been translated into thirty languages. Her novels include *Purple Hibiscus*, which won the 2004 Hurston/Wright Legacy Award and the 2005 Commonwealth Writers' Prize; *Half of a Yellow Sun*, which won the 2007 Orange Broadband Prize for Fiction; and *Americanah*, which was among *The New York Times* ten best books of 2013. Adichie was awarded a MacArthur Foundation fellowship in 2008.

pp. 91–93

Gabourey Sidibe

Gabourey Sidibe was born in Brooklyn in New York, USA. She studied psychology before being cast in the titular role in the 2009 film *Precious*. Her debut performance earned critical acclaim, winning her an Independent Spirit Award for Best Female Lead and a National Association for the Advancement of Colored People Image Award for Outstanding Actress in a Motion Picture. For this role, she was also nominated for Academy, British Film and Television and Golden Globe Awards. Sidibe has since appeared in roles on film and television, including *American Horror Story*, *Empire* and *The Big C*. Her memoir *This is Just My Face: Try Not to Stare* was released in 2017.

p. 94

Véronique Vasseur

Véronique Vasseur was born in Paris, France. She graduated with a doctorate in medicine from Université Broussais Hotel Dieu in 1976. Vasseur worked in French medical social security

before being employed at La Santé Prison, Paris, in 1992; becoming the prison's chief medical officer in 1993. Her book *Médecin-chef à la Prison de la Santé*, which recounted her experiences at La Santé, was published in 2001, and resulted in death threats and a parliamentary inquiry. Vasseur is a member of the International Observatory of Prisons, and now works in the Hôpital Saint-Antoine, a public hospital. Vasseur is also a painter.

p. 94

Jurnee Smollett-Bell

Jurnee Smollett-Bell was born in New York City, USA. A working actor since childhood, she has received critical acclaim for her performances in *Eve's Bayou*, *The Great Debaters*, *Friday Night Lights* and *Underground*, among other roles. Her awards include a Critics' Choice Movie Award for Best Young Performer, and three National Association for the Advancement of Colored People Image Awards. Smollett-Bell is a committed activist working for racial justice and children's rights and to stop HIV/AIDS. She is on the board of directors of Children's Defense Fund and was a long-term board member of Artists for a New South Africa.

p. 95

Eva Orner

Eva Orner was born in Melbourne, Australia. She obtained a bachelor of arts (honours) degree from Melbourne's Monash University. In 2008, Orner won an Academy Award for Best Documentary Feature as producer of *Taxi to the Dark Side*, which investigates the torture and murder of an innocent Afghan taxi driver while detained at Guantanamo Bay Detention Camp. She has directed and produced numerous other highly acclaimed, award-winning documentaries including *Chasing Asylum*, *Out of Iraq* and *The Network*.

p. 95

Alfre Woodard

Alfre Woodard was born in Tulsa in Oklahoma, USA. A multiple-award-winning actor and activist, she is a founder of Artists for a New South Africa, an organization dedicated to ending apartheid, advancing democracy and equality, and fighting HIV/AIDS. In 2009, Woodard was appointed by Barack Obama to serve on the President's Committee on the Arts and Humanities.

pp. 96–99

Sarah Beisly

Sarah Beisly was born in Auckland, New Zealand. She holds a business degree from Massey University. In 2002, Beisly visited Kolkata, India, where she discovered and was inspired by Freeset, a pioneering business that provides alternative employment for women trapped in the sex trade. After spending a year in Bangladesh learning Bangla – one of the most spoken languages in Kolkata – in 2011 Beisly and her husband, Paul, moved to Kolkata. Together, they established The Loyal Workshop, an ethical leather-goods workshop that offers employment to women seeking to free themselves from sex work.

p. 100

Laure Hubidos

Laure Hubidos was born in Romans, France. Hubidos worked as a press secretary for the Franche-Comté regional council before founding La Maison de Vie, a home dedicated to those requiring palliative care, in 2011. She is a health consultant and founder of the national association of Maison de Vie.

p. 100

Mary Coussey

Mary Coussey was born in Plymouth, England. She has worked for the United Kingdom's Race Relations Board and its Commission for Racial Equality. For three years she was the Independent Race Monitor for the immigration service, monitoring how immigration staff treated certain nationalities prescribed by the Minister of State for Immigration on arrival in the United Kingdom. She now advocates for social justice and chairs the independent monitoring board for the Yarl's Wood Immigration Removal Centre.

p. 101

Christine Nixon

Christine Nixon was born in Sydney, Australia. She holds a bachelor of arts degree in philosophy and politics from Macquarie University and a master's in public administration from Harvard University. Nixon joined the New South Wales Police at age nineteen and became president of the women's branch of the Police Association of New South Wales at twenty-one. In 1994, Nixon became the New South Wales Police's director of human resources. From 2001 to 2009, she was chief police commissioner of the Victoria Police. Nixon has been awarded the Australian Police Medal, National Medal, Centenary Medal and New South Wales Police Medal.

p. 101

Miss Tic

Miss Tic was born in Paris, France. She is a French street-art pioneer whose stencil work and accompanying poems have been widely exhibited internationally, in public spaces, galleries and art fairs; her works have been acquired by the likes of the Fonds

Municipal d'Art Contemporain de la Ville de Paris, the Victoria and Albert Museum in London and the Museum of European and Mediterranean Civilizations in Marseilles. Miss Tic has collaborated widely, including with fashion houses Kenzo, Comme des Garçons, Longchamp and Louis Vuitton, and with the French Postal Service on a series of collector's stamps of her works for International Women's Day 2011.

pp. 102–104

Callie Khouri

Callie Khouri was born in San Antonio in Texas, USA. Her first screenplay, 1991's *Thelma & Louise*, won critical acclaim and numerous awards, including an Academy Award, a Golden Globe and a PEN Award. A lifelong feminist, Khouri is also a lecturer and a director of films – including *Divine Secrets of the Ya-Ya Sisterhood* and *Mad Money* – and the creator of the television drama series *Nashville*. She has served two terms on the Writers Guild of America's board of directors and, in 2014, was honoured by the United States' National Women's History Museum.

pp. 105–107

Gillian Anderson

Gillian Anderson OBE was born in Chicago in Illinois, USA. She is a critically acclaimed film, television and theatre actor, activist and writer. She is an active supporter of numerous non-profit organizations focussed on global social issues, as well as animal and human rights.

p. 108

Jude Kelly

Jude Kelly CBE was born in Liverpool, England. She holds a bachelor of arts in drama and theatre arts from the University

of Birmingham, and has directed numerous award-winning theatre and opera productions. In 2006, Kelly became the artistic director of the Southbank Centre, the United Kingdom's largest cultural institution. She is the founder of several arts organizations and events, including WOW – Women of the World Festival, which celebrates women and girls, and promotes gender equality. Kelly was made a Commander of the Order of the British Empire for services to the arts in 2015.

p. 108

Zelda la Grange

Zelda la Grange was born in Johannesburg, South Africa. She completed a three-year executive-secretary diploma at the University of Technology, Pretoria, in 1992. In 1994, she became assistant to the private secretary of South Africa's first democratically elected president, Nelson Mandela; in 1997, she herself became one of the president's private secretaries. Following President Mandela's retirement from the presidency in 1999 until his death in 2013, la Grange served him in various capacities, including as executive personal assistant, spokesperson, aide-de-camp and manager of his private office. In 2014, she published her bestselling memoir, *Good Morning, Mr Mandela*.

pp. 109, 278–279

Cleo Wade

Cleo Wade was born in New Orleans in Louisiana, USA. As an artist, speaker and poet, Wade is an inspiring voice in today's world for gender and race equality. Her poems speak to a greater future for all women, people of colour and the LGBTQI community. Wade's work is founded on the idea that art should not only be in the name of all people, but should serve all people.

p. 109

Nadia Remadna

Nadia Remadna was born in Créteil, France. She graduated as a special-education teaching graduate from the Institut Régional du Travail Social and is a social worker. In 2014, she founded The Mothers' Brigade, a grassroots organization in the Paris suburb of Sevran that supports families, and that aims to save children from recruitment into lives of extremism, fundamentalism and crime. Remadna's 2016 memoir, *Comment j'ai sauvé mes enfants*, describes her experiences raising children in a suburb plagued by radicalization.

p. 110

Josefine Cox

Josefine Cox was born in Marburg, Germany. She holds a degree in international business management from Cardiff University. She has been working in the field of corporate, product and service design solutions for more than fifteen years, and taught communication and design thinking processes at the Institute for Marketing and Communication. In 2015, Cox co-founded Musik Bewegt – meaning 'music moves' – an online donation platform through which musicians can gather support for their social endeavours and not-for-profit activities. Cox is managing director of Musik Bewegt and runs a small design consultancy.

p. 110

Linda Jean Burney

Linda Jean Burney was born in Leeton, Australia, which is part of the Wiradjuri nation. She worked as a teacher before becoming involved in the development and implementation of Aboriginal Education Policy, and in reconciliation. She headed the New South Wales Aboriginal Education Consultative Group

and the state's Department of Aboriginal Affairs before becoming the first Aboriginal person to serve in the New South Wales Legislative Assembly in 2003. In 2016, Burney became the first Aboriginal woman to serve in the House of Representatives in the Australian Parliament.

p. 111

Collette Dinnigan

Collette Dinnigan was born in Mandini, South Africa. She studied fashion and textiles in New Zealand before moving to Australia, where she established her eponymous fashion label in 1990. In 1995, Dinnigan became the first Australian-based designer to be invited by the Chambre Syndicale du Prêt-à-Porter des Couturiers et des Créateurs de Mode to show a ready-to-wear collection in Paris. Her many honours include *Collette Dinnigan: Unlaced*, a retrospective of twenty-five years of her work at the Museum of Applied Arts & Sciences in Sydney, which opened in 2015 for eighteen months. Dinnigan is now focussed on interior design projects and collaborations.

p. 111

Deborah Santana

Deborah Santana was born in San Francisco in California, USA. Her non-profit, Do A Little, serves women and girls in the areas of health, education and happiness. In 2005, Santana published a memoir, *Space Between the Stars*. Santana has produced five short documentary films, including four with Emmy Award-winning director Barbara Rick: *Road to Ingwavuma*, *Girls of Daraja*, *School of My Dreams* and *Powerful Beyond Measure*. Santana's films highlight the work of non-profit partners in South Africa and of a free secondary boarding school for girls in Kenya. Santana is mother to three adult children: Salvador, Stella and Angelica.

pp. 112–115

Winnie Madikizela-Mandela
1936–2018

Nomzamo Nobandla Winnie Madikizela-Mandela was born in the former Transkei, South Africa. Because of her anti-apartheid activism, she was regularly detained by the South African government. She endured house arrest, torture and imprisonment in solitary confinement, and was banished to the town of Brandfort in 1977. Madikizela-Mandela was married to Nelson Mandela for thirty-eight years, twenty-seven of which he was imprisoned. In 1985, she won the Robert F. Kennedy Human Rights Award for her role in South Africa's liberation struggle. Madikizela-Mandela was a member of the South African Parliament and a member of the African National Congress' national executive committee.

p. 116

Sapana Thapa

Sapana Thapa was born in Jhapa, Nepal. At the age of seven, she was sent to Kathmandu to be the primary caregiver of her grandmother. She was admitted to Bhim Sengala Secondary School, and upon graduation began working as a social worker at the Mitrataa Foundation, providing support for teachers, learners and parents.

p. 116

Clémentine Rappaport

Clémentine Rappaport CLH was born in Nantes, France. She began her career as a psychiatry assistant at Robert Ballanger Hospital in Aulnay-sous-Bois, near Paris; she founded an adolescent inpatient service at the hospital in 2000 and has led its child-psychiatry department since 2012. Rappaport was made a Knight of France's National Order of the Legion of Honour in 2017.

p. 117

Imany

Imany was born in Istres, France. She pursued a successful international modelling career before returning to France to become a singer, releasing her debut album, *The Shape of a Broken Heart*, in 2011. In 2014, Imany produced the soundtrack for the film *French Women*, and in 2016 released her second album, *The Wrong Kind of War*, which sold almost one hundred thousand copies; her song 'Don't Be So Shy' was a number-one single in France, Germany, Poland, Austria and Russia.

p. 117

Zoleka Mandela

Zoleka Mandela was born in Soweto, South Africa. She is the founder of the Zoleka Mandela Foundation and of the Zenani Mandela Campaign for road-safety awareness. Mandela is also an ambassador for the global SaveKidsLives road-safety organization, and the author of the autobiographical *When Hope Whispers*. She is the granddaughter of Nelson Mandela and Nomzamo Nobandla Winnie Madikizela-Mandela.

pp. 118–120

Roxane Gay

Roxane Gay was born in Omaha in Nebraska, USA. She is the author of several acclaimed books, including *The New York Times* bestselling *Bad Feminist*, a collection of essays exploring issues related to modern feminist identity and her experiences as a first-generation American born to Haitian parents. An associate professor at Purdue University, Gay is a contributing opinion writer for *The New York Times*, and, in 2006, co-founded *PANK Magazine*, a literary magazine fostering access to emerging and innovative poetry and prose.

pp. 121–123

Ai-jen Poo

Ai-jen Poo was born in Pittsburgh in Pennsylvania, USA. She has worked as a labour organizer for twenty years, transforming the landscape of working conditions and labour standards for domestic or private-household workers. Poo is executive director of the National Domestic Workers Alliance (NDWA) and a co-director of Caring Across Generations. In 2012, she was listed as one of *TIME*'s 100 most influential people and, in 2014, she was awarded a MacArthur Foundation fellowship. Her first book, *The Age of Dignity: Preparing for the Elder Boom in a Changing America*, was published in 2015.

p. 124

Hodan Isse

Hodan Isse was born in Hargeisa, Somalia. She holds a PhD in economics from George Mason University in Virginia and two master's degrees – in economics and international development – from Ohio University. She is a clinical assistant professor emeritus at the University at Buffalo School of Management. Isse is a co-founder and board member of the United States – based Somali Mental Health Foundation, a member of the board of directors for the Central Bank of Somalia and a founder of H.E.A.L., a not-for-profit based in Buffalo, New York, that helps refugees settle into their new lives. She is the first lady of the Puntland State of Somalia.

p. 124

Marilyn Waring

Marilyn Waring CNZM was born in Ngāruawāhia, New Zealand. She holds a doctoral degree in political economy from the University of Waikato, and at age twenty-three she became a member of parliament, serving until 1984. Waring's internationally influential critique of gross domestic product, *If Women Counted: A New Feminist Economics*, appeared in 1988. Since 2006, she has been a professor of public policy at the Institute of Public Policy at AUT University. In 2008, Waring was made a Companion of the New Zealand Order of Merit for her services to women and economics.

p. 125

Balika Das

Balika Das was born in Gomai in West Bengal, India. Her family arranged her marriage when she was eleven years old, and three years later a trafficker sold her to a brothel in Kolkata's red-light district, where she worked for twenty-three years. In 2014, she began working as an artisan at The Loyal Workshop. Das now lives in the suburb of Khidirpur, in Kolkata.

p. 125

Allison Havey

Allison Havey was born in New Jersey, USA, and grew up in New York City. She has worked internationally as a journalist and producer for the likes of NBC News, Associated Press, ABC News and The Biography Channel. In 2012, she co-founded The RAP Project to promote sexual awareness for teenagers, particularly in regard to negotiating the digital landscape and understanding how porn and social media influence attitudes and expectations. Havey is a co-author of *Sex, Likes and Social Media*, which was published in 2016.

pp. 126–129

Isabel Allende

Isabel Allende was born in Lima, Peru. She is the author of twenty-three books in her native Spanish, which have

been translated into thirty-five languages. Her award-winning works include *The House of the Spirits*, *City of the Beasts* and the international bestseller, *Paula*. Allende has received numerous awards, including the 2010 Chilean National Prize for Literature and the 2014 United States' Presidential Medal of Freedom. In 1996 – in memory of her daughter, Paula – Allende established the Isabel Allende Foundation to support initiatives aimed at preserving the rights of women and children.

p. 130

Ghada Masrieyeh

Ghada Masrieyeh was born in Beirut, Lebanon, to Palestinian parents. She was born in Sabra refugee camp and has lived in Beirut's Bourj El Barajneh refugee camp for thirty-two years. She works with Soufra, a catering social enterprise established by the Women's Program Association. Soufra employs women from Bourj El Barajneh to produce Palestinian dishes that are sold outside of the camp.

p. 130

Hibo Wardere

Hibo Wardere was born in Somalia. When civil war erupted in Somalia in the late 1980s, she was sent to Kenya, where she stayed illegally before seeking asylum in the United Kingdom when she was eighteen. Wardere is a campaigner against female genital mutilation (FGM), an author and a public speaker. Her 2016 memoir *Cut: One Woman's Fight Against FGM in Britain Today* chronicles her experiences as survivor of type-three FGM. Wardere's testimonials and campaigning work have appeared in publications that include *The Telegraph*, *BBC News Magazine* and *The Guardian*.

p. 131

Ambika Lamsal

Ambika Lamsal was born in Patlekhet, Nepal, into the Ghimire caste. Upon her marriage, at the age of thirteen, she became a member of the Lamsal caste – taking the last name Lamsal – and moved to Panchkhal, in central Nepal. She was widowed at age seventeen and became the sole caregiver for her two daughters. Since her widowhood – which carries with it strict cultural practices in Nepal – Lamsal has worked as a labourer in order to provide for and educate her daughters.

p. 131

Maggie Beer

Maggie Beer AM was born in Sydney, Australia. In 1979, Beer and her husband, Colin, established the highly acclaimed The Pheasant Farm restaurant in the Barossa Valley, which operated until 1993. Beer is the award-winning author of nine cookbooks and, in 2014, established the Maggie Beer Foundation to improve the quality of food for those in aged care. In 2012, Beer was made a Member of the Order of Australia for service to the tourism and hospitality industries as a cook, restaurateur and author, and to the promotion of Australian produce and cuisine.

pp. 132–134

Maria Shriver

Maria Shriver was born in Chicago in Illinois, USA. She is a mother, producer, a Peabody and Emmy Award – winning journalist and a *New York Times* bestselling author. She is the founder of Shriver Media. As California's first lady from 2003 to 2010, Shriver advocated for women, the working poor, military families and the disabled. In 2009, Shriver launched The Shriver Report, a non-partisan initiative that

raises awareness around the issues women and their families face. Shriver is also a leading Alzheimer's advocate, and the founder of the Women's Alzheimer's Movement; in 2017, Shriver was awarded the Alzheimer's Association's lifetime achievement award.

pp. 135–137

Laura Dawn

Laura Dawn was born in Pleasantville in Iowa, USA. She is a political activist, writer and filmmaker. From 2003 to 2012, she was the creative and cultural director for MoveOn. org, a public-policy advocacy group and political action committee. In 2012, she co-founded Art Not War, a cultural strategy group specializing in campaigns for social justice and progressive issues.

p. 138

Kanchan Singh

Kanchan Singh was born in Gurugram, India. She lives in Gurugram with her parents and brother. In 2015, Singh left her work as a delivery person and became a driver for Bikxie Pink, an app-based bike-taxi service in Gurugram founded to provide safe transport and employment for women.

p. 138

Pauline Nguyen

Pauline Nguyen was born in Saigon, Vietnam, and moved to Australia in 1978. Nguyen is a co-owner and co-founder of the acclaimed Red Lantern restaurant in Sydney. An author, spiritual entrepreneur and speaker, Nguyen's writing has appeared in Robert Drewe's *The Best Australian Essays 2010*, and her memoir *Secrets of the Red Lantern* saw her recognized as newcomer writer of the year at the 2008 Australian Book Industry Awards.

p. 139

Nokwanele Mbewu

Nokwanele Mbewu was born in Cala, South Africa. She manages the Mentor Mother Programme at the Philani Maternal Child Health and Nutrition Trust in Khayelitsha township in Cape Town, South Africa. The Philani Clinic provides holistic health and nutrition support to women and families in townships; its Mentor Mother Programme has been extended to South Africa's Eastern Cape, as well as to Swaziland and Ethiopia.

p. 139

Bec Ordish

Bec Ordish was born in Sydney, Australia. She graduated from Bond University with an honours degree in law, then specialized in intellectual property law. Ordish is a founder of the Mitrataa Foundation, a not-for-profit organization dedicated to inspiring Nepali people to empower themselves through education, skills, training, networks and self-belief. Ordish has lived and worked in Nepal since 2011, and has two adopted daughters, Nimu and Saraswoti.

pp. 140–143

Jody Williams

Jody Williams was born in Vermont, USA. She was involved in her first protest, against the Vietnam War, in 1970. During the 1980s, she worked against United States military involvement in Central America. Williams was awarded the Nobel Peace Prize in 1997 for her work coordinating the International Campaign to Ban Landmines. She helped found, and is the chair of, the Nobel Women's Initiative, which unites women recipients of the Nobel Peace Prize to support grassroots women's organizations in conflict areas.

p. 144

Sara Khan

Sara Khan was born in Bradford, England. She holds a master's degree in understanding and securing human rights from the University of London's School of Advanced Study. She is one of the United Kingdom's leading female Muslim voices on countering Islamist extremism and promoting human rights, and the co-founder of Inspire, a counter-extremism and women's-rights organization. In 2019 Khan was appointed by the British Government to lead an independent Commission for Countering Extremism in the wake of the 2017 terror attacks. She is also the author of the book *The Battle for British Islam: Reclaiming Muslim Identity from Extremism*.

p. 144

Lisa VeneKlasen

Lisa VeneKlasen was born in Cañon City in Colorado, USA, and grew up in New Mexico. She graduated from Smith College in Massachusetts and holds a master's degree in public policy from the John F. Kennedy School of Government at Harvard University. VeneKlasen is an activist, educator, strategist and organization builder, who has worked with social justice and women's rights and development organizations in Asia, Africa, Latin America and Eastern Europe. She is co-founder and executive director of Just Associates, an international network dedicated to strengthening the voice, visibility and collective organizing power of women.

p. 145

Claudie Haigneré

Claudie Haigneré was born in Burgundy, France. A rheumatology and neuroscience graduate and practitioner, Haigneré became an astronaut candidate to the French space agency in 1985. She has had two space missions as a European Space Agency (ESA) astronaut to the Mir space station in 1996, and to the International Space Station in 2001. Haigneré held several French political positions between 2002 and 2005, including minister for research and new technologies, and minister for European affairs. Since 2015, Haigneré has worked with the European Space Agency on its research and development plans for the construction of a village on the moon. Haigneré is a Grand Officer of the French Legion of Honor.

p. 145

Caster Semenya

Caster Semenya OIB was born in Ga-Masehlong, South Africa. She holds a bachelor's degree in sports science from the University of Pretoria. A professional middle-distance runner, she is an 800-metre-event world champion and a two-time Olympic gold medallist. Through the Caster Semenya Foundation, Semenya trains and assists young athletes, and supports campaigns to distribute menstrual cups to disadvantaged South African girls, supporting them to remain in school during their menstrual cycles. In 2014, Semenya was granted the bronze Order of Ikhamanga by the South African government for her achievements in sports.

pp. 146–148

Alexandra Paul

Alexandra Paul was born in New York City, USA. She began her acting career at age eighteen and became internationally recognized for her role as Stephanie Holden in the television series *Baywatch*. Paul has become a dedicated environmental and animal rights activist, and advocates on the issue of overpopulation.

She has been arrested for civil disobedience several times, including while advocating on behalf of nuclear disarmament and protesting the 2003 Iraq War. She is the twin sister of Caroline Paul (p. 152).

pp. 149–151

Ruth Bader Ginsburg

Ruth Bader Ginsburg was born in Brooklyn in New York, USA. She holds a bachelor of laws from Columbia Law School. Ginsburg co-founded the Women's Rights Project of the American Civil Liberties Union (ACLU) in 1971, later serving as the ACLU's general counsel and on its board. She was appointed a judge of the United States Court of Appeals for the District of Columbia Circuit in 1980 and an associate justice of the Supreme Court of the United States in 1993. She was awarded a Thurgood Marshall Award for contributions to gender equality and civil rights in 1999.

p. 152

Jodi Peterson

Jodi Peterson was born in Orange County in California, USA. She earned a bachelor's degree in communications and sociology from Boston University, before working in marketing, communications and public relations. Peterson is development director of the Interfaith Sanctuary Homeless Shelter in Boise, Idaho.

p. 152

Caroline Paul

Caroline Paul was born in New York City, USA. She obtained her pilot's license at twenty and eventually flew paragliders and ultralights. At twenty-three she joined an all-women whitewater team, rafting unexplored rivers in places like Borneo and Australia. A Stanford graduate, Paul joined the San Francisco Fire Department soon after,

becoming the fifteenth female firefighter in a department of fifteen hundred men. She is currently a writer, and the author of four books, including *The New York Times* bestseller *The Gutsy Girl: Escapades for Your Life of Epic Adventure*. She is the twin sister of Alexandra Paul (pp. 146–148).

p. 153

Gillian Caldwell

Gillian Caldwell was born in New York City, USA. She holds a bachelor of arts degree from Harvard University and a juris doctor degree from Georgetown University Law Center. As executive director of WITNESS, which trains and supports people using video in their fight for human rights, Caldwell helped produce over thirty documentary shorts and films. She was campaign director for the United States 1Sky climate and energy campaign. Caldwell is chief executive officer of Global Witness, a not-for-profit that exposes the hidden links between demand for natural resources, corruption, armed conflict and environmental destruction.

p. 153

Amy Eldon Turteltaub

Amy Eldon Turteltaub was born in Hampstead in London, England. When she was nineteen, her brother, Dan – who was a Reuters photographer and war correspondent – was stoned to death in Somalia. Inspired by his memory, in 1997 she and her mother, Kathy Eldon, founded the Creative Visions Foundation, dedicated to inspiring and empowering creative activism. Creative Visions' film, *Dying to Tell the Story* – in which she explored the lives of war correspondents – was nominated for a Primetime Emmy Award for Outstanding Non-Fiction Special in 1999.

pp. 154–157

Divya Kalia

Divya Kalia was born and raised in Delhi, India. She earned her master's degree in economics from the Gokhale Institute of Politics and Economics in Pune. Kalia began her career as an analytics and consulting professional for Genpact, then the Royal Bank of Scotland, before working in consumer-finance strategy for Boston Consulting Group. Kalia is the chief operating officer of Bikxie Pink, an app-based bike-taxi service that she co-founded in Gurgaon in 2015.

p. 158

Amy Stroup

Amy Stroup was born in Boston in Massachusetts, and grew up in Abilene in Texas, USA. She holds a bachelor's degree in business administration and marketing from Lipscomb University in Nashville, Tennessee. A singer-songwriter, Stroup has released three solo albums: *Chasing Greenlights*, *The Other Side of Love* and *Tunnel*, and has had more than one hundred of her songs feature in television shows and commercials, and films. In 2010, she co-founded Milkglass Creative, an independent identity and brand development studio.

p. 158

Nadya Tolokonnikova

Nadya Tolokonnikova was born in Norilsk in Siberia, Russia. She studied philosophy at Lomonosov Moscow State University. She is an artist, political activist and founding member of punk-rock art collective Pussy Riot. In 2012, following an anti-Putin performance in Moscow's Cathedral of Christ the Saviour, Tolokonnikova was sentenced to two years in prison for hooliganism; she was released in 2013. Tolokonnikova is a member of prisoners' rights group Zona Prava and is a founder of the independent news service MediaZona. In 2014, she received the Hannah Arendt Prize for Political Thought.

p. 159

Monika Hauser

Monika Hauser was born in Thal, Switzerland. She studied medicine in Innsbruck, Austria, going on to specialize in gynaecology. In 1993, in response to the mass rape of women during the Bosnian War, Hauser and a team of twenty Bosnian psychologists and doctors opened a women's therapy centre in Zenica. This evolved into Medica Mondiale, an international women's rights organization of which Hauser remains executive member of the board. In 2008, her service was honoured with a Right Livelihood Award, and, in 2012, she was awarded the Council of Europe's North – South Prize.

p. 159

Sabila Khatun

Sabila Khatun was born in Sundarpur, Nepal. In 1993, she and her husband, together with four children, moved to Kathmandu to find work. Unable to find employment and unsupported by her alcoholic husband, Khatun and her children were forced to beg for money and sleep on the streets. A mother of eight, Khatun has gone on to become a tradesperson; with this income and the financial support of foreigners, she has been able to provide an education for six of her children.

pp. 160–162

Bobbi Brown

Bobbi Brown was born in Chicago in Illinois, USA. She founded Bobbi Brown Essentials in 1991; the brand was acquired by the Estée Lauder Companies Inc. in 1995. In 2013, Brown launched the Pretty Powerful Campaign for Women & Girls, supporting women's empowerment through training and education. In 2016, Brown stepped down from Bobbi Brown Cosmetics to create a new lifestyle platform that celebrated empowerment and confidence. She recently published her ninth book, *Beauty from the Inside Out*, and was named creative consultant of the American department store Lord & Taylor, where she created JustBOBBI, an in-store and digital lifestyle concept boutique.

pp. 163–165

Angela Davis

Angela Davis was born in Birmingham in Alabama, USA. She holds a bachelor of arts degree from Brandeis University in Massachusetts, and a PhD in philosophy from Humboldt University of Berlin. Her work as an educator has always emphasized the importance of building communities of struggle for economic, racial and gender justice. She is the author of ten books, including *Are Prisons Obsolete?* and *Freedom is a Constant Struggle: Ferguson, Palestine and the Foundations of a Movement*. She is a distinguished professor emerita of history of consciousness and feminist studies at the University of California, Santa Cruz.

p. 166

Becky Lucas

Becky Lucas was born in Brisbane, Australia. In 2014, she was chosen to perform as part of the Melbourne International Comedy Festival's *The Comedy Zone* showcase. She performed her debut solo comedy show, *High Tide*, in 2015, and a second full-length show, *Baby*, in 2016. Lucas has written for the International Emmy-nominated television series *Please Like Me*.

p. 166

June Steenkamp

June Steenkamp was born in Blackburn, England, and moved to South Africa in 1965. In 2013, Steenkamp's daughter, Reeva Steenkamp, was shot and killed by Paralympian Oscar Pistorius, who had been dating Reeva for several months. Pistorius was later convicted of Reeva's murder. In 2015, Steenkamp established the Reeva Rebecca Steenkamp Foundation to educate and empower women and children against violence and abuse.

p. 167

Georgie Smith

Georgie Smith was born in Perth, Australia. A filmmaker, chef and designer, Smith is the founder of A Sense of Home, a not-for-profit organization based in Los Angeles that is dedicated to creating homes for young people who are exiting the foster-care system. In 2016, Smith was named a Top 10 CNN Hero for her work with A Sense of Home and, in 2017, was nominated for a Women's Choice Awards Shero Award.

p. 167

LaTanya Richardson Jackson

LaTanya Richardson Jackson was born in Atlanta in Georgia, USA, and graduated from Spelman College. An actor and philanthropist, she is a Trustee of the American Theatre Wing and Board Council of the Smithsonian's National Museum of African American History and Culture. She supports a number of charitable organizations, including the Children's Defense Fund and the American Civil Liberties Union, and was a long-time board member of Artists for a New South Africa. She met her husband, Samuel L. Jackson, in 1968 on a plane travelling to protest Martin Luther King, Jr.'s assassination. Their daughter, Zoe, is a senior television producer.

pp. 168–171

Elif Shafak

Elif Shafak was born in Strasbourg, France. She holds a degree in international relations from Middle East Technical University, a master's degree in gender and women's studies and a PhD in political science. Shafak is the author of fifteen books, including the bestselling *The Bastard of Istanbul* and *The Forty Rules of Love*. Her books have been published in forty-seven languages and have been long- and short-listed for numerous awards. Shafak is also a political commentator, TEDGlobal speaker, a member of the World Economic Forum Global Agenda Council on Creative Economy and a founding member of the European Council on Foreign Relations.

p. 172

Dana Gluckstein

Dana Gluckstein was born in Los Angeles in California, USA. She is a graduate of Stanford University, where she studied psychology, painting and photography. She has photographed Indigenous Peoples worldwide as well as iconic figures that include Nelson Mandela and Muhammad Ali. Her 2010 book *DIGNITY: In Honor of the Rights of Indigenous Peoples* and its associated exhibition *DIGNITY: Tribes in Transition* have received international acclaim.

p. 172

Linda Biehl

Linda Biehl was born in Geneva in Illinois, USA. When Biehl's daughter Amy was killed while working in South Africa, in 1993, she and her family – including daughter Molly Biehl (p. 87) – established the Amy Biehl Foundation to focus on personal development, job skills development and income-generating opportunities in South African communities.

Biehl now focusses on her work in the United States as chief executive officer of the Amy Biehl Foundation, USA, and works with programmes centred on human rights, forgiveness, restorative justice, and other lessons learned from South Africa.

p. 173

Sergut Belay

Sergut Belay was born in Addis Ababa, Ethiopia. She fled Ethiopia in 2012, after her husband became a political prisoner of the Ethiopian government; she hasn't had contact with him for five years. Belay lives in Boden, Sweden, and is a project administrator at Havremagasinet, an art gallery that exhibits Swedish, Nordic and international contemporary art. She is also a volunteer supporter of new immigrants.

p. 173

Amber Heard

Amber Heard was born in Austin in Texas, USA. As an actor, she is known for roles in *The Danish Girl*, *Pineapple Express*, *Zombieland*, *North Country* and *All the Boys Love Mandy Lane*. Heard is an activist and vocal advocate for women's and LGBTQI rights, and has worked to raise awareness of domestic and sexual violence. She is a supporter of the American Civil Liberties Union, The Art of Elysium, Amnesty International and Children's Hospital Los Angeles.

pp. 174–176

Nicole Avant

Nicole Avant was born in Los Angeles in California, USA. She graduated from California State University, Northridge. In 2009, she was named the thirteenth United States Ambassador to the Commonwealth of the Bahamas after a unanimous senate confirmation. Avant was the

first African-American woman and the youngest person to hold this title. She has been honoured for her philanthropy by organizations including The Trumpet Awards and Children Mending Hearts. She is a board member for several not-for-profit organizations, including Girls Inc. and the Los Angeles County Museum of Art board of trustees.

pp. 177–179

Vidya Balan

Vidya Balan was born in Mumbai, India. She holds a bachelor's degree in sociology from St. Xavier's College, a master's degree in sociology from Bombay University (now University of Mumbai) and has passed the junior vocal examination in carnatic music at Karnataka University. Balan is an acclaimed actor in Indian cinema, whose work has been recognized with more than fifty awards, and she was on the 2013 Cannes Film Festival jury. Balan is an ambassador for the Indian government's sanitation programmes, and, in 2014, was awarded the Padma Shri Award by the Indian government.

p. 180

Elisabeth Masé

Elisabeth Masé was born in Basel, Switzerland, and lives in Berlin. She is a graduate of the Academy of Art and Design FHNW in Basel and is a fine artist. Her paintings and works on paper appear in public and private collections in Switzerland, Germany and the United States. She is the author of two books: *Der Hibiskus Blutet* and *Amerika: Give Me a Reason to Love You*. Masé has received numerous awards, including the SwissAward in 1987, the Manor Art Prize in 1992 and a scholarship at the Cité Internationale des Arts in Paris in 1985.

p. 180

Elida Lawton O'Connell

Elida Lawton O'Connell was born in Pristina, Kosovo. She began working as a producer for Associated Press in 1997, covering the Kosovo War for five years. Since then she has continued to work for Associated Press as a producer and editor.

p. 181

Dianna Cohen

Dianna Cohen was born in Hollywood in California, USA. She holds a bachelor of fine arts degree from the University of California, Los Angeles (UCLA) and is a visual artist who has worked primarily with plastic bags as her material. In 2009, she co-founded the Plastic Pollution Coalition, a global alliance that aims to stop plastic pollution and that now comprises more than five hundred non-governmental organizations and businesses around the world.

p. 181

Alexandra Zavis

Alexandra Zavis was born in Stockholm, Sweden. She spent a decade as a journalist with the Associated Press, reporting from war-torn countries in Africa, Asia and the Middle East, including Liberia, Sierra Leone, the Democratic Republic of the Congo, Sudan, Somalia, Afghanistan and Iraq. In 2006, Zavis joined the *Los Angeles Times* as an international-affairs writer and editor. She is a recipient of the American Academy of Diplomacy's Arthur Ross Media Award for distinguished reporting and analysis on foreign affairs and the Society of Professional Journalists' Sigma Delta Chi Award for foreign correspondence.

Dolores Huerta

———

Dolores Huerta was born in Dawson in New Mexico, USA. A teacher, lifelong labour activist, community organizer, and feminist, she co-founded the Stockton, California, chapter of the Community Service Organization and founded the Agricultural Workers Association. She and César Chávez co-founded and led the National Farm Workers Association, which became United Farm Workers of America. Huerta heads the Dolores Huerta Foundation, developing grassroots community organizers and national leaders. She received the Eleanor Roosevelt Award for Human Rights, the Ellis Island Medal of Honour and was inducted into the National Women's Hall of Fame. She was awarded the Presidential Medal of Freedom.

———

Safia Shah

———

Safia Shah was born in London, England, and is the daughter of Sufi philosopher Idries Shah. She has worked with Afghan refugees on the Pakistan – Afghan border, has owned a traditional British food store and is the author of numerous books and short stories. In 1990, *Afghan Caravan* – a miscellany collected by Shah's father and edited by her – was selected as the *Daily Telegraph* Book of the Year.

———

Gina Belafonte

———

Gina Belafonte was born in New York City, USA. She attended the High School of Performing Arts and is a graduate of State University of New York at Purchase. Belafonte is a civil rights activist, actor, producer and director, who has appeared on stage, film and television. She produced the acclaimed documentary *Sing Your Song* about her father, Harry Belafonte, and is the director of *Lyrics from Lockdown*, a hip-hop musical about racial profiling. She co-organized the 2017 Women's March in Los Angeles and co-directs Sankofa.org, a social justice organization using culture and entertainment in advancing justice, peace, equity and equality.

———

Dana Donofree

———

Dana Donofree was born in Dayton in Ohio, USA. She earned a degree in fashion design from Savannah College of Art and Design before becoming a design assistant in New York. In 2014, Donofree founded AnaOno, a lingerie and loungewear company that designs specifically for women who have had breast reconstruction, breast surgery, mastectomy, or are living with other conditions that cause pain or discomfort. Herself a breast cancer survivor, Donofree is active in the breast cancer community, serving as the co-chair on the board of Jill's Wish and as a member of the Living Beyond Breast Cancer board.

———

Valerie Van Galder

———

Valerie Van Galder was born in Chicago in Illinois, USA. A graduate of the University of California, Los Angeles, Van Galder has worked in the entertainment industry for over thirty years. Van Galder currently runs Depressed Cake Shop, a global pop-up concept, raising awareness and funds to help people suffering from mental health issues. She is on the board of directors of St. Joseph Center in Venice, California, an agency assisting low-income families and the homeless.

———

Danielle Brooks

———

Danielle Brooks was born in Augusta in Georgia, USA. She attended the South Carolina Governor's School for the Arts and Humanities, then the Juilliard School in New York. Her work in the Netflix series *Orange Is the New Black* has been recognized with three Screen Actors Guild Awards for Outstanding Performance by an Ensemble in a Comedy Series, and in 2014, Brooks won the Young Hollywood Breakthrough Actress Award. Her performance in *The Color Purple* on Broadway saw her nominated for a 2016 Tony Award for Best Featured Actress in a Musical and earned her a Grammy Award for Best Musical Theater Album.

———

Meryl Marshall-Daniels

———

Meryl Marshall-Daniels was born in Los Angeles in California, USA. She has worked as a criminal trial lawyer and an entertainment lawyer, was vice president of compliance and practices for NBC television network, was an independent television producer and has also served as the chairperson and chief executive officer of the Academy of Television Arts & Sciences. Now a facilitator, mediator and executive coach, Marshall-Daniels specializes in leadership, organizational development and conflict.

———

Pamela Novo

———

Pamela Novo was born in Buenos Aires, Argentina. Her family emigrated to Australia when she was two years old. She holds a bachelor's degree in design and technology, and a master's degree in secondary education from Western Sydney University, and has completed post-graduate studies in leadership, Adobe software and information communication technologies. Since 2009, Novo has been a secondary-school computing, design and technology teacher. She is studying towards a bachelor's degree in computer science (gaming) at Charles Sturt University. In 2016, she was awarded a Westpac Bicentennial Foundation Young Technologists scholarship. In May 2017, she gave birth to her son, Valentino.

———

Tracy Gray

———

Tracy Gray was born in Omaha in Nebraska, USA. Gray holds a bachelor's degree in mathematical science from the University of California, Santa Barbara, and dual master's degrees in business administration from the University of California, Berkeley, and Columbia University. In 2013, she founded and became managing partner of The 22 Capital Group, a Los Angeles venture-capital and advisory firm. In 2016, Gray founded We Are Enough, a not-for-profit whose mission is to educate women on investing in women-owned or women-led businesses, and how to invest with a 'gender lens.' She started her career as a systems engineer on the NASA Space Shuttle program.

———

Elin Rova

———

Elin Rova was born in Kangos, Sweden. Rova studied nursing at the Luleå University of Technology and has been a practicing nurse since 2015. She is currently working as a trauma nurse, as well as studying midwifery at Umeå Institute of Technology. She also trains and competes as an elite CrossFit athlete; she placed first in CrossFit Boden's Battle of the North, and fourth in the Greek Throwdown, in 2017.

———

Tabitha St. Bernard-Jacobs

Tabitha St. Bernard-Jacobs was born in Arima, Trinidad and Tobago. After studying at St. Francis College and the Fashion Institute of Technology in New York City, she launched a zero-waste clothing label, Tabii Just. She is an outspoken advocate for ethical manufacturing and the disruption of fabric waste. In 2014, she began chronicling her experience raising an interracial child in an interfaith home. In 2016, she became the youth coordinator for the Women's March on Washington, creating the Youth Ambassador Program. She was named among *Elite Daily*'s '100 Women Who Have Stood up to Trump in his First 100 Days.'

Aminatta Forna

Aminatta Forna OBE was born in Glasgow, Scotland, and raised in the UK and Sierra Leone. She is the award-winning author of three novels, *The Hired Man, The Memory of Love* and *Ancestor Stones*, and the memoir *The Devil That Danced on the Water*. Forna is a Fellow of the Royal Society of Literature and has acted as a judge for numerous literary awards, including the Man Booker International Prize. In 2002, Forna established the Rogbonko Project, which works to improve education, sanitation and maternal health in Sierra Leone. She was made OBE in the Queen's New Year's Honours 2017.

Marita Cheng

Marita Cheng was born in Cairns, Australia. She holds a bachelor of engineering in mechatronics and a bachelor of computer science from the University of Melbourne. In 2012, Cheng was named Young Australian of the Year

for her work as the founder of Robogals Global, which teaches girls robotics artificial intelligence and encourages their interest in engineering. She is the founder and chief executive officer of aubot, which builds robots that help people in their everyday lives. She was made a Member of the Order of Australia (AM) in 2019.

Julie Taymor

Julie Taymor was born in Boston in Massachusetts, USA. Upon graduation from Oberlin College, she spent four years in Indonesia on a Watson Foundation fellowship and, in 1991, received a MacArthur 'Genius' Fellowship. Her theatre credits include the all-time highest-grossing Broadway musical, *The Lion King*, for which she won two Tony Awards; *Grounded*, starring Anne Hathaway at the Public Theatre; and *M. Butterfly*, with Clive Owen. Her operas include *Oedipus Rex*, with Jessye Norman; and *The Magic Flute* at the Metropolitan Opera. Her films include *Titus*, starring Anthony Hopkins; the Academy Award – winning *Frida*, starring Salma Hayek; *Across the Universe*; *The Tempest*, starring Helen Mirren; and *A Midsummer Night's Dream*.

Pearl Tan

Pearl Tan was born in Perth, Australia. She is a National Institute of Dramatic Art acting graduate, and holds a communications degree from Edith Cowan University and a master's degree in commerce from the University of Sydney. Tan is the director of Pearly Productions, which creates independent films, including *The Casting Game*, and the award-winning web series, *Minority Box*. In 2014, Tan co-founded the Equity Diversity Committee, and, in 2016, was

included in the Australian Financial Review and Westpac 100 Women of Influence. In 2017, she delivered a TEDx Talk on reimagining diversity.

Carla Zampatti

Carla Zampatti AC, OMRI was born in Lovero, Italy, and immigrated to Australia in 1950. She founded her eponymous and award-winning fashion-design business in 1965. In 2004, Zampatti was made a Commander of the Order of Merit of the Italian Republic, and, in 2008, her achievements were recognized with the Australian Fashion Laureate Award. In 2009, Zampatti was made a Companion of the Order of Australia for service through leadership and management roles in the fashion and retail property sectors, to multicultural broadcasting, and to women as a role model and mentor.

Santilla Chingaipe

Santilla Chingaipe was born in Livingstone, Zambia, and moved to Australia with her family when she was nine years old. A graduate of RMIT University in Melbourne, she is an award-winning journalist for Australia's SBS World News and a documentary filmmaker. Chingaipe's work has been recognized at the Victorian African Community Awards and at the Celebration of African Australians Awards, and she is also a four-time finalist for the United Nations Association of Australia Media Peace Awards.

Rosemary Jones

Rosemary Jones was born in Worcester, England, as Robert Anthony Jones. She earned a bachelor of medicine from the University of Bristol,

going on to specialize in gynaecology. Jones has worked in South Africa, Zimbabwe, England and Australia, and specializes in endometriosis, hormone-replacement therapy, laparoscopy, menopause, pelvic pain and testosterone. She is a co-founder of the Beaumont Trust, an organization established in the United Kingdom that provides information and support relevant to gender dysphoria and transgender-related matters. Jones now operates a private menopause clinic in Adelaide, Australia, and is a member of Doctors for Voluntary Euthanasia Choice.

Anita Heiss

Anita Heiss was born and raised in Sydney, Australia, and is a member of the Wiradjuri Nation of central New South Wales. Heiss' award-winning published works include the novel *Not Meeting Mr Right*, the *Macquarie PEN Anthology of Aboriginal Literature* and the memoir *Am I Black Enough For You?* Heiss has been a communications advisor for the Aboriginal and Torres Strait Islander Arts Board of the Australia Council, and deputy director of Warawara – Department of Indigenous Studies at Macquarie University. She is a lifetime ambassador of the Indigenous Literacy Foundation and manages the Epic Good Foundation.

Kaylin Whittingham

Kaylin Whittingham was born in Saint Ann, Jamaica. She holds bachelor's degrees in economics and literature, and is a graduate of Northeastern University School of Law. She was staff counsel at the Attorney Grievance Committee of New York State's First Judicial Department before founding Whittingham Law, a legal ethics and alternative

dispute resolution firm. She is president of the Association of Black Women Attorneys, an advisor to the American Immigration Lawyers Association's *Ethics Compendium* and sits on the New York State Bar Association's House of Delegates. In 2016, she was honoured with a Black Women of Influence Trailblazer Award.

pp. 204-206

Jessica Gallagher

Jessica Gallagher was born in Geelong, Australia. At the age of seventeen, she was diagnosed with cone dystrophy, a rare eye disease, and was classified as legally blind. Gallagher went on to represent Australia as a Paralympic alpine skier, track-and-field athlete, and tandem cyclist. She won alpine-skiing bronze medals at both the 2010 Vancouver and 2014 Sochi Winter Paralympics, and at the 2016 Rio Paralympics became the first Australian to medal at both summer and winter games when she won a track-cycling bronze medal. Gallagher is an osteopath, and global ambassador and board director for Vision 2020 Australia.

pp. 207-209

Deana Puccio

Deana Puccio was born in Brooklyn in New York, USA. After becoming a lawyer, then prosecutor, she worked as assistant district attorney in the Kings County, Brooklyn, sex crimes and special victims unit. In 2001, Puccio moved to London where she taught US law. In 2012, Puccio co-founded The RAP Project to promote teenage sexual awareness, particularly in the digital landscape, and an understanding of the influence of porn and social media. Puccio is the co-author of *Sex, Likes and Social Media*, which was published in 2016.

p. 210

Julia Leeb

Julia Leeb was born in Munich, Germany. She studied international relations and diplomacy in Madrid, Arabic in Alexandria, and television and digital media in Munich. She works as a war photojournalist and filmmaker, and is the author of *North Korea: Anonymous Country*. Leeb's long-term projects have been published internationally and document political upheaval in the Democratic Republic of the Congo, Egypt, Syria, Libya, Afghanistan, South Sudan and Iran. She also produces virtual reality and 360-degree content about remote regions like Transnistria, in Moldova, and the Nuba Mountains, in Sudan.

p. 210

Jane Caro

Jane Caro was born in London, England, and emigrated to Australia at the age of five. Caro graduated from Macquarie University with a bachelor of arts in 1977 and became an award-winning advertising copywriter. Now an author, social commentator, speaker and broadcaster, Caro appears regularly on Australian television, and has authored and co-authored eight books. She was made a Member of the Order of Australia (AM) in 2019.

p. 211

Hlubi Mboya Arnold

Hlubi Mboya Arnold was born in Alice in Eastern Cape, South Africa. She is best known for her role in the South African Broadcasting Corporation drama *Isidingo*, in which she portrayed the long-running show's first HIV-positive character. Mboya Arnold is a social-justice activist, a social-entrepreneurship advocate, a sportswoman, an educator and a scholar, and is an executive director of two not-for-profit organizations: Future CEOs, which supports South Africans whose socioeconomic circumstances exclude them from accessing top business education and professional development opportunities; and Sunshine Cinema, a solar-powered mobile cinema that converts solar energy into social impact.

p. 211

Nahid Shahalimi

Nahid Shahalimi was born in Kabul, Afghanistan. She holds degrees in international politics and Southeast Asian studies, and in fine arts from Champlain College and Concordia University in Canada. She is the founder and chairwoman of the Hope Foundation for Women and Children of Afghanistan and supports of UNICEF Germany. In 2009, she launched *We, the Women – Germany*, a book and travelling exhibition that honours strong, inspirational German women. In 2017, her book *Wo Mut die Seele trägt: Wir Frauen in Afghanistan* profiled women and girls in Afghanistan.

p. 212-215

Geena Rocero

Geena Rocero was born and raised in Manila, in the Philippines. At seventeen, she moved to the United States, where she began a successful modelling career. In 2014, she came out as transgender at the annual TED Conference; her TED Talk has since been viewed over 3 million times on ted.com and has been translated into thirty-two languages. An award-winning producer and television host, Rocero is the founder of Gender Proud, a media production company that tells stories to elevate justice and equality for the transgender community worldwide. Rocero has spoken about trans rights at the White House, the World Economic Forum and the United Nations.

p. 216

Véronique de Viguerie

Véronique de Viguerie was born in Toulouse, France. She holds a master's degree in law and studied photojournalism. In 2004, she travelled to Afghanistan, where she worked for three years before continuing her photojournalism work internationally. De Viguerie's work has been featured in publications worldwide, including in *The New York Times*, *Paris Match*, *Der Spiegel* and *The Guardian*, and has been recognized with numerous awards, including the 2006 Canon Female Photojournalist Award. De Viguerie is the co-author of three books, including *Carnets de Reportage du XXIe siècle* and *Profession: Reporter*, both with Manon Quérouil.

p. 216

Yassmin Abdel-Magied

Yassmin Abdel-Magied was born in Khartoum, Sudan, and moved to Australia just before her second birthday. She holds a bachelor of mechanical engineering from the University of Queensland. An author, mechanical engineer, activist and television presenter, Abdel-Magied sits on the boards of ChildFund Australia, the Australian government's Council for Australian – Arab Relations and the domestic-violence-prevention organization Our Watch. In 2015, she was recognized as Queensland's Young Australian of the Year.

p. 217

Christy Haubegger

Christy Haubegger was born in Houston in Texas, USA. She holds a bachelor's degree in philosophy from the University of Texas at Austin and a law degree from Stanford Law School. In 1996, Haubegger founded *Latina* magazine, serving as its publisher,

president and chief executive officer until 2001. She was an associate producer of the 2003 film *Chasing Papi* and executive producer of the 2004 film *Spanglish*, and has been an executive at Creative Artists Agency since 2005. In 2000, Haubegger was inducted into the American Advertising Federation's Hall of Achievement for increasing understanding of the United States Hispanic market.

p. 217

Andrea Mason

Andrea Mason was born in Subiaco in Perth, Australia. She is a member of the Ngaanyatjarra and Kronie People. In 2004, she became the first-ever Indigenous Australian woman to lead an Australian political party, the Family First Party. In 2009, Mason became chief executive officer of the Ngaanyatjarra, Pitjantjatjara and Yankunytjatjara Women's Council, an organization that works with women to increase their capacity to lead safe and healthy lives. In 2016, Mason was named Telstra Australian Business Woman of the Year for her work in Central Australia. She was named Northern Territory Australian of the Year in 2017.

pp. 218-220

Ruchira Gupta

Ruchira Gupta was born in Kolkata, India. A former journalist, Gupta directed and produced the Emmy Award-winning 1997 documentary *The Selling of Innocents*, which investigated the sex-trafficking industry. In 2002, Gupta co-founded Apne Aap Women Worldwide, an organization working to empower girls and women to resist and end sex trafficking. She has received numerous awards for her activism, including being made a Knight of France's National Order of Merit and being awarded the

Clinton Global Citizen Award for Commitment to Leadership in Civil Society. She campaigns for a world in which no human being is bought or sold.

pp. 221-223

Alice Waters

Alice Waters was born in New Jersey, USA. In 1971, she opened her restaurant Chez Panisse, in Berkeley, California. Waters has written fifteen books, including *The New York Times* bestsellers *The Art of Simple Food* and *The Art of Simple Food II*, and the memoir, *Coming to My Senses*. In 1995, she founded the Edible Schoolyard Project, which is dedicated to building a national edible-education curriculum. Waters' work has been widely recognized, earning her seven James Beard Awards, a National Humanities Medal in the United States, in 2014, and induction into the French Legion of Honour, in 2010.

p. 224

Emma Davies

Emma Davies was born in London, England. She is a graduate of the Corona Theatre School. A television, film and stage actor, Davies' work has included appearances in *Emmerdale, Mosley, Royal Wives at War* and *Cape Wrath*.

p. 224

Jessica Grace Smith

Jessica Grace Smith was born in Taihape, New Zealand. She graduated from Toi Whakaari: New Zealand Drama School with a bachelor of performing arts in 2009. An actor, writer, director and producer, Smith appeared in the long-running and award-winning Australian drama series, *Home & Away*, between 2014 and 2015. Her first short film, *Everybody Else Is Taken* – the story of a young girl who refuses to let her gender define her – premiered at the New York

International Children's Film Festival in 2017.

p. 225

Pia Sundhage

Pia Sundhage was born in Ulricehamn, Sweden. She made her debut for the Sweden women's national football team at age fifteen and was capped 146 times, scoring 71 goals. Sundhage was the head coach of the United States women's national football team from 2008 to 2012, her team winning two Olympic gold medals and placing runner-up in the 2011 FIFA Women's World Cup. In 2012, Sundhage was named FIFA World Coach of the Year for Women's Football and became head coach of the Sweden women's national football team; the team earned a silver medal at the 2016 Rio Olympic Games.

p. 225

Sharon Brous

Sharon Brous was born in New Jersey, USA. Ordained as a rabbi in 2001, Brous has become a leading voice in reanimating religious life in America, working to develop a spiritual roadmap for soulful, multifaith justice work around the country. In 2004, she co-founded IKAR, one of the fastest-growing Jewish congregations in the United States. IKAR is credited with sparking a rethinking of religious life in a time of declining affiliation. She works to inspire people of faith to reclaim a moral and prophetic voice in counter-testimony to the extremism prevalent in so many religious communities.

pp. 226-229

Ruth Reichl

Ruth Reichl was born in New York City, USA. She wrote her first cookbook at the age of twenty-one and later was a restaurant critic for the *New York Times* and *Los Angeles*

Times. She was editor in chief of *Gourmet* magazine from 1999 to 2009. A television host and producer, Reichl is also the author of four memoirs: *Tender at the Bone, Comfort Me with Apples: More Adventures at the Table, Garlic and Sapphires* and *For You Mom, Finally.* Reichl has been recognized with six James Beard Awards.

p. 230

Fereshteh Forough

Fereshteh Forough was born to Afghan parents in Iran. She and her family lived in Iran as refugees until, after the fall of the Taliban regime in 2001, they returned to live in Herat. Forough completed her bachelor's degree in computer science at the University of Herat before completing a master's degree in Germany. Forough is the founder of Code to Inspire, the first coding school for women in Afghanistan, and is dedicated to empowering women through education in technology.

pp. 4-5, 230

Januka Nepal

Januka Nepal was born in Panchkhal, Nepal. She was entered into an arranged marriage when she was eight years old and was widowed soon thereafter. In the fifty-six years that have followed her widowhood, Nepal has adhered to Nepalese traditional cultural practices, which dictate that widows remain chaste, commit to a vegetarian diet and abstain from wearing red clothes.

p. 231

Katherine Acey

Katherine Acey was born in Utica in New York, USA. An activist in the women's, racial justice and LGBTQI movements, Acey served as executive director of the Astraea Lesbian Foundation for Justice from 1987 to 2010. Acey is the director

of strategic collaborations for GRIOT (Gay Reunion in our Time) Circle, which addresses the needs of older LGBTQI people of colour. She is a senior activist fellow emerita at the Barnard Center for Research on Women, and a board member for both the Center for Constitutional Rights and for Political Research Associates.

p. 231

Sarah Outen

Sarah Outen MBE was born in Wegberg, Germany. Raised in the United Kingdom, she is a biology graduate of St. Hugh's College, Oxford. In 2009, she became the first woman and the youngest person to row solo across the Indian Ocean. In 2011, she was made a Member of the Order of the British Empire for services to rowing, conservation and charity. In 2015, travelling by rowing boat, bicycle and kayak, Outen completed a four-and-a-half-year, round-the-world-journey. She is a supporter of The Adventure Syndicate, CoppaFeel!, Inspire+, YHA, Youth Adventure Trust and Jubilee Sailing Trust.

p. 232

Suha Issa

Suha Issa was born in Beirut, Lebanon, to Palestinian parents. Issa studied English language and literature at Beirut Arab University, and currently works as an English teacher to both Palestinian and Syrian refugees in Beirut. She is married and mother to four children who are all university graduates.

p. 232

CCH Pounder-Koné

CCH (Carol Christine Hilaria) Pounder-Koné was born in Georgetown, Guyana. She received her bachelor of fine arts and an honourary doctorate from Ithaca College, New York. An award-winning

actor and Grammy-nominated spoken-word artist, she garnered Emmy nominations for her roles in *The No. 1 Ladies' Detective Agency*, *ER*, *The X-Files* and *The Shield* and has appeared in *NCIS: New Orleans* since 2014. Her films include *Bagdad Café* and *Avatar*. A visual artist, curator, and social justice advocate, Pounder-Koné is a founding board member of the African Millennium Foundation and a co-founder of Artists for a New South Africa.

p. 233

Mariam Shaar

Mariam Shaar was born in the Bourj El Barajneh refugee camp, Lebanon, where she now lives, to Palestinian parents. She has been a social worker for almost twenty years, and runs the Bourj El Barajneh Center of the Women's Program Association, an organization that provides education, vocational-skills training and microloans to women in eight out of the twelve Palestinian refugee camps in Lebanon. In 2013, with seed funding from Alfanar, a venture philanthropy, she founded Soufra, a catering business that employs women from Bourj El Barajneh camp.

p. 233

Patricia Grace King

Patricia Grace King was born in Charlottesville in Virginia, USA. She holds a master of fine arts from Warren Wilson College and a PhD in English from Emory University. An author, educator and cancer survivor, in the early 1990s she worked in Guatemala with the non-governmental organization Witness for Peace, which aims to change United States policies and corporate practices that affect Latin America. She later directed a language school and cross-cultural-experience programme, CASAS, in Guatemala City. Her novella, *Day of All Saints*, reflects upon stories of refugees

from Guatemala's civil war and won the 2017 Miami University Novella Prize.

pp. 234–236

Nomvula Sikhakhane

Nomvula Sikhakhane was born in Katlehong, South Africa. From the age of six, Sikhakhane was abused by her stepfather. Later, while living with her grandmother, Sikhakhane met Sahm Venter (pp. 237–239) and Claude Colart, who became her unofficial guardians. A graduate of the HTA School of Culinary Art, Sikhakhane now works as a chef.

pp. 237–239

Sahm Venter

Sahm Venter was born in Johannesburg, South Africa. As a journalist for more than twenty years, her career focussed on covering the anti-apartheid struggle and South Africa's transition to democracy. Venter works as the senior researcher at the Nelson Mandela Foundation. She edited the highly acclaimed *The Prison Letters of Nelson Mandela*, co-edited *491 Days: Prisoner Number 1323/69* by the late Winnie Madikizela-Mandela, and co-authored *Conversations With a Gentle Soul* with the late Ahmed Kathrada. Venter and her partner, Claude Colart, are unofficial guardians of Nomvula Sikhakhane (pp. 234–236).

p. 240

Zamaswazi Dlamini-Mandela

Zamaswazi Dlamini-Mandela was born in Welkom, South Africa. She is the granddaughter of Nelson Mandela and Nomzamo Nobandla Winnie Madikizela-Mandela, and of King Sobhuza II of Swaziland and Mbhono Shongwe. A business developer, public speaker and self-described serial entrepreneur, she launched her

luxury fashion range, Swati by Roi Kaskara, in 2017.

p. 240

Joanne Fedler

Joanne Fedler was born in Johannesburg, South Africa. She studied law at the University of the Witwatersrand and at Yale University before returning to South Africa, where she lectured in law and became legal advisor at People Opposing Women Abuse (POWA), a women's rights organization that provides both frontline and advocacy services. Fedler's debut novel, *The Dreamcloth*, was nominated for South Africa's *Sunday Times* Fiction Prize in 2006, while *Secret Mothers' Business* was on the 2008 *Der Spiegel* bestseller list. Now a full-time author and writing mentor, Fedler works with aspiring female authors to help them find their voices through the power of writing.

p. 241

Jan Owen

Jan Owen AM was born in Brisbane, Australia. She has spent twenty-five years growing Australia's youth, social-enterprise and innovation sectors. In 2000, she was made a Member of the Order of Australia. In 2012, she was named overall winner of the inaugural *Australian Financial Review* Westpac 100 Women of Influence awards. Owen is the author of *Every Childhood Lasts a Lifetime* and *The Future Chasers*. She is also the chief executive officer of the Foundation for Young Australians and of YLab, a global youth-futures design and learning lab.

p. 241

Anne-Sophie Mutter

Anne-Sophie Mutter CLH was born in Rheinfelden, Germany. She began her international violin career at age thirteen, at the 1976 Lucerne Festival, and

performed as a soloist under the conductor Herbert von Karajan at the 1977 Salzburg Festival. A four-time Grammy Award winner, Mutter has performed twenty-five world premieres. She works to support next-generation musicians and is committed to numerous philanthropic projects, including the Anne-Sophie Mutter Foundation. Mutter has received numerous honours, including the Great Cross of Merit of the Federal Republic of Germany and the French Legion of Honour in the rank of Chevalier.

pp. 242–244

Miranda Tapsell

Miranda Tapsell was born in Darwin, Australia. She is a First Nations woman of the Larrakia tribe. Tapsell is best known for her role in *The Sapphires* – the story of four Indigenous Australian women who travelled to Vietnam in the sixties to perform for United States troops – and her role in the drama series *Love Child*, which deals with the subject of historical forced adoptions of Indigenous Australian children. In 2015 Tapsell won a Logie award for her performance in *Love Child*, and, in her acceptance speech, called for more people of colour to appear on television.

p. 245–247

Louise Nicholas

Louise Nicholas ONZM was born in Rotorua, New Zealand. A survivor of childhood and adult sexual violence, Nicholas is a campaigner and advocate for victims of sexual violence, liaising with survivors and their families, with communities and with police. Nicholas is the co-author of *Louise Nicholas: My Story*, which she wrote with investigative journalist Phil Kitchin. In 2007, Nicholas was recognized as the *New Zealand Herald's* New Zealander of the Year, and, in 2015, she was made an Officer of the Order of New Zealand for

services to the prevention of sexual violence.

p. 248

Lisa Congdon

Lisa Congdon was born in Niskayuna in New York, USA. She spent fifteen years working in public education before embarking on a career as a writer, illustrator and fine artist. Congdon is the author of seven books, including *Whatever You Are, Be a Good One; Art Inc.; Fortune Favors the Brave; The Joy of Swimming*; and *A Glorious Freedom: Older Women Leading Extraordinary Lives*. Her clients include New York City's Museum of Modern Art, Harvard University and *Martha Stewart Living*. The organization Forty Over 40 included Congdon in their 2015 list of the Forty Women Over 40 to Watch.

p. 248

Lavinia Fournier

Lavinia Fournier was born in Romania. She moved to France at age fourteen and holds a master's degree in international relations from the National Institute of Oriental Languages and Civilsations, at Paris-Sorbonne University, before working as a financial and administrative manager for AFGE, a French corporate-governance association, and for the not-for-profit Educateam. Fournier began helping Roma living in France in 2014 and became a social worker dedicated to reducing shantytowns on a national level in 2016.

p. 249

Shami Chakrabarti

Shami Chakrabarti CBE was born in London, England. She holds a bachelor of laws from the London School of Economics and Political Science, and trained as a barrister before joining the Home Office in 1996. Chakrabarti

became in-house counsel for British civil-liberties-advocacy organization Liberty in 2001 and was its director from 2003 to 2016. In 2007, Chakrabarti was made a Commander of the Order of the British Empire for her services to human rights. In 2016, she was appointed to the House of Lords and became Labour shadow attorney general for England and Wales.

p. 249

Florence Aubenas

Florence Aubenas was born in Brussels, Belgium. She graduated as a journalist from the Centre de Formation des Journalistes in Paris in 1984, before embarking on a reporting career with *Libération*, *Le Nouvel Observateur* – today *L'Obs* – and *Le Monde*. In 2005, while working in Baghdad, Iraq, Aubenas was abducted; she was released five months later. In 2010, her book, *Le Quai de Ouistreham* – which chronicled her experiences working undercover as a cleaner on ferries operating out of Ouistreham port, near Caen, France – won her the Jean Amila-Meckert prize and the Joseph Kessel Prize.

p. 250–253

Margaret Atwood

Margaret Atwood CC was born in Ottawa, Canada, and received her undergraduate degree from Victoria College, University of Toronto, and her master's from Radcliffe College. She has authored more than forty books of fiction, poetry and critical essays, including the dystopian novel *The Handmaid's Tale*. Her writing has garnered numerous awards, including the Booker Prize, the Governor General's Award, and the Arthur C. Clarke Award. Atwood has served as president of the Writers' Union of Canada and the International PEN Canadian Centre and is an environmentalist and conservationist. She was granted the Order of Canada in 1973.

p. 254–255

Märta, Karin, and Linnéa Nylund

The Nylund sisters – Märta, Karin and Linnéa – were born in Markusvinsa in Lappland, Sweden, where they still live together; their village is home to twenty people and is north of the Arctic Circle. All three women trained as teachers, with Karin specializing in the Swedish minority language, Meänkieli. Since retiring from full-time teaching, the sisters have owned and operated a restaurant and hotel in Korpilombolo, a neighbouring village. They are also the organizers of the Korpilombolo European Festival of the Night, a philosophy, literature and arts festival that is held annually between 1 and 13 December.

Index

The Charities

Ten per cent of the originating publisher's revenue received from book sales and exhibitions of *200 Women: who will change the way you see the world* will be distributed to organizations primarily devoted to protecting and advancing the rights of women. Each contributor has nominated an organization or individual (or herself if she is in financial need) to receive her portion of the charitable pool. The beneficiaries include those listed below.

93'Or d'enfants, Service de Pédopsychiatrie, Centre Hospitalier Robert Ballanger
A Sense of Home
Aboriginal Literacy Foundation
Acid Survivors Trust International
AFM-Téléthon
African Millennium Foundation
Ambika Lamsal
American Civil Liberties Union
American Jewish World Service
Amy Biehl Foundation USA
Animals Australia
Apne Aap Women Worldwide
Arab American Association of New York
Association of Black Women Attorneys, New York City
Asylum Seeker Resource Centre
Barada Syrienhilfe
Barnfonden
Berivan Vigoureux
Black Girls Code
Brave Trails
Breast Cancer Cure
Butterfly Home
Canon Collins Educational & Legal Assistance Trust
CARE Australia
CARE International
Caster Semenya Foundation
Changing Behaviour: Creating Sanitation Change Leaders
Children's Defense Fund
Children's Hospital at Westmead
Chinese American International School, San Francisco
Code to Inspire
Collectif National des Maisons de Vie
Coppafeel
Covenant House New York
Creative Visions
Critical Resistance
Daraja Education Fund
Desmond & Leah Tutu Legacy Foundation
Deutsche Stiftung Weltbevölkerung
Divya Kalia
Doctors Without Borders
Dolores Huerta Trust
Dress for Success
Droit au Logement
Endometriosis UK

Edible Schoolyard Project
ENDOmind
Equal Access
Eva McGauley
FAIR Girls
For Film's Sake
Foundation for Young Australians
Fred Hollows Foundation
Friends of the Elizabeth Blunt School
Fund for Global Human Rights
Future Hope
Girls Not Brides
Global Witness
Good Shepherd Microfinance
Graça Machel Trust
Groundswell Project
Guttmacher Institute
Gynécologie Sans Frontières
H.E.A.L. International
Hibo Wardere
Honor the Earth
Hope Foundation for Women and Children of Afghanistan
HORIZONT
Hunger Project
Indigenous Literacy Foundation
Innovations for Poverty Action
Interfaith Sanctuary
International Women's Development Agency
International Women's Media Foundation
Isabel Allende Foundation
James W. Foley Legacy Foundation
Jane Goodall Institute, New Zealand
Januka Nepal
Jessica Grace Smith
Just Associates
Kanchan Singh
Kids Creative
Korpilombolo European Festival of the Night
Kosovo Rehabilitation Centre for Torture Victims
L'association pour l'intégration sociale des handicapés physiques
L'association Rêves
L'Observatoire des violences policières
La Brigade des Mineurs
La Maison des Femmes
Les Restaurants du Cœur

LEYLA
Lisel Mueller Scholarship, established by Friends of Writers
Long Walk to Freedom Library Project
Louise Nicholas Trust
Loyal Workshop
Luke Batty Foundation
MADRE
Maggie Beer Foundation
Māori Women's Refuge, Gisborne
medica mondiale e.V.
METAvivor
Mitrataa Foundation
Move This World
Naidoo Pillay Fund
National Breast Cancer Foundation
National Domestic Workers Alliance
New Zealand Prostitutes Collective
Nicky Asher-Pedro
Nicole Tung
No Kid Hungry
Nobel Women's Initiative
Nokwanele Mbewu
NPY Women's Council
Our Watch
OzHarvest
Padres Contra El Cáncer
People Opposing Women Abuse
Philani Family Fund
Philani Maternal, Child Health and Nutrition Project
Pilipino Workers Center
Planned Parenthood
Plastic Pollution Coalition
Political Research Associates
Population Media Center
Population Services International
Positive Exposure
Prison Insider
Public Education Foundation
Qaqamba Gubanca
RAP Project
Reaching Out – Montclair
Reeva Rebecca Steenkamp Foundation
Restaurant Opportunities Centers United, Washington, DC
Robogals
Rogbonko Village School Trust
Room To Read
Sabila Khatun

SAIL (Sudanese Australian Integrated Learning) Program
Sands (Stillbirth & neonatal death charity)
Sankofa.org
Sergut Belay
Seven Tepees Youth Program
SOS Children's Villages (Syria)
STEAM Education
Stephanie Alexander Kitchen Garden Foundation
Sydney Community Foundation
Sydney Story Factory
Teddy Bear Clinic
Terre des Femmes
TGI (Transgender, Gender Variant, and Intersex) Justice Project
Thistle Farms
Tirzah International
Transgender Law Centre
Trey AA Simon-Pritchard
Tribes in Transition Education Fund
Tukela Organization School
Ububele
UNICEF
UNICEF (Australia)
Vision Australia
WaterAid
We Are Enough
Winifred Nomzamo Mandela Trust
Wirringa Baiya – Aboriginal Women's Legal Centre
Wolf Conservation Centre
Women Awareness Centre Nepal, Kathmandu
Women for Women International
Women for Women International, Munich
Women's Aid, UK
Women's Alzheimer's Movement
Women's Community Shelters
Women's Programs Association
Youth Without Borders
Zizile Institute for Child Development
Zoleka Mandela Foundation
Zonta International – Fistula program

Acknowledgements

We are immensely grateful to the many generous and kind souls without whom this book would not have been possible.

First and foremost, our profound thanks and gratitude to our intrepid travelling team, including the family members we roped in. To the imperturbable Kieran E. Scott, who so selflessly put his career on hold for a year to embark on this adventure with us: your exquisite images beautifully honour these two hundred incredible women, and we simply couldn't have asked for a more passionate and assiduous partner. To Josef Scott, whose superb video captured each and every interview and faithfully recorded our travels: your musical talent and perennially genial outlook were cherished by all of us on the road. To Elizabeth Blackwell, who cajoled, choreographed and coordinated every last little thing: your diplomacy and dedication to the cause were second to none. And to Tam West: your kindness and grace added a special lustre to the touring party when you joined us.

To our editorial collaborators Sharon Gelman, Marianne Lassandro and Elisabeth Sandmann, who helped us persuade, wrangle, corral and interview: thank you for the professionalism, generosity and enthusiasm you brought to the project throughout.

We would also like to thank our many friends and colleagues who opened their address books, hearts and homes to us: Michelle Mouracade at Alfanar and Mariam Shaar at Soufra, Lebanon; Gina Belafonte; Meryl Marshall-Daniels; Gillian Anderson; Zelda la Grange; Ruchira Gupta; Ricky Sandberg and Ingela Ögren Weinmar at Havremagasinet gallery in Boden, Sweden; Ivy Ross; Joanne Fedler; Jonny Geller; Sarah Beisly and Jake Thomas at The Loyal Workshop, Kolkata; Bec Ordish, Nimu Sherpa Ordish, Sapana Thapa and Sarita Gurung at Mitrataa, Kathmandu; Sello Hatang and Verne Harris at the Nelson Mandela Foundation; Manu and Felix Pierrot; Friedrich-Karl and Philipp Sandmann; and especially Georgie Smith and Melissa Goddard. A particular thank you to Sahm Venter and Claude Colart – your little black books never failed to deliver, and your boundless support and friendship carried us through many an uncertain moment.

Thank you also to Susan Buchanan, Miriam Dean, Claudia Edwards and Andrea Holmes for being test subjects at the outset of the project; and Genevieve Senekal from Canon New Zealand and Greg Webb from Hasselblad New Zealand for their generous assistance with advice, equipment and materials; and Daryl Simonson and Troy Caltaux from Image Centre Group.

Huge thanks to the talented publishing team at Blackwell & Ruth: Leanne McGregor, Kate Raven, Dayna Stanley, Christian Scott, Stefanie Lim, Helene Dehmer and Joyce Liu, and more recently Nikki Addison and Olivia van Velthooven, but especially Cameron Gibb, Benjamin Harris, Lisette du Plessis and Elizabeth Blackwell. This was a gargantuan team effort, and your commitment to excellence never fails to astonish and humble us.

Finally, to the exceptional women who grace these pages: your stories inspired us, your generosity humbled us, and your strength fortified us. Thank you from the bottom of our hearts for being part of this extraordinary project. We hope that together we will change the way people see the world.

Ruth Hobday and Geoff Blackwell

Geoff Blackwell and Ruth Hobday are the award-winning New Zealand creative team behind a range of internationally bestselling books founded on humanity, equality and the environment. Their books have been published in forty languages.

Kieran E. Scott is an award-winning photographer whose work has appeared in magazines, books and advertising campaigns. He is based in New Zealand.

Web: twohundredwomen.com
Facebook: 200 Women
Instagram: 200women
Twitter: @200women
YouTube: @twohundredwomen

First published in the United States of America in 2019 by Chronicle Books LLC.

Produced and originated by Blackwell and Ruth Limited
Suite 405, Ironbank, 150 Karangahape Road, Auckland 1010, New Zealand
www.blackwellandruth.com

Created by: Geoff Blackwell and Ruth Hobday
Publisher: Geoff Blackwell
Editor in Chief: Ruth Hobday
Photography: Kieran E. Scott
Interviewers: Geoff Blackwell, Ruth Hobday, Kieran E. Scott, Sharon Gelman,
 Marianne Lassandro and Elisabeth Sandmann
Videography: Josef Scott and Kieran E. Scott
Design Director: Cameron Gibb
Designer & Production Coordinator: Olivia van Velthooven
Publishing Manager: Nikki Addison
Project editorial: Benjamin Harris, Lisette du Plessis
Project co-ordinator: Elizabeth Blackwell

Library of Congress Cataloging-in-Publication Data available.

ISBN: 978-1-4521-8465-4

Chronicle Books LLC
680 Second Street, San Francisco, CA 94107
www.chroniclebooks.com

10 9 8 7 6 5 4 3 2

Printed and bound in China by 1010 Printing Ltd.

This book is made with FSC®-certified paper and other controlled material and is printed with soy vegetable inks. The Forest Stewardship Council® (FSC®) is a global, not-for-profit organization dedicated to the promotion of responsible forest management worldwide to meet the social, ecological, and economic rights and needs of the present generation without compromising those of future generations.